THE WORLDS OF

JOHN WICK

THE YEAR'S WORK:

STUDIES IN FAN CULTURE AND CULTURAL THEORY

Edward P. Dallis-Comentale and Aaron Jaffe, editors

THE WORLDS OF

JOHN WICK

THE YEAR'S WORK AT THE
CONTINENTAL HOTEL

EDITED BY CAITLIN G. WATT
& STEPHEN WATT

INDIANA UNIVERSITY PRESS

This book is a publication of

Indiana University Press
Office of Scholarly Publishing
Herman B Wells Library 350
1320 East 10th Street
Bloomington, Indiana 47405 USA

iupress.org

Manufactured in the
United States of America

First printing 2022

Cataloging information is available
from the Library of Congress.

ISBN 978-0-253-06240-6 (hardback)
ISBN 978-0-253-06241-3 (paperback)
ISBN 978-0-253-06242-0 (ebook)

CONTENTS

· ACKNOWLEDGMENTS · *ix*

· INTRODUCTION The Worlds of *John Wick*
 CAITLIN G. WATT & STEPHEN WATT · *1*

· PART I *JOHN WICK* AND ACTION CINEMA
1 Red Circle of Revenge: Anatomy of the
 Fight Sequence in *John Wick*
 LISA COULTHARD & LINDSAY STEENBERG · *41*

2 Hidden in Plain Sight: Stunt-Craft Work in *John Wick* and
 the Networked Worlds of 87Eleven Action Design
 LAUREN STEIMER · *63*

3 Killing in Equanimity: Theorizing *John Wick*'s Action Aesthetics
 WAYNE WONG · *84*

· PART II The Economies and Phenomenology of the Wickverse
4 The Continental Abyss: *John Wick* versus the Frankfurt School
 SKIP WILLMAN · *121*

5 Bitcoin, Shitcoin, Wickcoin: The Hidden
 Phenomenology of *John Wick*
 AARON JAFFE · *146*

· PART III *John Wick*: Other Cultural Forms and Genres

6 Fortune Favors the Bold: The State of Games
and Play in the *John Wick* Films
EDWARD P. DALLIS-COMENTALE · *169*

7 "The One You Sent to Kill the Boogeyman": Folklore and
Identity Deconstruction in the *John Wick* Universe
CAITLIN G. WATT · *194*

8 Captain Dead Wick: Grief and the Monstrous
in the *John Wick* and *Deadpool* Films
MARY NESTOR · *216*

· PART IV *John Wick*'s Matrix: Space and Time

9 Classical Orders, Modernist Revisions, Fantastical Expansions:
Reading the Architecture of the *John Wick* Franchise
ANDREW BATTAGLIA & MARLEEN NEWMAN · *241*

10 Out of Time and Going Sideways: John Wick, Time Traveler
CHARLES M. TUNG · *265*

11 John Wick's Blank Cosmopolitanism and the
Global Spatiality of the Wickverse
MI JEONG LEE · *290*

- PART V Gender and the Body in *John Wick*

12 John Wick's Multiply Signifying Dogs
KARALYN KENDALL-MORWICK · 317

13 Masculinity, Isolation, and Revenge: John Wick's Liminal Body
OWEN R. HORTON · 339

14 Professionalism and Gender Performance in the John Wickverse
VIVIAN NUN HALLORAN · 358

15 Style and the Sacrificial Body in *John Wick 3*
STEPHEN WATT · 378

- BIBLIOGRAPHY · 401
- INDEX · 431

ACKNOWLEDGMENTS

We are grateful to Gary Dunham and Indiana University Press both for supporting this project in its earliest stages and for introducing us to our editor, Allison Chaplin. We also want to thank two anonymous readers for their enthusiastic support and wise suggestions about how to make this a better book, and we thank Chris Holmlund, Ed Dallis-Comentale, and Aaron Jaffe, with whom we shared ideas about this project at various steps in its evolution. We also want to acknowledge Mi Jeong Lee's assistance throughout this project and thank Ingrid Kastle of the Albertina Museum in Vienna.

Many of the essays in this book began as keynote lectures or presentations at a meeting on the Indiana University Bloomington campus some two months before anyone had ever heard of COVID-19. This meeting, "The Worlds of John Wick," was made possible by the generosity of several people and academic units: the Office of the Vice Provost for Research; the College of Arts and Sciences and Associate Dean Paul Gutjahr; the College of Arts and Sciences Humanities Institute and its director, Jonathan Elmer; the Media School and Dean Jim Shanahan; Dean Peg Faimon of the Sidney and Lois Eskenazi School of Art, Architecture + Design; and the Department of English. We want to convey special thanks to Rachel Stoeltje and Jamie Thomas of the Moving Image Archive at the Herman B Wells Library, who graciously agreed to cohost this event. And thanks, too, to Douglas Case and Owen Horton

of the English department for helping organize the event (and, in Doug's case, paying the bills too!).

Many of our colleagues and friends supported the meeting and participated in it, too many to count. They include Ann C. Hall; Erik Bohman; Mary Borgo Ton; Jack Raglin and his graduate students in kinesiology, one of whom shared his experiences as a stuntman on the television series *Vikings*; Deb Christiansen, Mary Embry, and Kate Rowold from the Eskenazi School's Department of Fashion Design; Scot Barnett, Patty Ingham, DeWitt Kilgore, and Derek DiMatteo from the English department; Jon Vickers from IU Cinema; Jeff Stuckey from the Office of Advancement; and many more film scholars and Wick fans, some of whom traveled a great distance to attend the event. This includes our roster of stellar contributors, who made the task of organizing and editing this volume a pleasure. We reserve our final note of appreciation for Nonie and Brendan Watt, whose support makes everything we do possible, and for our extended family of uncles and cousins, who may even be bigger fans of John Wick than we are.

THE WORLDS OF

JOHN WICK

INTRODUCTION
THE WORLDS OF JOHN WICK

CAITLIN G. WATT & STEPHEN WATT

One of the most successful action film franchises of the young twenty-first century—in many ways, surprisingly so—is *John Wick*. One measure of this success is monetary, of course, as each of the first three films in the series earned nearly twice as much as its predecessor: *John Wick* (2014), made for some $20 million, returned a box office of $86 million; *John Wick: Chapter 2* (2017), budgeted at $40 million, grossed over $171.5 million worldwide; and *John Wick: Chapter 3—Parabellum* (2019), produced for $75 million, took in $327.3 million worldwide.[1] To be sure, this last amount hardly approaches the earnings of *Aladdin* ($1.05 billion) and *Avengers: Endgame*, which garnered the almost grotesque sum of $2.798 billion. Still, as Scott Mendelson reported in June 2019, "*Aladdin* and *John Wick: Chapter 3* are both holding like champs partially because they are offering big-screen thrills of the sort you can't find anywhere else in theaters or on TV."[2] His thesis was corroborated by the announcement of plans for *John Wick: Chapter 4* scarcely two weeks after fans crowded theaters to see *John Wick 3* upon its release in May. As Brooks Barnes put it in the *New York Times*, the *Wick* franchise "has grown remarkably more powerful with each installment," adding that this "kind of audience expansion—extremely rare—is a dream result for Lionsgate, which has been struggling to turn around its movie operation, in part because Netflix has started to crank out the type of low- and mid-budget films in which Lionsgate has long specialized."[3]

This "dream result" was not without its challenges, however. As its makers concede, the film's plot, in which a retired, widowed hitman seeks revenge for the theft of his car and the killing of his puppy, is neither particularly complex nor original, nor does it align neatly with contemporary action cinema. "The success of *John Wick* as a franchise shouldn't be underplayed," Richard Newby advises, "because it was never a sure thing. In an action-movie landscape where superhero movies and sci-fi epics have dominated, the *John Wick* franchise has become a welcome surprise hit." For Newby, *John Wick* seemed to come "out of nowhere," or, as French critic Simon Riaux quipped, it was made "practically on the sly" (*"quasiment en catimini"*).[4] As Newby implies, the franchise does not tantalize audiences with imminent planetary cataclysm requiring the interventions of Marvel-style heroes; no Wookies, Klingons, or Transformers populate Wick's universe; and the *Wick* films are neither spinoffs from nor remakes of earlier franchises. In the history of action/vigilante films from, say, the five *Death Wish* films (1974–94) starring Charles Bronson and continuing through the installments of *Taken* (2008–2014), *John Wick* stands as an impressive—and, in many ways, unique—achievement.

Comparisons to *Taken* and *Death Wish* illuminate and, at the same time, complicate two other dimensions of *John Wick*'s ascent: its connections to the "aging action star comeback" subgenre and its success as a franchise in an era in which other film series have faltered. As numerous commentators have observed, *John Wick* emerges not from nowhere but in part from the popularity of franchises like *Taken*, *The Expendables*, and *The Equalizer*, a subgenre of action dominated by such stalwarts as Liam Neeson, Sylvester Stallone, and Denzel Washington. Tom Philip indirectly alludes to these films when gushing about Keanu Reeves's performance in *John Wick 3* while also emphasizing his age: "What

a joy it is to see the 54-year-old Reeves grabbing this exhausting role with both hands."[5] But since the actors we just mentioned celebrated their fifty-fourth birthdays some (or many) years ago, labeling *John Wick* as a vehicle for an *"aging* action star" seems inaccurate. This fact plus Reeves's uncanny youthfulness—in *Mixed-Race Superman* (2019), Will Harris marvels that, his "neat beard" aside, Reeves's face "hasn't changed much over the years"—attenuate the comparison further.[6] Chronicling Reeves's rise to stardom in the 1980s and 1990s, Michael DeAngelis underscores his impersonation of characters "at least a decade younger" than he was at the time.[7] In short, there is little evidence in any of the *Wick* films of Reeves's decrepitude, although as Harris quips, "in spite of his superheroic gift for kicking ass," he is "nonetheless constantly getting his ass kicked."[8]

Nor can the notion of the comeback quite explain the franchise's success—instead, it serves to frame it within a lens that figures Keanu Reeves as mirroring his character's return to action. Cat McCarrey's review explicitly equates actor and character: describing a conversation in which John asserts that he is "back" in Assassin World, McCarrey remarks, "It's true for Wick and Reeves. After the box office failure of his passion project '47 Ronin,' Reeves needed a comeback."[9] This last comment reveals the fragility of the parallel: unlike John Wick, Keanu Reeves never retired, but his films between *The Matrix* and *John Wick* tend to get erased from discussions of his comeback or, rather, regarded as irrelevant.[10] As Travis M. Andrews notes, "There was no big controversy. . . . Just a string of forgettable movies that slowly faded his star. Until now."[11] Searching for explanations of *John Wick*'s success through the lens of the aging action star comeback thus seems fruitless, as it is the film itself, as well as its own narrative of return, that casts Reeves's career between *The Matrix* and *John Wick* into shadow and renders his

performance a comeback. Neither can the success of *John Wick*, comeback or not, explain the exponential growth of the franchise. For about the time *John Wick 3* was released, as Mendelson points out, two films originating in highly durable attractions—*Men in Black: International* and *The Secret Life of Pets 2*—"struggled" or "outright tanked" at the box office.[12] As the former earned over $182 million during its first ten days, "outright tanked" seems more than ungenerous; more illuminating from a financial perspective are the fates of two remakes of Charles Bronson's star vehicles from the 1970s, *The Mechanic* in 2011 and *Death Wish* in 2018. *The Mechanic*, starring Jason Statham, earned over $76 million on a $40-million budget, a sum respectable enough to merit a sequel. Although *The Mechanic: Resurrection* (2016) was even more successful, netting $125.8 million, reviews were decidedly mixed (it scored a 38 on Metacritic, compared with *John Wick 2*'s 75). And *Death Wish*, with Bruce Willis playing Bronson's vigilante Paul Kersey, really *did* tank, earning only $49.6 million.

So, what happened? In his column in *Forbes* the day after reporting on their box office numbers, Mendelson returned to *Avengers: Endgame*, *Aladdin*, and *John Wick 3* to explain why this troika "towered" over the competition. His conclusion? All three not only gave audiences what they wanted to see but also "offered something new," not a "downgrade" or "weirdly regressive" facsimile of an original.[13] Even more effusive with his superlatives, *Rolling Stone*'s David Fear lauded *John Wick* as "*the* seriously batshit crazy, go-for-broke, open-world action-flick franchise of the 21st century." Its "artisanal touch . . . transformed a B-movie series into A-plus outrageousness" and "quality pandemonium."[14] Much of this "A-plus outrageousness"—what audiences wanted to see—was action, and the *John Wick* films don't disappoint on this score. But not just any action. As director Chad Stahelski emphasized to a reviewer,

insofar as possible the "tone of the action" must match the "tone of the film."[15] Unwilling to countenance this violence, whatever its tone, some detractors denigrated the films' narratives as little more than action sequences sutured together to display Wick's talents at killing adversaries—or "trashing" cars.[16] The excesses of these sequences (specifically, their body counts) at times elicited sarcasm even among critics who appreciated their execution. Riaux in *L'Ecran Large*, for example, wryly called attention to Wick's motivation for enacting such retribution: "If the theft of a car and the murder of a puppy justify, in your eyes, massacring the equivalent of the population of Luxembourg... then you're ready for John Wick" (our translation).[17] One person's enjoyment of "A-plus outrageousness," it would seem, might be another's incredulity about attachments to classic cars or emotional investments in puppies.

Yet even Jeannette Catsoulis, who deemed *John Wick* a "fluke" and denigrated the franchise as "dumb as dirt," admitted that the fight choreography in *John Wick 3* is "staggeringly accomplished."[18] Critics in America and around the world agreed that the action sequences were extraordinary, masterfully paced, and "magnificently choreographed" ("*magnifiquement chorégraphiées*").[19] Peter Travers in *Rolling Stone* applauded "the bristling beauty of the fight scenes . . . with cinematographer Dan Laustsen and editor Evan Schiff performing well beyond the call of duty."[20] Reviewing the film for the BBC, Mark Kermode employed the seldom-used adjective *balletic* to describe the precision, even elegance, of the fight choreography. He also pointed to the "showdown" in *John Wick 3* between Wick and Zero (Mark Dacascos) in the all-glass-and-mirror room in the Continental as striking a delicate balance of violence and dark humor, recalling the precedent of Harold Lloyd and Charlie Chaplin.[21] So, while Michael Phillips complained that the film "grows wearying in the second half," Kermode clearly did not find it

so.[22] Nor did Travers, who claimed that "instead of feeling exhausted when director Chad Stahelski calls a halt at 130 minutes, you're panting for Chapter 4."[23]

Mark Kermode and Simon Mayo, Kermode's colleague at the BBC, attribute much of the breathless excitement to Keanu Reeves's performance.[24] And they are hardly alone. Bilge Ebiri probably put Reeves's assumption of the title character best when writing about the first film in the franchise: "With any other actor in the role, the relentless revenge flick *John Wick* could have been just another variation on the Neesonian man-with-special-set-of-skills-kills-everybody genre. But with an actor as ethereal and ageless as Keanu Reeves in the lead, it becomes something else—more abstract and mythic."[25] Ebiri's remarks not only highlight the appeal of Reeves's portrayal but also hint at the ways in which *John Wick*, as we have suggested, transposes the conventional keys of the action film into new aesthetic registers.

Although *John Wick* may begin as a "relentless revenge flick"— Thomas Périllon's review compares Reeves's performance to Tom Cruise's in *Jack Reacher* (2012) and Denzel Washington's in *The Equalizer* (2014)—Ebiri positions it within a different context.[26] Detecting hints of "arty action" in the "defiant unreality" of the film, he identifies traces of Luc Besson's *La Femme Nikita* (1990) and *Léon: The Professional* (1994), which, he asserts, were built "not on anything real, but on our collective cinematic dreams of genre." In his comparison of *John Wick*'s violence to that of Antoine Fuqua's *The Equalizer*, in which the "brutality" of Robert McCall's foes "increased exponentially," Ebiri commends the narrative of the former as "cleaner: It gives us a visceral reason for the bloodshed, but then it plays it cool. Its ambitions are aesthetic."[27] Terms like *aesthetic* and *mythic* hint at *John Wick*'s contributions to action cinema, new dimensions implied by reviewers' use of such descriptors as "majesty" and "elegant simplicity."[28] The essays that follow offer

multi- and interdisciplinary perspectives of these and other qualities, all the while demonstrating how the *Wick* films are far more than enervated comeback vehicles or formulaic revenge dramas.

The most compelling evidence for this claim is the films' distinctive world-building, a project that reflects the seriousness with which Stahelski and his collaborators regard action cinema as a cinematic genre. The films' meticulously choreographed action; what Ebiri terms their highly varnished "aesthetic"; Wick's complex and intriguing backstory; the superb performances of Reeves, Ian McShane, Common, Laurence Fishburne, Anjelica Huston, Lance Reddick, Halle Berry, and others— all contribute to the nuance, even elegance, of a fictive universe that may very well define the films' greatest achievement. Stahelski is very clear about the primacy of world-building to the *Wick* franchise: "We just wanted to isolate and show you a hidden world, and believe in the mythology."[29] And, as he underscored in an interview before the release of *John Wick 3*, world-building is for him a careful business.[30] It is therefore hardly accidental that Mendelson applauds the first film's "robust and creative world-building that puts the would-be 'Let's make a Marvel-style expanded universe' copycats to shame."[31] Or that Asia Kate Dillon, the Adjudicator in *John Wick 3*, finds that the most "exciting thing about the second film and [*John Wick 3*] is that we go deeper and deeper into the John Wick World." "Everything in the movie," Dillon notes, has "a deeper meaning" linked to religion, art, and a multitude of other cultural forms.[32] And this meaning grows just as the smaller fictive worlds constitutive of this "Wickverse" expand with each new installment, setting the franchise apart from less successful peers. For Peter Sobczynski, who commended *John Wick* as a film "of wit, style, and vision," *John Wick 3* is "a work of pop cinema so blissfully, albeit brutally, entertaining that you come out of it feeling even more resentful of its multiplex neighbors for not making a similar effort."[33]

We agree. Yet at times the painting, ballet, and myriad cultural allusions in John Wick's world are so seductive and dizzying that decoding them is not a simple task. In an uncertain reading of *John Wick 2*, Erik Kain characterizes the "entire setup" of the film as "almost medieval. Knights and barons, kings and castles. Betrayal and revenge." Then, apparently changing his mind, he revises his analogy: "It's all very Shakespearean and florid and sort of beautiful and garish all at once."[34] Kain's response is telling, as the films create a multifoliate world that fascinates, even dazzles, but may also befuddle. Still, such rich heterogeneity does not promote chaos. As Nelson Goodman posits in *Ways of Worldmaking* (1978), "Worldmaking as we know it always starts from worlds already on hand," but a "willingness to welcome all worlds builds none."[35] A fictive universe is thus a purposeful, not promiscuous, aggregation of worlds, and that of John Wick proves no exception.

The Worlds and Storyworlds of *John Wick*

Eric Hayot's riff in *On Literary Worlds* (2012) on a compact sentence in Martin Heidegger's "The Origin of the Work of Art" (1950) is electric with implications, some of them potentially unsettling.[36] This evocative sentence—*"World worlds"*—might invite confusion, for instance, about the title of this volume, *The Worlds of* John Wick, considering Goodman's thesis that a world originates in other worlds. The volume knob turned up on his phrasing, Hayot's unpacking of Heidegger is more than virtuosic: "The intimacy Heidegger proposes between the work and the world relies . . . on the flamboyantly deployed quasi-tautology that binds *world* together as subject and predicate of its own tiny sentence. *World worlds*."[37] In its more common use as a noun, *worlds* denotes the extant materials that compose a work's diegetic space; as a predicate in this "quasi-tautology," the word connotes a self-propagative qua

parthenogenetic capacity—that is to say, whatever shards of borrowed material it might contain, a world "worlds" itself. Moreover, in *John Wick*, not only is the viewers' world "set off by a sharp and categorical boundary from the *represented* world in the text," but their "real" world is also distanced within the films themselves.[38] This is why Wick does not kill police officers or travel to Rome in *John Wick 2* to assassinate the pope. He must not impact *that* world, and the films generally observe this proscription. So, early in *John Wick*, Jimmy the policeman (Thomas Sadoski), investigating a noise complaint, rings Wick's doorbell just seconds after he has dispatched the last of Viggo Tarasov's (Michael Nyqvist) hitmen. The front door is open just enough for Jimmy to notice a body strewn across the floor, leading him to ask Wick if he is working again. Satisfied by the answer, "No, just sortin' some stuff out," Jimmy promises to "leave [him] be" and says goodnight. The everyday realities of crime procedurals and the attendant generic expectations they create—the calling of police backup and ambulances, the arrival of a forensics team—end at the threshold of Wick's world.[39] The boundaries of this world are not always impermeable, but they are usually observed.

It may be useful to enlarge this idea of the "real" world, distinguishing it from the different categories of "worlds" that comprise the Wickverse. On one level, this realm is populated by its cast and crew, with the skills, ideas, and influences they bring to the films' production; its borders are delimited by the resources required to produce a feature-length film. In announcing the production of *John Wick 2*, Jason Constantine, Lionsgate's president of acquisitions and coproductions, said, "With such tremendous fan and critical support for John Wick, we knew there was still so much more of this story to tell."[40] Implicit in this remark is a kind of causality: there is more story to tell precisely *because* the film has been supported by fans and critics. Its artistic potential as a fictional world also depends on its success as a product for consumption.

In addition, such factors as the actors' willingness to participate in the franchise, the studios' decisions about release dates and theaters to exhibit the film, and the impact of COVID-19 on production schedules all operate in the world outside the films but have shaped the world inside them.[41] This world is also informed by its creators' immersion as stunt performers in the world of action cinema; as Lauren Steimer underscores later in this volume, the real-world professional connections and work experiences of Stahelski and David Leitch's production crew shape the films' action and characterization, situating them within an archive that includes *The Matrix*, *The Bourne Identity*, and the world of international martial arts cinema. As Goodman posits, the "so-called possible worlds of fiction lie within actual worlds"; likewise, actual worlds inform aspects of what narratologist Marie-Laure Ryan defines as the storyworld.[42]

In her consideration of this term, Ryan considers various definitions of *world*, fictional and philosophical: an author's world, for example, may refer to "the social and historical setting typical of the author's works . . . and the author's general ideas and philosophy of life," which is to say, it may encompass the external aspects of a film's world discussed above. By contrast, a storyworld is separated by several ontological degrees from the world inhabited by writers, actors, audiences, and film producers: "If a storyworld is anybody's world, it is the world of the characters."[43] The storyworld, too, might be divided into a number of smaller domains comprising a story universe: around the central shared world of the characters (what Ryan calls the "Text Actual World," an analogy with the "actual world" of possible-worlds theory) orbit a number of subworlds existing in the lives or minds of each character. These "satellite worlds include knowledge-worlds, obligation-worlds, wish-worlds, pretend worlds, and so on."[44] By this calculus, the worlds of the Wickverse are not limited to the "real world" of police and civilians

and the "underworld" of assassins and gangsters but also include the worlds of John Wick the assassin and John Wick the mourning husband, the inner worlds of the many other characters, the worlds ruled over by the Continental, the Bowery King, the High Table, and so on. The term *Wickverse*, then, which appears in fan spaces such as Reddit, Twitter hashtags, and Fandom.com as well as in critical reviews, gestures toward the expansiveness and complexity enabled by the shared "universes" of fictional worlds.

Ryan's "principle of minimal departure," which assesses the distance between a fictional storyworld and the world inhabited by its audiences, is especially helpful in exploring this universe. This principle, moreover, enables us to reconcile what Ebiri calls the franchise's "defiant unreality" and the paradoxical "authenticity" so many reviewers valorize when discussing its stunt work. The principle of minimal departure presupposes that fictional worlds are ontologically complete: "To the reader's imagination, undecidable propositions are a matter of missing information, not ontological deficiency."[45] This is to say that if the authors of a text make no remarks about, for example, how gravity works in the text's storyworld, its audiences will assume that gravity works for its characters in much the same way it does in the real world. The world of *John Wick*, however, both does and does not conform to our assumptions about how the real world works, at times deliberately contrasting moments of authenticity with the unreal nature of action cinema and, at others, straining our suspension of disbelief in its construction of a complex web of assassins.

An initial sign that the *John Wick* storyworld overlaps with our own is the mapping of its locations onto such cities as New York, Rome, and Casablanca (though, as Mi Jeong Lee argues later in this volume, sharp distinctions exist between this apparent cosmopolitan gesture and the conditions that govern real-life global travel). In an illustration of the

ways in which fictional worlds are perpetually in conversations with real ones, the authenticity of the Wickverse's global reach is enhanced by a cast of international performers. If casting the Russian brothers Abram and Viggo Tarasov with Swedish actors Michael Nyqvist and Peter Stormare is not accurate or realistic—native Russian speakers critiqued *John Wick*'s Russian-language dialogue—the films' casting nonetheless suggests that the movies are supposed to take place in a world that, like ours, has such places as Belarus, Italy, and Morocco and that this world has points of contact with the world of international action cinema.[46] The producers' own immersion in this world means that the Wickverse is populated by such figures as Chinese actor and stunt performer Tiger Hu Chen, star of Reeves's 2013 *Man of Tai Chi* and with whom Stahelski and Leitch worked on *The Matrix* movies, and Indonesian actors and martial artists Yayan Ruhian and Cecep Arif Rahman, whose performances in *The Raid 2* (2014) led Stahelski to recruit them for *John Wick 3*.[47]

In addition to these gestures toward a global landscape based on a real-world map, *John Wick* foregrounds details, often omitted in action films, that link fictional characters to the laws governing human bodies and objects in our world: physical activity and recovery from wounds are exhausting, guns eventually run out of bullets, dead bodies and blood will not magically vanish unless and until someone cleans them up. In his commentary on the *John Wick* Blu-Ray, Stahelski remarks on the erasure of such realities from most action films: "If you think about it, [in] every action movie you always see . . . the hero leaves a wake of dead bodies, and I guess no one ever cleans it up!"[48] The work of Charlie (David Patrick Kelly) and his employees in *John Wick*, rolling dead henchmen up in plastic sheeting and squeegeeing blood from John's windows, underlines the consequences of John's profession: it produces corpses. In case we were tempted to forget this, Charlie's return to clean

up after Ms. Perkins's (Adrianne Palicki) execution reminds us once again that real-world violence produces material results.

In other respects, however, the *John Wick* franchise indicates that its world is not ours. As Jimmy's willingness to overlook evidence of homicide implies, the films take place in a world in which familiar political, legal, and economic components of a realistic social superstructure have been replaced by hierarchies of criminal organizations and guilds of assassins. In *John Wick 2*, John and Cassian (Common) exchange a volley of gunfire through a crowd, who ignore this gunfight as if it is an everyday occurrence. Perhaps it is, in a world in which everyone from street musicians to sushi chefs to pedestrians pushing baby carriages might be disguised assassins. It also, however, marks a departure from what a viewer constructing the world from real-world experience might expect, a moment when what we thought was a secret and arcane underworld is revealed to have exceeded its borders.

If the physical laws that limit human potential operate as normal in the *John Wick* universe, in other ways the filmmakers eschew realism in favor of a more stylized alternate reality. As Charles Tung's essay in this volume explains, the storyworld of the franchise seems to take place outside of a predictable and mimetic present, instead mingling antique computers with classic cars with carrier pigeons in a mélange of retro references. Even the action sequences, praised for their rawness or authenticity, are stylized in a way that, as Lisa Coulthard and Lindsay Steenberg delineate in chapter 1, invites audiences to read fast-paced, highly choreographed violence as a source of aesthetic pleasure rather than as an index of authentic brutality. For viewers hoping to fill in gaps in the storyworld of *John Wick*, in accordance with the principle of minimal departure, the viewing experience can present a disorienting tension between unexpected moments of realism (Stahelski comments on the value of "just seeing a guy clean up after a party, wake up,

and do some of the more mundane human side of things that you don't ever see our action heroes do nowadays") and unpredictable points of ostentatious unreality.[49]

If the implausibility, stylization, and occasional parodic moments of *John Wick*'s storyworld distance audiences from emotional engagement or narrative immersion, they in no way impede its "worldness" as a construct or "mental representation" that is "logically consistent, large enough to stimulate the imagination, and experienced as complete."[50] The storyworld's ability to stimulate a viewer's imagination, in fact, brings it into contact with other worlds: the nondiegetic webs of allusion and influence that connect parts of the fictional world, for example, and the world of fan consumption. This latter world is not entirely congruent with the economic system of film production, as Jared Gardner's analysis of the convergence of comic books and films in the twenty-first century reveals. That is to say, the kinds of affective investments that fans of comics and *John Wick* make do not always work "in neat consort with the efficiencies and demands of the consumer marketplace," as deeper engagement with the medium does not always motivate financial investment in, say, Funko Pop figurines (though of course you can also buy Funko Pop figurines of John Wick and comic book characters).[51] Fan contributions thus expand the worlds of *John Wick* to include fanfiction, memes, art, and attentive commentary on filmic details. Like comic books, in other words, the *Wick* films have created an audience of "active agents who were inclined to become producers themselves," and in our mappings of the worlds of *John Wick*, we have benefited from the networks of fans who have scrutinized the numbers and methods of kills in the movies, derived principles of the assassin economy, and identified the franchise's numerous cultural and cinematic allusions.

Such allusions, visible in the casting, set design, props, costuming, choreography, and cinematography, help create another universe

of worlds in which *John Wick* and its sequels are situated, requiring for its comprehensibility both the fictional storyworld on-screen and the active reading of audiences. The notion of "twofoldness," coined by Richard Wollheim to describe "our apprehension, at once, of both the depicted object and the marked surface, . . . the recognitional and configurational aspects of seeing-in," captures the paradoxical phenomenon of perceiving both the fictional world depicted and the web of aesthetic cues and references that imbue this world with additional meanings.[52] As Stahelski describes, these references and influences include Sergio Leone, Akira Kurosawa, Jackie Chan, and Buster Keaton; to these figures and the films and genres associated with them, we might add video games, comic books, folklore, epic poetry, Renaissance art, and Greco-Roman mythology.[53] The "twofoldness" of this cinematic world, or universe, fills in lacunae in the occasionally sparse dialogue to reveal new aspects of characters or scenes and deepen our engagement in the "worldness" of the franchise. And, as we shall outline, several general principles guide its creation.

John Wick and Ways of Worlding

Theses like Eric Hayot's on the construction and ontology of worlds illuminate methods of worlding, one of which involves time, as Hayot unexpectedly discovered when consulting the *Oxford English Dictionary* to better understand the etymology of *world*. There, he found uses of the word that pertain more to time than to geography or space, leading him to speculate, reasonably enough, that anyone "accustomed to thinking of 'world' as having only spatial implications" would be surprised.[54] One scholar who wouldn't be is Pheng Cheah, who, in *What Is a World? On Postcolonial Literature as World Literature* (2016), juxtaposes the "hetero-temporality of precolonial oral traditions" with

the normative force of imperial time and a conception of the world as a "spatial category" that "can be divided into zones of quantitatively measurable time."[55] Indeed, a "world only is and we are only worldly beings if there is already time."[56] Worlding, it seems, is thus not at base a "cartographical process that epistemologically constructs the world by means of discursive representations but a process of temporalization."[57]

Even if we wanted to quibble about the privilege that Hayot and Cheang accord time in world-building (and we don't) and were inclined to rebut the contention that the capitalist world-system relies on "Northern- and Eurocentric regimes of temporal measurement" (and we can't) there is little denying the ways in which time is related to both power and world-building in *John Wick*.[58] This is particularly true of that part of the narrative that spans the final sequence of *John Wick 2* through the opening scenes of *John Wick 3*. The final sequence of *John Wick 2* begins at dusk with an injured and bloodied Wick hobbling down the steps of the Bethesda Terrace in Central Park to meet Winston (Ian McShane). Their conversation quickly turns to his punishment for "conducting business" on Company grounds: no access to services, excommunication, and, eventually, the forfeiture of his life. After Wick asks why he isn't dead already, Winston responds, "Because I deemed it not to be." Then, after advising Wick, "You have one hour—I can't delay it any longer," he hands him a marker that he might need "down the road," after which Wick warns Winston that he will kill anyone who pursues him. As Wick leaves, Winston phones the Continental Switchboard to make the "excommunicado" official, to stipulate the one-hour grace period, and to have the contract on Wick circulated. The opening scene of *John Wick 3* begins minutes later—well, actually and somewhat inexplicably, over an hour later, as Charles Tung explains—after Wick has exited the park and is preparing for the onslaught to come.

Winston's admonition that he "can't delay it any longer" could be regarded as an indication of his own constraints, something like "I can't give you more time because the High Table would then turn on me." But this scene and earlier ones demonstrate Winston's wielding of monarchical power in *his* world, the Continental, a power over his dominion analogous to that the Bowery King (Laurence Fishburne) defiantly outlines to the Adjudicator in *John Wick 3*. Winston exercises his dominion throughout the films: he approves the Continental's coinage and compliments the artisan who produced it; he excommunicates wrongdoers, as he does with Wick; and he determines punishments for transgressions, as he does in *John Wick* with Ms. Perkins. As ruler of his domain, he can assert his prerogative to do what he pleases, including his refusal to revoke Wick's membership when Santino D'Antonio (Riccardo Scamarcio) demands it, reminding Santino that "this kingdom is mine and mine alone." More relevant to worlding and worlds as temporal phenomena, he can determine the time when a contract can be enforced, much as the Adjudicator from the High Table gives the Bowery King seven days to settle his affairs before he is forced to "abdicate" his "throne." But in the closing scene of *John Wick 2*, Winston can do even more than this: he can stop time. With a nod of his head, a crowd strolling past Wick and Winston stops, as if frozen in place. When Winston nods again, the passersby resume walking as if nothing has happened. The effect is clear: his power extends beyond the walls of the Continental, and the Continental extends beyond the walls of hotels. It even extends beyond space; in his kingdom, Winston controls time.

Of course, space is involved as well. And, in constructing it—its dimensions, architecture, and decoration—Stahelski relies on both conventional and unconventional representational means, often in subtle ways. One concerns a kind of institutional gigantism and its intimation

of dominance in John Wick's world, a topic David Wittenberg can help us unpack. Wittenberg begins his rumination about size and world-building by recalling a trip with his then-two-year-old daughter to the Chicago Zoo and their entrance into an installation on the American Family Farm, complete with a model barn. Smaller than the structure commonly seen in the rural Midwest, the barn contained a live cow, "the bulk of which dominated both the interior of the barn" and his daughter's "tiny figure."[59] This experience triggers Wittenberg's meditation on larger-than-manageable spaces and objects, then his elaboration of a "scalar taxidermy" that to be understood requires not only a refined "skill in seeing more than just the sheer presence of bigness" but also, after Hegel, an "intellectual understanding" of "relationships of difference" that are "undeniable or irrefutable."[60]

As in many films, the worlding of *John Wick* at times privileges bigness and all that it connotes about the Continental's and later the High Table's power. As an example of conventional ways in which films represent excess or grandeur, Wittenberg identifies a shot that he facetiously names the "waste pan" intended to convey scope or scale—the "seemingly infinite stock of Kane's crated-up possessions" at the end of Orson Welles's *Citizen Kane* (1941), for instance. Waste pans, however, frequently "pause the progress of a film" and, in some cases, seem largely the result of a desire to "show off . . . the sheer profligacy of sets, effects, of extras."[61] Welles's deliberately paced overhead shots of scores of wooden crates, statuary, variously sized urns, faded photographs and paintings, and even a gramophone lead eventually to a workman's hand grabbing a sled and tossing it into a blazing furnace with other "junk"; the sled, famously, has "Rosebud" stenciled on it. In one sense, the sequence hardly seems a waste, as *Citizen Kane* begins with an aged Kane muttering "Rosebud" and ends with an explanation of its possible meaning. But Wittenberg's witticism is nonetheless helpful, as prior to a

close-up of the smoldering sled, the "waste pan" surveys the cluttered inventory of Kane's wealth, his obsessive acquisitiveness before hoarding became a thing. More visually expansive are the digital enhancements of legions of soldiers steeling themselves for battle in Peter Jackson's *The Hobbit: The Battle of the Five Armies* (2014), although there is no denying the exhilaration when Thorin Oakenshield and his compadres burst through columns of dwarf soldiers to confront Azog the Defiler's orcs. Before this, Jackson employs more than a few pans of dwarf, elf, and human armies (not to mention the arrival of oversized were-worms!) to create a sense of the enormity of the imminent confrontation. The sheer magnitude of the conflict is, borrowing Wittenberg's phrasing, "undeniable"; its epic scale, "irrefutable."[62]

A miniature barn, a bulbous cow, and waste pan shots intimate two strategies of worlding in *John Wick*. One involves the appearance of characters of a size unusual or exceptional in the world of the viewer. On the diminutive end of the scale, munchkins reside in Oz, and a tiny, dying member of the Arquillian royal family occupies the head of a human-sized robot in *Men in Black* (1997); on the other end, after H. G. Wells's 1898 novel, massive Martian "tripod" war machines run riot in *War of the Worlds* (2005), and Gort—the gleaming eight-foot robot in *The Day the Earth Stood Still* (1951), who is over three times taller in the 2008 remake—looms ominously guarding Klaatu's spaceship. A similar yet muted strategy obtains in John Wick's world: Francis, the Russian bouncer in *John Wick*, is played by 6'10" former wrestler Kevin Nash; Yama, the nearly six-hundred-pound former Sumo champion turned assassin in *John Wick 2*, fails to stop Wick; and Ernest, Wick's first opponent in *John Wick 3*, is played by 7'4" professional basketball player Boban Marjanović.[63] In a second strategy, Stahelski, like Welles and Jackson, employs waste pans to suggest the powerful reach of the Continental and High Table. When Winston contacts "Accounts Payable" at the end

of *John Wick 2*, for example, a vertical pan of three floors of shelves, dossiers, and ledgers—floors and bookcases resembling the research stacks of university libraries—conveys the vastness of the archive; a similar shot in *John Wick 3* reiterates this sense after the Adjudicator calls to deconsecrate the Continental. As the battle at the end of *John Wick 3* is about to begin, two large buses arrive at the hotel, and a battalion of heavily armed troops ("emissaries from the High Table") exits; meanwhile, Winston leads Wick and Charon (Lance Reddick) to a weapons vault deep inside the hotel from which to make a "withdrawal" from the scores of guns stored there. If not so impressive as Welles's pan of Kane's warehouse, a medium shot of Winston standing before assault rifles mounted on the walls confirms the Continental's very considerable firepower. And if not quite so imposing as were-worms or as panoramic as battalions of orcs, dwarves, and elves, such moments reinforce the larger-than-life scale of Wick's world. A violent and large "transaction," the Adjudicator's term, is about to commence.

Another crucial aspect of world-building, as several contributors to *The Worlds of* John Wick describe, is gender. In some ways, the Wickverse reflects the male-centric hierarchy and marginalization of women that Yvonne Tasker detects in action cinema more generally; moreover, unlike other genres "in which the male figure advances the narrative whilst 'woman' functions as spectacle, the male figure in the contemporary action picture often functions in both capacities."[64] Because male characters occupy both of these roles, many action heroes seem to live in an artificially male world, as John Wick does. His tattoos, tailored suits, and movement during fight scenes render him a source of visual pleasure as he interacts with the largely male world of assassins, with Addy (Bridget Regan) and Ms. Perkins serving as exceptions that prove the rule. Perhaps the most important woman in the franchise in terms of driving the plot, Helen (Bridget Moynahan), is dead. This, too,

corresponds with the convention of women functioning as motivations for male characters rather than as characters in their own right.

At the same time, gender in *John Wick* also functions in more complicated ways. On a purely statistical level, more female and genderqueer characters appear with each new film, whether as opponents (such as Ares, the Adjudicator, or the violin-playing assassin played by Heidi Moneymaker in *John Wick 2*), allies (Sofia and the Director), or old acquaintances-cum-victims (such as Gianna D'Antonio). On another level, what is missing from John Wick's world seems equally significant: the absence of a romantic subplot, and for all the gory and intensely stylized violence, none is of a sexual nature. In general, the films are short on nudity or sexualized focus on the female body and long on stylish suits for characters of a range of genders; Iosef Tarasov may entertain women in a spa, but for the most part, the women of John Wick's world are not objects of romantic interest but assassins, bodyguards, and major players in the criminal underworld. Damsels in distress are nowhere to be found. As Melanie McFarland sums up, at no point in *John Wick* or its sequels does a woman "throw herself at [John] for any reason other than to lend her physical power to a side kick or a punch."[65]

Some viewers have connected this seemingly egalitarian element of world-building to its aesthetic principles. Marjorie Liu, for example, describes *John Wick* as "an action film where there's no hint of sexual violence, only true love lost; a world that keeps peeling back its layers, revealing tantalizing hints of a baroque neo-medieval gothic underworld that is more feminine than masculine in its aesthetic."[66] Liu's mention of "love lost" gestures toward another seemingly subversive element in the film's depiction of gender: the emotional vulnerability of its hero, with his longing for domesticity and focus on grief. "In a genre prone to linking masculinity with emotional denial," McFarland asserts, "John Wick is fearsome because he is very much in his feelings," while

Liu insists that Wick is, "unabashedly, unreservedly, coded feminine," representative of "a masculinity of another sort."[67] As Owen Horton and Vivian Halloran describe in separate chapters in this volume, this mingling of masculine and feminine elements at the very heart of the *John Wick* franchise, its protagonist, reverberates throughout its design in complex formations of gender that, much like other aspects of the Wickverse, "world" its many worlds.

The Worlds of This Book

While planning for this volume, two things became abundantly clear. The first, perhaps overly obvious, was that because action is so central to *John Wick*, we needed to begin with its choreographic, rhythmic, and visual dimensions; its editing, sound, and shot selection; and its blend of martial artistry, driving (or horse riding!), and gunplay. As Lisa Coulthard and Lindsay Steenberg quip in the chapter that follows (tongue only partly in cheek, we think), "It may be more accurate to say that *John Wick* does not have fight sequences; it *is* a fight sequence." Our second epiphany emerged from the worlds from which the Wickverse was "worlded" and the varied expertise needed to explore it. Mapping this territory required scholars from a range of disciplines: film studies, of course, but also critical and cultural theory, folklore and mythology, animal studies, architecture, game theory, gender studies, and more. The chapters in this anthology thus engage the worlds of *John Wick* from the multifoliate perspectives that these disciplines enable and bring into sharper critical focus.

Like the films themselves, action scenes in the *Wick* franchise possess dimensions that demand close attention, and "*John Wick* and Action Cinema," the first grouping of essays, addresses these dimensions. In "Red Circle of Revenge: Anatomy of the Fight Sequence in *John*

Wick," Coulthard and Steenberg juxtapose the "run and gun" style of the *Bourne* series and its "rapid-fire editing" and "shaky" cameras with the fight scenes in *John Wick*, which "foreground bodies moving through byzantine spaces dominated by reflective surfaces, filmed in medium and long shots, and scored with energizing rock, trance, and ethereal electropop beats." Few sequences in *John Wick* exemplify this more compellingly than that in the Red Circle nightclub, which comprises a chase across five interior locations, several shoot-outs, and nine hand-to-hand altercations. For Coulthard and Steenberg, this sequence not only reveals "distinguishing characteristics that have become unique selling points of *John Wick* as a brand" but also implicitly argues for the artistic value of action cinema, value traditionally valorized in cultural forms—painting, sculpture, ballet—that also enrich the fictive universe in which Wick resides.

As accomplished a performer as Reeves and his adversaries are, action films invariably require the often-ignored talents of stunt workers. Similarly unnoticed, martial artistry emerges from philosophical, historical, and aesthetic contexts that, in part, comprise the genealogy of the franchise itself. The next two chapters in "*John Wick* and Action Cinema" address these issues. While Coulthard and Steenberg acknowledge the "extensive" stunt work (and CGI) employed in fight scenes, Lauren Steimer in "Hidden in Plain Sight: Stunt-Craft Work in *John Wick* and the Networked Worlds of 87Eleven Action Design" advocates for "an ethnographic approach to media industry workers," not only as an interpretive methodology but also as "an attempt to turn the craftwork of humanities scholarship toward the labor of production." She brings to light "hidden labor practices and underhistoricized cultural formations" by providing a brief history of stunt workers and organizations in Hollywood, identifying their contributions, and charting the innovations of Stahelski and Reeves's work on *The Matrix* series

(1999–2003). These importantly include the influence of Hong Kong martial artistry, which Wayne Wong discusses in "Killing in Equanimity: Theorizing *John Wick*'s Action Aesthetics." Wong traces the ways in which the "aesthetic and philosophical core of Hong Kong action" is "incorporated and creatively reinvented in transnational Hollywood action blockbusters," a reinvention intimated by "the quietness of the mise-en-scène." Throughout his discussion, Wong locates this convention and other elements of Hong Kong martial arts ideation in an archive of American action films: from Bruce Lee's *Enter the Dragon* (1973) through *Lethal Weapon* (1987), *The Matrix*, and others. Taken together, the three chapters in this section establish an analytical, material, and philosophical foundation for the readings that follow.

In "The Economies and Phenomenology of the Wickverse," Skip Willman and Aaron Jaffe illustrate the myriad ways the criminal world Wick reenters is both tethered to capitalism and reflective of its most destructive practices. For however unique and separate from the world that filmgoers inhabit, this underworld is nonetheless a product or avatar of capitalism. This pair of essays begins with an assessment of the at-times short distance between *John Wick* and the products of the so-called culture industry and concludes with an essay that meditates on the similarity of currency used in exchange in Wick's world to cryptocurrencies and the blockchains that support them. In "The Continental Abyss: *John Wick* versus the Frankfurt School," Willman argues that the *Wick* franchise "represents an intensification of the reversal of means and ends within the culture industry in which violence, once considered a means to an end, becomes an end in itself." The implication here is that such violence is precisely what moviegoers pay to see, but that is hardly all there is to the matter. Within other interpretive frames—those provided by the hard-boiled detective novel and film noir—Wick is akin to a detective restoring a symbolic order, however corrupt, that has been

overthrown. But, perhaps most important, as Willman contends, the closing scene of *John Wick* 3 promises more than a restoration of or capitulation to a prior order akin to that of "cutthroat capitalism," as Wick and the Bowery King appear poised to foment a revolution against the High Table.

In "Bitcoin, Shitcoin, Wickcoin: The Hidden Phenomenology of *John Wick*," Aaron Jaffe meditates on a question that attracted considerable attention on the internet—"John Wick would totally use bitcoin, right?"—and considers both the nature and function of currency in the Wickverse and "Wickonomy." Unlike paper currency—bits of dirty paper "too small and too crowded with print and pictures to be usable," as Bernard Shaw once snarled—the gold coins circulated in Wick's world possess intrinsic value.[68] Indeed, they may even have *artistic* value, as in *John Wick* 2 Winston, with a jeweler-like demeanor and eye loupe in place, carefully inspects newly minted coins, deeming their craftsmanship "impeccable." But, as Jaffe explains, their beauty has nothing to do with why Wick and other assassins exchange them, nor are they mere replicas of the coins and bills most of us (still) use. Because in the Wickverse a gold coin can buy a drink, a night in a first-class hotel room, and dozens of other things, they function more like tickets, business cards, or "magic beans" than currency; they announce, as Chad Stahelski notes, that "*I'm in the know.*"[69] Alternately, they function much like Bitcoins, "performing fictions of human trust" with no middlemen or institutions like banks to assure their worth. In this essay, then, Jaffe juxtaposes our "real" (small *r*) world of currency and strained trust with that in which Wick operates.

The chapters of the third section, "*John Wick*: Other Cultural Forms and Genres," examine *John Wick*'s points of contact with the worlds produced by other media. Rooted less in the "real" worlds of production methods and capitalism than in the frameworks that genres such as

video games, fairy tales, and parodies use to generate their worlds, these essays seek to elucidate the rules, references, allusions, and narrative structures that situate the *Wick* films within a web of cinematic, literary, and artistic formations. Employing insights from cultural and narrative theory, this section establishes a variety of vantage points from which to understand the generic constraints that produce John Wick as a character and the world he inhabits.

Employing the theoretical work of Johann Huizinga and Roger Caillois, Edward P. Dallis-Comentale's "Fortune Favors the Bold: The State of Games and Play in the *John Wick* Films" outlines the ways that the laws and customs of the High Table and assassin society resemble the rules of a game. This game, however, seems dangerously entangled with powerful forces that render it compulsive, excessive, or prone to manipulation; as Dallis-Comentale explains, building from Caillois's insights on the corruption of play, the internal agendas and compromised motives of players such as Iosef, Santino, and Zero undermine the boundaries separating the play space from the real world and transform play into something more like debt. Neither John nor his allies are exempt from this corruption, and his continued participation in the game takes on the air of a compulsion from which there is no escape. His efforts to preserve the value of his humanity only enmesh him further in a network of debt and, more broadly, in an increasingly bureaucratized and gamified world where "the presumedly highest form of play . . . occurs within and alongside an economy that mirrors and saps its key pleasures and critical functions."

In "'The One You Sent to Kill the Boogeyman': Folklore and Identity Deconstruction in the *John Wick* Universe," Caitlin G. Watt similarly addresses the question of John Wick's loss of individual agency within larger systems—in this instance, the repetitive structure of fairy tales. Examining the repeated references to fairy tales in the *Wick* films,

the essay argues that they provide a way of reading Wick's character arc as one increasingly evacuated of a monstrous hybridity. Examining the construction of John Wick as "Baba Yaga" (traditionally a female witch in Russian fairy tales) through studies of the character and her depictions in other Anglophone films, Watt argues that Wick's status as a legendary figure within the Wickverse is a function of his being not a fairy tale hero but a figure who, much like Baba Yaga in folklore, combines elements of the helper, the monster, and the supernatural mystery. As the series progresses, however, the folklore roles identified by Vladimir Propp and associated with Wick in the first film are reassigned to other characters and to the hierarchy of the assassin world itself, a shift accomplished through casting, plotting, and elements of mise-en-scène. This shift is not necessarily permanent, for while Wick's initial legendary status has been almost completely deconstructed by the end of *John Wick 3*, the film's final scenes leave open the possibility of "the resurrection of the complex Baba Yaga identity."

Mary Nestor's "'Captain Dead Wick': Grief and the Monstrous in the *John Wick* and *Deadpool* Films" offers a reading of the connection between art, violence, and morality through a comparative examination of parody, humor, and monstrosity. She takes as her starting point the several connections between the *John Wick* and *Deadpool* film franchises. *Deadpool* is commonly understood as a self-referential parody of comic book films, but similarly, Nestor argues, the *Wick* films function as parodies of action movies. The two franchises' approaches to parody yield very different results in the character arcs of their protagonists, however, and juxtaposing them thus provides insight into the relationship between humor, parody, and redemption.

Contributors to the fourth section, "*John Wick*'s Matrix: Space and Time," scrutinize the temporal and spatial characteristics of John Wick's world, examining, as Mikhail Bakhtin famously delineated, the

ways in which "time, as it were, thickens, takes on flesh, becomes artistically visible" and "space becomes charged and responsive to the movement of time, plot, and history."[70] Addressing such aspects of the films as their architecture, their mixtures of different retro props and technologies, and Wick's method of getting from New York to Rome, these essays identify the ways in which the franchise locates its protagonist both outside of and imbricated in the constraints that govern a world in which space has been indelibly marked by history.

In "Classical Orders, Modernist Revisions, Fantastical Expansions: Reading the Architecture of the *John Wick* Franchise," Andrew Battaglia and Marleen Newman employ the architecture of John Wick's world as a means of understanding character. Wick's "poetic modernist" house, they argue, brings together the radical honesty and openness of the Modern movement's aesthetics with the emotional significance theorized by Portuguese architect Álvaro Siza, one of whose books appears on Wick's coffee table. The hybrid aesthetics of the house, with its open floor plan permitting both glimpses of Wick's life with Helen and fluid combat, render it a microcosm of the ways in which John's grief, memories, and capacity for violence are intertwined. This architecture poses a stark contrast to the historical styles—particularly classicism and neoclassicism—of the Continental and the High Table. Characterized by symmetry and order, such sites as the art galleries where Wick and Santino D'Antonio clash in *John Wick 2* serve "as a metonym of the ordered social relations in Wick's criminal world." As the franchise evolves, however, this dichotomy is complicated by the expansion of the Wickverse into settings that both lack a clear architectural language and signal new elements of lawlessness and duplicitousness. In sum, the films' built environment proves a "necessary supplement" to their narrative and dialogue, a heuristic complement to the "liminal spaces

that come without a clear or unified language (and thus have no clear or unified meaning)."

Charles M. Tung's "Out of Time and Going Sideways: John Wick, Time Traveler" similarly identifies the *Wick* films' "internally heterogeneous landscape of the present" in which different timelines and versions of history intersect and overlap. Extending Fredric Jameson's argument that modern action cinema, in its repetitive violence, effects a deterioration of history and future into a detemporalized "series of repetitive instants," Tung posits that the *Wick* films present a refusal of a unified, linear temporality. This point is illustrated with an exploration of "bullet time," made famous by *The Matrix*, which in its assemblage of perspectives on a single moment or object provides the opportunity to view the present as a collage of dilations, contractions, and variants rather than as a homogenous unity. Similarly, the present of the *John Wick* franchise is marked by a mash-up of historical technologies, outfits, and aesthetics; while the High Table and Continental attempt to maintain control over the present, Wick "represents the desire to exit the idea of a singular history and a unitary communication network."

Mi Jeong Lee's "John Wick's Blank Cosmopolitanism and the Global Spatiality of the Wickverse" takes up a notion implicit in Tung's argument that the franchise reveals a US-centric view of historical progression. In this view, Wick embodies a fantasy of power and mobility, and Lee charts how these change as his status within the Wickverse is destabilized. To explain these changes, she theorizes a "blank cosmopolitanism" that facilitates his mobility, multilingualism, and adaptability, a "veneer of universalism" that belies the "privilege behind the apparent seamlessness of both the films' completely globalized and borderless world space and the person who moves within it." Moreover, the revelation in *John Wick 3* of John's identity as Jardani Jovonovich

indicates that this blankness "is not something that he is born with but something he has fashioned to come across as blank only when juxtaposed against its negative." As John himself becomes less "blank" and more localized, New York City emerges as a "Wickverse" no longer congruent with the globalized space of the High Table; the expanded horizontal reach of the larger cinematic world now permits New York to be redefined as a local space that reflects the shifts in mobility and affiliation that Wick's character has undergone.

While the essays in the volume's last section, "Gender and the Body in *John Wick*," follow different theoretical and interpretive paths, they ultimately arrive at a common destination: John Wick's masculinity. Along the way, they also offer illuminating readings of elements central to the worlds of *John Wick*: dogs and puppies (including the popular genre of films featuring dog-human interactions) and their humanization of a professional assassin; liminality, hybridity, and the use of such means as bisexual lighting to deepen understandings of gender; the films' feminist critique of professional life and its inherent masculinism; bodily inscription and piercing, particularly Wick's tattoos, branding, and scarification; and a host of related topics.

Karalyn Kendall-Morwick's "John Wick's Multiply Signifying Dogs" begins by examining the narrative device "fridging"—the death or brutalization of a woman that motivates a male protagonist's action— and the substitution of Wick's puppy Daisy in deploying this convention. At the same time, this substitution recalls the Victorian conception of dogs as humanizing agents, a phenomenon Kendall-Morwick traces in such films as the melodramatic tear-jerker *Old Yeller* (1957) through the more recent *A Dog's Purpose* (2017) and *A Dog's Journey* (2019). But it is not just Wick who is redeemed by his interaction with dogs; so, too, is the reputation of the oft-maligned pit bull through the nameless "Dog" that Wick rescues near the end of *John Wick*. Throughout the franchise,

then, dogs serve as a catalyst for an "emotional-prosthetic" reading of Wick, underscoring his vulnerability while at the same time performing other cultural work and, in the case of Sofia's paired Belgian Malinois, adding spectacularly to the action.

For Owen Horton in "Masculinity, Isolation, and Revenge: John Wick's Liminal Body," Wick is engaged in a dance between two selves—husband and assassin—that prevents him from fully embracing his legendary role as Baba Yaga, but he cannot escape the role either. Like Newman and Battaglia, Horton studies the architecture of Wick's house, regarding its design as reflective of his complicated masculinity: the loving husband occupies the house's second floor, and the monster is buried in the basement. To use Horton's metaphor, the "domestic layer cake" of Wick's home thus reads not as a unified, blended, or hybrid space but rather as analogues to the distinct selves he embodies or exists between. Similarly, the "bisexual lighting" with its reds, pinks, purples, and blues in the Red Square sequence discussed earlier by Coulthard and Steenberg underscores Wick's "neither-and-both hybridity." In the end, Horton sees Wick as paying homage to but challenging the hypermasculinity of a generation of "super action" heroes who preceded him.

This hypermasculinity is challenged even further in Vivian Nun Halloran's "Professionalism and Gender Performance in the John Wickverse." For Halloran, the Wickverse affords no opportunity for a "work-life balance"; instead, its criminal organizations enforce a corporate culture with a near obsession for expressions of company loyalty. For Wick in *John Wick 3*, the cost of "such a declaration of fealty" is the loss of his left ring finger. More important, and as a result of Wick's rejection of this identity, the *Wick* franchise furthers what amounts to a feminist critique of American masculinist standards of so-called professional conduct, even though its champion is a cisgender White-identified male character.

In "Style and the Sacrificial Body in *John Wick 3*," Stephen Watt unpacks the uncanny relationship between Wick and the ballerina he observes in rehearsal in search of transport out of New York: both characters feature Latin inscriptions on their upper backs, both display primitively etched (not painted, multicolored, or abstract) tattoos, and both suffer for larger causes. To support this juxtaposition, Watt examines tattooing, piercing, scarification, branding, and other dermal signifiers, arguing that bodies and skin communicate significantly—and differently—in the *John Wick* franchise than in most action films. And, in the case of Wick's body, this communication confirms a spiritual commitment akin to martyrdom.

Our hope is to provide an initial foray into the questions and scholarly discussions prompted by the meticulous world-building that defines *John Wick*—that is to say, *The Worlds of* John Wick: *The Year's Work at the Continental Hotel* is only a provisional entry into the series, whose planned fourth and fifth films propose to show "how deep the world goes, and not just about assassins but everything that's included."[71] "Everything that's included" is quite a lot, an aesthetic and philosophical inventory that will be even further expanded by a prehistory of Winston's role in founding the Continental, the premise of a new television series that Lionsgate announced in the spring of 2021.[72] The multidisciplinarity of *The Worlds of* John Wick calls attention to the variety of critical tools required to reach a fuller understanding of this expanding franchise. Clearly, more years' work at the Continental Hotel may be necessary.

Notes

1. These are the figures quoted in the Internet Movie Database. In an interview for *John Wick 3*, Chad Stahelski implies that the budget for *John Wick* was less than

the figure reported: "To come from a tiny, $18 million, kill-20-people-over-a-puppy to where we are now, we're very thankful." See Eric Francisco, "Why the Director of 'John Wick' Is Obsessed with Ballet," *Inverse*, May 10, 2019, www.inverse.com/article /55687-john-wick-chapter-3-director-interview-why-ballet-matters.

2. Scott Mendelson, "Box Office: 'Avengers: Endgame' Nears $2.75 Billion, 'Aladdin' Tops $800 Million, 'John Wick 3' Nears $300 Million," *Forbes*, June 23, 2019, https://18wallstreet.wordpress.com/2019/06/24/box-office-avengers-endgame-nears -2-75-billion-aladdin-tops-800--million-john-wick-3-nears-300-million/.

3. Brooks Barnes, "'John Wick: Chapter 3' Puts Keanu Reeves Back on Top at the Box Office," *New York Times*, May 19, 2019, https://www.nytimes.com/2019/05/19 /movies/john-wick-chapter-3-box-office.html.

4. Richard Newby, "How 'John Wick 3' Scales Back While Pushing Forward," *Hollywood Reporter*, January 17, 2019, https://www.hollywoodreporter.com/heat -vision/how-john-wick-3-trailer-tops-what-came-before-1176801; Simon Riaux, "John Wick: Critique qui déglingue," *EcranLarge*, February 4, 2018, https://www.ecranlarge .com/films/930015-john-wick/critiques.

5. Tom Philip, "Review: *John Wick: Chapter 3—Parabellum* Expands on an Already Great Franchise," *GQ*, May 15, 2019, https://www.gq.com/story/review-john -wick-chapter-3-parabellum.

6. Will Harris, *Mixed-Race Superman: Keanu, Obama, and Multiracial Experience* (Brooklyn: Melville House, 2019), 35.

7. Michael DeAngelis, *Gay Fandom and Crossover Stardom: James Dean, Mel Gibson, and Keanu Reeves* (Durham, NC: Duke University Press, 2001), 189, 185.

8. Harris, *Mixed-Race Superman*, 27.

9. Cat McCarrey, "Review: Deliciously Ridiculous 'John Wick' Showcases Star Keanu Reeves at Action-Packed Best," *Daily Free Press: Boston University*, October 31, 2014, https://dailyfreepress.com/2014/10/31/review-deliciously-ridiculous-john-wick -showcases-star-keanu-reeves-at-action-packed-best/.

10. See, for example, Thomas Périllon's description of the film as Reeves's "return to the screen" *"retour à l'écran"* ("'John Wick' avec Keanu Reeves: Ludique and bien fichu, un film d'action comme on les aime," *Le Nouvel Observateur*, October 31, 2014, modified November 1, 2014, http://leplus.nouvelobs.com/contribution/1266085-john -wick-avec-keanu-reeves-ludique-et-bien-fichu-un-film-d-action-comme-on-les-aime .html); or Jacob Wolin's review, which begins with his pronouncement of Reeves's return before admitting to falling asleep during *47 Ronin* ("Review: Reeves Makes Comeback in 'John Wick,'" *Utah Statesman: Utah State University*, November 4, 2014, https://usustatesman.com/review-reeves-makes-comeback-in-john-wick/).

11. Travis M. Andrews, "Keanu Reeves Is Having a Keanussance with the John Wick Series—but Did He Ever Really Go Anywhere?," *Washington Post*, May 21, 2019, https://www.washingtonpost.com/arts-entertainment/2019/05/21/keanu-reeves-is-having-keanussaince-with-john-wick-series-did-he-ever-really-go-anywhere/.

12. Mendelson, "Box Office."

13. Scott Mendelson, "Why 'Avengers: Endgame,' 'John Wick 3,' and 'Aladdin' Are Towering over the Competition (Box Office)," *Forbes*, June 24, 2019, https://www.forbes.com/sites/scottmendelson/2019/06/24/box-office-avengers-endgame-john-wick-keanu-reeves-aladdin-toy-story-pikachu-godzilla-x-men-spider-man/#29a8bf663223.

14. David Fear, "In Praise of 'John Wick,' the Last Great American Action-Movie Franchise," *Rolling Stone*, May 16, 2019, https://www.rollingstone.com/movies/movie-features/john-wick-the-last-great-american-action-movie-franchise-832310.

15. Steve "Frosty" Weintraub, "'John Wick 3': Chad Stahelski on the Action Scene That's a 'F**k You' to Other Action Scenes," Collider, March 21, 2019, https://collider.com/chad-stahelski-interview-john-wick-3/. Given Stahelski and David Leitch's close collaboration, it is more accurate to refer to them as "codirectors" of *John Wick*. For *John Wick 2* and *John Wick 3*, Leitch is credited as an executive producer.

16. Peter Bradshaw, for example, calls *John Wick* a "humorless and violent film, which grinds on and on" and trashes "more and more gleaming Black SUVs." See "John Wick Review—the Action Sequences Grind On and On," *The Guardian*, April 9, 2015, www.theguardian.com/film/2015/apr/09/john-wick-review-keanu-reeves-in-humourless-violent-generic-action-film.

17. Original: "Si le vol d'une voiture et le meurtre d'un chiot justifient à vos yeux de massacre l'équivalent de la population Luxembourgeoise . . . alors vous êtes mûr pour John Wick."

18. Jeannette Catsoulis, "'John Wick Chapter 3' Review: Keanu Reeves Is Back for Another Brutal Round," *New York Times*, May 16, 2019, www.nytimes.com/2019/05/16/movies/john-wick-chapter-3-parabellum-review.html.

19. Anna Li, "Critique Cinéma: John Wick," *Caramie's Zone* (blog), October 20, 2014, https://caramiezone.blogspot.com/2014/10/critique-cinema-john-wick.html.

20. Peter Travers, "'John Wick: Chapter 3' Review: He's Back, Bloodier and More Brutal Than Ever," *Rolling Stone*, May 15, 2019, https://www.rollingstone.com/movies/movie-reviews/john-wick-chapter-3-parabellum-movie-review-keanu-reeves-834728/.

21. Mark Kermode Reviews *John Wick: Chapter 3—Parabellum*," BBC Radio, May 17, 2019, https://www.bbc.com/programmes/p079jt2z.

22. Michael Phillips, "'John Wick 3' Review: Keanu Reeves Burns Ultraviolence Candle at Both Ends," *Chicago Tribune*, May 14, 2019. www.chicagotribune.com /entertainment/movies/sc-mov-john-wick-3-keanu-review-0514-story.html.

23. Travers, "John Wick: Chapter 3."

24. See Simon Mayo, "Keanu Reeves Interviewed by Simon Mayo," BBC Radio 5 Live, May 17, 2019, www.bbc.com/programmes/p079j4pl.

25. Bilge Ebiri, "*John Wick* Is a Violent, Violent, Violent Film, but Oh-So Beautiful," *New York Magazine/Vulture*, October 24, 2014, www.vulture.com/2014/10 /john-wick-movie-review.html.

26. Périllon, "'John Wick' avec Keanu Reeves."

27. Ebiri, "*John Wick* Is a Violent Film."

28. See Jacob Hall, "Heartbreaks and Headshots: The Action Movie Majesty of the 'John Wick' Series," /Film, February 15, 2017, https://www.slashfilm.com/john-wick -chapter-2-analysis/; Brian Lloyd, "The Elegant Simplicity of 'John Wick,'" *Entertainment.ie*, February 2, 2019, https://entertainment.ie/cinema/movie-news/the -elegant-simplicity-of-john-wick-388874/.

29. Quoted in Luke Y. Thompson, "How 'John Wick' Developed Its Unique Fighting Style," *Forbes*, June 13, 2017, https://www.forbes.com/sites/lukethompson /2017/06/13/john-wick-chapter-2-keanu-reeves-chad-stahelski-interview /#6de44a047749.

30. Weintraub, "John Wick 3."

31. Scott Mendelson, "Review: 'John Wick,' with Keanu Reeves, Is a Terrific Action Blast," *Forbes*, October 15, 2014, www.forbes.com/sites/scottmendelson/2014/10/15 /review-john-wick-with-keanu-reeves-is-a-terrific-action-blast/#90b1bc17ba28.

32. Quoted in Michael Rougeau, "John Wick 3: Why the Underground World of Secret Assassins Is So Alluring," Gamespot, May 15, 2019, https://www.gamespot.com /articles/john-wick-3-why-the-underground-world-of-secret-as/1100-6466941/.

33. Peter Sobczynski, "John Wick: Chapter 3—Parabellum," RogerEbert.com, May 17, 2019, https://www.rogerebert.com/reviews/john-wick-chapter-3--parabellum -2019.

34. Erik Kain, "'John Wick 2' Is a Completely Pointless Sequel," *Forbes*, May 30, 2017, www.forbes.com/sites/erikkain/2017/05/30/john-wick-2-is-a-completely -pointless-sequel/#76a69a0f16c5.

35. Nelson Goodman, *Ways of Worldmaking* (Indianapolis: Hackett, 1978), 6, 21.

36. Eric Hayot, *On Literary Worlds* (New York: Oxford University Press, 2012), 24.

37. Hayot, *Literary Worlds*, 23.

38. Hayot, *Literary Worlds*, 14. Here Hayot is quoting Mikhail Bakhtin, "Forms of Time and of the Chronotope in the Novel," in *The Dialogical Imagination: Four Essays,*

trans. Caryl Emerson and Michael Holquist (Austin: University of Texas Press, 1981), 253.

39. A similar encounter with the "real world" occurs after Wick's house is destroyed in *John Wick 2* when close-ups of burning photographs of his wife are edited with images of the house engulfed in flames. A long shot of the conflagration leads to a tight shot of his left hand and wedding ring while he sits on the running board of a fire truck. Thus, while his world is kept at a distance from that of police officers and firefighters, boundaries between them are inevitably breached.

40. Mike Fleming Jr., "Lionsgate Selling 'John Wick' Sequel at Cannes," *Deadline*, May 4, 2015, https://deadline.com/2015/05/lionsgate-selling-john-wick-sequel-at-cannes-1201420556/.

41. Adam Chitwood, "'John Wick 4' Release Date Delayed a Full Year," Collider, May 1, 2020, https://collider.com/john-wick-4-release-date-delayed/.

42. Goodman, *Ways of Worldmaking*, 104.

43. Marie-Laure Ryan, "Story/Worlds/Media: Tuning the Instruments of a Media-Conscious Narratology," in *Storyworlds across Media: Toward a Media-Conscious Narratology*, ed. Ryan and Jan-Noël Thon (Lincoln: University of Nebraska Press, 2014), 31.

44. David Herman, *Basic Elements of Narrative* (Hoboken, NJ: John Wiley and Sons, 2009), 122.

45. Marie-Laure Ryan, "Possible-Worlds Theory," in *The Routledge Encyclopedia of Narrative Theory*, ed. David Herman, Manfred Jahn, and Marie-Laure Ryan (London: Taylor and Francis, 2010), n.p.

46. u/dfinkelstein, "In the John Wick movies, the spoken Russian is so bad that a native speaker often also needs the subtitles," Reddit, July 31, 2019, https://www.reddit.com/r/movies/comments/ckb9rc/in_the_john_wick_movies_the_spoken_russian_is_so/.

47. See Jessicha Valentina, "'John Wick 3': Excellent Fighting Scenes with Dash of Indonesian Culture," *Jakarta Post*, May 16, 2019, https://www.thejakartapost.com/life/2019/05/16/john-wick-3-excellent-fighting-scenes-with-dash-of-indonesian-culture.html.

48. Chad Stahelski and David Leitch, "Audio Commentary," *John Wick*, Santa Monica, CA: Summit Entertainment, 2014. Blu-ray.

49. Stahelski and Leitch, "Audio Commentary."

50. Marie-Laure Ryan, "From Possible Worlds to Storyworlds: On the Worldness of Narrative Representation," in *Possible Worlds Theory and Contemporary Narratology*, ed. Alice Bell and Marie-Laure Ryan (Lincoln: University of Nebraska Press, 2019), 82.

51. This and the following quotation are from Jared Gardner, "Film + Comics: A Multimodal Romance in the Age of Transmedial Convergence," in Ryan and Thon, *Storyworlds across Media*, 206.

52. Murray Smith, "On the Twofoldness of Character," *New Literary History* 42, no. 2 (2011): 279.

53. u/JohnWickMovie, "Hey, I'm director Chad Stahelski! Let's talk about John Wick: Chapter 3—Parabellum—AMA," Reddit, May 14, 2019, https://www.reddit .com/r/IAmA/comments/booyih/hey_im_director_chad_stahelski_lets_talk _about/.

54. Hayot, *Literary Worlds*, 38.

55. Pheng Cheah, *What Is a World? On Postcolonial Literature as a World Literature* (Durham, NC: Duke University Press, 2016), 13, 2.

56. Cheah, *What Is a World*, 2.

57. Cheah, *What Is a World*, 8.

58. Cheah, *What Is a World*, 1.

59. David Wittenberg, "Bigness as the Unconscious of Theory," *ELH* 86, no. 2 (2019): 333.

60. Wittenberg, "Bigness," 341.

61. Wittenberg, "Bigness," 340.

62. Wittenberg, "Bigness," 340.

63. Underscoring the assassin's size in *John Wick 2*, John Gunning describes Yama as "the heaviest Japanese rikishi in history at 266 kg." See "Yama Succeeds after Sumo," *Japan Times*, January 18, 2020, https://www.japantimes.co.jp/sports/2020/01 /18/sumo/yama-succeeds-sumo/#.XtvLWkBFwot.

64. Yvonne Tasker, *Spectacular Bodies: Gender, Genre, and the Action Cinema* (New York: Routledge, 2008), 16.

65. Melanie McFarland, "Why Do Women Love John Wick? (It's Not Just the Puppy)," *Salon*, May 16, 2019, https://www.salon.com/2019/05/16/why-do-women -love-john-wick-its-not-just-the-puppy/.

66. Marjorie Liu, "The Hero We Need: Keanu Reeves Is Demolishing All Our Dumb Stereotypes," *Literary Hub*, June 14, 2019, https://lithub.com/the-hero-we -need-keanu-reeves-is-demolishing-all-our-dumb-stereotypes/.

67. McFarland, "Women Love John Wick"; Liu, "Hero We Need."

68. Bernard Shaw, *The Intelligent Woman's Guide to Socialism, Capitalism, Sovietism, and Fascism* (New York: Random House, 1928), 254.

69. Quoted in Screen Junkies, "Honest Reactions: John Wick Directors React to the Honest Trailer!," YouTube, February 16, 2017. https://www.youtube.com/watch?v =3DNQJE8eHjw.

70. Bakhtin, "Forms of Time," 84.

71. Allie Gemmill, "'The Continental': New Plot Details for 'John Wick' Spinoff Show Teased by Chad Stahelski," Collider, May 16, 2020, https://collider.com/john-wick-the-continental-plot-details-update-chad-stahelski/.

72. See, for example, Ryan Lattanzio, "'John Wick' TV Series Details Emerge: 'The Continental' Will Be a Gritty Prequel about Young Winston," IndieWire, April 24, 2021, https://www.Indiewire.com/2021/04/john-wick-tv-series-the-continental-prequel-1284632796/.

CAITLIN G. WATT is Lecturer in the Department of English at Clemson University. Her work focuses on gender and sexuality and narrative theories of character in medieval romances. Her work has appeared in *Neophilologus, Erasmus Studies, Medieval Feminist Forum,* and *Postmedieval.* Her current project examines the development of the Arthurian storyworld in medieval manuscripts.

STEPHEN WATT is Provost Professor Emeritus of English and former Associate Dean of the Eskenazi School of Art, Architecture + Design at Indiana University Bloomington. Most of his published writing treats one of three topics: Irish studies; drama, film, and performance studies; or the contemporary university. His most recent books include *Bernard Shaw's Fiction, Material Psychology and Affect: Shaw, Freud, Simmel* (2018) and *"Something Dreadful and Grand": American Literature and the Irish-Jewish Unconscious* (2015). With Edward P. Comentale and Skip Willman, he edited *Ian Fleming and James Bond: The Cultural Politics of 007* (2005).

PART I
JOHN WICK *AND ACTION CINEMA*

RED CIRCLE OF REVENGE 1
ANATOMY OF THE FIGHT SEQUENCE IN JOHN WICK

LISA COULTHARD & LINDSAY STEENBERG

Introduction

From the OK Corral to the Colosseum, the fight sequence is one of the primary building blocks of Hollywood cinema. Despite its ubiquity, it has received little critical attention as a discrete unit of cinema. This chapter begins to address this gap by turning to the *John Wick* franchise (Chad Stahelski, 2014–2019), a series of films that might be best understood as a succession of interlocking fights. In fact, it may be more accurate to say that *John Wick* does not have fight sequences; it *is* a fight sequence.

Written through bodies and architecture, fighting in *John Wick* draws audiovisual attention to surfaces. The films are defined by a slick aesthetic of expensive cars, tailored suits, and elaborate hyperreal spaces. Characterized by cinematic formalism oriented around mobile camera framing, the fight scenes foreground bodies moving through byzantine spaces dominated by reflective surfaces, filmed in medium and long shots, and scored with energizing rock, trance, and ethereal electropop beats. Eschewing the rapid-fire editing, intensified continuity, and shaky cameras made ubiquitous with the "run and gun" style of the *Bourne* series (2002–2016), *Wick*'s action is perceptible and palpable on a human scale, tied to the body and star persona of Keanu Reeves as John Wick.[1]

Reeves's body in action becomes a kind of compressed celebrity symbol that enmeshes John Wick with Keanu Reeves, endowing the film character with the mixed-race background, tragic romantic past, single-minded athleticism, professionalism, and understated likeability associated with Reeves's star persona. These factors play a key role in the perceived authenticity and skill associated with the *Wick* series' fight choreography, which foregrounds Reeves's physical adeptness and highlights his dance-like movements as he fights his way through impressive gothic, neoclassical, and modernist spaces.

This perception of Reeves holds sway even though the films make extensive use of stunt work and sophisticated CGI. Fans and critics alike stress the authenticity of the action, Reeves's skills, and the realism of the violence. The fight sequences are repeatedly lauded as "fresh," "raw," and "brutal." A particularly effusive *LA Times* review of *John Wick: Chapter 3—Parabellum*, praising its "mesmeric synchronicity" and "balletic ballistics," suggests that the film asks us to take action cinema as seriously as a Caravaggio painting, a Tarkovsky film, or a Greco-Roman sculpture—three of many references to high art in the film.[2] The *Wick* series, however, does not just elevate low cultural objects (such as action cinema); instead, it treats Roman classicism, Caravaggio's paintings, and martial action as parallel and equally significant aesthetic objects, each crystallizing as cool surface shimmers in the film settings. Both high art and populist action in *Wick* become attractive patterns of color and texture. Highlighting this attention to surface, *Wick*'s fight sequences are filmed with elaborate mobile framing augmented by pulsing rhythms of sound, music, and violence. John himself can be read as a polished surface, as the sleek athleticism of Reeves's kinetic body, fashionably armored in bespoke protective suits, is more significant to the films than any dialogue. This Wickian *mise-en-surface* focuses on the architectural features of the set piece and spectacle of

John Wick strutting and striding through hyperreal spaces—dynamic action that is reflected in the rock, pop, and techno music that drives John's kineticism and the affective action of the films.

Between Blood and Data

The *John Wick* films oscillate between what we term *blood* and *data*—that is, between visceral authenticity and digital augmentation. These two dominant strains shape the franchise's fight scenes, which are grounded in the realism of corporal violence while simultaneously celebrating the reality-bending possibilities of digital effects. We suggest that this central tension is a feature of the contemporary big-budget fight scene that tarries between physicality and digitality, authenticity and effects, and realism and hyperreality. This tension is echoed in the labor practices of the franchise, particularly its use of stunt performers who are simultaneously celebrated and effaced, revealing the ways in which the Wickverse can claim authenticity and realism (for example, Reeves's fight skills and the stunt performer as director) while also experimenting with sophisticated digital effects. The films dazzle with special effects (including sound effects and computer-generated visual effects), elaborate sets (the glass house and the weapons museum), electronic throbbing music, and visually enhanced spectacular kineticism. In addition, through its fight scenes, the franchise draws heavily from cultural texts and icons, whether action cinema and its hitman subgenre or neoclassical ideals and iconography. Like their shiny surfaces, the films are reflective and refractive of their genre and the cinematic history of fight scenes (see fig. 1.1). They shine back to the viewer a dazzling and accelerated compendium of film fighting in the digital era.

Focusing on a single significant fight scene (the seven-minute, thirty-one-second Red Circle Club sequence in *John Wick*) as an

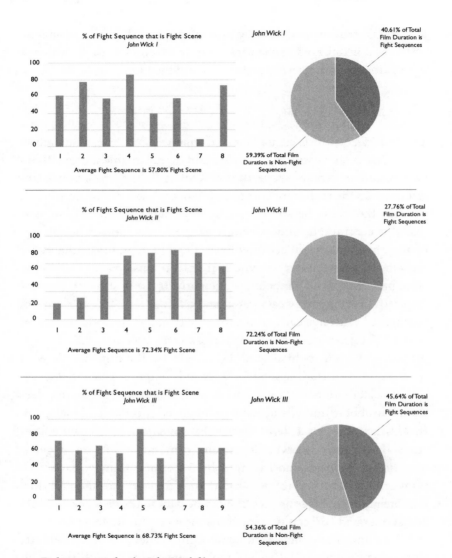

1.1. Fight statistics for the *John Wick* films.

illustrative example, this chapter anatomizes and analyzes *Wick*'s fight aesthetics in order to interrogate their *mise-en-surface*. *Wick*'s fight scenes do not depart from established norms so much as build on and exaggerate current trends; therefore, we use this sequence as a deep dive into the operations of the cinematic fight. We break down the ways in which bodies and spaces, sound and vision, and blood and data work to create a kinetic action sequence of entertaining and exaggerated physical violence. We focus this inquiry on how audiovisual aesthetics and schematics articulate the "impact aesthetic" and balletic ballistics associated with action cinema's fight scenes.[3]

The multilevel fight at the Red Circle nightclub reveals an established pattern in the fight scenes across the *John Wick* franchise and, indeed, postmillennial action cinema more widely. In looking at this fight, we approach violence as a language-reinforced architectural orchestration of the set piece, the ludic logic of its narration, and the suturing to the body and perspective of John in a way that parallels the dance sequence in the musical.[4]

The Red Circle Fight

The fight at the Red Circle nightclub is the second of eight fights in the first *John Wick* film. The sequence follows the eponymous John Wick as he tracks his target, Iosef Tarasov (Alfie Allen), into a glitzy nightclub. He first encounters the doorman, Francis (Kevin Nash), whom he spares out of professional courtesy. John then sneaks into the club and kills one of Iosef's main protectors, Victor (Toby Leonard Moore). After stalking and killing several bodyguards, John finds Iosef in an opulent subterranean bathhouse, where he fights several underlings. Iosef flees onto the busy dance floor with John in pursuit. Following Iosef relentlessly up the stairs and into a VIP room, John shoots multiple assailants,

who are identically dressed in black jackets and red shirts. The shoot-out spills onto a mezzanine, where he must fight at closer range and engage with more skilled guards, including their leader, Kirill (Daniel Bernhardt), who throws John from the balcony onto the emptying dance floor, where he lands with a visceral thud, signaling the end of the fight itself. The scene follows John and the hysterical crowds as they rush out of the club.

Across the 187-shot sequence, John kills twenty-seven people. His kinetic chase across five interior locations (changeroom, bathhouse, dance floor, VIP room, and mezzanine) is punctuated by several shoot-outs and can be further subdivided into nine significant hand-to-hand altercations between him and the adversaries blocking his target. The Red Circle fight is typical of the way the *John Wick* franchise arranges its fight sequences as multilevel, ludically informed, hyperreal, dynamic, and highly aestheticized set pieces that insist on violent authenticity through mediated stylistic gestures. Like the other fights, it focalizes John as the prime agent, tying his movement to music and rhythm and highlighting his point of view and point of audition.

While we argue that the fight sequences in the *John Wick* series are not radical departures from the established style and choreography of similar sequences in other action films, they share a collection of distinguishing characteristics that have become unique selling points of *John Wick* as a brand. First, the *John Wick* action sequences lavish attention on the minute preparations for the fight, which we label the "para-action" sequence. For example, in *John Wick 2*, John visits the "gun sommelier" at the Continental Hotel in Rome and has his tactical/bulletproof suit tailor-made; in *John Wick*, he calls for "dinner reservations" when he needs the corpses cleared from his house. In advance of the Red Circle fight, as with the earlier home invasion sequence, he dresses and accessorizes in ritualized detail. Once John engages in violence, the

films mix wide shots and longer takes with detailed close-ups to insist on the authenticity of the fight and to allow the spectator to admire the mise-en-scène of the set piece, thus reinforcing the architectural nature of the violence. This is further bolstered by the use of a mobile but not overly shaky or unstable camera. Such framing and cinematography are ideally suited to the smooth but economical movements of gun fu, a practice of close-range armed combat informed by Hong Kong action cinema and filmmakers such as John Woo, which is augmented by digital special effects across the *John Wick* films.

The *John Wick* series engineers fight scenes that play with proximity, range, and movement across multiple axes, using all available dimensions of space to showcase multiple participants, weapons, and levels. This renders the fight both dance-like and game-like. Danijela Kulezic-Wilson has noted that there has long been a connection between music and movement, and the cinematic fight sequence combines this musical kinesis with audiovisual action. As she notes, these elements have come together in a unique way in action cinema since the release of *The Matrix*, which blends "the musical elegance of martial arts choreography" with Hollywood big-budget spectacle and uses "expressive gestures, choreographed actions, rapid editing, amplified sound effects and music to produce a new type of audiovisual kinesis."[5] The Red Circle sequence heightens and accelerates this kinesis through cinematic formalism, propulsive music, and John's spectacularized athleticism and skill. Enhanced and driven by audiovisual aesthetics, the athletic spectacle of John's kinetic violence also highlights the importance of Keanu Reeves's star persona to the *John Wick* fight scenes, as the success of the franchise spurred Reeves's surge in popularity, particularly on social media, where he gained a reputation as "the internet's boyfriend." The Red Circle fight showcases all of these features and is illustrative of the franchise fight design as a whole.

Compared with other fight scenes in the film, this sequence is particularly dense in terms of actual violent acts. To be more precise, 83.48 percent of this sequence consists of fighting (both armed and unarmed) rather than arguing, preparing, or recovering.[6] The large-scale shoot-out at the church (fight 4 at 86.21%) and the final showdown between John and crime boss Viggo (Michael Nyqvist) at the docks (fight 8 at 73.11%) are similarly lengthy and involved, but neither represents the level of carnage, dynamism, or rhythmic musicality of the Red Circle fight.

Schematic of the Fight

We have divided our analysis of the Red Circle fight based on its five main locations and their dominant modes, which are determined by audiovisual aesthetics, architectural space, and fight style. Traveling through these separate modes is the rhythm of sound, music, and choreographed violence.

Location	Changeroom
Mode	Entry, access
Altercation 1	Victor
Shots	1–21
Average shot length	3.4 seconds
Time	1 minute, 11 seconds
Body count	2

Having spared Francis outside the club, John confronts a bathrobed Victor in a scene engineered to reinforce the impact of John's mythological reputation as the "Baba Yaga." He inhabits off-screen space, his ghostlike presence haunting the shot like the techno music (Le Castle Vania's "The Drowning"), muted to indicate proximity but also a spatial

remove from the dance floor and the bathhouse. Bolstered by the candlelit lighting scheme, with its dramatic use of red neon circles mounted on the walls, this sequence sets up the confrontation in a stealth-like mode of a covert attack, echoed in the muted music and restricted sound design. After the door closes mysteriously, John emerges silently into the frame (we do not hear his movement or footsteps). His first kill happens in the background, audible to us in the loud knife sound and body drop. It is also notable to the bodyguard Victor as he glances in the mirror and sees the blood in the background of the frame. The camera remains relatively static in the mid-distance, moving only to uncomfortable close-ups when John strangles Victor, partially drowns him, and delivers a final blow that breaks his neck.

This sequence has both a more proximate and more static camera, which reinforces the sense of furtiveness and preparation for the hunt. Here John's violence is not part of a matched fight, designed to showcase skill and build pacing; rather, it is staged as two efficient assassinations on the way to the main target, the sadistically incompetent Iosef. It also focuses on John and his vengeance in an intimate way that prepares the audience for the exhilarating action to follow by justifying his revenge and aligning the audience with his perspective. This is also, significantly, the only point in the sequence where John speaks with his victim (in Russian via colorfully rendered integrated subtitles), ritually restating his purpose and moral impetus for violence: "You stole my car. And you killed my dog." These staccato statements are typical of John's way of speaking, tapping into Keanu Reeves's iconic speech patterns. The music reaches a crescendo before a conclusive silence that closes off the scene as John leaves the room. This musical marking of the scene's conclusion is paired with an ellipsis, as we do not see the intervening time it takes John to move from the changeroom to the bathhouse downstairs. The isolation of this sequence thus sets the stage for the spatial fluidity

and more thematically significant fights that follow. This section brings his violence into sharp relief—his ritual vow of revenge reconfirms the purpose of the fight scene and ultimately provides the fuel that propels the indefatigable movement of the sequence.

Location	Bathhouse
Mode	Stalking, stealth
Altercation 2	Knife in the neck
Altercation 3	Knife versus gun
Altercation 4	Strongman
Shots	22–97
Average shot length	2.0 seconds
Time	2 minutes, 31 seconds
Body count	7

The shallow focus and candlelight of the changeroom give way to the vault-like space of the bathhouse complex, with its white gossamer curtains, columns, and groups of swimsuit-clad patrons—the central of which is Iosef himself, drinking champagne in a small pool and singing Russian folk songs with his entourage. The music shifts to showcase the melodic female vocals of Kaleida's electropop "Think," and the lighting now features diffuse, underlit blue from the pools with dramatic red spotlights and harsher blues projected onto John as he learns the layout of the space and takes down several bodyguards. Red circular patterns provide spotlights for John's methodical but murderous rage. The bathhouse level is marked by slow and smooth tracking shots that are the signature of this mode of fight—stealth. John stalks his prey quietly, which is reconfirmed by music shifting in perspective to indicate John's POV as he moves from behind glass into the main room. He has a singular purpose (made manifest in the lingering higher-angle close-up shots

on his intense expression as he watches his victim die), and the viewer is sutured to this purpose.

Still specter-like, John is the Baba Yaga or Boogeyman killing to get closer to his prey. There are partially obscured POV shots as John watches Iosef through architectural features that highlight verticality (curtains, columns, and shelves piled with plush towels), contrasting with John's and the camera's lateral movement. He kills one bodyguard off-screen and throws his body against a glass partition in time with the beat of the music and with a deep thud of the body's impact and splat of blood. The muting of the music serves a dual purpose here: it gives audio perspective, spatializing John in relation to his prey; and it highlights a sense of quiet and stealth that renders the kills brutal while simultaneously stressing that this hidden violence is as yet unnoticeable to Iosef. However, this scene and its three main hand-to-hand altercations mark a transition from entry and stealth modes to the more frenetic pace of the gun fights, complex fight choreography, and louder music to follow.

If John is an off-screen myth at the start of the sequence, he emerges from the bathhouse shadows in sharp focus in his monstrous and stylish assassin form. His suited body is washed in reds and blues; his scarred face (shown in steady close-ups) maps the labyrinthine space, and the camera begins to favor low/mid-angle shots at a distance sufficient for the viewer to follow (and appreciate) the sophistication of the fight choreography. Each of the three hand-to-hand altercations with Iosef's bodyguards unfolds with less than four central beats, with each beat representing a choreographed strike or move. These altercations are not sustained in a single take, as elsewhere in the film or sequence, but include dramatic cutaways to key moves (e.g., John steps on his heavily muscled adversary's foot) or key weapons (e.g., a bodyguard reaches

for his gun, and the camera follows). This type of constructive editing produces staccato fights that do not flow with balletic smoothness but jar with a sharp and visceral brutalism reinforced by the sound design (the high-pitched slicing as John knifes a guard in the throat) and heightened by the counterpoint of soothingly melodic, anempathetic, and incongruent music.

The turning point of the scene, which shifts modes from stealth to chase, is a two-second slow-motion tracking shot from John's POV as he shoots at Iosef through large glass panes. The music stops, as does every other sound except the blast of gunfire and the loud shatter of breaking glass. This special moment returns to regular time as the prey, the guards, and the pursuer move up the stairs to the next location—the dance floor, the proximity of which has been indicated by heavy-hitting house music layered underneath the electropop of the bathhouse.

Location	Dance floor
Mode	Chase, pose, rhythm
No hand-to-hand combat, gunfire only	
Shots	98–110
Average shot length	2.9 seconds
Time	38 seconds
Body count	2

John chases Iosef upstairs to the dance floor, where Le Castle Vania's highly repetitive techno "LED Spirals" blares in time with strobe lights and rotating purple and green spotlights. A circular black-and-white pattern projected on a screen covers the entire back wall, creating a visual rhythm that matches the throbbing beats and focuses the eye and attention on John. These opening shots stress the movement of pursuit through tracking shots of Iosef from behind, intercut with backward tracking focused on John. Iosef's desperate half-naked stumble serves

1.2. John's deadly "strut to camera."

to heighten the smoothness and power of John's well-tailored form, his unhurried fashion-runway gait falling in time with the trance music; it is further reinforced by slow-motion cinematography shot from the low angle of Iosef's POV. Le Castle Vania's techno/trance (here "LED Spirals," later "Shots Fired") underscores John's machinelike drive—nothing will stop him, and the pulsing, propulsive music suggests and supports this mechanized metaphor.

This moment likewise recalls the many strut-to-camera shots favored by earlier cinematic hitmen, from the suited criminals in *Reservoir Dogs* (Quentin Tarantino, 1992) to the guitar-playing gunman in *Desperado* (Robert Rodriguez, 1995) to Alain Delon's iconic assassin in Melville's 1967 *Le Samourai* (another well-dressed hitman who fought in a glamorous nightclub). *John Wick's* slick slow motion recalls previous stylish hitmen and, more significantly, the dominant aesthetics that framed them (see fig. 1.2). As John moves toward a backward-tracking camera, the impression is one of a fashion runway, an association that gains greater weight through the tailored lines of his bespoke suit. More

than this, we argue, the audiovisual rhythm mechanizes John—his blank facial expression; steady, rhythmic (perhaps preprogrammed) movements; and position in the frame suggest a deadly automaton. The dance-floor scene is dominated by this sense of mechanical/technical rhythm—the music, John's relentless gait, the muffled pound of gunfire as John methodically takes down two bodyguards. The audiovisual rhythm is further accentuated by the crowd of dancing patrons, who carry on as if nothing is amiss and whose dance movements contrast with Iosef's frantic stumbling and John's steady pursuit.

Location	VIP room
Mode	Ludic, shoot-out
Altercation 5	Gun fu versus henchmen in red and black
Altercation 6	Gun jitsu versus henchman in red and black
Shots	111–124
Average shot length	3.1 seconds
Time	44 seconds
Body count	10

This rhythmic mechanization continues in the next section of the fight as John follows Iosef up the stairs to the VIP room. The rhythm remains steady, but as John moves to the VIP room, the lighting switches to a harsher white light, accenting the white, red, and black color scheme of the room with its leather-padded columns, glamorous patrons, and uniformed attendants/guards. The insistent music bridges the two locations, as "LED Spirals" moves almost imperceptibly into the more accelerated rhythms and strong metrical percussion of Le Castle Vania's "Shots Fired." The camera is momentarily (relatively) static as Iosef warns bodyguards that John is right behind him. The camera, music, and movement of bodies pick up pace, building to an exhilarating speed and introducing a new, higher-frequency, shrill (almost siren-like) sound as

John runs toward the camera with gun drawn, bursting into the room firing. The shots intercut between frontal and rear camera movement, which recall both third- and first-person perspectives of combat video games—arguably the dominant mode of this section of the fight sequence. This is echoed by the near-fetishistic attention to guns in the scene, as evidenced by John reloading his gun mid-massacre, a feature much discussed and celebrated by fans. The ludic quality of the fighting here motivates the escalation of gunfire as John faces off against a series of opponents wearing uniforms of identical black jackets and red dress shirts. The body count begins to mount.

The pounding rhythm of the music provides structure for accelerating beats of violence, the frenetic pace augmented by the use of an unstable and disorienting handheld camera. This is further reinforced by the slightly longer average shot length of this sequence (3.1 seconds as opposed to 2.0 seconds for the bathhouse). Gone are the fluid tracking movements of the bathhouse; in their stead is cinematography that permits, underscores, and draws attention to closer-range fighting (limited to four beats per encounter). This section of the fight is marked by the cinematic fighting style known as "gun fu," to which *Wick*'s fight choreographers add an even closer-range form of hybridized armed fighting that we propose labeling "gun jitsu." John's gun jitsu mixes many recognizable martial arts systems (such as judo, aikido, and Brazilian jujitsu) with established cinematic fighting conventions from Hollywood action films and, in particular, Hong Kong–produced cinema.

What is notable about this style of fighting is the intimacy of the encounters, as John grapples with his assailants on the floor and uses leg sweeps, joint locks, and choke holds. To overcome the challenges of filming grappling at such close range, the choreography reserves this style of fighting for when John confronts multiple adversaries, as it allows him to immobilize one with flair while shooting others with

sniper-like efficiency. It further varies the levels of fighting, from standing and running to crouching or rolling on the floor. These moments double close-up handheld camerawork with the proximity of the fighters, creating heightened disorientation exacerbated by the fact that John and his opponents are both dressed in black trousers and jackets (perhaps echoing the black-and-white patterns on the dance floor earlier in the sequence). The tightness of the frame during these close-range fights permits a magnified view of the graphic wounds inflicted on John's defeated foes, including one who is left with a smoking bullet wound in the eye.

The video-game-inspired shoot-out and disorientation of gun jitsu spills out of the VIP room and onto the mezzanine of the club, overlooking the dance floor. This location segment continues and escalates the mode of the previous fight, offering more adversaries at closer range and ending with John's most challenging opponent, head bodyguard Kirill.

Location	Mezzanine
Mode	Leveling up (and down), face-off with key adversary
Altercation 7	One versus many series
Altercation 8	Bearded henchman
Altercation 9	Kirill
Shots	125–187
Average shot length	2.4 seconds
Time	2 minutes, 29 seconds
Body count	6

The music increases in volume and accelerates in percussive rhythm as John fights individual minions at closer range. Each opponent is dispatched in approximately three to four beats, followed quickly by another with almost no screen time between skirmishes. Coupled with the strobe lighting, this acceleration mounts until the moment that John

loses sight of Iosef, still in a white towel, and must face Kirill. The fight with Kirill is marked off by a shot that sees Iosef escaping out the front door of the club, temporarily breaking the self-contained nature of the fight sequence's architecture, a shift that is reinforced by the drastic change in music perspective. Until this cutaway, the Red Circle night-club functioned as a game space with clear and insurmountable boundaries. Now that Iosef has escaped and the borders of the game space have been breached, the fight takes on a distinctly different nature and mode: the showdown between two professionals at cross-purposes—two skilled killing machines aimed at one another, where hyperviolence is the only possible outcome. If John's professional code let him spare Francis at the start of the sequence, this is impossible now.

The music shifts (dominated by synth notes) and then restarts as John rushes Kirill's gun and flips him over his shoulder with an audible roar. Harsh purple and pink illuminate the men as they grapple on the floor. Kirill's martial skills are confirmed with a series of three power-ful multilevel kicks, followed by a barrage of punches to John's face and torso. Kirill lands devastating blows, first by flipping John to the ground and then by smashing and stabbing him with a champagne bottle. The fight is over when Kirill throws John from the mezzanine to the dance floor below, relegating him to a lower level in an assertion of the se-quence's video-game logic.

John's descent to the dance floor, reinforced by the beats in the mu-sic, is marked by a visceral and hollow crack as he hits the hard ground. The music stops, and the fight is over; John lies for a moment, exhausted and injured, lit by a black-and-white spotlight. However, with mechani-cal resilience, he rises. He limps, bleeding, out of the building in a shot that again mimics his striking slow-motion walk onto the dance floor. The contrasts are telling. His movements are jerky and his gait uneven. Replacing the pulse of the electronic music are loud, diegetic sounds of

frightened people shuffling and whimpering and a moody, nondiegetic score played low in the mix. The sequence ends with John issuing a threat to Iosef on a dead bodyguard's phone: "Everything's got a price." This is the same phrase with which Iosef threatened John early in the film when trying to buy his car. While the phrase serves as a reminder that John cannot be bought by Iosef's influential crime family, in this context, the supposed truism describes the heavy price that both John and Iosef must pay in the mechanized and cyclical system of revenge.

Conclusion

The Red Circle fight is representative of a trend in recent digital action cinema to extend the fight sequence into lavishly mounted and choreographed set pieces that can last up to twenty minutes of screen time and that escalate the exhaustive pace of action beyond the "pause-burst-pause" pattern influentially described by David Bordwell in *Planet Hong Kong* (2000). There seems to be no pausing, just constant bursting. However, like *Kill Bill 1*'s (Quentin Tarantino, 2003) House of Blue Leaves sequence, the Moroccan chase sequence in *The Bourne Ultimatum* (Paul Greengrass, 2007), or the stairwell battle in *Atomic Blonde* (David Leitch, 2017), the Red Circle fight sequence is, of course, not a single fight but a series of fights linked by temporospatial unity. The Red Circle sequence demarcates a unit of action and architecture with several subsets of fights set in the various levels of the club; the nine altercations mentioned above are fought in the changeroom, the bathhouse, the VIP room, and the mezzanine, while the gunfights extend across all levels (except the changeroom, where John initially gains entrance to the club). The sequence's movement is propulsive, as John ascends upward from the basement to the upper mezzanine and stalks his victims

through horizontally oriented tracking shots. Effectively, the Red Circle fight is at least nine hand-to-hand fights, or five fight scenes, layered on top of one another and connected like video-game levels—a connection reconfirmed by the video-game logic of the sequence's plotting and aesthetics. Counted together, these interconnected altercations, fight scenes, or levels form the overall sequence, which has an exceptionally high fight density—that is, both a high percentage of actual violence to sequence runtime (as illustrated in the pie charts above) and a multilayered mobility through fight ranges and architectural locations. This produces a richly textured fight schematic that, we argue, stands as an excessive and illuminating example of the fight scene as a set piece and formal cinematic unit.

It is set pieces like the Red Circle fight that are most recirculated via both publicity machines and fan-generated networks. They can be read as microcosmic doubles of the film as a whole or function as insular narrational and spectacular units—short films in themselves, recalling the previz or stunt reel. As a distinct formal unit, the fight sequence has been critically regarded as analogous to the dance number in the film musical, and for this reason, musically inflected movement has evolved to become a crucial element in action cinema fights. Focusing on speed of movement, Lisa Purse notes in her book *Contemporary Action Cinema* (2013) that exhilarating sequences of unreal, inhuman speed invite the spectator to vicariously experience "a spatialized mastery, the fantasy of expansive spatial penetration, of force, forward momentum and progress."[7] The same could be said of the corporeal kinesis of the action cinema that pushes spatial mastery and expansion into the realm of the body, which we have argued becomes architectural. In this kind of spatial mastery, bodies move, drop, run, somersault, and impact each other with exhilarating and emphatic force and power. Even weapons

and vehicles become prosthetic or cybernetic extensions of the kinetic fighter's body, as John Wick uses guns, clothing, animals, and cars as extensions of his body rather than separate objects.

This chapter frames this expansive corporeal kineticism through the *mise-en-surface* attention to bodies and spaces as forms of architectural violence that we contend are illustrative of the tension between blood and data. Highlighting a seeming authenticity of action while simultaneously spectacularizing the fighting, *Wick*'s Red Circle fight becomes an extended metaphor for John's machine-like drive for vengeance—it offers an affective map of his violent journey. Starting with a violent interaction that confirms the worthlessness of his victims, we move from the (relatively) more personal confrontations (e.g., Victor) and stealth stalking of the bathhouse (scored appropriately by female-vocalized melodic pop) to the ludically charged, exhilarating, and accelerated violence of the dance floor, VIP room, and mezzanine spaces (driven by beat-based techno and more frantic camerawork). The contours of the sequence map a trajectory that frames John's vengeance as worthy, unstoppable, mechanical, and ruthless: nothing will stop him, and the hypermobile framing, constant movement, and propulsive music articulate and support this. Once the vengeance narrative is put into motion, it drives the violence forward without pause—a cyclical structure that mirrors the ubiquitous red circles punctuating the film's most masterful fight sequence.

Notes

1. David Bordwell, "Unsteadicam Chronicles," David Bordwell's Website on Cinema, August 17, 2007, http://www.davidbordwell.net/blog/2007/08/17/unsteadicam-chronicles/
2. Jen Yamato, "Review: 'John Wick 3' Expands the Wickverse with Another Artfully Ridiculous Body Count," *Los Angeles Times*, May 15, 2019, https://www

.latimes.com/entertainment/movies/la-et-mn-john-wick-chapter-3-parabellum
-review-keanu-reeves-20190515-story.html.

3. Geoff King, "Spectacle and Narrative in the Contemporary Blockbuster," in *Contemporary Action Cinema*, ed. Linda Ruth Williams and Michael Hammond (New York: Open University Press, 2006), 340.

4. This is the first, speculative step in a larger project (funded by the Social Sciences and Humanities Research Council of Canada) that will map the fight scene across a large number of Hollywood action films released since Neo downloaded kung fu in *The Matrix* (Lana and Lilly Wachowski, 1999) at the turn of the millennium. Although the spectacle of the Hollywood action film is usually associated with explosions, car chases, or other pyrotechnics, this project prioritizes hand-to-hand combat and interpersonal violence in order to analyze the fight's claims to brutal and embodied authenticity via the suffering body, which is in turn granted a new kind of corporeality via digital effects. It is fitting (and symmetrical) that Keanu Reeves's kung fu should be our larger fight scene project, as Reeves's embodiment of John Wick provides our central illustrative case study fifteen years later.

5. Danijela Kulezic-Wilson, *The Musicality of Narrative Film* (New York: Palgrave Macmillan, 2015), 26.

6. This sequence opens at 47:29 inside the Red Circle nightclub changeroom, with John Wick striking the first blow at 47:48. John fires the last shot at 54:37, shooting up at the glass balcony from below and narrowly missing Kirill. The entire sequence ends at 55:00, as John walks away from the Red Circle, having delivered his threat to Iosef. Overall, 83.48 percent of this Red Circle sequence is dedicated to fighting, consisting of a string of fights that carry temporally and sonically across the nightclub's various spaces.

7. Lisa Purse, *Contemporary Action Cinema* (Edinburgh: Edinburgh University Press, 2011), 64.

LISA COULTHARD is Professor of Cinema and Media Studies at the University of British Columbia. She has published widely on cinematic violence and sound, crime television, and European and American cinemas. She is currently completing a manuscript based on research funded by a Social Sciences and Humanities Research Council (SSHRC) of Canada Insight Grant on sound and violence.

Along with Lindsay Steenberg as collaborator, she holds a current SSHRC Insight Grant researching the fight scene in cinema.

LINDSAY STEENBERG is Reader/Associate Professor in Film Studies at Oxford Brookes University, where she coordinates their graduate program in popular cinema. She has published numerous articles on violence and gender in postmodern and postfeminist media culture. She is author of *Forensic Science in Contemporary American Popular Culture: Gender, Crime, and Science* (2012) and *Are You Not Entertained? Mapping the Gladiator in Visual Culture* (2020), for which she was awarded a Research Excellence Fellowship from Oxford Brookes.

HIDDEN IN PLAIN SIGHT 2

STUNT-CRAFT WORK IN JOHN WICK AND THE NETWORKED WORLDS OF 87ELEVEN ACTION DESIGN

LAUREN STEIMER

This chapter departs from the approaches of later chapters in this volume by shifting from the *John Wick* series as a collection of cultural palimpsests, rife with at times contradictory meanings begging to be deciphered, to a detailed deconstruction of the work of action production and specificities of the stylistic innovation evident in the series via production studies and industry studies analyses. The imaginative action sequences of the series are the product of histories of transnational exchange in stunt work craft communities, via which action design techniques are learned, adapted, and transformed. Production studies, an ethnographic approach to media industry workers, is not simply a methodology; it is also a means to supplement the misleading assumptions of previous approaches to media analysis. It is an attempt to turn the craftwork of humanities scholarship toward the labor of production, not to verify and uphold singular creators and discursively constructed origin stories but to bring to light hidden labor practices and underhistoricized cultural formations. This approach does not foreclose or deny the usefulness of textual-analytical approaches, and it can, in fact, be used to supplement them or to change the direction of earlier disciplinary obsessions, in particular film studies' long-standing fixation on the director as author. Industry studies, the wider discipline in which this chapter is situated, is stuck in a seemingly endless semantic war between a celebratory embrace of media industry workers as "creative

laborers," empowered to leave their own marks on films, television pro-grams, and other media objects, and the Frankfurt-School-forward ap-proach positioning the same workers as "cultural laborers," shills for and dupes to an endlessly churning media factory.[1] While we industry stud-ies scholars play these semantic games of one-upmanship in the top-tier cultural studies journals (and are we not also shills for and dupes to an endlessly churning factory?), while many of us are stuck in a one-word war between the creative and the cultural, workers are having their work stolen; they are being sexually harassed and racially oppressed; and people are dying on set. What good is our enthusiasm for their work and what use is our Marxism if we spend more time on semantics than we do bringing the conditions of their labor into view? This chapter may certainly address the degree to which stunt work and stunt workers are hidden in plain sight in the *John Wick* series, as they are in all action media. It must begin, however, with a bit of Hollywood stunt labor his-tory to set the mood—as that history has also been hidden and can be uncovered only via archival and transnational ethnographic research on stunt workers and their ever-evolving craft.

Hollywood Stunt Revolution: 1970s

The visceral action spectacles of the *John Wick* franchise transcend the limits of modern American action design, an industry coinage for stunt work, fight choreography, action cinematography, and editing arrange-ments. Many contemporary American action films forgo extended complex practical action design scenes in favor of computer-generated simulation, otherwise known as "visual effects," to keep actors safe and budgets low. The films of the *John Wick* series (and those created by the 87Eleven Action Design team more generally), though obviously suf-fused with visual effects, defy this fairly modern convention in favor of

wider shots and longer takes designed to emphasize the material conditions of the action production in a manner that foregrounds the star's more active participation in the action. The films of 87Eleven captivate us because they combine tactics from the lost worlds of action design and stunt-craft history. Action design in the films of 87Eleven is a transnational stunt-craft amalgam that combines the practical American stunt-craft of the 1970s with craft practices common to Hong Kong action cinema of the 1980s and 1990s.

In the early 1970s, two sex-segregated groups of Los Angeles stunt performers rebelled from the establishment network of stunt-craft organizations and formed their own small communities of like-minded, highly skilled professionals. Stunts Unlimited was created in 1970 by legendary stuntmen Hal Needham, Ronnie Rondell, and Glenn Wilder because the Stuntmen's Association of Motion Pictures had become complacent and was not invested in new techniques or innovative training regimes.[2] Similarly, the Society of Professional Stuntwomen was formed in 1975 by preeminent stuntwomen Julie Johnson, Jeannie Epper, May Boss, Jadie David, and Stevie Myers because the Stuntwomen's Association of Motion Pictures had ballooned and many members lacked the training that distinguishes expert stunt performers.[3] The selective membership processes of the Society of Professional Stuntwomen and Stunts Unlimited were designed to distinguish these communities as expert stunt workers, who could ensure safety on set and deliver a wider range of stunts beyond the standard high falls, horse transfers, drags, and car hits. Stunts Unlimited's break with the Stuntmen's Association should have ended the careers of all of its members, as they were effectively blacklisted by the many high-profile stunt coordinators with ties to the association. But by the early 1970s, the Hollywood Western was dying, and film and television productions started to favor motorcycle jumps over horse tricks and the cutting-edge design

of cannon rollovers (in which a nitrogen cannon is positioned under a car with a roll cage and trigger to propel the car into the air at an angle) to simple car crashes. The classical era of Hollywood stunts had come to an end, and the stunt industry reorganized into small communities of practice in the model of Stunts Unlimited and the Society of Professional Stuntwomen.[4] These communities featured specialists in precision driving, motocross, martial arts, fire burns, and other physical skills. The primary function of these groups was to secure work for their members through promotion and preferential hiring practices. In the decades that followed, other stunt communities were designed in the image of these rogue factions: collections of (often sex-segregated) stunt professionals with viable track records in film and television production. Much like the organizations that preceded them, the primary function of these groups was promotional: securing work for members through stunt-craft networks.

The only official criterion for employment in the Hollywood stunt industry is a SAG card, unlike the more rigid qualification and hierarchized registration systems of the United Kingdom, Australia, and more recently, the Republic of Ireland. Though all you officially need is a SAG card, there is, however, an internal vetting system in place, and stunt coordinators tend to select stunt performers from within their own network of practice, with the stunt organization with which they are affiliated providing a built-in hiring ground. A network of practice is a much larger and more loosely affiliated collective of individuals who share a common practice or profession.[5] Without a certification and registration system, the only way that stunt coordinators can ensure safety on set is by hiring from their own community of practice or through their larger network of practice via word-of-mouth accounts of an individual stuntie's performance, shared work histories, or membership in another recognized stunt-craft community of practice. There was a

time, before these communities were on the internet and able to use social media as a means of promotion for members, during which a hotline and a quite large "little black book" of stunt workers existed; but today, Hollywood stunt coordinators can use iStunt to select a performer based on height, weight, race, gender, or training profile. That said, the old ways prevail, and most coordinators hire based on communities and networks of practice in Hollywood, especially due to the presumed rise in stunt deaths and injuries during the current content boom. By *Hollywood*, I mean the Southern California production context more generally. There is a presumption among coordinators and stunt professionals working in Southern California and participating in these communities and networks of practice that the stunt job market in domestic runaway productions (in Georgia, North Carolina, and Louisiana, for example) does not operate on the same hiring system. But given the shorter histories of stunt-craft practice in those areas, the degree to which injuries go unreported, and the union's (SAG-AFTRA) lack of willingness to collect statistics on stunt deaths and injuries, it is impossible to reach an objective conclusion on this issue. However, with the recent content boom in those runaway context job markets and a number of highly publicized on-set accidents in those states, California stunt networks of practice hold ever more strongly to their internal vetting process as a criterion of distinction.

87Eleven and its members are not distinct in that they tend to follow the standard hiring practices for the Hollywood stunt-craft industry: they hire with preference given to members of the 87Eleven community of practice and their wider transnational networks of stunt-craft practice. However, a few notable craft techniques distinguish 87Eleven and their network of practice from other communities of stunting practice in Los Angeles and, as such, make the *John Wick* film series they spawned so remarkable as to warrant its own scholarly volume. One

principal difference between 87Eleven and other stunt communities in Hollywood is that it serves many functions: as a tightly controlled community of highly sought-after stunt professionals, as a Los Angeles creative hub with a pedagogical imperative for stunt workers, as the center of a transnational network of stunt experts, and as a production company.

Hong Kong Stunt-Craft Infiltrates Hollywood Stunt Communities

Though the organization that came to be known as 87Eleven was formed in 1997, the core of the collective was formed after *The Matrix* series (1999–2003), the film franchise that utterly transformed Hollywood stunt-craft and forced a transition in the industry in terms of aesthetics, techniques, and training requirements much in the same way that Stunts Unlimited and the Society of Professional Stuntwomen had accomplished in the 1970s.[6] The work histories of two of the founders, Chad Stahelski and David Leitch, uniquely positioned 87Eleven to produce pioneering action design work in this new, third era of American action aesthetics. Stahelski's work as a stunt double for Keanu Reeves and Leitch's stunting work on *The Matrix* series provided them with invaluable access to Yuen Woo-ping's fight coordination process.[7] The division of labor on the set of Hong Kong action films of the 1970s through the 1990s was such that fight coordinators, sometimes referred to as "fight directors" or "action directors," were commonly given more power over the production process than stunt coordinators had historically been awarded in Hollywood. In Hollywood, the traditional structure for action production until the last two decades was for stunt coordinators to work with second-unit directors (and less often first-unit directors) to film action sequences. Commonly, a film's "director" does not actually direct the action in an action film or television series,

though he or she may have a say on how that scene is edited. The stunt coordinators are in charge of selecting the stunt workers and making sure that all stunts are designed to keep the team, and in particular the actors, safe. The second-unit director, in conjunction with the director of photography and camera operator, concentrates on getting the shot list completed. Under this system, stunt doubles typically train the actors for whom they double to perform a short series of moves and reactions (often this training takes place on set the day of shooting) so that the actions of the stunt performer can be matched to shots in which the actor's face is visible. As Stahelski explains,

> It started when I was 21. I think I did *Bloodsport* 2 and *Bloodsport* 3. . . .
> So even back then, on the low-budget stuff, they really didn't ever have a fight coordinator or choreographer. They kinda had a guy that trained the actors that would kinda put the fights together. But, as you're brought on, they brought you on to kinda perform it, choreograph it with the actor, work with it. It was very loose and very undisciplined at the time. So that went on for years, and years, and years, and years, and years, and years, and years.[8]

Before *The Matrix*, there were no fight directors or choreographers to gaff the action for high-budget films. Stahelski continues, "If you look at movies, really, before *The Matrix*, they were barroom brawls, and quick punches, and, you know, *Rocky*—as kind of boxing fights. But there were really no mainstream big-budget Hollywood martial art films. They didn't exist yet."[9] Stunt performers with martial arts training were generally assigned to low-budget straight-to-video releases. As such, martial artists who wanted to find more frequent work in the stunt industry were expected to be utility-oriented and supplement their core strength with training in precision driving, fire burns, water work, and the like. Stahelski and Leitch both trained for decades in various martial

arts as well as attended and taught at the famous Inosanto Academy (formed by Dan Inosanto, a student of Bruce Lee in Jeet Kune Do and an expert in the Filipino martial art of Kali). They were forced to expand their repertoires far beyond these bodily disciplines to the shooting, driving, and motorcycle stunts that had become common markers of action spectacle after the stunt-craft uprisings of the 1970s.

New Structure of Action Production Post-*Matrix*

One of the Hong Kong–style action craft tools that has infiltrated stunt communities of practice outside of Hong Kong through the transnational function of assemblage is the use of "previz" videos featuring elaborate action choreography complete with blocking, decisive camera placement, and well-timed cuts to emphasize the skill of an individual stunt performer, stunt team, or action choreographer. In my conversation with Cale Schultz, the operational director and member of 87Eleven Action Design, he identified the influence of Yuen Woo-ping's use of previz for the action design of *The Matrix* as a primary means by which the tool infiltrated stunt communities of practice in the United States. Chad Stahelski observed and later adapted Yuen's previz craft practice into his own repertoire of technique. When one examines one of the previzes for *The Matrix*, it is not simply the choreography but also the framing and editing that are oddly familiar. The mise-en-scène, cinematography, and editing of Yuen Woo-ping's previz of the "Dojo Fight" from *The Matrix* are a near shot-for-shot template for the finished scene. While a previz is generally crafted with spare sets and cardboard boxes serving for walls or prominent objects in the mise-en-scène, it is designed to operate as a template. The action is packaged with the cinematography and editing—this is action design, more than just choreography. The previz as craft tool preserves the Hong Kong division of

labor, with the choreographer given the status and the presumed level of input of a master of action. This is not how American action films were made before 1999. However, post-*Matrix*, this is how most action film and television scenes are produced worldwide. The stunt team shoots a previz, either to secure a job or as a function of the job that they already have in hand. This is the standard not only for Hollywood but for all of the stunt communities that I have visited in New Zealand, Australia, the Republic of Ireland, and the United Kingdom, as the tool spread through a network of stunting practice through the exposure prompted by transnational production environments.

Though previz-production skills are now a prerequisite, there is something quite distinctive about 87Eleven's use of this stunt-craft practice, and they featured it very early on to secure employment and to make a name for their team for projects such as *Serenity* (Joss Whedon, 2005) and *The Wolverine* (James Mangold, 2013). While communities of stunting practice may employ the previz as a template, unless they have complete control over production, it is unlikely that they can maximize the tool. This is something that 87Eleven realized early on, with one of their first projects after *300*, as member and fight choreographer Jojo Eusebio explains: "When we went to *Ninja Assassin*, the hardest part for us was that we can only choreograph and control so many variables. . . . There is more to choreography and fights, stunt action, or action design than just doing the choreography. You've got to control how it's shot. You've got to control how it's edited. You've got to have influence on those things."[10] 87Eleven sought a project on which they could have more complete control of the production process, but second-unit directors and stunt coordinators were not going to be trusted with a big-budget film, even with Keanu Reeves tied to the project, and so 87Eleven pioneered a new economic model for action design, which would affect both the narrative structure and the construction of every action

scene in the *John Wick* series moving forward. Their formula would be wider shots, longer takes, and a composite martial art form designed to foreground characterization, highlight the comportment or habitus of the actor, and account for the budgetary constraints of the production. These films would be organized on an action-forward narrative design.

The Economics of Action Design

Stunt workers hide in plain sight for a variety of reasons: (1) it is their job to masquerade as the actor they double; (2) promotional material strongly implies or states that certain actors "do their own stunts"; (3) on higher-budget productions, their faces are actually digitally erased and supplanted with the actor's face for whom they are doubling; (4) if they told the truth about the work they did, they would not find any more work; and (5) in the US, more powerful stars and stunt professionals belong to the same union. Because their union, SAG-AFTRA, has not actively supported an Oscar for stunt work, stunt professionals started their own campaign for recognition, and 87Eleven team members actively participate in this viral call to #StandUpForStunts. Stars do not do their own stunts. As stunt coordinator for *John Wick: Chapter 3—Parabellum* Scott Rogers reminds us, stunts require some degree of risk, and Hollywood, as an industry, is risk averse: "You can't mitigate all of the risk. If you can—it's not a stunt. It's something that the actors can do."[11] This is a rule of thumb we should all use going forward—if the actor can do it, it's not a stunt. Rogers explains that the stunt team attempts "to make it 80% safe. We try to make it 80% safe. If it's 100% safe you can put the actor in."[12] By this count, Keanu Reeves did not do his own stunts for the *John Wick* films, but he most certainly did most of his own fight work, and that is relatively unheard of in Hollywood. While

filmgoers often hear stars discuss the training they did for a project or see behind-the-scenes featurettes on this process as video evidence of their commitment to character, these common testimonials and proclamations hover somewhere between outright fabrication and total self-delusion. To put it as succinctly as possible: actors lie, either to us or to themselves.

With Reeves signed on as a producer and given their work history with him on *The Matrix* series, Stahelski, Leitch, and fight choreographer Jojo Eusebio trained Keanu for more than double the two-month minimum that they require of other actors. This did not make Reeves an expert stunt performer, but given the repeated one-on-one training periods in jujitsu and judo, strength training, sparring, and his extended choreography practica for the series, Reeves has had more fight training for a role than any non-stunt performer in Hollywood history. Team members repeatedly attest that they "trained him like a stuntman," by which they mean six hours a day, three to five days a week. Reeves, at the very least, has acquired the intermediate level of training for a stuntman specializing in fights. This training facilitated the wide shots, longer takes, and most importantly, high-count fight beat arrangements. A fight beat is a choreographed point of contact, intentional miss, or near miss. They did not have the budget to afford the multiple camera setups that are normally required when actors "do their own action"—typified by a very low fight beat count because of the small working memory for domains of bodily practice of actors versus those of stunt professionals—nor did they have the budget for the performance capture techniques common to the *Fast and Furious* series, for which actors' faces are digitally sutured to stunt drivers' bodies. Teaching Reeves to perform longer chains of fight beats solved part of their problem, but most martial art forms require staging, blocking, and camerawork that cut up the

2.1. Matt Damon's Kali-inspired moves with a pen in *The Bourne Identity* prefigure John Wick's execution by pencil.

action into discernible attacks and counters. For this reason, Stahelski, Leitch, and Eusebio opted to design a style for Reeves and the Wick character that was not kick-heavy (like the wushu of *The Matrix* films) but, given Reeves's bodily disposition and the need for fewer camera setups, would allow for more flow between movement and response.

John Wick's martial art form is, in the Inosanto Academy mixed martial arts pedagogical tradition, an amalgam of judo, Machado Brazilian jujitsu, Bruce Lee's Jeet Kune Do system, and the Filipino close-combat art of Kali. Cale Schultz described the 87Eleven martial art design process as a definitive 87Eleven stunt-craft element: "Part of what 87Eleven prides itself on is actually like creating styles, not just teaching someone this martial art or that martial art, but like giving them a style, which is awesome."[13] *Wick* series fight choreographer Jojo Eusebio notes that they consider various elements when crafting the martial art forms

2.2. John Wick's pencil trick.

for the films: "So, when you're doing these kind of fight scenes . . . you have to make a style that fits the physical nature of the actor doing it. But, also what is his character like, is he a passive person, is he an aggressive person, is he like, does he just do things for defense? So, these are all the things, like you have to read this story and understand what that character is. What's is his motivation for doing it?"[14] Eusebio continues, "But it's like writing a song. When people, song writers write about their songs, it's about the experiences they're feeling now. So, when we're choreographing, at the time it's not like I think, 'oh I'm making this new style.' It's like it's just stuff we're training in at the time."[15] The current training regimes and other media projects that individual 87Eleven team members are engaged in also affect martial arts design choices. For example, Eusebio confessed that Matt Damon's choreography for *The Bourne Identity* (Doug Liman, 2002) is the base from which John

Wick's style emanates. Jason Bourne is trained in Kali (knife-based close combat and grappling) because he was Special Forces, and the movements are direct and forceful because of Damon's habitus. Most of Bourne's moves are reminiscent of the basic Kali weapon forms. This is why, when he encounters a pen, he treats it as you would a knife in Kali. While they wanted Wick to have a stronger Japanese judo influence, Eusebio felt that Reeves had more flow to his movement, possibly because his habitus was affected by *The Matrix* wushu training and Reeves's distinctive comportment. Even with the Japanese influence, the Kali slips through long enough for us to see that John Wick borrowed his pencil from Jason Bourne (fig. 2.1 and 2.2). The collaborative and economical process of crafting a martial art style for Wick included Reeves's stunt double for the series, Jackson "Spider" Spiedel, who notes that he and Stahelski pondered, "'What weapons have we not used?' I just came off *Deadpool*, and we were like SWORDS!"[16] And so Wick's pencil is on loan from Jason Bourne, and his sword is a hand-me-down from Deadpool. An examination of the bathhouse fight from *Deadpool 2* (David Leitch, 2018) showcases Spider's history of training in tricking (acrobatic martial arts), and he flips through the air while demonstrating a style of playful sword work that becomes more rigid and refined in the *Wick* series.

As mentioned above, there was a time, not too long ago, before we all entered the Matrix, when stunt performers were more likely to be former rodeo stars, hired to jump off a horse, fall down a set of stairs, or flip a car, than to be gymnasts and martial artists selected to fly through the air and to "know kung fu." In the current era of Hollywood stunt production, stunt workers are increasingly specialized, and stunt coordinators look to their extended network of practice to select uniquely skilled individuals to train their actors. Supplemental action design is secured from the wider network of practice, and while old stunties shot

guns and rode horses, today, you can outsource those skills. A prime example of this is the selection of sharpshooter and national tactical champion Taran Butler, who was employed both to train Reeves and Halle Berry and to design their custom guns to facilitate longer takes and close-quarters combat. All of the *John Wick* films are computer-graphic-heavy, as all of the gunshots were added in post. These guns, unlike the weapons normally used on any film or television set, load and drop cartridges but do not shoot. They were specially modified so that there could be continuous action. Reeves would have to reload on camera, and they did not stop shooting if he flubbed this process. The custom guns serve the same purpose as the martial arts style that they designed for Wick—to preserve continuity, manufacture a realist aesthetic, and facilitate the flow between short-range, midrange, and long-distance combat, all of which save time, save money, and keep the star in view.

The 87Eleven team had a similar approach to working with animals in *John Wick* 3. They recruited experts from their network of practice, including Tad Griffith, a trick rider from a prominent family working in the rodeo tradition for over a century. While Reeves had some previous riding experience, he trained extensively with Griffith. Reeves did not simply become more proficient in trick riding; he developed the skills of comportment and balance on a horse and learned how to safely hang off the side using a special saddle. He also acquired a system for communication with these trained animals, a system of integrated human and nonhuman acting and action, which scholar Kelly Wolf calls "multi-species performance."[17] The five horses that he worked with were linguistically much more advanced than Reeves in this communication system. The horses were selected because they were already expert communicators who were comfortable with trick riding, and some could do a contacted kick—controlled back kick into a standing human—on

command. Keanu, in short, had to learn a language in which the horses were already fluent. For their parts, the horses had to learn additional skills including performing within four feet of the camera, running on a noisy New York street, acclimatizing to motorcycles, and last, but certainly not least, working with the wire rig, a wire strung on either side underneath their saddles connected to a crane hovering above. The horses were not being controlled by Keanu; they were being driven by the trainer through the wire rig. Keanu was also in a separate wired harness rig suspended by the same system with a crash mat positioned next to the horse. There is an extensive tradition of horse-bound wirework in the American Western. However, from the 1920s through the 1950s, it was most commonly the horse and not the rider who was attached to the wire rig. This was done to force the horse's front legs to bend backward at a predetermined point. When the horse reached the end of the wire, its front legs would bend backward at the knee, and the horse would tumble face-first into the dirt on its mark right in front of the camera, a stunt-craft technique known as the "running w." The "running w" wired saddle rig was a sadly common feature of the classical Hollywood Western before the regulatory presence of the American Humane Society on set prompted a shift toward new training techniques.[18] When the modern stunt horse runs, falls, or rears up on its hind legs, it does so because it has been trained to perform these "tricks" safely and without wires. Even so, there is an inherent suspicion when wire rigs are used for horse stunts, and as such, extra care was taken to secure American Humane certification for this *John Wick* 3 action scene. An American Humane Society representative was there for the previz construction, on location in New York, and present during visual effects sequences.

Interestingly, this scene was initially planned as a much longer sequence—what would have been the longest action scene in the series

thus far—and what was certainly the most complicated to coordinate. Scott Rogers, a stunt coordinator outside the 87Eleven community of practice but familiar to their wider network of practice, was selected as *John Wick 3*'s stunt coordinator. Rogers is a utility man trained in the pre-*Matrix* stunt world and is considered a rigging expert, having worked on films such as *Cliffhanger* (Renny Harlin, 1993). While much of the press and behind-the-scenes marketing deservedly addresses Reeves's work deftly performing the closest thing to a real stunt that any action actor can perform, we should not overlook the work of those horses, who were accommodating in the face of various degrees of discomfort and disquiet and who executed twenty flawless contacted kicks, and the stuntman who sold those contacted kicks from the horses twenty times. While doubtless Reeves's performance is extraordinary, this is a collaborative effort.

Somewhat similarly, it would be unconscionable to examine the *John Wick* series and ignore the multispecies performances of dogs in the series, a topic Karalyn Kendall-Morwick discusses in more detail later in this volume. The most notable and distinguished canine multispecies performance in regard to stunt work is evident in the third film in the series. Five Belgian Malinois puppies—two actor dogs chosen for looks and three stunt-double dogs chosen for their skills—were selected from military installations across the US. They were trained for eight months in a system of communication so that they could work with Halle Berry, her stunt double Anisha Gibbs, and the fifteen men on the stunt team. The dogs were trained by Andrew Simpson, the animal wrangler who trained the wolves for *Game of Thrones* and reportedly one of the few trainers willing to work to 87Eleven's specifications.[19] Normally, a stunt scene with a dog contains a maximum of one or two fight beats and lasts a few seconds. Much like the action design for the

rest of the series, however, Stahelski and Leitch wanted an extended fight beat sequence each time the dogs attacked a stuntman. They refer to this as "doggy jujitsu." The dogs were trained to bite a green tug toy, which was removed in postproduction, and to shake it vigorously. The dog toys were attached to the stuntman, but the dogs were too good at their job, and so the toys then had to be rigged with a trigger release system. Much of the publicity for the film claims that Berry acted as a trainer for the dogs on set. This is effective marketing but not entirely accurate, though that may not be intentional, as people outside animal trainer communities of practice are less familiar with their craft practices. Through three to four months of exposure and training, Berry became part of an exceptionally skilled multispecies performance team. The extended training regimes, martial arts stylization, and work with nonhuman animals for the *Wick* series are all done in the service of economical action with actors or stunt performers on screen for periods far exceeding the norm for the genre.

To borrow a turn of phrase from a Keanu intertext and to uncharacteristically move this essay from materialism to metaphor, one function of this chapter is to "offer you the red pill," to give you a chance to see beyond the matrix of meaning-bearing structures in *John Wick* to the cultural architecture of its production. Much like Morpheus's proposal to Neo, the choice of what to do with this information is up to you. We may engage in cultural critique, feel the affective charge of the action, and passionately make meaning from the *John Wick* series, but when we sit down and watch these films, we must emphatically stand up for stunts. When we speak with specificity about the work of action design and the quasi-invisible individuals who perform that work, we add legitimacy to the call of stunt industry professionals to require the Academy of Motion Picture Arts and Sciences and the British Academy

of Film and Television Arts to recognize the precarious labor of stunt workers with awards much like those given to the actors for whom they double. The thematics of risk, trust, and security that Aaron Jaffe later in this volume so deftly argues permeate the economic unconscious of the *John Wick* series are as relevant to the economics and affective structures of production of these films. The bond between stunt double and the doubled actor is built on a mutual trust in which the stuntie takes all the risk so as to provide the actor with security on set. In addition, the skilled and unknown stunt double makes the actor look like a viable action star and offers the actor the prospect of job security in a transnationally successful film and television genre. The stunt double's reward for a job well done is anonymity. It's long past time that we show their work the scholarly attention that it deserves.

Notes

1. See Daniel Mato, "All Industries Are Cultural," *Cultural Studies* 23, no. 1 (2009): 70–87. See also Toby Miller, "From Creative to Cultural Industries: Not All Industries Are Cultural, and No Industries Are Creative," *Cultural Studies* 23, no. 1 (2009): 88–99.

2. John Baxter, *Stunt: The Story of the Great Movie Stunt Men* (New York: Doubleday, 1974), 93–301; Kevin Conley, *The Full Burn: On the Set, at the Bar, behind the Wheel, and over the Edge with Hollywood Stuntmen* (New York: Bloomsbury, 2009), 151–53; Hal Needham, *Stuntman! My Car-Crashing, Plane-Jumping, Bone-Breaking, Death-Defying Hollywood Life* (Boston: Little, Brown, 2011), 169–82.

3. Mollie Gregory, *Stuntwomen: The Untold Hollywood Story* (Lexington: University Press of Kentucky, 2015), 85–87.

4. Following Jean Lave and Etienne Wenger, communities of practice are collective learning environments in which the knowledge and resources of an individual area or intersecting areas are shared with participants. See Lave and Wenger, *Situated Learning: Legitimate Peripheral Participation* (Cambridge: Cambridge University Press, 1991); Etienne Wenger, *Communities of Practice: Learning, Meaning, and Identity* (Cambridge: Cambridge University Press, 1999).

5. John Seely Brown and Paul Duguid, "Knowledge and Organization: A Social-Practice Perspective," *Organization Science* 12, no. 2 (2001): 198–213; Igor Pyrko, Viktor Dörfler, and Colin Eden, "Communities of Practice in Landscapes of Practice," *Management Learning* 50, no. 4 (2019): 485–87.

6. Lana Wachowski and Lilly Wachowski, dirs., *The Matrix* (Burbank, CA: Warner Brothers, 1999); Lana Wachowski and Lilly Wachowski, dirs., *The Matrix Reloaded* (Burbank, CA: Warner Brothers, 2003); Lana Wachowski and Lilly Wachowski, dirs., *The Matrix Revolutions* (Burbank, CA: Warner Brothers, 2003).

7. Cale Schultz in discussion with Lauren Steimer, June 7, 2016, Los Angeles, CA.

8. Chad Stahelski, interview with Cale Schultz, May 17, 2019, in *87Eleven Action Design Podcast*, podcast audio, 43:03, https://www.87eleven.net/podcasts/.

9. Stahelski, interview with Cale Schultz.

10. Jonathan "Jojo" Eusebio, interview with Cale Schultz, June 3, 2019, in *87Eleven Action Design Podcast*, podcast audio, 55:56, https://www.87eleven.net/podcasts.

11. Blake Sporne and Jon Auty, "John Wick Special with Scott Rogers," June 16, 2019, in *The Stunt Pod*, podcast audio, 1:24:08, https://player.fm/series/the-stunt-pod/john-wick-special-with-scott-rogers.

12. Sporne and Auty, "John Wick Special."

13. Cale Schultz in discussion with Lauren Steimer.

14. Eusebio, interview with Cale Schultz.

15. Eusebio, interview with Cale Schultz.

16. Jackson "The Spider" Spidell, interview with Cale Schultz, May 20, 2019, in *87Eleven Action Design Podcast*, podcast audio, 52:36, https://www.87eleven.net/podcasts.

17. Kelly Wolf, "Performance Unleashed: Multispecies Stardom and Companion Animal Media" (PhD diss., University of Southern California, 2013), 1–49.

18. Arthur Wise and Derek Ware, *Stunting in the Cinema* (New York: St. Martin's, 1973), 55–60.

19. David Benioff and D. B. Weiss, creators, *Game of Thrones* (HBO, 2011–19).

LAUREN STEIMER is Associate Professor of Media Arts and Film and Media Studies at the University of South Carolina. Her book *Experts in Action: Transnational Hong Kong-Style Stunt Work and Performance* (2021) traces a history of transnational exchange by identifying and defining unique forms of expert performance common to contemporary globalized action film and television genres. Her work considers the transnational movement of style and technique and comes to terms with the effects of cultural policies, production structures, and financing arrangements on the creation of action spectacles. Her latest project on stunt labor markets and training techniques is based on extensive research on stunt workers in California, New Zealand, Australia, the UK, Northern Ireland, and the Republic of Ireland.

3 KILLING IN EQUANIMITY

THEORIZING JOHN WICK'S ACTION AESTHETICS

WAYNE WONG

Introduction

In *John Wick* (2014) and *John Wick: Chapter 2* (2017), John Wick is described by his enemies as "a man of focus, commitment, [and] sheer will." This memorable line portrays Wick as a formidable hitman who kills with efficiency and accuracy. However, the significance of this line lies beyond its connection to the characterization and narrative. It has crucial implications for the film's action aesthetics. Wick's deep focus exudes an intricate sense of equanimity amid expressive actions, striking a balance between brutality and beauty. Such beauty results from the cultivation of "martial ideation," a theory derived from Chinese aesthetic philosophy focusing on the manifestation of tranquility after the fulfillment of authenticity and expressivity.[1]

Connecting *John Wick* to the concept of martial ideation reveals that the franchise can be read in the broader context of transnational martial arts cinema.[2] Considering the fact that Chad Stahelski and Keanu Reeves have collaborated with choreographers familiar with kung fu cinema such as Yuen Woo-ping in *The Matrix* (1999) and Tiger Hu Chen in *Man of Tai Chi* (2013), *John Wick* can be seen as the synthesis of Hong Kong and Hollywood actions at different levels.[3]

On one level, the martial arts performance in *John Wick* prioritizes "archival," "cinematic," and "corporeal" authenticity, referring to real

martial arts techniques, minimal mediation, and genuine martial capabilities.[4] From David Bordwell's perspective, the brutality of the franchise lets the spectators "feel the blow," emphasizing the "expressive amplification" of emotions.[5] At another level, *John Wick*'s experimentation with martial ideation demonstrates that the influence of Hong Kong martial arts cinema on global action filmmaking is not limited to the concepts of authenticity and expressivity. It prompts action filmmakers to explore the subtle relationship between cinematic martial arts, aesthetics, and philosophy.

The Hong Kong connection of *John Wick* is embedded in Chad Stahelski's martial arts background. Not only did Stahelski receive Jeet Kune Do (the Way of the Intercepting Fist or JKD) training at the Inosanto Academy, but he also was the stunt double of Brandon Lee, Bruce Lee's son, in *The Crow* (1994).[6] To a great extent, the beginning of Stahelski's stunt career in the 1990s was intertwined with Hong Kong action in the sense that the kung fu and *wuxia* genres were experimented with and incorporated in Hollywood action blockbusters at a scale much greater than previous attempts in the 1970s and 1980s.[7] Due to the decline of the local market and the impact of the Asian financial crisis in the 1990s, many Hong Kong action filmmakers sought opportunities in Hollywood.[8] The crossover allowed more frequent and in-depth exchanges of action filmmaking techniques between the two industries. As Stahelski was the stunt double of Keanu Reeves in *The Matrix*, he had firsthand experience of how Hong Kong action styles were synthesized with that of Hollywood. In view of this, one key approach to the theorization of *John Wick*'s action aesthetics is to examine its intimate connection to Hong Kong action cinema.

However, *John Wick* should not be read as Hollywood's passive uptake of Hong Kong action aesthetics in the past two decades. Rather, it creatively modifies the established ideational frameworks so that the

original culturally and geographically specific aesthetics can be appropriated to suit the diverse contexts of the action genre and develop a broader audience base. In particular, the franchise proposes alternative approaches to evoking martial ideation. The original formulation features a direct portrayal of tranquility through choreography, cinematography, and narrative. The new focus, however, is to embody martial ideation in the mise-en-scène. *John Wick* presents intense action sequences in three kinds of tranquil spaces—namely, the milieux of stability, fluidity, and acuity, corresponding to the three manifestations of martial ideation in Hong Kong action: *ren* 仁 (humaneness), *wu* 無 (nothingness), and *guan* 觀 (perspicaciousness). In this light, *John Wick* is a quintessential example demonstrating that the aesthetic and philosophical core of Hong Kong action can be incorporated and creatively reinvented in transnational Hollywood action blockbusters with less cultural or geographical specificity.

Theorizing Martial Ideation

While *tranquility* and *serenity* are common nouns to articulate the aesthetic quality embodied in cinematic action, careful contextualization is often required to make those nouns theoretically and epistemologically meaningful in the transcultural remediation of action aesthetics between Hong Kong and Hollywood. Specifically, locating tranquility in action cinema involves a close scrutiny of the theorization of *yi* 意 (ideation) in Chinese aesthetics.[9] In its earliest definition in the pre-Qin 先秦 period (ca. 2100–221 BCE), when classical Confucianism was prominent, ideation was considered by literati as a political aspiration that could bring about effective governance and was one of the essential qualities possessed by benevolent rulers.[10] Nevertheless, with the increasing influence of Daoism and Buddhism during the Wei 魏

(220–266) and Jin 晉 (266–420) dynasties, ideation was reinterpreted as an aesthetic and literary concept expressing personal emotions.[11] In the Tang 唐 (618–907) dynasty, the prolific translation of Buddhist classics from Sanskrit into Chinese gave birth to new terms useful for the systematic conceptualization of ideation.

Wang Changling 王昌齡, a renowned Tang poet, borrowed the Buddhist term *jing* 境 (realm) to describe a three-step process for the formulation of ideation in artistic creation—namely, *wujing* 物境 (the realm of objects), *qingjing* 情境 (the realm of affect), and *yijing* 意境 (the realm of ideation).[12] In so doing, Wang provided a tripartite schema for the theorization of ideation—from authenticity to expressivity to tranquility. After Wang, the discussion of the concept continued from the late Tang dynasty (755–907) to the Song dynasty (960–1279) through the scholarly works of Jiao Ran 皎然, Sikong Tu 司空 圖, and Yan Yu 嚴羽. They built on Wang's framework and used numerous literary examples to expound on the tripartite concept of ideation.[13]

The theorization of ideation underwent a breakthrough in the Republican era (1912–49) when Zong Baihua 宗白華, an eminent Chinese aesthetician, used a comparatist approach to examine the difference between Chinese and European paintings. He argued that ideation embodies the synthesis of *shi* 實 (presence) and *xu* 虛 (absence).[14] Rather than perceiving ideation as an abstract idea, Zong emphasizes the significance of concreteness in its constitution. Using Chinese mountain-river paintings as an illustration, Zong argues that the ideational experience lies in the intricate interplay between the black ink and the white space, visibility and invisibility. Combining Wang Changling's and Zong Baihua's ideas, the formulation of ideation can be interpreted as different configurations of presence and absence to achieve the aesthetic goals of authenticity, expressivity, and tranquility.

In cinema studies, there are two lines of inquiry into the concept of ideation. Similar to Zong's proposition, one line accentuates ideation's association with "absence" and the other line with "presence." First, Mary Farquhar contends that "the power of the concept [of ideation] lies in an acknowledgment that neither the cinematic nor painterly image is real."[15] Farquhar's approach to formulating ideation stresses the concept's association with the abstract, the fantastical, and the unreal. She uses the digitally enhanced landscapes in Zhang Yimou's *Hero* (2002) to exemplify this definition. Understanding ideation from this perspective highlights the operatic root of Chinese martial arts cinema. In Beijing opera, for example, body movements are highly stylized and exaggerated so that the performers express what Bordwell calls "motion emotions."[16] In other words, the first line of inquiry into the concept of ideation in cinema studies focuses on its absence, which is one of the two constitutional components of ideation pointed out by Zong Baihua.

The second line concentrates on presence. Victor Fan investigates Chinese realist films in 1930s and 1940s Shanghai and asserts that ideation "is best achieved not by abstracting forms out of such concrete reality; rather, it is attained when landscape and the human figures within it are captured as is."[17] To Fan, the realist nature of the cinematographic image can be ideational. This alternative understanding of ideation makes the concept applicable to not only martial arts films but also realist films.

However, the above approaches have two limitations. First, they focus on just one constitutive component of ideation. Action cinema, especially the martial arts genre, is characteristic of the synthesis of presence and absence. It is the subtle balance between authenticity and expressivity that makes cinematic action appealing to the spectator. The aesthetics of cinematic action lies in the key moments when the

muddled grappling in real fights is mediated by the intricate exchange of punches and kicks. The suspension of belief creates a visual spectacle not readily available in everyday conflicts and elicits visceral responses within the spectator's body.[18] In this light, the theorization of ideation needs to be more comprehensive and consider both ends of the spectrum.

Second, the theorization of ideation is to some extent oversimplified and overgeneralized as the equivalence of realism and expressionism. It is often tempting to recycle existing terms and stretch their meanings to a different cultural context. A more constructive approach is to combine Wang Changling's and Zong Baihua's frameworks and interpret ideation as a process in which presence and absence are negotiated by different aesthetic means from authenticity (portraying the real) to expressivity (eliciting emotions) to tranquility (cultivating equanimity). The critical question, then, is what presence and absence are in the context of action cinema.

According to the earliest Chinese dictionary, *Shuowen jiezi* 說文解字 (Explaining graphs and analyzing characters), written in the Han dynasty (202 BCE–220 CE), the *wu* 武 (martial arts) consists of two components: action (*ge* 戈) and stasis (*zhi* 止). This insight is crucial to understanding how ideation is formulated in Hong Kong action through the interplay of action and stasis. In the context of martial arts cinema, action instantiates the presence dimension of the ideational construction, as it expresses a sense of flow, movement, and continuity. In contrast, the absence dimension is represented by stasis or a moment of inaction such as a choreographic (cinematographic) pause or a resolution of conflict.

The formulation of ideation is a three-step process. The first step is the realm of object (*wujing*). In the context of Hong Kong martial arts

films, action and stasis are synthesized to achieve the faithful reproduction of forms, or what Leon Hunt describes as archival authenticity. The second step concerns the realm of affect (*qingjing*), which features the expressive amplification of emotions through the interplay of bursts and pauses, thus attaining Bordwell's notion of "motion emotion." Finally, the realm of ideation (*yijing*) presents action and stasis on-screen as vessels for the cultivation of equanimity. Consequently, ideation as a concept does not deny the importance of authenticity and expressivity. Rather, it is a new way of understanding cinematic action beyond the two dominant paradigms.[19]

Placing tranquility as the aesthetic core offers new insights into the intricate relationship between cinematic action, martial arts practice, and philosophy. In kung fu cinema, for example, southern Chinese martial arts styles such as Wing Chun and Hung Gar emphasize the centerline principle and the strength of the lower body.[20] Internalization of these principles allows the practitioner to learn about the significance of physical and, more importantly, mental stability during combat. Philosophically, regulating emotions through martial arts rituals was an essential part of the classical Confucian teaching in the Spring and Autumn era (770–403 BCE). Despite Confucius's antiwar stance, archery was used as a method to nurture humaneness. Standing straight and holding the bow properly are the martial embodiment of integrity and uprightness.[21]

From this perspective, the theorization of cinematic action should pay closer attention to different facets of martial arts—as performance, philosophy, and practice. Rather than merely focusing on action (presence) and stasis (absence), as Bordwell's "pause-burst-pause" pattern suggests, it is more important to consider how the creative interplay of the two generates different aesthetic experiences highlighting authenticity, expressivity, and ultimately tranquility.[22]

Ideational Connection between Hong Kong and Hollywood Action

Before delving into *John Wick*'s reinvention of Hong Kong action aesthetics, it is vital to expound on the three key manifestations of martial ideation, which are *ren* 仁 (humaneness), *wu* 無 (nothingness), and *guan* 觀 (perspicaciousness). The three concepts, representing three kinds of tranquility, are not mutually exclusive but interconnected. Moreover, each manifestation connects to a specific philosophical tradition in Chinese culture (Confucianism, Daoism, and Buddhism) and references a specific martial arts style (Hung Gar, Jeet Kune Do, and Wing Chun).

The first manifestation is the martial ideational *ren*, or the martial reification of Confucian tranquility through balance and stability. Such an attribute can be traced back to *The Story of Wong Fei-hung: Part I* (1949), the film that pioneered kung fu cinema. It portrays the early twentieth-century Hung Gar master Wong Fei-hung as a Confucian sage who strikes a balance between martial prowess and moral virtue.[23]

Choreographically, Hung Gar, as a prominent style of southern Chinese martial arts, pays particular attention to steadiness. The wide stance of the style ensures greater stability during movement, and the hard *qigong* (internal energy) training increases the volume of the lower body so that a fighter can withstand a larger amount of force without losing balance.[24] Cinematographically, such stability is instantiated by long takes of bona fide kung fu masters demonstrating martial arts routines or balanced composition highlighting Wong's steadiness in the middle of violent conflict. Narratively, Wong's tranquility is put to the test as he is publicly humiliated or asked to remain calm in intense situations, yet, perhaps ironically, the firmness of his moral virtue is manifested when he chooses to fight back while others stay silent. These

semantical and syntactical signs have shaped the generic features of kung fu cinema.[25]

The second manifestation is martial ideational *wu*. It is the martial representation of Daoist tranquility embodying fluidity and arbitrariness. In *Daodejing* 道德經, the foundational text of Daoism, *wu* is an invisible and formless metaphysical void. It follows the movement of *fan* 反, which has a double meaning—reversal and return.[26] Reversal refers to Laozi's delicate preference for absence over presence, whereas return refers to the circulation of the reversing movement, leading to a state of Daoist tranquility in which action and stasis become arbitrary.[27]

In Bruce Lee's films in the early 1970s, the martial ideational *wu* is manifested through the imagery of the circle. While the circle is traditionally interpreted as an attribute of expressivity in Chinese operas, it is repurposed by Lee to signify its connection to Daoist tranquility.[28] On the one hand, perfect circles are used to highlight expressivity. In the dojo scene of *Fist of Fury* (1972), for example, the intense fight is set off by a high-angle shot overlooking Lee being surrounded by dozens of karateists, who form an ideal circle. Similarly, Lee's (reverse) roundhouse kicks embody beautiful circular arcs. On the other hand, Lee also used eccentric circles as a way of manifesting his unpredictability and arbitrariness. In the coliseum fight scene in *The Way of the Dragon* (1972), Lee uses a thirty-three-second take to feature circular footwork in an erratic pattern as he evades Chuck Norris's attacks. In *Bruce Lee: A Warrior's Journey* (2002), a documentary containing deleted footage of *Game of Death* (1978), Lee encircles Dan Inosanto with irregular footwork and confuses him with deception and interception. Such unpredictability connects Lee's choreography with Daoist tranquility.

The third manifestation is the martial ideational *guan*, the actualization of Buddhist tranquility characteristic of insight and sensitivity.

In Mahāyāna Buddhism, *guan* refers to the level of insight required to enter enlightenment. Such insight is inseparable from the notion of *zhi* 止 (calmness). According to Zhiyi 智顗 (538–97), an influential monk in Chinese Buddhist history who founded the Tendai tradition (*Tiantai zong* 天台宗), the synthesis of the two is known as śamathavipaśyanā (*zhiguan* 止觀, or calmness-insight). It is the key meditative practice across Buddhist disciplines that leads to the destruction of *kleśa* (*fannao* 煩惱, or afflictions) and *vimokṣa* (*jietuo* 解脫, or liberation from rebirth).[29]

In Hong Kong martial arts cinema, the notion of *guan* is demonstrated when fighters close their eyes and enter a meditative state during intense conflict. Flashback is often used to reinforce the motif of seeing, as it represents the crucial insight cultivated from such a brief and incredible moment of calmness. The *Ip Man* biopics (2008–19) exemplify the martial ideational *guan*, as the Wing Chun style emphasizes the technique of listening (*ting* 聽) as a way of seeing in the sticking hand training (*chishou* 黐手).[30] The sticking hand routine in Wing Chun requires practitioners to pair up, extend their forearms, and engage in a continuous exchange of attack and defense. In the process, the four forearms stay connected as much as possible so that the practitioners' sensitivity toward the flow of energy is sharpened. Such a technique is choreographically demonstrated in *The Grandmaster* (2013). Ip Man (Tony Leung) employs the technique not only to read and manipulate the flow of energy during combat but also to identify the weak spot of his opponent's thinking. In this respect, the ideational *guan* is both martial and intellectual in martial arts cinema. Cinematographically, there is a flashback of Ip (Donnie Yen) recollecting in tranquility his wooden dummy training in the past at the end of *Ip Man* (2008). He strikes the dummy with a sense of calmness. The martial ideational *guan* manifests not in the idea of triumphing over the opponent but in his insight

of withholding his anger, which ends the vicious cycle of revenge and enters nirvana from the Buddhist perspective.

The above three manifestations were evident in the late 1990s as Hong Kong action aesthetics were taken up by Hollywood through films such as *Lethal Weapon 4* (1999), *Charlie's Angels* (2000), and *Shanghai Noon* (2000). However, the ideational connection between Hong Kong and Hollywood is best exemplified by *The Matrix*. Intertextually, it is the film that brings together Keanu Reeves and Chad Stahelski, preparing them for their reinvention of ideational aesthetics in *John Wick* two decades later. In this connection, it is crucial to examine how the three manifestations of martial ideation are represented in *The Matrix*.

First, the martial ideational *guan* (perspicaciousness) is manifested in the scene where Neo (Keanu Reeves) resurrects himself from the dead and awakes from the Matrix, a machine simulating reality in a postapocalyptic world. The intimate relationship between calmness and insight is cinematographically instantiated by a close-up of Neo's eyes, through which the audience can follow his gaze and look into the "ultimate reality" of the Matrix as a blur of computer codes.

Rather than portraying Neo's enlightenment as an exhilarating experience, the film highlights his calmness through the choreography. As Agent Smith (Hugo Weaving) rushes to Neo and throws punches at him, Neo calmly blocks them all with the Wing Chun *tanshou* 攤手 (spreading hand) technique. The relationship between listening (as a way of seeing) and insight is represented by Neo's ability to change his blocking from two hands to single hand, open eyes to closed eyes. In this light, Neo's heightened sensitivity allows him to achieve the martial ideational *guan* on technical, emotional, and intellectual terms.

Second, the martial ideational *wu* (nothingness) is illustrated not only through Neo's flexible blocking techniques but also through the specific way he defeats Agent Smith. Overriding the Matrix, Neo is not

restricted by the simulated time and space. Rather than relying on guns or hand-to-hand combat, he turns himself into a fluid stream, entering Smith's body and destroying him from within. After he breaks out from Agent Smith's body, the space around Neo is wobbling in fluidity, which signifies his mutability and adaptability.

Third, for the martial ideational *ren* (humaneness), Neo's stability is highlighted by his unique fighting stance. Rather than rushing to defeat the other two agents, Neo performs the classic Hung Gar form *zhiqiao* 制橋 (subduing bridge) to signify his steadiness. The next shot is a close-up of Neo taking a deep breath. His calmness is cinematographically matched by the center framing, conveying a sense of balance. The scene ends with Neo (re)opening his eyes in frontality. This connects the martial ideational *ren* with that of *guan*, thus consolidating the tripartite schema of martial ideation.

In brief, the ideational connection between Hong Kong and Hollywood action can be traced back to the late 1990s, and theories of *John Wick*'s action aesthetics should consider the influence of such a crossover. Although *John Wick* manifests a sense of tranquility as *The Matrix* does, it transcends the original framework by extending the three manifestations of martial ideation to the mise-en-scène.

Tranquility as Stability: Holding on to the Martial Ideational *Ren* (Humaneness)

At first glance, *John Wick* seems to have little to do with *ren* (humaneness), as the films feature brutal fight scenes, and the narratives are based on an ex-hitman's reckless revenge plans. Wick is portrayed as a ruthless and expert assassin. The total number of killings amounts to 299 people, and most of the kills are swiftly executed on-screen.[31] This is perhaps why Zero (Mark Dacascos) says to Wick in the third

film, "We're the same, you know." Zero sees Wick as a top-notch hitman like him, who excels at (even enjoys) killing with precision and efficacy. Wick nevertheless disagrees and indifferently replies, "No, we're not."

Wick's idiosyncrasy is not so much based on his ability to kill with precision and efficiency; instead, it is his delicate, if not suppressed, humaneness. When Abram Tarasov (Peter Stormare) says in fear in the second film, "John Wick is a man of focus, commitment, and sheer fucking will," he refers to his ability as an assassin. What he cannot see is that Wick's focus and determination are also instantiated by his unwillingness to forsake his humaneness in the cruel world of assassins. Rather than going with the flow of gold coins, Wick stands his ground firmly and follows his humane instinct. Ideationally speaking, Wick's humaneness is the source of his stability, which in turn allows him to cultivate tranquility in action.

In the first film, Wick's humaneness is demonstrated by his enduring love for and memory of his deceased wife, Helen (Bridget Moynahan), who had bought a puppy when she was dying and then sent it to him as a posthumous gift to give him a companion. Wick treats the dog as the embodiment of the happy life he once had with his wife, and the puppy is crucial for Wick to resume a seemingly normal life. When Iosef Tarasov (Alfie Allen) kills the puppy, Wick instantly loses his sanity and decides to seek revenge. Surely, Wick's action can be interpreted as irrational and overreacting—as Tarasov complains to his father, "It's just a fucking dog!" If human lives in the world of John Wick are considered a dispensable and disposable commodity, showing compassion for a dog would be absurd. However, if one considers how much the puppy means to Wick, his action is generously humane and highly sympathetic.

There are many details in the franchise demonstrating Wick's kind and tender heart. Throughout the trilogy, he is portrayed as a sentimental man who holds dear everything that helps him remember his wife.

Wick carries photographs of his wife with him all the time. He looks at them when he is critically injured at the beginning of the first film. He even places one inside a library book alongside his most precious personal items connected to his upbringing in *John Wick: Chapter 3—Parabellum* (2019). Wick's humaneness is exemplified at the end of the first film when he releases a pit bull puppy scheduled to be euthanized in an animal clinic, and his consistent demonstration of humaneness sets him apart from other assassins such as Zero.

The key scene that exemplifies Wick's humaneness occurs at the end of *John Wick 2*. Wick shoots Santino D'Antonio (Riccardo Scamarcio) in the head inside the Continental, which is forbidden by the High Table. One way to read this scene is to highlight Wick's recklessness and irrationality. However, an alternative way is to focus on Wick's insistence on his principles and values, even at the cost of being declared "excommunicado." To Wick, what is irrational is not his action but the rules set by the High Table and those who benefit from an unjust system while exploiting others. In this sense, Wick's humaneness prompts him to take action even though the rules require him to remain still. He disregards the rules not because he's impulsive but because he sees their irrationality and the necessity to overthrow the High Table. Behind the veil of a ruthless and reckless hitman, Wick is a man of consistency and stability. His humaneness helps him (and the spectators) cultivate a sense of tranquility in the midst of endless slaughters.

Nevertheless, the ingenuity of *John Wick* goes beyond the original framework of the martial ideational *ren*. The concept is externalized to the mise-en-scène, formulating the milieu of stability. The milieu of stability is first instantiated by the New York Museum in *John Wick 2*, which is doubled by Galleria Nazionale d'Arte Moderna in Rome. Unlike the first film, in which most fight scenes take place outdoors in a busy street or inside a messy garage, the museum in the second

film exudes a different ambiance, one characteristic of quietude and reflexivity. Specifically, the museum is a tranquil space in which action and stasis are carefully "curated" so that they are artistically embodied in the artworks, choreographically represented in the fight sequences, and cinematically instantiated by the alternation between the moving camera and still characters.

First, the dialogic relationship between action and stasis is artistically embodied in the artworks exhibited in the museum. The work highlighted is Giovanni Fattori's *La Battaglia di Custoza* (or *The Battle of Custoza*), painted in 1880. The painting depicts the overpowered Italian army's tragic defeat in their attempt to take back Venetia from a much smaller Austrian force in the Third Italian War of Independence. The once-intense battle is now crystallized on an immobile canvas framed in a quiet and orderly space. The historical context of the painting also drives the actions of the film. Not only does it foretell D'Antonio's "civil war" with his sister, Gianna D'Antonio (Claudia Gerini), but it also foreshadows his coming downfall as he underestimates Wick's ability to fight back despite D'Antonio's strong numerical advantage. From this angle, the quietness of the mise-en-scène is purposefully used to contrast with the violent actions that follow.[32]

Second, choreographically, when Wick fights D'Antonio's men inside the museum at the end of the film, their intense actions are contrasted with the stasis of the sculptures and paintings. Ideationally, the quietude of the museum is the embodiment of *ren* in that powerful emotions are properly and orderly regulated.

Third, cinematographically, static and balanced shots are often used to contain volatile actions and the powerful overflowing of emotions (fig. 3.1). For example, when Wick walks into the private viewing room where D'Antonio is looking at Fattori's painting on a bench, they are

3.1. The interplay of action and stasis: John Wick meets Santino D'Antonio with Giovanni Fattori's painting *La Battaglia di Custoza* (1880) in the background. *John Wick: Chapter 2*, 2017.

shown on both sides of the frame. The balanced composition constructs the milieu of stability, which offers a sense of calmness despite the growing conflict between Wick and D'Antonio.

The idea of balanced framing is also evident later, when D'Antonio decides to kill Wick. When making the decision, he stands in the center of the frame, with Antonio Canova's *Ercole e Lica* (1795) behind him in the background and twelve Greco-Roman gods (six on each side) sandwiching him. Then the camera slowly zooms in to highlight D'Antonio's fear. At one level, the moving action of the camera is contrasted with D'Antonio's stasis. At another level, D'Antonio's volatile emotion is juxtaposed with the sculptures' frozen motion (fig. 3.2). In short, the

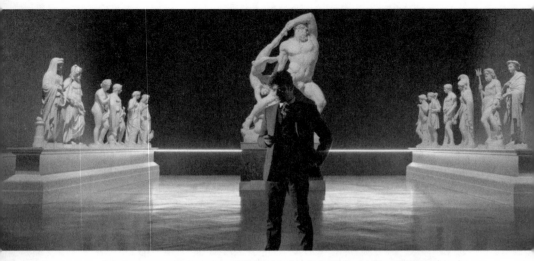

3.2. Santino opens a contract on Wick with Antonio Canova's *Ercole e Lica* (1795) and twelve Greco-Roman gods in the background. The steadiness of the sculpture is contrasted with Santino's anxiety as he anticipates Wick's revenge. *John Wick: Chapter 2*, 2017.

multilayered negotiation of action and stasis is cinematographically presented in a quiet and orderly space to signify how the mise-en-scène instantiates the motif of stability.

The externalization of the martial ideational *ren* is also evident in the first fight scene of *John Wick* 3. Although the New York Public Library is a placid space like the Galleria Nazionale d'Arte Moderna, it is a more subtle manifestation of Wick's inner stability. When Wick is running to the circulation counter, he is placed right at the center of the screen in two shots: one from the front and another from the back. The centrality of Wick in the shots reveals his personal connection to the library, a connection embodied in the choreography. Wick uses a book

to kill Ernest (Boban Marjanović), the 7'4" Serbian basketball player. Before Wick's retrieval, the book, *Russian Folk Tale* (1864), written by Alexander Afanasyev, sits on the shelf for a long time, and no one discovers the book's secret.[33] It is a hollow book containing a few valuable personal items, including a rosary with a large cross, a token, and a photograph of his deceased wife. These items are crucial for Wick to survive the pursuit brought by the excommunicado. Metaphorically, Wick is the book that is not meant to be found or read, as it becomes a deadly weapon once retrieved.

The choreography, on the one hand, corresponds to the franchise's consistent endeavor to explore the lethality of everyday objects, such as pencils and belts. On the other hand, using a book to finish off Ernest reveals Wick's persistent striving for balance and stability. After killing Ernest, Wick does not take away the book. Instead, he calmly returns it to the shelf and restores the order of the library, where he keeps his precious memory safe and intact. In other words, the library and the book are the structural and material manifestations of Wick's inner stability and balance. The franchise carefully curates the spaces of fighting so that a sense of tranquility can be cultivated amid brutal combats.

Tranquility as Fluidity: Following the Martial Ideational *Wu* (Nothingness)

Wick's fluid fighting style is the second constitutive component of his tranquility. As Stahelski describes in a featurette, Wick's style is a synthesis of "Japanese jujitsu, Brazilian jujitsu, tactical 3-gun, and standing Judo."[34] One key source of this combination is the martial arts background of the films' production team—Stahelski (director), David Leitch (codirector), and Jonathan Eusebio (fight choreographer)—who were all extensively trained under Dan Inosanto at the Inosanto

Academy in Los Angeles.[35] Bearing this in mind, it is not a surprise that Jeet Kune Do and Escrima's (Philippine martial arts) emphases on practicality, fluidity, and unpredictability are incorporated into the action aesthetics of the franchise.

Compared to *The Matrix*, for example, which evinces a stronger affiliation with kung fu cinema and the operatic tradition, the choreography of *John Wick* is less theatrical and more pragmatic. If *The Matrix* is a postmodern fusion of Hong Kong action classics in the late 1970s and 1980s such as Yuen Woo-ping's *Drunken Master* (1978) and John Woo's *A Better Tomorrow* (1986), which focus on agile body movement and balletic gunplay, respectively, *John Wick* belongs to an earlier period of Hong Kong action and bears a closer resemblance to Bruce Lee's *Enter the Dragon* (1973). Stahelski's familiarity with Lee's fighting philosophy allows him to discard the redundant and focus on the practical. As Eusebio admits, "The concepts of Jeet Kune Do / Jun Fan Gung fu allowed me to cross train in many different disciplines and its philosophy of absorb[ing] what is useful and reject[ing] what is useless is helpful when I develop a fight style for characters onscreen."[36] In other words, the Daoist fluidity inherent in Jeet Kune Do plays a crucial role in shaping the action choreography of *John Wick*.[37]

In addition, Wick's flexibility is not limited by martial disciplines. When he runs out of bullets and faces an overwhelming number of enemies, he turns everyday objects into lethal weapons. For example, Wick uses objects such as kitchen counters and pencils to kill several assailants in the first and second films, and in the third film he uses a book to break his opponent's neck. In short, the martial ideational *wu* manifested in the trilogy is based on Wick's multidisciplinary and multimedium fighting approach.[38]

However, what distinguishes *John Wick* from other action films taking a flexible approach in fight choreography (such as *The Raid* [2011])

is its unique synthesis of martial arts action and gun work. This characteristic enhances the Hong Kong connection of John Wick, as the combination of kung fu and guns can be traced back to the late 1980s when John Woo made his name through films such as *A Better Tomorrow* and *The Killer* (1989). Woo's balletic gun work was then transplanted to Hollywood action via films such as *Face/Off* (1997) and *MI: 2* (2000).

Yet unlike its predecessors, *John Wick* strikes a balance between realism and aestheticism. Similar to Bruce Lee, Wick manifests fluidity by playing with the motifs of straightness and roundness, which are the vital components of Lee's choreographic work.[39] Lee exhibits the fluidity of Daoist tranquility through the random alternation of roundhouse kicks and side kicks or evasive circular footwork and undisguised direct attack. Similarly, Wick's straightness is represented by the effectiveness of the gun work, and roundness is demonstrated by his constant use of jujitsu throws. The synthesis of the two formulates the martial ideational *wu*, allowing Wick and the spectators to experience tranquility through the motif of nothingness.

In addition to choreography, the production process instantiates the martial ideational *wu*. Stahelski had limited resources in the first film and needed to be as flexible as Wick. Rather than following the conventional approach to making cinematic action that relies on "selling the hit" through punches and kicks, he devised a new style that could "hold all the shots": "It's more about solving problems. The more times you use a stunt double means more edits, more coverage, more time. We're gonna save time because we only have 50 days—less, 47 days on the first movie. The more you do punches and kicks, the more you gotta miss, because you gotta sell the hit, you gotta change the angle. So okay, we're gonna get rid of punches and kicks. We're gonna do judo, jujitsu, and tactical gun work, so we can hold all the shots, no cuts. So we developed a style and reverse-engineered from there."[40] Given this, *John*

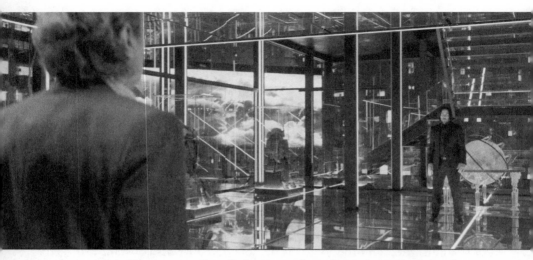

3.3. Quotidian images such as the formation of snowflakes are projected onto the glass (on the left side of the screen), suggesting the fluidity of nature. *John Wick: Chapter 3—Parabellum*, 2019.

Wick's frequent use of long takes is an extension of Stahelski's creative adaptation to the constraints of production. Not only can it save editing time, but it also increases the realism and authenticity of the action.

Nevertheless, *John Wick* also reconfigures the martial ideational *wu*, externalizing the concept to the mise-en-scène as a milieu of fluidity and signifying a Daoist sense of adaptability and arbitrariness. Toward the end of *John Wick 3*, Wick meets Winston (Ian McShane) in a secret glass gallery in the Continental. As he first enters the gallery, there is a subtle background soundtrack creating a Zen-like, meditative experience inspired by the gentle and soothing sounds of nature. The track becomes more distinct as Wick walks up the stairs in well-composed, balanced shots manifesting his inner stability and ascension to

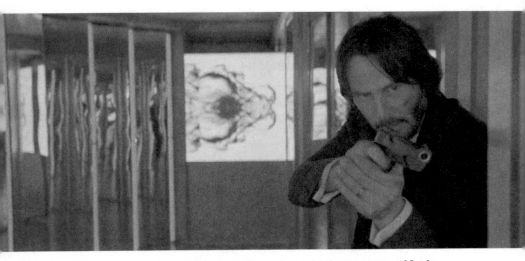

3.4. Wick enters a mirror maze filled with LCD screens displaying images of fluidity and irregularity. *John Wick: Chapter 2, 2017.*

enlightenment.[41] For these reasons, the images projected on the glass panels deserve a closer look. They include a quiet lake, sunset-tipped ripples, gently moving silver grasses, a water drop falling into a mirrorlike water surface, and time-lapses of the movement of clouds and the formation of snowflakes (fig. 3.3).[42] All these images connect to the motif of constant change and arbitrary motion inherent in the objects of nature.

It is not coincidental that Stahelski links nature to fluidity and tranquility. His martial arts background demonstrates the possibility of incorporating into his films Daoist ideas, which are prominent in Lee's Jeet Kune Do philosophy.[43] Before Stahelski began his stunt career, he taught Jeet Kune Do at the Inosanto Martial Arts Academy. He

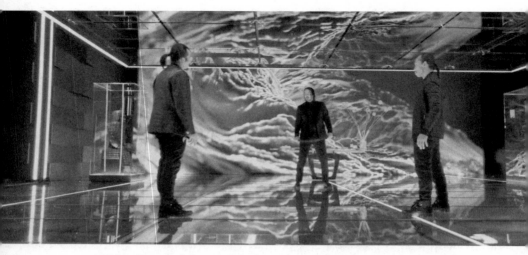

3.5. Wick's climactic fight with Shinobi 1 and 2 before a huge screen displaying rapid movement of clouds in vibrant colors. *John Wick: Chapter 3—Parabellum*, 2019.

understands the martial and philosophical connection between fluidity and tranquility from a Daoist perspective. If Bruce Lee manifests this connection through his choreography, Stahelski externalizes it to the mise-en-scène, making it crucial to scrutinize how the milieu of fluidity is constructed in the franchise.

In the ending fight scene of *John Wick 2*, Wick enters a mirror maze filled with LCD screens displaying images of fluidity and irregularity. Those images are characteristic of constant movement. Different light colors, often saturated and dramatic, are also assigned to those images to highlight their incessant change (fig. 3.4). In *John Wick 3*, there is a huge screen behind Winston, showing random images signifying fluidity, such as aquatic plants flowing underwater. This fluidity is then amplified by the rapid movement of clouds in vibrant colors during

Wick's fight with Shinobi 1 (Cecep Arif Rahman) and Shinobi 2 (Yayan Ruhian) (fig. 3.5).

In brief, the milieu of fluidity constructed in the films helps cultivate a sense of tranquility in which all things are changing and evolving. Such an understanding of tranquility can be traced back to Bruce Lee's Jeet Kune Do philosophy and Daoism. While the adaptability of Wick's techniques is one key source of fluidity, the motif of constant change in the mise-en-scène is perhaps more important, demonstrating how nature's serenity can coexist with brutal and expressive actions.

Tranquility as Acuity: Cultivating the Martial Ideational *Guan* (Perspicaciousness)

The final trait of *John Wick*'s action aesthetic is the martial ideational *guan* (perspicaciousness). The literal meaning of *guan* is beholding. In the context of Buddhist meditation, developing insight requires calmness and concentration. To *guan* is to behold an object with single-mindedness and look beyond its illusive presence. Wick's action is characteristic of the martial ideational *guan* because he is described as "a man of focus, commitment, [and] sheer will." Such a focus allows Wick to cultivate insight despite incessant interruption. Ideationally, the motif of beholding is the key to Wick's equanimity, and the object of Wick's beholding is specific: his wife. The sole reason for Wick to carry on living, as he confesses before the Elder (Saïd Taghmaoui) of the High Table in the third film, is "to remember her."

John Wick at the outset highlights the importance of beholding choreographically (watching the video clip on a cell phone), cinematographically, and narratively (the use of flashbacks within flashbacks). At the beginning of the first film, Wick is crawling out of a wrecked car, holding his blood-soaked mobile phone, and desperately watching

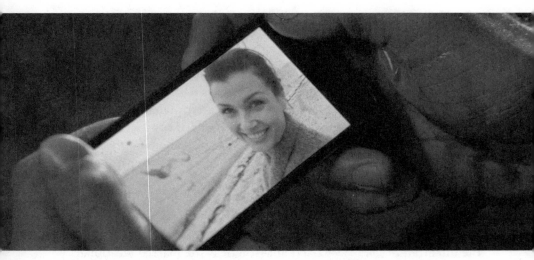

3.6. Critically injured, Wick attempts to revitalize himself by viewing a video of his past. His equanimity is cultivated from his focus on and commitment to his deceased wife. *John Wick*, 2014.

a video clip that he took for his wife (fig. 3.6). The next shot is a flashback. Wick wakes up in a large, empty mansion where he and his dog are the only occupants, followed by another series of flashbacks showing Wick's wife dying in a hospital, being buried in a funeral, and giving the dog to Wick as a gift after her death.

The prime example demonstrating the ideational relationship between beholding and equanimity is in *John Wick 3*, when Wick is asked to show his fealty to the High Table by mutilating his ring finger and forsaking the ring. To the Elder, Wick's dearest memory with his wife is "his weakness," which constrains Wick's ability "to serve" the High Table. Although the Elder tells Wick that the way to commemorate his wife is "by living," his real intention is to deprive Wick of his ability

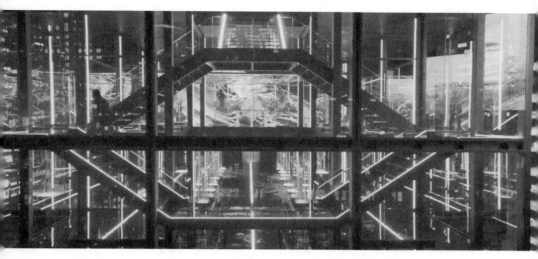

3.7. The glass structure offers a sense of perspicacity enabled by clarity. *John Wick: Chapter 3—Parabellum,* 2019.

to behold (*guan*). By taking away Wick's finger and his ring, the Elder believes that he can cause Wick to lose his focused attention to his deceased wife, thereby evoking the Baba Yaga once again.

However, the Elder misses the fact that Wick's cultivation of perspicaciousness is no longer dependent on beholding possessions. Since the first film, Wick has been trained to perfect his ability to *guan* in extreme circumstances where his valued possessions are gradually and painfully taken away from him, including his car, his dog, his house, his friendship, and eventually his finger and wedding ring. While Wick in the first two films has a much stronger reaction toward his losses, he has developed new insight over time so that his beautiful memory of Helen is inherent and not attached to his possessions.

Similar to the previous two manifestations of martial ideation, *guan* is externalized to the mise-en-scène as the milieu of acuity, signifying a Buddhist sense of insight and sensitivity. The glass gallery in *John Wick 3* is the embodiment of acuity as Winston oversees the Continental from a privileged vantage point. The transparency of the glass structure represents Winston's keen insights and his strategic move against the High Table. The structure offers a sense of perspicacity enabled by clarity (fig. 3.7). Despite the High Table's threat, Winston confidently stands in front of a chessboard placed on a glass table, conveying the idea that Winston possesses penetrating insight (against the High Table) and is in control of the situation.

The structural clarity represents a turning point in the narrative of the third film. When Wick enters the glass gallery, he is supposed to shoot Winston in the head and complete the mission given by the Elder. However, Winston gives Wick a new insight regarding his reason to live. Giving Wick his gun, Winston offers Wick a choice of dying as the Baba Yaga or as a man who "loved and was loved by his wife." Rather than commemorating his wife through living at the cost of selling his soul to the High Table, Wick is convinced that he can "remember her" in death. Such enlightenment is crucial, as it marks a sharp turn in the narrative and leads to the showdown at the Continental.

Choreographically, fighting in a glass gallery requires greater martial capability and authenticity, as the actors cannot cheat. Mark Dacascos (Zero) comments on the difficulty of filming the climactic fight scene, admitting, "A few people actually ran into the glass." He continues, "As a fighter, a glass set is very spooky, because you can't hide anything technically. You have to be super sharp, but the challenge was fun, and the final look is really cool."[44] In this respect, the milieu of acuity highlights the insight and sensitivity that a fighter needs to maintain a clear and calm mind during combat.

From the aesthetic and philosophical standpoint, the clarity of the glass structure implies a Buddhist sense of perspicacity, which enables the fighter to look beyond illusory appearances and see reality as it is. This implication is also evident at the end of *John Wick 2*, when Wick enters an exhibition full of mirrors at the museum. The idea of breaking the illusion is explicitly stated in an announcement when Wick first enters the exhibition: "Within this exhibition, the interplay of light and the nature of self-images coalesce to provide an experience which will highlight the fragility of our perception of space and our place within it. We hope through this exhibit we can provide new insights into your understanding of the world, just possibly lead you into deeper reflection into the nature of self." The setting, on the one hand, is Stahelski's way of paying tribute to the hall-of-mirrors scene in Bruce Lee's *Enter the Dragon*, thus connecting the film to the tradition of Hong Kong martial arts cinema. On the other hand, placing the final fight scene within the exhibition can be seen as a metacommentary on the aesthetic and philosophical potentials of action cinema. Rather than perceiving martial arts performance as a visual and visceral excitement, a well-choreographed fight scene in the milieu of acuity enables the characters and spectators to cultivate perspicaciousness so that they can not only survive the fight but also develop a sense of tranquility in times of turmoil.

Conclusion

Although *John Wick* features brutal fight scenes, the franchise's aesthetics transcends the dominant frameworks of authenticity and expressivity. By connecting the films to the aesthetic and philosophical core of Hong Kong action, it is possible to reconcile rage and revenge with repose and restfulness. This is not saying that the existing frameworks of authenticity and expressivity are no longer important. Instead, this

chapter proposes a three-step process in understanding the aesthetic and philosophical core of cinematic action—from authenticity to expressivity to tranquility.

The relationship between courage and fear described by Nelson Mandela offers a good illustration of the paradigmatic shift of cinematic action aesthetics from one highlighting authenticity and expressivity to one cultivating tranquility. He writes, "I learned that courage was not the absence of fear, but the triumph over it. The brave man is not he who does not feel afraid, but he who conquers that fear."[45] Similarly, tranquility in cinematic action should not be considered as a passive state of inaction denying the excitement generated by genuine martial capabilities or explicit violence involved in a realistic fight scene. Instead, it is the art of both managing and negotiating the powerful overflow of emotions so as to maintain stability when things get out of control, seek fluidity when change is not possible, and cultivate acuity when hastiness is the norm.

Ideationally, then, the action aesthetics of *John Wick* transcends realism and expressionism. Its ingenuity lies in its improbable reconciliation of beauty and brutality found in the liminal space of tranquility. Unlike the initial formulation, *John Wick* shifts the focus from what the fighter does to where the fight takes place. If Hong Kong action aesthetics were literally transplanted into *The Matrix* two decades ago, *John Wick* demonstrates that such tranquility can be subtly reconfigured in the milieux of stability, fluidity, and acuity. Moreover, while the concept of martial ideation is originally derived from Hong Kong martial arts cinema with reference to specific martial arts styles and philosophical traditions, it undergoes a process of generalization and decontextualization. In the case of *John Wick*, the archival and regional specificity associated with the concept is fading. Such reinvention, however, is crucial

for the development of global action cinema, as the films are made for a much broader audience base.

Above all, the purpose of formulating an ideational framework is not about rejecting existing theories on action aesthetics and holding a cultural-essentialist view that the Chinese path is better than its Euro-American counterpart. Rather, it aims at opening up a new comparative, theoretical space in which new perspectives, understandings, and theorizations about action cinema can be developed. And from this project, one so well realized in the *John Wick* franchise, perhaps one larger question emerges: Considering the increasingly significant role that action sequences play in global filmmaking and the escalating sociopolitical conflicts we experience in everyday living, can martial ideation be the key to negotiating with our emotions and bringing about tranquility in the midst of violence, brutality, and chaos?

Notes

1. On the concept of martial ideation, see Wayne Wong, "Action in Tranquillity: Sketching Martial Ideation in *The Grandmaster*," *Asian Cinema* 29, no. 2 (2018): 201–23, https://doi.org/10.1386/ac.29.2.201_1; Wayne Wong, "Nothingness in Motion: Theorizing Bruce Lee's Action Aesthetics," *Global Media and China* 4, no. 3 (2019): 362–80, https://doi.org/10.1177/2059436419871386.

2. For the sake of brevity, the term *John Wick* refers to the whole franchise. When referring to a specific film, I call it the first, second, or third film.

3. Yuen Woo-ping was the martial arts choreographer of *The Matrix*, and Chad Stahelski was Keanu Reeves's double in the film. For *The Man of Tai Chi*, Chad Stahelski was the martial arts choreographer.

4. Leon Hunt, *Kung Fu Cult Masters* (London: Wallflower, 2003), 29–41.

5. David Bordwell, *Planet Hong Kong: Popular Cinema and the Art of Entertainment*, 2nd ed. (2000; repr., Madison, WI: Irvington Way Institute Press, 2011), 146–53.

6. Jeet Kune Do is a multidisciplinary style accentuating fluidity and adaptability. Bruce Lee, *Tao of Jeet Kune Do: Expanded Edition* (1975; repr., Valencia, CA: Ohara, 2015), 212–15.

7. Jackie Chan, for example, made several attempts to break into the US market in the 1980s, appearing in what are criticized as "substandard films directed by by American hacks" due to their poor execution in synthesizing Hong Kong and Hollywood action styles. See, for example, Steve Fore, "Home, Migration, Identity: Hong Kong Film Workers Join the Chinese Diaspora," in *Fifty Years of Electric Shadows*, ed. Kar Law (Hong Kong: Hong Kong International Film Festival/Urban Council, 1997), 127.

8. Esther Ching-mei Yau, ed., *At Full Speed: Hong Kong Cinema in a Borderless World* (Minneapolis: University of Minnesota Press, 2001), 8–9.

9. Wong, "Action in Tranquillity," 202–7.

10. Michael J. Puett, *To Become a God: Cosmology, Sacrifice, and Self-Divinization in Early China* (Cambridge, MA: Harvard University Press, 2002), 289–315.

11. Shaokang Zhang, *Zhongguo wenxue lilun piping jianshi* [A concise history of Chinese literary criticism] (Hong Kong: Chinese University of Hong Kong, 2004), 92.

12. Bowei Zhang, *Quantang wudai shige jiaokao* [A study of the poetic styles in Tang's Five Dynasties] (Xi'an: Shanxi renmin chubanshe, 1996), 172–73; Wong, "Action in Tranquillity," 203.

13. Ran Jiao, *Shishi* [On poetic forms] (Shanghai: Shangwuyinshuju, 1937); Tu Sikong, *Ershisi shipin* [Appreciating the twenty-four forms of poetry] (Taipei: Jinfeng chubanshe, 1987); Yu Yan, *Canglang shihua* [Canglang poetry talks] (Taipei: Jinfeng chubanshe, 1986).

14. Baihua Zong, *Zong Baihua quanji* [Complete works of Zong Baihua], vol. 2 (Anhui: Anhui Jiaoyu Chubanshe, 1994), 361.

15. Mary Ann Farquhar, "The Idea-Image: Conceptualizing Landscape in Recent Martial Arts Movies," in *Chinese Ecocinema: In the Age of Environmental Challenge*, ed. Sheldon Hsiao-peng Lu and Jiayan Mi (Hong Kong: Hong Kong University Press, 2009), 100.

16. Bordwell, *Planet Hong Kong*, 127.

17. Victor Fan, "The Something of Nothing: Buddhism and the Assassin," in *The Assassin: Hou Hsiao-Hsien's World of Tang China*, ed. Hsiao-yen Peng (Hong Kong: Hong Kong University Press, 2019), 182.

18. Aaron D. Anderson, "Action in Motion: Kinesthesia in Martial Arts Films," *Jump Cut* 42 (1998): 5–6.

19. For an extended discussion on the limitations of authenticity and expressivity, see Wong, "Action in Tranquillity," 205–7.

20. Chun Ip, *Ye Wen: Yongchun* [Ip Man: Wing Chun] (Hong Kong: Infolink, 2009), 50.

21. James Legge, *The Sacred Books of China: The Texts of Confucianism* (New Delhi: Atlantic, 1990), 448.

22. The "pause-burst-pause" pattern refers to the insertion of pauses amid or after a rapid series of punches, kicks, blocks, and parries in fight scenes. David Bordwell, "Aesthetics in Action: Kung Fu, Gunplay and Cinematic Expressivity," in Yau, *At Full Speed*, 80.

23. Hector Rodriguez, "Hong Kong Popular Culture as an Interpretive Arena: The Huang Feihong Film Series," *Screen* 38, no. 1 (1997): 6, https://doi.org/10.1093/screen /38.1.1.

24. Xianhai Dang and Dong Lu, "Shilun guangdong nanquan de xingcheng ji tedian" [Discussing the formation and characteristics of the southern fists], *Wushu Yanjiu* [Martial arts studies] 1, no. 9 (2016): 51.

25. Rick Altman, *Film/Genre* (London: BFI, 1999), 207.

26. Laozi, *Daodejing*, trans. Edmund Ryden (Oxford: Oxford University Press, 2008), ch. 2, 25, 40.

27. Ku-ying Chen, *Laozi jinzhu jinyi* [A contemporary commentary and translation on Laozi], 3rd ed. (1970; repr., Taipei: Shangwuyinshuguan, 2017), 12.

28. Ruru Li, *The Soul of Beijing Opera: Theatrical Creativity and Continuity in the Changing World* (Hong Kong: Hong Kong University Press, 2010), 63.

29. Zhiyi, *The Essentials of Buddhist Meditation: The Classic Śamathā-Vipaśyanā Meditation Manual*, trans. Bhikshu Dharmamitra (Seattle: Kalavinka, 2009), 6–7.

30. Ip, *Ye Wen*, 145–46.

31. Daniel Rutledge, "Total Number of John Wick Kills in All 3 Movies Revealed," *GeekTyrant*, May 24, 2019, https://geektyrant.com/news/the-total-number-of-people -that-john-wick-has-killed-in-his-films-has-been-revealed.

32. A similar motif is demonstrated by Antonio Canova's "Ercole e Lica" (or "Hercules and Lichas"), sculpted in 1795. The immovable sculpture crystallizes the moment when Hercules kills Lichas in full rage. Rather than focusing on violence per se, the film finds ways to embed intense actions in static objects. The museum is therefore a crucial milieu demonstrating the balance between action and stasis.

33. A. N. Afanas'ev, *Russian Folktales from the Collection of A.N. Afanas'ev: A Dual-Language Book*, trans. Sergey Levchin (Mineola: Dover, 2014).

34. JoBlo Movie Trailers, "JOHN WICK 2—Gun Fighting Featurette," YouTube, January 25, 2017, https://www.youtube.com/watch?v=oDrZ_oNOXsw.

35. Inosanto played a key role in the unfinished *Game of Death* and was one of Bruce Lee's favorite students.

36. Pedro Olavarria, "Keanu Reeves's Fight Choreographer Talked to Us about 'John Wick,'" *Fightland Blog*, November 12, 2014, http://fightland.vice.com/blog/we-talked-to-keanu-reeves-fight-choreographer-on-his-new-film-john-wick.

37. Due to the American counterculture in the 1960s, Lee's Jeet Kune Do is a fusion of different philosophical traditions. Lee was interested not only in Daoism but also in Zen Buddhism, especially through the works of Alan Watts and Daisetz T. Suzuki. He was also greatly influenced by the writings of Jiddu Krishnamurti.

38. For an extended discussion of the flexibility of Wick's fighting approach, see Birger Langkjær and Charlotte Sun Jensen, "Action and Affordances: The Action Hero's Skilled and Surprising Use of the Environment," in *Screening Characters: Theories of Character in Film, Television, and Interactive Media*, ed. Johannes Riis and Aaron Taylor (London: Routledge, 2019), 266–83.

39. Wong, "Nothingness in Motion," 371–76.

40. Luke Y. Thompson, "How 'John Wick' Developed Its Unique Fighting Style," *Forbes*, June 13, 2017, https://www.forbes.com/sites/lukethompson/2017/06/13/john-wick-chapter-2-keanu-reeves-chad-stahelski-interview/#6de44a047749.

41. Narratively speaking, it is the turning point in the film, as Wick eventually realizes that he could commemorate his wife even in death. I elaborate this point in detail with the third manifestation of martial ideation, *guan* (perspicaciousness), in the next section.

42. The montage of natural elements exudes a sense of Daoist tranquility and bears a close resemblance to the acclaimed bamboo forest fight scene in King Hu's *wuxia* classic, *A Touch of Zen* (1971).

43. One of the most famous analogies in Jeet Kune Do is "be water." It is derived from chap. 8 of Laozi's *Daodejing*. Laozi, *Daodejing*, 19.

44. "Halle Berry John Wick: Chapter 3—Parabellum," Girl.com.au, accessed April 28, 2020, https://www.girl.com.au/halle-berry-john-wick-chapter-3-parabellum.htm.

45. Nelson Mandela, *Long Walk to Freedom: The Autobiography of Nelson Mandela* (London: Abacus, 1995), 748.

WAYNE WONG teaches in the School of East Asian Studies at the University of Sheffield. He holds a joint PhD in film studies and comparative literature from King's College London and the University of Hong Kong. He has published essays in *Asian Cinema, Global Media and China, Journal of Contemporary Chinese Art,* and *Martial Arts Studies.* His research interests include comparative film theories and philosophies, Chinese and transnational cinemas, and martial arts studies.

PART II
THE ECONOMIES AND PHENOMENOLOGY
OF THE WICKVERSE

THE CONTINENTAL ABYSS 4
JOHN WICK *VERSUS THE FRANKFURT SCHOOL*

SKIP WILLMAN

In October 2019, Martin Scorsese ignited a Twitter firestorm with an interview in *Empire* magazine in which he claimed that the Marvel movies were "not cinema" and likened them to a "theme park." Later that month, Francis Ford Coppola defended Scorsese and called the Marvel films "despicable." The inevitable backlash against the legendary directors forced Scorsese to clarify his position. In an op-ed for the *New York Times*, Scorsese tried to pacify outraged Marvel fans and Hollywood insiders by arguing that he was raised in a different time with a different idea of cinema, but he nevertheless reiterated his criticism of the Marvel Cinematic Universe: "They are sequels in name but they are remakes in spirit, and everything in them is officially sanctioned because it can't really be any other way. That's the nature of modern film franchises: market-researched, audience-tested, vetted, modified, re-vetted and remodified until they're ready for consumption." For Scorsese, these formulaic films do not advance an "art form" of "aesthetic, emotional, and spiritual revelation." In his conclusion to the op-ed, Scorsese underscored the disingenuous, free-market rationale for the never-ending stream of superhero movies: "And if you're going to tell me that it's simply a matter of supply and demand and giving the people what they want, I'm going to disagree. It's a chicken-and-egg issue. If people are given only one kind of thing and endlessly sold only one kind of thing, of course, they're

going to want more of that one kind of thing."[1] Scorsese's argument replicates Max Horkheimer and Theodor Adorno's scathing critique of the culture industry in *Dialectic of Enlightenment* (1947): "Capitalist production so confines them [consumers], body and soul, that they fall helpless victims to what is offered them." Like Scorsese, the Frankfurt School scholars excoriate the carefully rationalized production techniques in Hollywood that result in "a constant reproduction of the same thing."[2]

Like the Marvel Cinematic Universe, the *John Wick* franchise appears to be an exemplary product of a contemporary Hollywood that "impresses the same stamp on everything."[3] The films offer nonstop thrill rides of violence that up the ante with every installment but rarely depart from the established formula. Inspired by the work of Adorno, Walter Benjamin, and fellow travelers Fredric Jameson and Slavoj Žižek, my analysis explores the violence of the *Wick* franchise and the representation of its criminal underworld. First, the franchise represents an intensification of the reversal of means and ends within the culture industry in which violence, once considered a means to an end, becomes an end in itself. The story functions as merely an excuse for the "gun fu," expertly staged by talented stunt people and enhanced by CGI. Admittedly, the *John Wick* films are hardly the only action films that exhibit these features, but they exemplify the latest iteration of a disheartening trend in the culture industry that sacrifices narrative for stunts. Second, the tragic backstory of John Wick not only serves as an alibi for the violence but also performs an ideological task: his rich private life obfuscates the fact that, objectively, Wick is a professional killer. Third, the film is not without its redemptive possibilities, despite its relentless repetition of violence, and here I depart from the Frankfurt School's condemnation of mass culture and veer into Jameson's more nuanced theory of its utopian promise. That is to say, as the criminal underworld

of the franchise symptomatically mirrors the cutthroat capitalist world, exposing the systemic violence (as opposed to the subjective violence) inherent to it, the rebellion against the High Table in *John Wick: Chapter 3—Parabellum* hints at the revolutionary potential lurking in dissatisfaction with the dominant social system.

The Inversion of Means and Ends in *John Wick*

Scorsese's and Coppola's remarks make clear that the fundamental problems with the culture industry identified by Horkheimer and Adorno remain an ongoing concern. In *Grand Hotel Abyss: The Lives of the Frankfurt School* (2016), Stuart Jeffries offers a necessary corrective to the dismissive reception of Horkheimer and Adorno as "European snobs" attacking mass culture while championing high modernism. Certainly, when they moved to California in 1941, their brush with Hollywood amid a German exile community of serious artists (including Thomas Mann, Bertolt Brecht, Arnold Schoenberg, Fritz Lang, and Hanns Eisler) left them profoundly disillusioned with America.[4] Indeed, they compared the US to the Third Reich in terms of oppressiveness, domination, and cruelty. However, Jeffries writes that their problem with mass culture lay primarily in its "conformism and repression": "What they championed was neither high art nor low culture, but art that exposed the contradictions of capitalist society rather than smoothing them over."[5] Jeffries argues that what Horkheimer and Adorno "defended was not elitist art per se, but art that refused to be affirmative," or an "art that could express suffering."[6] Perhaps echoing his friend Walter Benjamin's commitment to the "tradition of the oppressed," Adorno writes in his lectures on aesthetics that "great art . . . could be said to stand with the victims; that history goes against the

grain . . . that what calls out from works of art is in fact always the voice of the victim . . . art is the voice of the suppressed, for, essentially, expression always amounts to an expression of suffering."[7] We need to hold on to these thoughts regarding art's obligation to expose the contradictions of capitalism and suffering, for the *Wick* franchise begins as a simple tale of retribution but moves increasingly toward representing the systemic violence of capitalism.

In his preface to *Minima Moralia* (1974), Adorno laments our "damaged life," particularly the absurd relationship between "life and production, which in reality debases the former to an ephemeral appearance of the latter." To be more precise, Adorno claims that "means and ends are inverted."[8] The means of production should serve the ends of humanity, but instead humanity has become the servant of the economic system, a proposition sadly confirmed by President Donald Trump's call in 2020 to return to work in the middle of the COVID-19 pandemic to save the economy. Horkheimer and Adorno argue that this inversion of means and ends has conquered Hollywood and created movies devoid of ideas but rich in technical skill: "The development of the culture industry has led to the predominance of the effect, the obvious touch, and the technical detail over the work itself—which once expressed an idea, but was liquidated together with the idea."[9] Indeed, Adorno would later describe this particular inversion of ends and means as the "fetishism of methods," although he had in mind music rather than cinema: "That overvaluation evident in the entire development of contemporary art of technical procedures, which have been perfected to an extraordinary degree, in relation to the *terminus ad quem* . . . the *raison d'être* of the work of art, the cause for such a work of art to exist at all."[10]

The *Wick* franchise displays the way in which the "technical detail" of the violent stunts, which used to be a component of the work

as a whole, has become the sole purpose of the work, while "the idea" and narrative languish as excuses for the outrageously brutal fight sequences. The films are celebrated for this choreography of violence, what Horkheimer and Adorno might call their "conspicuous production," but this feature exposes a curious contradiction between chance and planning.[11] The fight sequences that occur within the narrative as spontaneous are ultimately planned down to the last punch, kick, and headshot. Movies require such planning with storyboards and camera angles, shots and reverse shots, of course, but the *Wick* films dismiss the suspension of disbelief as a requirement. The films foreground the technical difficulties of staging and filming the gun fu for the connoisseur of film violence to enjoy, the more outlandish the better, even as the films strive to retain a veneer of "realism." Witness the conscientious moments of discarding empty clips and reloading weapons. Earlier in this volume, Lauren Steimer argues that the "action design" team of 87Eleven should be given directorial credit for the film, since the carefully choreographed fight sequences drive both the film's narrative and its shooting.[12] The 87Eleven team created previzes with stuntmen that ultimately guided the shot-by-shot filming of the fight sequences. In other words, Steimer suggests that the stunt team's work renders the director as auteur superfluous (and perhaps this irks the sensibilities of the auteurs Scorsese and Coppola). The rationalization of the film down to the very "beats" of the fight sequences corroborates the Frankfurt School contention regarding the reversal of means and ends: the action drives the narrative. With *Wick*, what should appear on screen as a spontaneous act of violence is carefully rationalized. The violence therefore betrays its detachment from reality, a move that nevertheless does not interfere with its wish-fulfilling fantasy of masculine mastery, domination, and power.

The film's focus on elaborately stylized violence should not surprise anyone, since Chad Stahelski, the film's director, was the stuntman for Keanu Reeves in *The Matrix* series. Nor is *John Wick* the first film to aspire to such an aesthetically rendered ballet of carnage, as one can cite *The Matrix* or almost any film in Quentin Tarantino's oeuvre as exemplars of stylized ultraviolence in contemporary American cinema, although Hong Kong action cinema represents a more accurate reference point for the ambitions of the *Wick* franchise.[13] The degree to which the narrative is subordinated to the violent action, however, is also part of a long-running trend in Hollywood to minimize dialogue (which doesn't always translate well into other cultures) and maximize action for global film markets. Scorsese is in full agreement with the position of Horkheimer and Adorno: market forces and demographic research drive Hollywood production, creating identical commodities for global consumption rather than works of art, while signaling the victory of the universal over the particular.

For all of its stylistic excesses of violence, *The Matrix* is firmly grounded in science fiction with its cautionary tale of artificial intelligence, virtual reality, and computer technology. Its premise that humanity has become enslaved to serve as batteries for the machines allegorically depicts the very inversion of means and ends that Adorno decries.[14] Moreover, this dystopia serves a critical function that Jameson illuminates when discussing science fiction: "The most characteristic SF does not seriously attempt to imagine the 'real' future of our social system. Rather, its multiple mock futures serve the quite different function of transforming our own present into the determinate past of something yet to come."[15] However, the subject of enslavement to our technology also provides a more soothing rationale for our intellectual enjoyment, representing an instance of enlightened false consciousness: we know very well that we come for the violence, but we

nevertheless rationalize our enjoyment of the film for its provocative dystopian imagination.[16] *John Wick* lacks such a thematic foundation, so its reversal of means and ends merely reflects the latest development in the culture industry.

While the *Wick* franchise unapologetically pursues its spectacular violence, the films provide a fig leaf of narrative motivation for their exuberant brutality. The opening of the first film presents the tragic death of Wick's wife, Helen, from illness in a brief series of flashbacks, but the brevity of this narrative material betrays the bad conscience of the film. It is as if we must maintain our ignorance of the big Other regarding the true motive of the film, its ballet of violence.[17] Depicting Wick's relationship with Helen as the motivation for his retirement provides the psychological cover necessary for the film to go on its subsequent rampage. In her contribution to this volume, Karalyn Kendall-Morwick notes that even this narrative element derives from a standard motif in comic books dubbed "Women in Refrigerators," in which the death of a woman early in the text motivates the protagonist in his quest for revenge. The narrative, in short, relies on stock formulas of the genre as a "motivation of the device," or, as Terry Eagleton explains, "Content was merely the 'motivation' of form, an occasion or convenience for a particular kind of formal exercise."[18] *John Wick: Chapter 2* self-consciously acknowledges the meager excuse for the violence in its opening, as Abram Tarasov (Peter Stormare) incredulously explains Wick's motivation to his underling: "He killed my nephew. My brother. A dozen of my men. Over his car. And a puppy." Responding to the misrepresentation of his motives in the third installment, Wick explains to the Director (Anjelica Huston), "It was more than a puppy." The playful metacommentary serves as a reminder that the films recognize their own ridiculousness; they are in on the joke, but they don't care.

The Facade of the Private Life

The *John Wick* franchise provides its protagonist with a wealth of charming and seemingly contradictory traits as a means of softening his violence. The assassin with a heart of gold adheres to what Robert Ray calls the "thematic paradigm" in classic Hollywood cinema, which reconciles contradictory American values inherent to the capitalist system, such as ruthlessness and benevolence.[19] Wick is a cold-blooded killer described in awed tones by both Tarasov brothers as the "Baba Yaga," the "Boogeyman," a man of "focus, commitment, and sheer fucking will." Nevertheless, he forms a touching attachment to his puppy, Daisy, a gift from his late wife, an important memento of their relationship, and a surrogate companion for him. Initially, Wick seems almost indifferent to Daisy, but his bewildered response to the puppy further humanizes him, insofar as the puppy trains the clueless owner in his domestic duties. When Iosef Tarasov (Alfie Allen) and his men cruelly slaughter the puppy and steal his Mustang, vestiges of his private life with Helen, Wick sets off on his violent course of retribution. To come full circle and reiterate Wick's humanity, at the end of the first film he treats his injuries at a veterinary hospital and rescues one of the caged animals, a pit bull designated to be euthanized, in order to reestablish the lost link to his wife.[20]

The films persist in asserting that the "richness" of Wick's "inner life" resides with his passionate attachment to Helen, particularly evidenced with every replay of the video of her on his phone. As he confesses to Viggo Tarasov (Michael Nyqvist) under brutal interrogation, "When Helen died, I lost everything. Until that dog arrived on my doorstep. A final gift from my wife. In that moment, I received some semblance of hope. An opportunity to grieve unalone. And your son took that from me." The scene stands out as an uncharacteristic show of anger from the

usually stoic Wick but also reaffirms the righteousness of Wick's violent revenge. While Wick's attachment to his stolen Mustang appears to be genuine, since Helen jokes about his love for it in her farewell note, his recovery of the vehicle that opens *John Wick 2* may also be driven by his sentimental desire to retrieve photos of Helen. When he finds the car at Abram Tarasov's garage, the first thing he does is check the glove compartment for her picture and carefully return it. He cares little for the condition of his stolen Mustang in the chase that ensues, although he later calls in Aurelio (John Leguizamo) to rebuild it. Aurelio is shocked by the damage: "What the hell? I thought you loved this car." Similarly, the destruction of his house by Santino D'Antonio (Riccardo Scamarcio) shortly thereafter matters less to Wick than the loss of his photos of Helen and the memories of their life together in their home. Ever mindful of the vicissitudes of his professional life, Wick has hidden stashes of identification documents, gold coins, and weapons in several locations, including a safety deposit box and a hollowed-out book of folktales at the New York Public Library. Significantly, he keeps a picture of Helen in each stash. This private motivation continues unabated into the third film. After his desert sojourn to find the Elder (Saïd Taghmaoui), the "invisible Master" of the High Table, and plead for his life, the Elder asks Wick a simple but important question that informs the rationale for all of the violence in the films: "Why do you wish to live?" Wick responds simply, "My wife, Helen. To remember her. To remember us."[21] To be allowed to "live for the memory of love," Wick pledges fealty, once again, to the High Table.

Žižek notes the dubious nature of such assertions of the subjective or private life of notorious figures. His "favorite example" is Reinhard Heydrich, "the architect of the Holocaust, who liked to play Beethoven's late string quartets with friends during his hours of leisure." Žižek argues that this depiction of "the richness of inner life" represents a lure that distracts us from their public roles:

The first lesson of psychoanalysis here is that the "richness of inner life" is fundamentally fake: it is a screen, a false distance, whose function is, as it were, to save my appearance, to render palpable (accessible to my imaginary narcissism) my true social-symbolic identity. One of the ways to practice the critique of ideology is therefore to invent strategies for unmasking the hypocrisy of the "inner life" and its "sincere" emotions. The experience we have of our lives from within, the story we tell ourselves about ourselves in order to account for what we are doing, is thus a lie—the truth lies rather outside, in what we do.[22]

John Wick is an assassin, pure and simple, who kills people for money. From Žižek's perspective, Wick's desire to retire from the assassin's life, a life from which he is violently removed, is thus "fake," a traumatic alibi that sanctions the slaughter he undertakes. Indeed, the desire for a private life serves the same purpose as actually having a private life, suggesting that Wick is somehow different from the other criminal characters in the film, although Viggo insists that they are fundamentally alike in being haunted by a violent past. Even this assertion suggests a rich inner life of guilt and remorse, which doesn't seem to trouble Viggo very much. For Wick, by contrast, the traumatic loss of Helen actually maintains the fantasy that he could have had a fulfilling private life.[23]

Wick's delicate handling of the assassination of Gianna D'Antonio (Claudia Gerini) in *John Wick 2* works to humanize him in a similar fashion, revealing not a ruthless killer but a compassionate professional. Tasked by Santino D'Antonio to kill his sister so he can take her place at the High Table, Wick evades her security detail by traversing the Roman catacombs and finds her alone. Comprehending her peril, Gianna first appeals to their friendship to save herself from "death's emissary": "There was a time not so long ago in which I considered us as friends." Wick acknowledges their friendship but divulges that he is bound to honor the marker held by her brother. Gianna asks if the marker was tied

to his retirement and reminds him of the cost he will likely pay for killing her, asking him if Helen was "worth the price that you now seek to pay," to which Wick responds laconically, "Yes." Gianna then shifts her appeal to his conscience, recognizing that Helen was the reason for his retirement and serves as his ego ideal: "What would your Helen think of you?" In a last-ditch effort at seduction, Gianna provocatively undresses and lets down her hair, but Wick does not respond to her overture, remaining thoroughly professional and faithful to the memory of his wife. When these appeals fail, Gianna opts for the Roman method of suicide by slitting her wrists in the bath, explaining to the baffled Wick, "Because I lived my life my way. And I'll die my way." Wick comforts her by holding her hand as she bleeds out in the bath and then puts a bullet in her head to confirm the honoring of his marker. Before she dies, she asks him, "Do you fear damnation?" His affirmative response registers the existence of his conscience, an admission that further humanizes him and differentiates him from the rest of the criminal underworld.[24]

Wick maintains his subjective "innocence" by performing the assassination under duress, honoring a marker held by Santino, who is ultimately pulling the strings. He has no choice, a point that Cassian (Common) acknowledges objectively but nevertheless rejects subjectively at the bar of the Continental after their epic fight through the cobblestone streets, stairwells, and balconies of Rome. Similarly, Santino dodges his ethical responsibility through the fetishistic disavowal of the act: he cannot be the one literally pulling the trigger, but he can contract someone to do so. The ignorance of the big Other must be maintained through the appearance of filial loyalty and plausible deniability. After the death of his sister, Santino continues the charade for the sake of the ignorance of the big Other by putting a contract out on her killer and avenging her. The lure of the subjective richness of Wick's inner life, one that includes a friendship with the woman he effectively murders with a

4.1. John Wick: compassionate assassin. *John Wick* (2014).

high degree of solicitude, obfuscates his objective role as a professional assassin. While audiences may be relieved that Wick doesn't technically murder Gianna, his mere presence precipitates her suicide (see fig. 4.1). Subjectively, Wick is blameless, at least within the social order established by the High Table, but objectively, he is responsible for her death, a fact not lost on her bodyguard.

The respectful relationship between Wick and Winston suggests the private depth of feeling lurking in the typically stoic Wick, thereby further obfuscating his objective position. In the first film, Winston (Ian McShane) serves as a donor figure, whose aid hints at a shared personal and professional history of courtesy and respect. Winston informs Wick of Iosef's location, provides a car as compensation for Ms. Perkins's attempted murder on the Continental grounds, and warns him

about the dangers of "returning to the fold." The Adjudicator indicts Winston for delaying the excommunicado order for an hour on the basis of his friendship with Wick. When Wick returns to the Continental to carry out his mission for the Elder and kill Winston, he persuades Wick to abandon the Elder's order on the grounds of friendship: "I'd rather die at the hand of a friend than that of an enemy." Like Gianna, Winston recognizes that the appeal to Helen as Wick's ego-ideal might sway him to alter his course and join the rebellion against the High Table: "The real question is, who do you wish to die as? The Baba Yaga? . . . Or as a man, who loved and was loved by his wife?" In this case, Wick throws in his lot with Winston, choosing to define himself through his relationship with Helen, his private self, rather than his public persona as the Baba Yaga. Winston's move is obviously cynical, insofar as he needs Wick's help to defend his position as manager of the Continental, but Wick nevertheless chooses friendship over his oath to serve the High Table.

Subjective and Systemic Violence

The *Wick* franchise elevates violence from a means to an end and legitimates that violence through its sympathetic portrait of the private life of its hero, but the violence in the franchise serves another ideological purpose. In "Critique of Violence," Benjamin distinguishes between two forms of violence: "All violence as a means is either lawmaking or law-preserving."[25] Jacques Derrida offers a useful gloss on these two forms of violence: "The founding violence, the one that institutes and posits law and the violence that preserves, the one that maintains, confirms, insures the permanence and enforceability of law."[26] Benjamin also argues that the infringement of the "unwritten laws" provokes a different response from the law than the breaking of laws: "retribution"

rather than "punishment."[27] The violence of the *Wick* franchise modulates across the films from what Benjamin describes as "lawmaking" to "law-preserving." In the first film, Viggo reveals that Wick performed an "impossible task" that "laid the foundation" of his criminal empire in exchange for permission to retire. While Wick's act does not strictly establish the law, the violence founds a new regime ruled by Viggo. When Iosef breaks the unwritten rules of the criminal underworld by violating the terms of Wick's retirement, Wick unleashes a storm of violent "retribution" until the symbolic debt is paid—that is, Iosef is delivered to him for justice and killed. Wick's violence reestablishes normality and balance to the symbolic order.

A slight detour into the world of detective fiction may help clarify the social and ideological coordinates of the *Wick* world in terms of these two forms of violence. According to Žižek, within the classic logic-and-deduction detective fiction universe, crime represents a violation of the symbolic order, which must be restored via the reintroduction of law and order through the detective's work. This includes interpreting the crime scene and its clues, identifying the culprit, and narrating the crime, thereby integrating it into the symbolic order: "The logic-and-deduction novel still relies on the consistent big Other: the moment, at the novel's end, when the flow of events is integrated into the symbolic universe, narrativized, told in the form of a linear story . . . brings about an effect of pacification, order and consistency are reinstated."[28] Classic logic-and-deduction detective fiction is inherently a conservative genre in its "transformation of the lawless sequence into a lawful sequence; in other words, the reestablishment of 'normality.'"[29] In contrast, the hard-boiled or film noir universe sees criminality at the heart of the symbolic order and the law—fortunes made through illegal activities, politicians bought and sold, law enforcement bribed, and so on. What is curious about *John Wick* is the way in which the film subscribes to both detective

fiction formulas. The classic logic-and-deduction formula initiates its plot: the attack on Wick by Iosef Tarasov and his accomplices disturbs the symbolic order and must be rectified to restore the unwritten rules of the criminal underworld.[30] As the films never tire of saying, rules "are what separate us from the animals." However, this parallel universe of assassins and mobsters emerges straight out of the hard-boiled realm of universal corruption. The film flips the formulas, though, in having the retired assassin stand in for the detective as the guarantor of the law (technically, the unwritten rules) by coming out of retirement.

Hard-boiled detective fiction and film noir expose the corruption of the law but propose an imaginary solution in the figure of the incorruptible hero, who could solve the case and achieve some limited justice. For Horkheimer and Adorno, the system itself was the problem, not its corruption by a few bad apples, but they proposed a novel cultural logic driving this system: instrumental reason. Jeffries contends that *Dialectic of Enlightenment* presented "instrumental reason as a new mythology, a justificatory lie to obscure the oppression, domination and cruelty beneath the smooth workings of bourgeois society."[31] In *Violence*, Žižek similarly addresses the violence inherent to the normal operations of capitalism. He defines the "often catastrophic consequences of the smooth functioning of our economic and political systems" as "systemic violence," which he differentiates from "subjective violence," or "violence performed by a clearly identifiable agent" in "acts of crime and terror, civil unrest, [or] international conflict."[32] From a Žižekian perspective, one of the more interesting features of the *Wick* franchise is the way in which the films dismantle the boundaries between "subjective violence" and "systemic violence." The criminal underworld of the *Wick* franchise is precisely such a smooth functioning system governed by rational calculation and the free-market exchange of services until perturbed by the irrational actions of a mob boss's son. Indicative

of such a violent normality, after the elimination of the hit team sent by Viggo Tarasov to clean up his son's mess, Wick encounters a police officer named Jimmy responding to a "noise complaint," who merely inquires politely if he is "working again" when he sees a dead body in the hallway. (Similarly, in *John Wick 2*, Jimmy returns to Wick's burning house and asks nonchalantly if a "gas leak" is responsible. Perfectly in keeping with the parameters of the noir universe, the law is complicit with this violence by looking the other way.) After he eliminates Viggo's hit team, Wick calls in a professional crew led by Charlie (David Patrick Kelly) to dispose of the bodies and clean up his house in exchange for one gold coin for each body. The code for requesting service, or making dinner reservations for the number of bodies to remove, provides a veneer of civilization to this most barbaric of duties. The film exposes the violence inherent to this criminal underworld's smooth functioning, which typically remains repressed in society. As a result, the films blur the boundaries between subjective and systemic violence, insofar as crime represents a closed universe governed by the High Table.

John Wick 2 hints at the origins of systemic violence in a way that evokes Walter Benjamin's famous claim from "Theses on the Philosophy of History" that "there is no document of civilization which is not at the same time a document of barbarism."[33] After destroying Wick's house as punishment for refusing to honor his marker, Santino meets Wick at a museum exhibiting his "father's collection." They sit on a bench in front of a large painting.[34] The framing of the shot is significant, as the artwork represents the "cultural treasure" secured by Santino's proposed act of violence: he requests that Wick kill his father's choice of successor to the High Table—his sister, Gianna. The next line from Benjamin's text is relevant here, too: "And just as such a document is not free of barbarism, barbarism taints also the manner in which it was transmitted from one owner to another" (296).[35] Santino's fratricidal actions and

his attempt to eliminate Wick, the tool of his machinations, underscore Benjamin's claim regarding the barbarism underlying the transmission of culture. Appropriately, Santino makes the call to put out a contract on Wick and eliminate the traces of his founding act of violence in the presence of classical statues from the same museum.

Conclusion: The Ideology of the Continental vis-à-vis the Culture Industry

Adorno's judgments of Hollywood fare are legendarily caustic and have been accused of advancing crude versions of ideological manipulation, positing consumers as mere dupes of the culture industry. Even a sympathetic critic like Andreas Huyssen, who refuses to reduce Adorno's position to "a notion of brainwashing or manipulation," contends that the culture industry cannot simply impose its "intentions" on a passive audience.[36] Yet, the ideologemes Adorno extracts from the patterns and plots of Hollywood are strangely compelling. For instance, he criticizes the decline of cartoons into "organized cruelty": "Insofar as cartoons do any more than accustom the senses to the new tempo, they hammer into every brain the old lesson that continuous friction, the breaking down of all individual resistance, is the condition of life in this society. Donald Duck in the cartoons and the unfortunate in real life get their thrashing so that the audience can learn to take their punishment."[37] Wick may dish out a satisfying retribution to the villains, but he is also relentlessly pursued and punished for his actions. Wick reaches a low point when he surrenders and offers his services to the Elder, who requires him to demonstrate his loyalty Yakuza-style by cutting off his finger. The lesson is clear: we are powerless to fight the system, whether it's capitalism or its obscene underside run by the High Table. Resistance is futile. Or is it?

Adorno's dour critique is not the last word within Western Marxism on the culture industry. In "Reification and Utopia in Mass Culture" (1979), Jameson salvages the Frankfurt School position of the culture industry as manipulation by arguing that mass culture manages social anxieties by presenting utopian wish fulfillment along with ideological repression: "The hypothesis is that the works of mass culture cannot be ideological without at one and the same time being implicitly or explicitly Utopian as well: they cannot manipulate unless they offer some genuine shred of content as a fantasy bribe to the public about to be so manipulated."[38] His reading of *Jaws* provides a persuasive case that the Steven Spielberg adaptation of Peter Benchley's novel represses the class struggle between Brody (the working-class cop) and Hooper (the rich kid) in the novel by presenting an imaginary solution in the film through their partnership: the law (Brody) and science/technology (Hooper) defeat the killer great white shark terrorizing Amity.

For our purposes, however, Jameson's reading of *The Godfather* offers more insight into the criminal underworld of the *Wick* franchise. He contends that "the ideological function of the myth of the mafia can be understood, as the substitution of crime for big business, as the strategic displacement of all the rage generated by the American system onto this mirror image of big business." What is the High Table if not a mirror image of multinational, corporate capitalism under the guise of a conspiratorial cabal of Mafia organizations? Jameson argues that ideological mystification occurs as economic injustice and systemic inequality are converted into an ethical matter of criminal activity: "The myth of the mafia strategically substitutes the vision of what is seen to be a criminal aberration from the norm, rather than the norm itself."[39] The High Table certainly represents this "criminal aberration from the norm," but its operations mirror the daily activity of capitalism so closely that the distinctions blur.

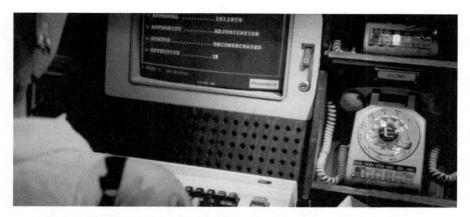

4.2. Registering the complexity of late capitalism through atavistic representation.

Jameson has similarly mused on the difficulties of "figuring" the complexities of late capitalism, and the *Wick* franchise presents a rather antiquated vision of the workings of the criminal underworld that ingeniously represents this cognitive dilemma in representation itself. The *Wick* franchise resorts to the antiquated imagery and technology of the preceding forms of capitalism in order to depict the operations of the criminal underworld. Symbolic and financial debts are registered in a handwritten ledger for the High Table (or big Other) rather than in some cloud in cyberspace. When Wick is declared excommunicado and a bounty is put on his head, the order is processed in a retrofitted office with ancient telephone switchboards, blackboards, Vic-20 computers with monochromatic monitors, ticker-tape machines, and rubber stamps.[40] These atavistic representations governed by a dream logic of association from the depths of the "political unconscious" register the cognitive difficulties of grappling with our current socioeconomic system (see fig. 4.2).[41] In our symptomatic reading of the film, then, these

departures from realism offer the clues necessary to decipher the true stakes of the film. Indeed, the third film provides a glance behind the curtain that we might even be tempted to call de-reification in a scene that further underscores the similarities between the everyday, capitalist world and the criminal empire governed by the High Table. Berrada (Jerome Flynn) explains the true function of the criminal underworld's proprietary currency to Wick and Sophia: "Now this coin, of course, it does not represent monetary value. It represents the commerce of relationships. A social contract in which you agree to partake. Orders and rules." Ordinary money represents the exact same thing. We encounter a Möbius band in which if we explore this criminal underworld far enough, we land right back in the normal functioning of capitalism.

Most assuredly, this criminal underworld sustains itself through a structure that contains all of the elements so necessary to late capitalism: hierarchy (the High Table governs much like a corporate board), a repressive state apparatus to enforce the rules (the Adjudicator and their henchmen), a communications network (the aforementioned bureaucratic headquarters that records and disseminates vital information, but also the Bowery King's carrier pigeons), surveillance (the Bowery King's system of homeless operatives), currency (the gold coins, but also the markers), and accountants (Winston keeps track of the fulfillment of these markers in a ledger). The archaic systems by which these functions are handled gesture toward History with a capital H. The *Wick* films represent not the deviation from capitalism but capitalism itself in all of its ruthless free-market frenzy and systemic violence.

Correspondingly, the utopian dimension of the *Wick* franchise resides in the coming to class consciousness of Wick and the revolutionary actions of the working class or contract labor in punishing the decadent capitalist class of inherited wealth: first, the profligate son,

Iosef Tarasov; then the patriarch, Viggo; and finally the fratricidal Santino D'Antonio as he dines on an opulent meal at the Continental. The breaking of the deal between Viggo and Wick underlines the inherent inequality of the relationship between those who sell their labor and those who purchase it. The ethical breach of the unwritten rules in the first film leads to a more systemic rebellion in the third as Winston and Wick defy the High Table. Thus, Wick moves from a legendary figure of "mythical violence" in the first film to one of "divine violence" by the third in his resistance to the High Table. Benjamin defines the distinction between these two forms of violence in the following way: "If mythical violence is lawmaking, divine violence is law-destroying; if the former sets boundaries, the latter boundlessly destroys them; if mythical violence brings at once guilt and retribution, divine power only expiates; if the former threatens, the latter strikes; if the former is bloody, the latter is lethal without spilling blood."[42] In the third film, the divine violence unleashed by Wick escalates into a rebellion against the High Table by Winston, the Bowery King (Laurence Fishburne), and Sofia (Halle Berry), although, contra Benjamin, *this* rebellion definitely spills blood.

Notes

1. Martin Scorsese, "I Said Marvel Movies Aren't Cinema. Let Me Explain," *New York Times*, November 4, 2019, https://www.nytimes.com/2019/11/04/opinion/martin-scorsese-marvel.html.

2. Max Horkheimer and Theodor Adorno, *Dialectic of Enlightenment* (New York: Continuum, 1972), 133, 134.

3. Horkheimer and Adorno, *Dialectic of Enlightenment*, 120.

4. Stuart Jeffries, *Grand Hotel Abyss: The Lives of the Frankfurt School* (New York: Verso, 2016), 228, 220.

5. Jeffries, *Grand Hotel Abyss*, 228, 229–30.

6. Jeffries, *Grand Hotel Abyss*, 230.

7. Theodor Adorno, *Aesthetics: 1958–1959* (Medford, MA: Polity, 2018), 48–49.

8. Theodor Adorno, *Minima Moralia: Reflections from Damaged Life*, trans. E. F. N. Jephcott (New York: Verso, 1974), 15.

9. Horkheimer and Adorno, *Dialectic of Enlightenment*, 125.

10. Adorno, *Aesthetics*, 72.

11. Horkheimer and Adorno, *Dialectic of Enlightenment*, 124.

12. See Lauren Steimer's essay in this volume for an in-depth look at 87Eleven's stunt and production work on the Wick films.

13. See Wayne Wong's contribution to this volume for an insightful look at the influence of Hong Kong action cinema on *John Wick*.

14. One should also note that most of the ridiculous violence occurs in the Matrix, which means that it's virtual and essentially a video game. The true messianic message of the film emerges when Neo (Keanu Reeves) manages to perform his godlike moves in the real world in the sequels.

15. Fredric Jameson, *Archaeologies of the Future: The Desire Called Utopia and Other Science Fictions* (New York: Verso, 2005), 288.

16. Peter Sloterdijk introduced the concept of "enlightened false consciousness" in *Critique of Cynical Reason* (Minneapolis: University of Minnesota Press, 1988). For the discussion that informs this particular usage, see Slavoj Žižek, *The Sublime Object of Ideology* (New York: Verso, 1989), 28–30.

17. For more on the necessity of maintaining the ignorance of the big Other, see Žižek, *Sublime Object of Ideology*, 198.

18. Terry Eagleton, *Literary Theory: An Introduction*, 2nd ed. (Minneapolis: University of Minnesota Press, 1996), 3. Jameson offers a slightly different definition of "motivation of the device," but one that still resonates with the *Wick* franchise: "A belief that justifies your own aesthetic after the fact." Fredric Jameson, *Late Marxism: Adorno, or The Persistence of the Dialectic* (New York: Verso, 1990), 68.

19. Robert Ray, *A Certain Tendency of the Hollywood Cinema, 1930–1980* (Princeton, NJ: Princeton University Press, 1985), 57. Similarly, in *Violence* (New York: Picador, 2008), Žižek describes the logic behind those whom he calls "liberal communists," including Bill Gates and George Soros: "In liberal communist ethics, the ruthless pursuit of profit is counteracted by charity. Charity is the humanitarian mask hiding the face of economic exploitation" (22). Ray identifies the "reluctant hero" as the means of reconciling such social contradictions at the heart of American mythology, a role Wick obviously fits.

20. This surrogate companion also provides a degree of levity in the sequel when Wick returns to the Continental, and Charon (Lance Reddick) agrees to watch the

dog while Wick conducts his business. These moments of understated humor also work to subjectivize Wick.

21. It is tempting to suggest a further parallel between Wick and the replicants in *Blade Runner* regarding their curious attachment to photos. The photos serve as the *objet petit a* around which these characters respond to the *"Che vuoi?"* and construct their fantasies of personal identity. For a careful explanation of the *"Che vuoi?"* within Lacanian psychoanalysis, see Žižek, *Sublime Object of Ideology*, 100–129.

22. Slavoj Žižek, *First as Tragedy, Then as Farce* (New York: Verso, 2009), 39–40.

23. While Žižek critiques the ideological uses of "the richness of inner life" as a means of subjectively humanizing the objectively monstrous, Adorno questions the very existence of a private life in our late capitalist world: "The illusory importance and autonomy of private life conceals the fact that private life drags on only as an appendage of the social process. Life transforms itself into the ideology of reification—a death mask." Theodor Adorno, "Cultural Criticism and Society," in *Prisms*, trans. Samuel Weber and Shierry Weber (Cambridge, MA: MIT Press, 1967), 30.

24. In *John Wick 3*, Zero notes that Wick stopped their impending fight in Grand Central Station when it was interrupted by a group of children passing between them, but Zero would not have done so. The film takes pains to establish Wick's solicitude for the innocent, whether it's children or puppies.

25. Walter Benjamin, "Critique of Violence," in *Reflections: Essays, Aphorisms, Autobiographical Writings* (New York: Schocken Books, 1978), 287.

26. Jacques Derrida, "Force of Law," in *Acts of Religion* (New York: Routledge, 2002), 264.

27. Benjamin, "Critique of Violence," 296.

28. Slavoj Žižek, *Enjoy Your Symptom! Jacques Lacan in Hollywood and Out* (New York: Routledge, 1992), 151.

29. Slavoj Žižek, *Looking Awry: An Introduction to Jacques Lacan through Popular Culture* (Cambridge, MA: MIT Press, 1992), 58.

30. Winston's "betrayal" of Wick by shooting him and renewing his pledge of fealty to the High Table at the conclusion of *John Wick 3* attempts to restore normalcy to the criminal underworld through an act of law-preserving violence. Significantly, Winston brags to the Adjudicator during their "negotiations" about the Continental being a "beacon of order and stability."

31. Jeffries, *Grand Hotel Abyss*, 235.

32. Žižek, *Violence*, 2, 1.

33. Walter Benjamin, "Theses on the Philosophy of History," in *Illuminations: Essays and Reflections*, trans. Harry Zohn (New York: Schocken Books, 1968), 296.

34. The two paintings in the scene, *The Battle of Custoza* by Giovanni Fattori and *Battle at Dogali* by Michele Cammarano, are not without thematic relevance to the film. MoSJ notes that both paintings depict Italian military defeats, foreshadowing the ultimate failure of Santino's violent quest for a seat at the High Table. MosJ, "The Significance of the Art in *John Wick 2*," Imgur, February 26, 2017, https://imgur.com/gallery/VBNkr.

35. Benjamin, "Theses," 296.

36. Andreas Huyssen, *After the Great Divide: Modernism, Mass Culture, Postmodernism* (Bloomington: Indiana University Press, 1986), 20, 22.

37. Horkheimer and Adorno, *Dialectic of Enlightenment*, 138.

38. Fredric Jameson, "Reification and Utopia in Mass Culture," in *Signatures of the Visible* (New York: Routledge, 1990), 29.

39. Jameson, "Reification," 32.

40. The office bears a striking resemblance to the monstrous bureaucratic machinery of Terry Gilliam's *Brazil* (Los Angeles: Embassy International, 1985), which, in turn, borrows liberally from its source material, George Orwell's novel *Nineteen Eighty-Four* (1949). However, this outdated administrative machinery fully integrates with the communications technology of today (most notably, cell phones) to notify the independent contractors/assassins of the bounty on Wick. The choice to blend old and new technologies rather than merely adopting the latest computer technology may be a stylistic flourish, a nod to the postmodernism of such films as *Blade Runner* in its random cannibalization of styles.

41. Later in this volume, Charles Tung proposes an alternative reading of the "Continental Switchboard" indebted to Jameson's thesis on the "end of temporality" in contemporary action films. His contention that the "posthistorical assemblage" of the Continental Switchboard points to the difficulty of representing the contemporary world system is not incompatible with my own interpretation: "The temporal jumble suggests that it is impossible to stack these synecdoches of the larger financial, bureaucratic, and administrative totality that is the Wickverse into a smooth, progressive media history" (291).

42. Benjamin, "Critique of Violence," 297.

SKIP WILLMAN is Associate Professor of English at the University of South Dakota. He has published essays on the work of Don DeLillo, Stanley Elkin, Ian Fleming, and Thomas Pynchon, as well as on the ideologies of conspiracy theory, in journals including *Contemporary Literature, Modern Fiction Studies, Critique,* and *Arizona Quarterly.* With Edward P. Comentale and Stephen Watt, he edited *Ian Fleming and James Bond: The Cultural Politics of 007* (2005). He is currently completing a project entitled *Cold War Catastrophes: Western Intelligence Failures in Post–World War Two Fiction.*

5 BITCOIN, SHITCOIN, WICKCOIN
THE HIDDEN PHENOMENOLOGY
OF JOHN WICK

AARON JAFFE

"John Wick would totally use Bitcoin, right?"[1] This exact question appeared on Reddit not too long ago, complete with an accompanying illustration. The image depicts a beaten-up Wick crossing hands, a pistol with silencer in one and an imaginary Bitcoin token pinched between thumb and forefinger in the other. Forget the impossible, indestructible body of Wick, all that is solid melting into air; actual physical Bitcoin is now somehow a solid, too. Of course, with Bitcoin, the "most widely used open-source peer-to-peer 'cryptocurrency' that you can send over the Internet without a bank or a middleman," there's no need for a physical object—the metal coinage, precious or otherwise—that you can actually hold.[2] Still, there remains a hauntology as haptic shorthand to show heft, something that's more than a chit in a hypothetical, submedial ledger. Why is Bitcoin necessarily skeuomorphic? Why must there be all these numismatic representations of something ready-made for the creative destruction of all those piles of gold coins, endless stacks of IOUs in vaults? If Wick used Bitcoin, writes one sensible subredditor, "at least he wouldn't have to bury [gold coins] in the floor of his house under fresh concrete."[3] As more than one viewer has observed, Wick isn't a gold bug—the point of the coins isn't their value as commodity metal. A coin is a ticket to access a different, illicit world. They're magic beans—one coin gets you a drink, a night at the Continental, an assassin babysitter, a tribute to a beggar, a corpse disposed of, a weapons arsenal, and so

on. Here's Chad Stahelski, the director: "We use them more as business cards. [They're for] access to the club. If you're worried what a coin costs [in terms of its gold], if you gotta ask the price . . . you shouldn't go eat at the restaurant. If you go to the hotel, a coin just symbolizes, *I'm in the know.* [It's] point of entry, it could be worth a meal, it could be worth a drink, . . . it's in flux. . . . You don't get change back."[4] That Wick-coins are tickets, or what some have called "magic beans," helps makes sense of their symbolic function in the films—that is, they are tokens for purchasing access to a seemingly ultrasecure illicit economy. The market for crypto has often been likened to similar markets for coupons, tickets, and other magic beans. There's even a cryptocurrency called beans. Some economists have likened the market for Bitcoin to a market for a different kind of tickets—namely, unused lottery tickets: "Just because the long-term value of bitcoin is more likely to be $100 than $100,000 does not necessarily mean that it definitely should be worth zero," one economist writes. "The right way to think about cryptocurrency coins is as lottery tickets that pay off in a dystopian future where they are used in rogue and failed states, or perhaps in countries where citizens have already lost all semblance of privacy."[5]

In fact, the arc in my title is backward—Bitcoin, Shitcoin, Wickcoin—as the order of the three sections of my essay starts with Wickcoin, wonders about Shitcoin, and wraps back to some more remarks about the general meaning of Bitcoin and blockchain. Of course— because reasons, to borrow internet slang—someone actually had to manufacture a tangible Bitcoin from solid brass as a kind of collector's item. The physical token precisely presents an inverted technical image of worthless, digitally forgotten paper money floating away from commodity money, an anchor in actual metal, dragging in the physical world of matter. "Each . . . collectible coin [says the advertising prospectus, is] backed by real Bitcoins embedded inside. Each piece has

its own Bitcoin address and a redeemable 'private key' on the inside, underneath the hologram."[6] Commodity metal is here little more than a ceremonial value-added container—a marker, a decoration, a bespoke costume, even, for encrypted hidden information about value. The manufacturer doesn't make them anymore to preserve a collector's aftermarket; they no longer need actual Bitcoins inside, as it were. Perhaps these oddly literal, physical instantiations of the virtual currency resemble the anachronistically totemic blood-debt markers more than the gold coins of the films: a marker is no small thing; it binds a soul to a blood oath. Palm-sized metal pieces that stand for blood oaths and John Wick's impossible task, for instance, have analogous structures as objects. A concealed button reveals authenticating debit and credit thumbprints in blood hidden inside, a redeemable "private key," linked to the information "registered and tracked by The Continental" in a leather-bound double-column account book kept by Winston. These markers are condensed, overly wrought redundancies from the history of money—Shitcoin, to adopt the jargon of Bitcoin; they indicate "the debt of a blood oath between two individuals." Opening the marker in the middle to reveal a divided surface, the debtor presses a bloody thumbprint on one side to commit to an oath that is owed, while the debtee likewise presses their bloody thumb to the other side to indicate when an oath has been fulfilled.

Would John Wick use blockchain?

Totally.

A secure, private, hidden ledger, not subject to the laws of any state, it's the perfect look for any hidden, cryptolibertarian assassin, working on the books, off the books, as it were. Under the table, over the High Table. A perfect unit of account and unit of exchange for a situation in which the contradiction between a desire for extreme anonymity (privacy of information) and the security of a peerless reputation ("I

am John Wick"—parole as control) is the operative paradox. This is the same meme-scape that Boris Groys describes as connected to a hidden phenomenology of the media:

> When we confront the media, we are constantly aware of the hidden presence of submedial space. Yet as mentioned before, we are structurally incapable of seeing through it as long as we are busy looking at the medial surface. Inevitably, this leads the media observer to suspect that a secretive manipulator dwells in the clandestineness of submedial space, a manipulator who, by means of the whole machinery of different media carriers and media channels, produces a level of signs on the medial surface for the sole purpose of concealing himself even more. The observer must experience this entire theater of signs as a dissimulation, a lie—a deceit completely regardless of whatever meaning the individual signs that compose this theater may have.[7]

"You can buy anything. You can't buy me." John Wick doesn't say this exactly. But his answer to the injunction of the market in *John Wick* (that, in effect, "everything has a price, bitch") keeps strictly with the compulsory ("voluntary or coercive") sincerity of a situation in which suspicion is the rule. "Not this bitch" is Wick's implied answer.[8] Wick's refusal to sell his car—his refusal to serve the absolute master, which is the market—in the sense that it takes a toll, it exacts a cost, belies his principle. Not freedom from exchange per se, but that Wick presents the constitutive exception. *Fortis Fortuna Adiuvat*, reads his tattoo. The one who boldly breaks the law founds a new law, a new Wickonomy—this is the sense of the ending of *John Wick: Chapter 2*, I believe, when Wick kills Santino D'Antonio inside the Continental, and *John Wick: Chapter 3—Parabellum*, when he expresses fealty to submedial space that "will serve" and "will be of service." Performative subservience is the point. As Winston puts it, "You dip so much as a pinky back into this pond,

you may well find something reaches out and drags you back into its depths." Rules—without them we live with the animals. But, living with the animals—isn't that exactly Wick's kind of thing?

The rules of the Wickonomy can be contextualized in terms of the cultural logic of the post-2008 financial crisis, or the crisis of criteria, of assured measurements, backed by the state, that followed. In particular, we might connect the strange economic mystifications of this world (the High Table, the Continental, Gold Markers, etc.) to the emergence of massively decentralized distributed databases and value instruments such as Bitcoin and Ethereum and their attendant, acutely libertarian ideologies meant to pay off in a dystopian future. To quote from Reddit again: "A coin used solely for assassination markets. Great. Isn't that bitcoin's endgame?"[9] If one of the durable conceptual problems of cryptocurrency (some would say its advantages) is its decentralized immutability and protean metaphoricity, this very quality defines the platform, infrastructure, and resource usage for Wick and the fantasy universe he inhabits.

In a *Forbes* think piece, the economist Adam Ozimek describes the role of the Continental as the guarantor for freelancers in the assassin service economy. The service provides security in a sense similar to "fairs and other events where they sell you tickets [to] use instead of cash."[10] In this sense, the ersatz tailors, sommeliers, and mapmakers in *John Wick 2* serve as vendors. There are two incentives for such a system, Ozimek writes:

> One, is to make it easier to tax revenues. Venders are charged a share
> of revenues as a fee. If the operator lets venders sell their items in cash,
> they have to trust that the vender is not underreporting how much
> they sold to reduce their tax. And let's be real folks, you can't trust
> carnies. [Or, assassins.] If the operator uses tickets instead, then in

order to actually get paid for their sales the venders have to turn in the tickets and the operator gives them cash. This gives them incentives to truthfully reveal the full amount of sales and ensures the operator doesn't get ripped off.[11]

This analysis makes some sense of the Wickonomy "if the Continental is taxing a share of revenues for all services."[12] "The second incentive for this type of system," writes Ozimek, "is that when customers buy tickets, some of them won't be spent. Instead, some fair customers will go home with tickets in their pockets, which is free money for the operator who sold the tickets, or in the John Wick case, minted the coin."[13] Fair enough, Wickcoins are tickets, but even in a ticket-coupon economy there should necessarily be an aftermarket. Where is the Stubhub for Wickcoins in the Wickverse? If a price is put on Wick's head at the assassin switching station for 2 million in Shitcoin (7 million? 12 million? exclusive? open?), how can that be converted to or paid out in Wickcoin?

In his analysis, the blogger Sonny Bunch notes the principle that "a price is a signal wrapped up in an incentive," observing that it's axiomatic in the Wickverse that there's "no dollar-to-gold-coin conversion rate": the "price-per-item for goods and services in The Continental [is] uniform: a coin for a drink, a coin for a gun, a coin for a favor, etc."[14] What then are the signals and incentives in the Wickonomy? "It seems clear," he writes, "that Winston has used his prices to incentivize hit men into using The Continental as little more than a way station. By pricing a cocktail and carbine at similar levels, Winston is making it far too expensive for the average assassin to use The Continental—with its rules against murder and such—as a permanent safe house. The relative cheapness of guns combined with their impotence onsite means that murderers are incentivized to go elsewhere, to pick up contracts and be on their way."[15] The figure of security from risk gives up the game, in

my view; it shows what makes Wick exceptionally singular. John Wick's extreme violation of one of the two inviolate rules, the murder of Santino on the premises of the Continental, is, as Bunch puts it, an explicit repudiation of this signal—the capacity of the platform to guarantee security. When Santino gets whacked by Wick, it may cost Wick access to the platform and its services, but it also prices him out of the system as total negation, persona non grata, signaling not that Wick is "priceless," as Bunch argues, but that his value cannot be floated by any marker, past, present, and future. He's the wreck of the system. Wick is nobody's bitch, bitch. The Continental is a platform, a cinematic instantiation of blockchain itself and its attendant fantasies about payoffs in a ruined future, and Wick is the bitch of the system. Berrada learns this, too.

Whether or not blockchain is in fact "the next everything" is probably best left to our future robotic overlords. Understanding it requires bold Wick-like alpha-numerical panglossia, hermeneutic mastery of all semiotic codes, Russian, Italian, Yiddish, and sign languages. Peerless feats of bookkeeping. Remember, Wick killed someone with a pencil. Here, the totemic supremacy of Wick's pencil for ordering the Wickverse should be underscored: the pencil is not as instrument of writing (the narrative of Wick's life) but a bookkeeper's stylus (recording debits and credits).

Stephen J. Williams's *Blockchain: The Next Everything* (2019), the book attached to a philosophically vacuous title, is—to this meek, human reader, at least—a dreary casserole of logical fallacies, outlandish claims, and unsummarizable discourse.[16] Equal parts techno-solutionist propaganda piece, indoctrination gospel for the next big tech revolution, and self-help pamphlet for data survival after the extinction event, *Blockchain: The Next Everything* comes leveraged in an untestable future tense, loaded with aspirational bullet-pointery and modal verbs (could, should, would, might), and abundant dead space padding out

every third page. It reads like the *Onion* send-up of a tech influencer drunk on memes, crypto, and cyberlibertarianism, served with a chaser of Death-by-PowerPoint.

The ideology of cyberlibertarianism, as David Golumbia puts it, "can be thought of as something like a belief according to which freedom will emerge inherently from the increasing development of digital technology, and therefore entails that efforts to interfere with or regulate that development must be antithetical to freedom—although what 'freedom' means in this context is much less clear than it may seem."[17] It resonates with the so-called California ideology: "The presumption that computer-based expertise trumps that of all other forms of expertise, sometimes because everything in the world is ultimately reducible to computational processes."[18] Relatedly, blockchain propaganda mobilizes a rich vein of deeply held tropes of extreme right-wing paranoia about money, markets, pricing, and value:

> That central banking such as that practiced by the U.S. Federal Reserve is a deliberate plot to "steal value" from the people to whom it actually belongs; that the world monetary system is on the verge of imminent collapse due to central banking policies, especially fractional reserve banking; that "hard" currencies such as gold provide meaningful protection against that purported collapse; that inflation is a plot to steal money from the masses and hand it over to a shadowy cabal of "elites" who operate behind the scenes; and more generally that the governmental and corporate leaders and wealthy individuals we all know are "controlled" by those same "elites."[19]

Make no mistake: *Blockchain: The Next Everything* is a brochure for something huge—something bigger than the High Table—that its author can never quite get a hold of but nevertheless badly desires to peddle. Know your merchandise. If there only were something to

sell—some miracle widget, a particular panacea, a branded patent medicine, a pill-pack of magic beans—it would be easier going on all of us. No mere huckster of cryptocurrency (he does hold some, he discloses), Williams proceeds with all the glib solemnity of a seasoned TED talker to demand a hard system reboot of everything (i.e., modern society) around the underlying technical specs first developed for Bitcoin.

I can recommend two books on blockchain that do more than fluffery: Golumbia's *Politics of Bitcoin: Software as Right-Wing Extremism* (2016) and David Gerard's *Attack of the 50 Foot Blockchain: Bitcoin, Blockchain, Ethereum, and Smart Contracts* (2017). Bitcoin and blockchain are different animals. Bitcoin is crypto, the front end; blockchain is the back end, the massively decentralized, distributed database. Crypto runs on blockchain, but so might other things: deeds and contracts, branded goods, markets for authentic antiques, Harry Potter first editions, bespoke body armor, exchanges for fairly sourced artisanal rare earths, the next eBay, the next Facebook, the next Amazon, the next internet, the next pigeon-based surveillance system. A ginormous, uncrackable transaction ledger of automatically protected digital information, secured by difficult, electricity-sucking computational problems, blockchain is as blockchain does, distributing itself among its constituent participants, secured by their consent to transact on the ledger, accessible to them separately only with complexly encrypted passkeys.

The conceptual origins of both crypto and blockchain are suitably shrouded in mystery. In a mysterious white paper from 2008, on or about the banking crisis of that same year, the enigmatic Satoshi Nakamoto proposed "a new electronic cash system that's fully peer-to-peer, with no trusted third party."[20] John Wick *is* Satoshi Nakamoto, according to one subredditor. Or is it the other way round? asks another. Seemingly, the world (not least the world of pseudonymous dealers in assassination and illicit drugs and ransomware criminals) had been waiting for one weird

trick, a secure technological means of stateless, automated data processing without "useless filthy fiat" money. Sketchy, antisocial, and pseudonymous, blockchain promises to obviate everything that depends on assurance from trusted third parties: banks, contracts, corporations, governments, nation-states, universities, and so on. Store your GPA on blockchain. Let's say rebooting everything is a good idea; why would blockchain be the preferred means of doing so?

One answer is modernity's rolling legitimacy crisis of trust itself— and the declining idea of the state (or other artificial gods, for that matter) to serve as its ultimate institutional guarantor. If anything, the internet has accelerated this decline. Alleged benefits of blockchain, according to its advocates, include a distributive, peer-to-peer digital means of ensuring security, privacy, and secure access to public utilities, health care, and other shared goods such as museums, public bathrooms, credit, insurance, identity documents, and so forth. Because blockchain promises a technical means of cutting out risky middlemen, first from currency and then from all things, it depends on a certain sleight of hand, consonant with the California ideology, by which the technical complexity of coding presents a more efficient replacement than various more cumbersome means of performing fictions of human trust. Trust, after all, involves a sequence of past-present-future risk operations that can only be confirmed retroactively. A ledger without a ledger-keeper. Did my payment go through? Money may mystify social relations, but blockchain mystifies them at a scale no one human can comprehend.

Part of the problem with blockchain—indeed, with less sophisticated ledger systems, the marker is no small thing—is the challenge it presents to conventional symbolic form. The sheer number of analogies and metaphors spinning off blockchain is both hard to track and symptomatic. Williams alone supplies too many to count. Blockchain, he says, is like a permanent, unhackable ledger, constellations of the

night sky, photographs of smoke, snowflakes in rural Vermont, large sailing ships uncomprehendible by pre-Columbian civilizations, a totally inclusive beach vacation/orgy, a hypothetical self-driving future car shaped like a three-sided onigiri, a school of fish, a thumbprint, the Milky Way, the blueprint for the new economy, a forest, and so forth. Daniel Drescher's book, *Blockchain: A Nontechnical Introduction in 25 Steps* (2017), even utilizes blockchain's multiplicity as an organizing premise: twenty-five steps, twenty-five "real world" metaphors. Do you have a mobile phone? Have you ever bought a car? Can you remember the last time you bought a CD for yourself in a music store or in a department store? Does the problem of trying to organize a group of individuals who do not accept or recognize authority sound familiar? And so forth. The blockchain hash may be, as Williams claims, the "symbol of our new reality," but here sixty-four characters that comprise it are precisely not symbolism but encryption—given not for human interpretation, letters, and reading but for quantification, numbers, and computation.[21]

In the fifth season of *Silicon Valley*, the plucky tech entrepreneurs from Pied Piper explore funding their start-up with an ICO (initial coin offering).[22] For advice, two of the show's principal characters, Richard Hendricks and Bertram Gilfoyle, seek out the bombastic, billionaire venture capitalist Russ Hanneman, who has put his fortune into crypto. They finally find him supervising a dozen day laborers in an enormous landfill. Hanneman explains that he converted all his thirty-six companies into ICOs, all but one of which failed ("One of them got shut down by the SEC, on a few we got scammed, but some of them worked, one of them worked"). The one that worked ("Up 3000% in the last two weeks") would "cover all the losers," but a housekeeper accidently threw out a thumb drive with the passkey. "300 million in Crypto is buried out here somewhere," he says, as heavy equipment scrapes away fecklessly

in the distance and the workers in the foreground in surgical gloves and masks rummage around in the filth with seagulls circling overhead. Suddenly, a worker finds not a thumb drive but an actual severed thumb, and Hanneman gets momentarily excited. It doesn't belong to John Wick, I should add. What makes this set piece perfect for this context is its reductio ad absurdum of the landscape of innovation into a real-life heap of bullshit jobs, menial labor, dead labor, and the ecological dead zone symbolized by the landfill. The ironic aperçu: if only the billionaire had one working passkey—a marker that binds a soul to a blood oath—he wouldn't need to exploit these workers. It is a commonplace that the wasted energy behind Bitcoin, blockchain, and the rest of it exceeds that of a small developed country. Blockchain promises a more efficient and secure way to process toxic information for a canceled future with a ruinous horizon. The heap isn't nature or culture; it's a total, totaled, and totalized wasteland. The hidden ledgers of value and trust—in so many words, the hidden archive of the present—can no longer be processed at human scales. They can't even be represented. They are the bitch of the system.

There's a hidden phenomenology in play in *John Wick*. It resembles something like crypto, but this resemblance isn't an aesthetic form for narrative per se. One reviewer describes the narrative form as approximating a tweet: "Keanu Reeves plays a killer. His wife dies of cancer. Thugs steal his 1969 Mustang and kill his puppy. He gets mad. People die, badly."[23] Just clearing the old bar for length, this tweet-synopsis nonetheless doesn't scale right for the scope of the cinematic action. The newer, 280-character buffer would provide more leeway, I guess: *Out to avenge a murdered puppy (departing gift from dying wife) and recover his stolen classic car from the Russian Mob, unretired contract killer Keanu*

dispatches all enemies from the underground underworld with extreme effi-ciency. Envision the first tweet as an exposition card for a silent film, nec-essary background for a fully visual meme-scape. Keanu kills everyone because of . . . a car, a dog, a technological memory of his wife. Think of the second as the obligatory text crawl, perfunctorily establishing info about replicants and retirements, rendered as a pass-phrase. Hitman Slick Wick is back to work, hunting down mobbed-up puppy-killers.

John Wick.

Because.

Reasons.

Yeah.

Comparing *John Wick* to a tweet underscores something crucial about the way the film revolves around hidden phenomenology, giving technical form to hiding information in plain sight. Squeezing story-thoughts into ersatz compression algorithms, simple, repeatable pass-phrases and protocols, miniaturizes causality into little more than a knowing wink exchanged between producers and consumers, between movie viewers and on-screen characters, between the essential and the sacrificial workers. *Because. He once killed someone with a pencil.* If the plot of *John Wick* is akin to an all-but-superfluous burst of alpha-numer-als, bandied about as texts on networked markets, the effect depends on extreme sports of metonymic compression. In this hitman revenge tale, in other words, we have a legendary killer ("the man, the myth, the legend"), who hung it all up for a woman whom he lost to illness (whose image is found displayed on a smartphone and gets stashed with other valuables in safety deposit boxes and libraries), motivated by puppy murder and theft of his vintage vehicle. Establishing info can't be deliv-ered quickly enough; it outstrips or is out of phase with the narrative. The basic, pared-to-the-bone story-beat compounds wins and losses, as

Mr. Wick cuts his way through all the tracksuits and bespoke suits in Gotham as payback increases for enumerated reasons.

Keanu Reeves is, in a sense, the perfect man from central casting for this kind of role. His appeal has always been as an archival vehicle—or, to borrow a relevant phrase from William Gibson, as "a very technical boy" (also the subtitle to his *Johnny Mnemonic* screenplay). Decades' worth of jokes about pitch meetings bear this out. One goes as follows:

PITCH MEETING FOR JOHN WICK.

"So there's this guy that's really good at killing people, and he goes around killing bad guys."

"OK. But why?"

"I dunno. They killed his dog?"

"Fine. Who are the bad guys?"

"Some real bad guys. Russians?"

"OK. But John Wick needs to be someone that looks like he's exhausted from a life of tragedy."

"Keanu Reeves?"

"Get it made."[24]

Here's the basic formula from twenty-five years ago: "These days, the joke goes, one adds 'in cyberspace' and 'Keanu Reeves' . . . to a classic film and the deal is done: 'DOA—in cyberspace—with Keanu' (Johnny Mnemonic)."[25] The premise draws on a certain generic, blank quality to Keanu's affect and his acting. Once, his void quality was connected to the emergent impossibilities of cyberspace (as it was then known); now, it is linked to impossible meme-magic. The common denominator is a certain plug-and-play technicity—call it submedial melancholy—to his quasi-vacancy. What's more, the movie pitch, as opposed to the mere summary or bare synopsis supplied by a movie reviewer or a spoiler,

may be the shape of the most minimal, technically functional version of cinematic form. The functionality depends on an implied commercial transaction—the bid to get financial backing, spread risk, build trust, and gain support from producers. *Because* + Keanu = Yeah. The deployment of Keanu will get it made.

This program was already clear in *Johnny Mnemonic* (1995), that classic of the Keanu canon adapted from the cyberpunk story by William Gibson. Does Johnny Mnemonic Keanu occupy the same universe as John Wick Keanu? Indeed, one fan theory has all the Keanus living inside the same matrix, as a sequence of programs, as it were.[26] Johnny Mnemonic Keanu is the eponymous data courier, trafficking a stolen payload in a portion of his brain technically altered for this express purpose. The premise stands on what seem now like very old ideas about info storage from a time when archiving a single hard copy somewhere specific mattered a whole lot more than it does now. Johnny brokers a fixed portion of his brain—including knowledge of his last name, his childhood, images of birthday cakes, and his mother—to become an efficient container for industrial espionage. If the briefcase is the unsung hero of Hollywood cinema, in *Johnny Mnemonic* that briefcase is Keanu's dome. His brain is effectively an archival carrier, a volatile floppy disk made flesh, accessible via an audio-jack-style port concealed behind the ear. The retro-refit of the new in the old is, of course, an aesthetic developed by the source material, where Johnny packs a "shotgun in an Adidas bag and pad[s] it out with four pairs of tennis socks": "If they think you're crude, go technical; if they think you're technical, go crude. . . . These days, though, you have to be pretty technical before you can even aspire to crudeness. . . . I'd had to dig up an old microfiche with instructions for hand-loading cartridges."[27] As Vilém Flusser has observed, this kind of kit-bashing underscores "the penetration of inhuman orders of magnitude into concrete everyday life," betraying the breakdown of

humanist capacities for measurement: "We are somewhere in the interior of a *matrjoschka* (Russian doll), a hierarchy of orders of magnitude in which each contains all smaller ones while being contained by all bigger ones."[28] The carrier of the archive, the penetralium of Keanu's head, hides a kind of commodious ledger book. You can stash important data in it—a passkey for three hundred million in crypto, for instance—and can subsequently download them back again.

Reviews of *John Wick* films repeatedly underscore not mimetic overload but methectic efficiency—that is, clear or transparently obvious relationships between a particular and a larger form—a point connected to the supposed (and, I hasten to add, incorrectly remembered) linearity of plot and concomitant lack of complexity of meaning. Examples are readily multiplied. Like blockchain, in this sense, the review summaries designate (rather than signify) sequences of inexorable events. The 1-simplex in geometry describes a distinct and distinctive line—so too, as one reviewer notes, "The movie's simple plot and bloody action scenes, which include more head shots than a casting director's portfolio, leave little room for complexity, and there's a lack of tension in the clichéd setups."[29] This connection gets interpreted in various ways, if *interpreted* is the correct word here. In one case, linearity suggests a lineup of "head shots [from] a casting director's portfolio," paralleling the progression of minor characters dispatched with perfunctory head shots.[30] In a related vein, this critique evokes comparisons with kills in a video game, with another review observing that *John Wick* proceeds "like a shoot-'em-up computer game, . . . in which there are no characters, only targets with varying scores."[31] In this regard, reviewers hostile to the *Wick* franchise frequently identify the nontrivial resemblance between *John Wick* and the NPC shooter game, both the film and this game genre interspersing occasional cut-scenes with a kind of automatic and repetitive violence: "Reeves has only a few lines of dialogue, which

he delivers in his usual monotone, and the film gradually sinks into video-game carnage."[32] Additionally, reviews tie the film's putative linearity to its dance-like choreography—for instance, "John is required to pulverize a veritable conga line of attackers." Another reviewer connects this explicitly to the repetitive work binding assassins and stunt workers in terms of performance craft. For both, "story is a lot less important than those fight sequences. But early on, smart, funny scenes attempt to answer questions other action movies don't address. For example: How do our invincible heroes navigate car chases so ably? In this case, we see John Wick practicing his skills amid obstacles in a parking lot."[33] In a sense, the idea of *John Wick* is a paean to the ultimate guild of essential workers, those employed in lines. This even extends in one comparison to the labors of restaurant workers: "The dust-ups are the film's main course and the directors know it, serving them up at steady intervals with narrative amuse-bouches passed out in the lulls. And bite-sized the story most certainly is, existing solely to set Wick in motion, then keep the corpses coming."[34]

From the restaurant, it's no great stretch to move over to the bar, considering the burn rate of supporting cast as amiable if well-oiled regulars lined up for service: "The Continental—a hitmen-only hotel that acts as a kind of homicidal Cheers bar. Gaffer in residence is a delightfully camp Ian McShane, one of several blink-and-you'll-miss-them pop-ups alongside Lance Reddick, John Leguizamo, and Clarke Peters."[35] In all these cases, disposable labor seems very much on the nose. The meaning of *John Wick* is understood in terms of a well-defined formal simplicity: exhibiting service production processes "basic to the point of brainless" that somehow elude all robots and automation for this very reason.[36] Who else but the sushi MasterChef, the wizard with knives, could be Wick's greatest fan? Yet, to call these observations interpretations (in the sense of divulging a secret meaning) of *John Wick*

misconstrues how the Wickverse works not as an invitation to exegesis but as a submedial safe room for a kind of inhuman, algorithmically constituted playscape of mise en abyme. Just as blockchain uses a secure sequence of events to hide and obscure identity and value, going deeper into the worlds of John Wick makes no sense except in terms of occult fealty to this sacrificial apparatus.

Notes

1. Helloluis, "John Wick would totally use Bitcoin, right?," Reddit, June 15, 2020 (July 9, 2019), https://www.reddit.com/r/Bitcoin/comments/cb28yj/john_wick _would_totally_use_bitcoin_right.

2. See "Physical Bitcoins by Casascius," Casascius, June 15, 2020, https:// en.bitocin.it/wiki/Casascius_physical_bitcoins.

3. Gld6000, comment, "John Wick would totally use Bitcoin, right?" *Reddit*, June 15, 2020 (July 9, 2019), https://www.reddit.com/r/Bitcoin/comments/cb28yj/john _wick_would_totally_use_bitcoin_right/.

4. Chad Stahelski, quoted in Screen Junkies, "Honest Reactions: John Wick Directors React to the Honest Trailer!," YouTube, February 16, 2017, https://www .youtube.com/watch?v=3DNQJE8eHjw&feature=youtu.be&t=1017.

5. Kenneth Rogoff, "Cryptocurrencies Are Like Lottery Tickets That Might Pay Off in Future," *Guardian*, December 10, 2018, https://www.theguardian.com/business /2018/dec/10/cryptocurrencies-bitcoin-kenneth-rogoff.

6. "Physical Bitcoins by Casascius."

7. Boris Groys, *Under Suspicion: A Phenomenology of Media* (New York: Columbia University Press, 2010), 36.

8. Groys, *Under Suspicion*, 13.

9. Mbrochh, comment, "John Wick would totally use Bitcoin, right?" Reddit, June 13, 2020 (July 9, 2019), https://www.reddit.com/r/Bitcoin/comments/cb28yj/john _wick_would_totally_use_bitcoin_right/.

10. Adam Ozimek, "Understanding the John Wick Economy," *Forbes*, April 9, 2017, https://www.forbes.com/sites/modeledbehavior/2017/04/09/understanding-the -john-wick-economy/#65c14f4d70ed.

11. Ozimek, "Understanding."

12. Ozimek, "Understanding."

13. Ozimek, "Understanding."

14. Sonny Bunch, "Gold Coins, Million-Dollar Contracts and the John Wick Economy," *Washington Post*, April 15, 2017, https://www.washingtonpost.com/news /act-four/wp/2017/02/15/gold-coins-million-dollar-contracts-and-the-john-wick -economy/.

15. Bunch, "Gold Coins."

16. Stephen J. Williams, *Blockchain: The Next Everything* (New York: Scribner, 2019).

17. Williams, *Blockchain*, 15.

18. Williams, *Blockchain*, 55.

19. Williams, *Blockchain*, 13.

20. Satoshi Nakamoto, "Bitcoin P2P e-cash paper," Cryptography Mailing List, October 10, 2008, https://satoshi.nakamotoinstitute.org/emails/cryptography/1 /#selection-5.0-5.25.

21. Williams, *Blockchain*, 39.

22. *Silicon Valley*, season 5, episode 7, "Initial Coin Offering," directed by Mike Judge, aired May 6, 2018, on HBO.

23. Peter Travers, "John Wick: Keanu Reeves Goes Ballistic in This Bloody Bit of B-Movie Fun," *Rolling Stone*, October 24, 2014, https://www.rollingstone.com /movies/movie-reviews/john-wick-95572/.

24. Geoff Stone, "Pitch meeting for John Wick," *Facebook*, July 1, 2019, https:// www.facebook.com/246457042638614/posts/pitch-meeting-for-john-wickso-theres -this-guy-thats-really-good-at-killing-peopl/402594333691550/.

25. J. D. Connor, review of *Rhetoric, Sophistry, Pragmatism*, ed. Steven Mailloux, *MLN* 110, no. 4 (1995): 979.

26. BitchesGetStiches, "John Wick is a prequel to The Matrix," Reddit, June 15, 2017, https://www.reddit.com/r/FanTheories/comments/6hjku7/john_wick_is_a _prequel_to_the_matrix/.

27. William Gibson, "Johnny Mnemonic," in *Burning Chrome* (New York: Arbor House, 1986), 1.

28. Vilém Flusser, "Orders of Magnitude and Humanism," in *Writings* (Minneapolis: University of Minnesota Press, 2002), 161.

29. Bruce Diones, "John Wick," *New Yorker*, https://www.newyorker.com/goings -on-about-town/movies/john-wick-2.

30. Diones, "John Wick."

31. Jonathan Romney, "John Wick Review: An Almost Zen-Like Exercise in Wholesale Slaughter," *Guardian*, April 12, 2015, https://www.theguardian.com/film /2015/apr/12/john-wick-observer-film-review-keanu-reeves.

32. Diones, "John Wick."

33. Stephanie Merry, "John Wick Takes His Licks," *Washington Post*, October 23, 2014, https://www.washingtonpost.com/goingoutguide/movies/john-wick-movie -review-keanu-reeves-takes-his-licks/2014/10/23/593c128c-59f0-11e4-bd61 -346aee66ba29_story.html.

34. James Dyer, "John Wick Review," *Empire*, March 23, 2015, https://www .empireonline.com/movies/reviews/john-wick-review/.

35. Travers, "John Wick."

36. Christy Lemire, "John Wick," RogerEbert.com, October 24, 2014, https:// www.rogerebert.com/reviews/john-wick-2014.

AARON JAFFE is Frances Cushing Ervin Professor of American Literature at Florida State University. His books include *The Way Things Go: An Essay on the Matter of Second Modernism* (2014), *Spoiler Alert: A Critical Guide* (2019), and the coedited collection *Understanding Vilém Flusser, Understanding Modernism* (2021). With Edward P. Dallis-Comentale, he edits the series The Year's Work: Studies in Fan Culture and Cultural Theory.

PART III
JOHN WICK: *OTHER CULTURAL FORMS AND GENRES*

FORTUNE FAVORS THE BOLD 6

THE STATE OF GAMES AND PLAY IN THE JOHN WICK *FILMS*

EDWARD P. DALLIS-COMENTALE

When, toward the end of *John Wick*, Russian mob boss Viggo Tarasov (Michael Nyqvist) turns to Marcus (Willem Dafoe) and says, "Well played, old friend," he makes clear what has been implied throughout the film—namely, that the world and action of the *John Wick* franchise largely take the form of an elaborate and compelling game. As many of the films' initial reviewers noted, a large part of the trilogy's appeal is due to its depiction of the intricately rule-bound nature of the assassin underground—specifically, a set of rigidly enforced restrictions and constraints, the skillful navigation of which, often in direct gladiatorial or competitive format, determines success or failure for Wick and his associates.[1] In fact, more than a complex mythology or a captivating feat of world-building, the structured activity of the underground, in which men are "pawns" ruled by an aptly named "High Table," bears all of the characteristics of games and play first delineated by cultural historians such as Johann Huizinga in his landmark 1938 study *Homo Ludens: A Study of the Play Element of Culture* and Roger Caillois in *Man, Play, and Games* (2001).[2] This essay explores how the world of John Wick mediates certain "idealist" traditions of play and games, most notably from Greek and Roman culture, and thus offers a model for understanding what Caillois regards as their modern "corruption." Specifically, in looking closely at how Wick and his associates play, the following discussion tracks how a modern economy built on rationalized exchange and debt

empties play and games of their crucial critical components and allows their empty structures to proliferate, endlessly and bureaucratically, across society at large.

I want to begin with the five defining principles of Huizinga's specifically modern theory of play, the historical nature of which is explored in the second half of the chapter. First, true play must be voluntary, entered freely by all participants. It cannot be coerced by others or driven by external need, for then it threatens to become little more than a chore. In theory, at least, Wick and his colleagues have chosen to participate in the world of the High Table and submit willingly to its intricate rules. Their relationships are decisively "contractual," as Berrada (Jerome Flynn) makes clear in *John Wick 3*, and thus bound to its "order and rules." They choose whether to take on the various competitive contracts offered by the High Table and broadcast worldwide through its intricate communications system. Their motives and means for killing are set by the game itself, and indeed, they advance in this system by nothing other than their allegiance to the game and the various high-level pleasures it might afford.

Second, play in Huizinga's account is neither ordinary nor real but decisively separate from everyday life; one's identity and actions at play remain distinct from what is projected in the real world. Similarly, Wick and his associates inhabit an alternate reality, one in which their decisions and actions have little bearing outside of their carefully controlled arena. They adopt new names and identities as well as distinct costumes in their work, and their exchanges occur with alternative forms of currency and communication. Even their bullets seem to have zero effect on anyone outside their field of play. All of this suggests that their "field of play" exists as a world distinct from the larger world and that what occurs in the former is meaningful and possible in its distinction from the latter.

Third, for Huizinga, play is disinterested or purposeless; nothing real is exchanged or earned during the game, and, at the end, all players return to their original state. In turn, any value generated by the game exists only within the space and time of the game. Similarly, in Wick's world, all losses and gains make sense only in relation to the world in which they take place. All transactions occur through a self-contained symbolic economy, and, as in, say, a game of Monopoly, players are rewarded in coins that seem to have no value in everyday life. Wick, in fact, burns all the currency and assets he finds at the Manhattan church, and his journey results in no clear material gain. Rather, the value of this play, its ability to generate new heroic capacities and skills, outsized reputations, and powerful allegiances, resides in its freedom from common, everyday values and the drudge-like means of attaining them.

So, fourth, for Huizinga, play must be limited in time and space, carefully separated from everyday life, its rules fixed and codified within clearly marked boundaries. Wick's world, too, has its boundaries, with the Continental serving as something like a home base and contracts being released at specific times and specific places. Such boundaries are carefully policed, with players incurring huge penalties—sometimes even death—for any breaches, penalties determined by impartial judges or "adjudicators" who assess the nature and severity of such breaches.

Finally, fifth, given its sometimes complicated rules and unique pleasures, play often occasions the formation of distinct communities and small secret societies for which such play is their sole reason for being. In this, we merely need to refer to the secret society of assassins and its competing factions as well as the fact that it exists as a self-perpetuating network with no apparent purpose other than to sustain itself, its history, and its various rules.

Certainly, for Huizinga and subsequent theorists of play, it is precisely these limitations on the world of play—restrictions that tend to

focus this world and render it, like a specimen on a microscopic slide, susceptible to careful, even obsessive, scrutiny—that make it so absorbing, exciting, and at times serious and dire. In its enforced detachment from everyday life, play is neither frivolous nor silly but profoundly "aesthetic" and deeply "ethical"; apart from life, it becomes a necessary adornment of life, at once interpreting, amplifying, and augmenting the human situation in transcendent ways. Play stands outside everyday life and its immediate wants, Huizinga proclaims, and thus becomes "something added thereto and spread out over [life] like a flowering, an ornament, a garment" (3, 7).

The *Wick* films are a clear demonstration of this capacity, as they everywhere tout the ideals of play and confirm, for both players and spectators, the absorbing seriousness of the play space. If play entails rules and order, for instance, it does so in a way that generates uncertainty and excitement. Its rules work to raise the stakes and increase tension, either between the player and the game or between players or teams who are deemed equal. The world of John Wick is absorbing in the same way that all play is absorbing, insofar as it allows us to watch someone navigate and ultimately overcome, heroically, an otherwise closed and challenging system. Relatedly, while separate from life, play focuses and amplifies some of life's basic skills, privileging some talents over others. The limited and clear order of play is one in which very specific abilities may be tested, cultivated, and displayed—physical strength, mental prowess, encyclopedic knowledge, and so on. These attributes might be wondrous in themselves, but they are also engines of progress and innovation for both the individual player and society at large, and they are magnets for often grander ideals regarding, say, a people, region, or nation. In this register, John Wick is a pro, a master of his craft, a charismatic figure of advanced, near-superhuman skill and technique in multiple forms of combat, and he is celebrated as a man of

"focus, commitment, and sheer fucking will" not just by the film's vast global audience but within the world of the film itself.

Moreover, the world of play is a world of ceaseless innovation. The rules of play often rearrange or remake the everyday world in more dynamic ways, while the work of the player often involves a dynamic reimagining of everyday life and its objects. The world of the High Table is no doubt one of surrealistic reimagination, a massive *retournement* of the everyday in which firearm purchases are equivalent to wine selection and tactical protection is a matter of high fashion. Similarly, Wick is nowhere more fascinating than in his momentous reinvention of everyday objects undertaken in the course of his work. His stunning redeployment of familiar things—guns, cars, a pencil, a library book, horses, the limbs of other bodies—reflects the playful reimagining of everyday modernity evidenced in the early work of slapstick artists Charlie Chaplin and Buster Keaton, who are both referenced throughout the trilogy.[3]

Given these crucial critical elements of play—its besting of obstacles, its focusing of human capacities, its imaginative reworking of the everyday—it's not surprising how theorists of play rhapsodize about its value and significance. For Huizinga, play is nothing less than the "influx of mind breaking down the absolute determinism of the cosmos," a suprabiological force of freedom and progress, and thus the very origin and impetus of culture itself (3, 46). But why, if Huizinga is right about this, does play in the *John Wick* films seem so terrible—at once compulsive, brutal, and dehumanizing? In fact, the films depict many different kinds of play, which I outline in a bit, but these are each presented in a somewhat perverse or corrupted form, as if twisted by other powerful forces and incapable of producing any of play's genuine pleasures or values. Here, another theorist, Roger Caillois, in his influential study *Man, Play, and Games*, offers some insight in his account of the specifically modern corruption of play. For Caillois, the well-bounded time

and space of play is always under threat; it can be easily broached or dissolved, so that the activity and effects of the game are no longer distinct from everyday life or identity. Similarly, in the world of *John Wick*, it is not always clear if we are in play or not, and this crisis seems typical of all modern play.

First and foremost, play can be corrupted when players are not free to play according to their own volition. One of the most important aspects of the films' plotting concerns the ways in which Wick's private world is disrupted by the world of the High Table and, in turn, his participation in the world of the High Table is complicated by his personal needs. His momentous return to the field of play appears thoroughly vexed by internal motives—his wife, his car, his dog, and so on—as well as by external forces. Thus, when Winston asks him in *John Wick* if he's "returned to the fold," Wick hesitates in response. His friend and mentor warns, "You got out once. You dip so much as a pinky back into this pond . . . you may well find something reaches out and drags you back into its depths." John's glib response, "It's personal," gives the lie to any ideal notion of "free play." But Wick is one of many characters for whom playing is not simply a choice but coerced in some way or shaped by impure motives, whether greed (Iosef), personal loyalty (Marcus), vengeance (Cassian), indebtedness (the Director), guilt (Sofia), or arrogance (Zero). In this way, the world of the High Table expands infinitely throughout the trilogy beyond its designated spaces and times, incorporating more and more of the population from which it initially seemed distinct. In fact, much of the films' plotting concerns the efforts of Winston and his colleagues to secure the boundaries of play, an apparently futile effort that also ultimately compromises their own relation to the rules of play and necessitates the work of further enforcers. In this regard, the Adjudicator becomes one of the trilogy's most important and interesting characters, a supposedly impartial or neutral

manager of the playscape's boundaries, whose very neutrality is also, in turn, always up for debate.

But such dangers seem constitutive to the active structures and simulations of play itself. Play is easily, and perhaps always, compromised by personal motivations that hide within and behind the impersonality of its seemingly inviolable rules. Arguably, all plotting in the Wick franchise is set in motion by singular abuses of the High Table's carefully constructed rules of honor. Iosef, Santino, Ms. Perkins—all exploit the rules designed to curb their motivated behavior, using the former to advance and mask generally sinister motives. But the so-called good guys, too—Marcus, Winston, and the Bowery King—hide personal commitments and moral agendas behind seemingly impersonal codes, and they are similarly punished in turn. Indeed, as suggested, Wick's own moves within the game are anything but pure, and despite his nicknames, tattoos, and costuming, he cannot maintain a clear distinction between himself as a player and the role that he plays. Perhaps the immersive nature of such play, which everywhere borrows the trappings and structures of everyday life (suits, hotels, pets, and so on), entails this loss of boundaries, but Wick also uses the game's terms to mask, excuse, and extend a decisively personal agenda, and his manic activity across the arena at once enflames and complicates the play of all his associates. In other words, if Wick appears at times as the savior of the High Table, aimed at restoring its purity from the likes of Iosef and Santino, he is also responsible for compromising its honor. The script is singularly witty in this regard, most notably when suggesting that, for Wick, play is also a very serious form of business: "Are you working, John?" "Are you here on business, sir?" Again and again, this continual confusion of Wick's activity threatens to destroy the arena designed to contain and cultivate such play. In his demonic mingling of personal motive and professional skill, he scares Viggo himself, who telephones

him pathetically pleading for a restoration of order: "Let us not resort to our baser instincts and handle this like civilized men." Wick, of course, hangs up on him.

Finally, though, if entering the game and playing the game are always already compromised, leaving it is even harder. Tellingly, play in the Wick universe always leaves a remainder or debt. There's always one more obligation or contract to fulfill, one more person to kill, one more guilt to appease. Viggo must collect and punish Marcus for his transgression; Winston needs to track down and silence Ms. Perkins. Wick himself plays compulsively, as if he owes a debt not just to other players but to the game itself. For him, as perhaps for all players at the High Table, the game is never over, and mastery is never experienced, for the very experience of play, either by the way the game is played or the reason it is played, always necessitates more play. As Santino bluntly explains, "No one gets out and comes back without repercussions." In an interview with /Film, screenwriter Derek Kolstad claims that in drafting *John Wick 2*, the idea of a marker was the one element that remained in all versions of the film's script.[4] Throughout the trilogy, as when Santino appears at Wick's door or Wick in turn appears at Sofia's in *John Wick 3*, the marker represents the indebted and enforced nature of play, the eternal fatedness of each player's debt to the field of play. Indeed, for Wick, exiting the game is structured and dictated by the game, affected by a contract that binds his future to the game. The impossible task by which he was released generates markers and responsibilities that shape his fate throughout all three films. As Viggo puts it, "This life follows you. It clings to you, infecting everyone who comes close to you. We are cursed, you and I."

As Caillois explains, when play loses its freedom, it becomes an object of obsession and addiction, and it occasions in its players a "tyrannical and compelling psychological attitude" (43–44). Whatever Wick

hopes to gain by entering the world of the High Table, the experience leaves him needing more, and this vicious dynamic—fated, mechanical, and decisively addictive—seems typical of specifically modern forms of play. As several critics have noted, the action of the films—in form as much as ethos—explicitly recalls the current world of video gaming.[5] Plotting alternates between brief, dramatic cut scenes and propulsive action sequences, with the latter recapitulating nearly every trope of the classic video-game shooter: stealth mode, melee attack, sniper view, boss fight, and so on. Wick's movements through cinematic space recall the format of the standard platformer, his body advancing level to level in the club or warehouse, his knife and gunwork composed of segmented or mechanical poses necessitated by a joystick or controller. Beyond that, his play resembles the workmanly activity of resource management, asset development, and bureaucratic intel management, all of which are key features of contemporary gaming modules. In this, though, the *John Wick* franchise borrows from the world of contemporary gaming at its most mechanical and restrictive. As game developer Chris Reid explains, "Videogames are calcified games, much more ludus (structured games) than paedia (free play).... [Their] rules are often better thought of as 'laws' in the 'natural law' sense—as a description of physics in the universe of the game, as non-negotiable boundaries to the players' range of activities. The videogame is an authoritative game master, turning guidelines into physical law. There is no act of rules interpretation, no apologetics between players and swayable referees. There are no mercy rules and no 'house rules.'"[6]

Certainly, the borrowings between today's action films and video games are deep and complex, but the key point here is that both now resemble a specifically mechanized and administrative form of *play-like* activity, one that entails a somewhat enlivened and romanticized version of work that otherwise appears dreary and soul-deadening.[7] Game

critic Tom Bissell is perhaps the most eloquent writer on the addictive qualities of video games. In *Extra Lives: Why Video Games Matter* (2011), Bissell compares the "dark gravitational pull" of the shooter to the manic rise and fall of narcotic addiction (130). Such games lure you in with the pleasure of simulated death and resurrection, a newly intensified world in which every person, object, and action appears more or less fatal (133–34). At best, these games transform the player into an avenging angel of life and death; he becomes the wielder of a brutal new ethos capable of controlling massive violence, tons of information, and complex moral and political situations (145, 149). At worst, they programmatically enact a vicious cycle of addiction: in their mechanized play, closed narrative, administrative tediousness, and boneheaded plotting, they empty players of anything like genuine pleasure or feeling, only to lift them up again with intense experiences of violent action (164). In other words, video games, like the *Wick* franchise, stage the death and resurrection of the gamer and his or her mundane world. Boredom is assuaged by spectacular violence; passivity and submission are redeemed by manic button-mashing. For Bissell, a recovering cocaine addict, the gamer experience whipsaws back and forth between sheer trashiness and moments of transcendence, raises and drops the ego over and over again (176–77, 181). Similarly, in *John Wick 2*, Santino taunts Wick as loser gameboy, saying, "John, you know what I think? I think you're *addicted* to it, to the vengeance. No wife, no life, no home. Vengeance, it's all you have." And, of course, the trilogy's indebtedness to the shooter is made clear in the final assault of the first film, when young Gregori is shown playing a shooter using the alias "Neo." "Will you stop playing the fucking video game?" Iosef shouts at the blank-faced player, but Gregori is lost in the gamer zone, flat-faced and unresponsive. Unfortunately, his game is ended only with the arrival of Wick and a decisively nondigital bullet to the head.

Perhaps the hypercharged drudgery of the *John Wick* playscape is most clearly evidenced by the ease with which it served as the basis of play in *John Wick Hex*, the first action strategy video game based on the franchise. To grant the player something like Wick's professional skill, the game literally stops time in the middle of a fight, allows the player to break down Wick's thrilling moves into a series of simple mechanical commands, and then replays them up to speed again in a "cinematic" mode. The structure of play thus exposes the fully mechanized and industrialized nature of play that is then romanticized in popular forms via the manipulation of sound and image.[8] But my point here is not simply to malign video games or movies that share their ethos (I'm horribly addicted to both). This detected similarity across media requires much more than a simple critique of their inherent violence and addictive features, for it reveals a much larger and more vicious dialectic that defines the current state of play as a whole.

Here, we need a longer view of the fully monetized and fallen world in which such play occurs, one that is most clearly glimpsed in the early scenes of the first film in the franchise. "Everything's got a price, bitch!" snickers Iosef Tarasov, as he eyes Wick's Mustang. As if we didn't get the point, Iosef's radio blasts a rap track by the Candy Shop Boys, the chorus of which—"'Cause I'll empty your pockets"—becomes something of a refrain for the film as a whole. This is the crass world that Wick refuses to abide—"Not this bitch," he counters—and his reentry into the realm of the High Table serves to counter its economy. Decisively, for Wick, his memories and possessions are not for sale, not fungible, and he reenters the game to assert their human value. When Wick meets up with Marcus at his wife's funeral, he rejects his friend's cynicism in a similar way. Marcus tells him there's "no rhyme or reason to life. It's days like today scattered among the rest." But Wick responds with an endearing earnestness and humility—"Are you sure?"—a phrase that

all his subsequent gestures serve to test. Again, "it's personal" for Wick, and by playing, he insists on the uniqueness of this particular Mustang, this particular wife, this particular puppy, as each is unique and essential to his identity. Every word, every bullet, all his training—it all counts again in the newly intensified world of the High Table. Indeed, when Wick enters the arena, even the corrupted symbols of exchange, the degraded currency of the social contract under the profit motive, are transformed into glittering gold coins of yore, suggesting a near-biblical redemption of all value.

In other words, in playing, John Wick chooses a talismanic or reanimated world; the energized agon of his mission serves to recharge the objects and people of an otherwise fallen economy. Correspondingly, both friends and foes relish John Wick's return to the arena. "I needed *that* guy!" Santino exclaims in *John Wick 2* after witnessing John in action. "I am a huge fan, John Wick, and so far you haven't disappointed," comments an enthralled Zero, right before their final battle in *John Wick 3*. In his dramatically staged death and rebirth, Wick brings a new aura to all players and objects of play. With the outsized ego familiar to any PlayStation or xBox gamer (seated perhaps in an X Rocker 51396 Pro Series Pedestal chair in front of an 80" UHD 4k screen), he appears as a form of fate itself, implacable and foregone, nothing less than the restorer of time and redeemer of history.

The issue remains, though, how quickly and fatefully such play starts to mirror the system it seeks to replace, infected by the world it opposes. Even as an effort of massive rehumanization of everyday life, such play entails significant sacrifices and hefty penalties. As mentioned earlier, John Wick is always in arrears, always owes a debt to the High Table or its players. As soon as he ends one mission and puts down his gun, his doorbell rings again. This debt is incurred in a very real way, since, for instance, Wick owes Santino a marker for the help he provided

with Viggo's "impossible task," but it is also incurred in a psychological and ethical sense, insofar as Wick owes his very humanity to the High Table. In other words, his earlier efforts to leave the High Table and settle down with his wife, not to mention his subsequent efforts to preserve her memory, all entail greater and greater feats of monstrous violence. Under this system, he can find humanity (or at least a veneer of civilian peace) only through inhuman violence, and this is the kind of debt that can never be fully cleared. Far into the third film, the Elder (Saïd Taghmaoui) offers him yet one more life—an extra life, perhaps—but makes explicit that it "might not be the life" John wants to live. Here, too, "it's personal," as John plays in order to assert his personhood, but the humanness he might win or lose in brutalized play can be restored only by playing again, through ever-greater acts of inhumanness, and so on and so forth. The books can't be balanced; the peace his wife tried to establish for him before her death cannot be reached. Thus, all of Wick's efforts to reassert his humanness also serve to chip away at his humanness. When, in the first film, Wick tells Iosef that "Victor's dead. . . . Everything's got a price," he mockingly adopts Iosef's line, but he also seems to have accepted the very economy he set out to destroy.

As I have suggested, Wick's obsessive form of play and the ceaseless debt it accrues represent no personal idiosyncrasy or cultural aberration but reflect a much larger history of a very specific economy. More specifically, the films' Greek and Roman references, everywhere on display in the background statuary in *John Wick 2* and *John Wick 3*, imply that the forms of play cultivated by the High Table represent a decisively Western world of capitalist exchange and competition.[9] Huizinga usefully outlines the ways in which the most famous modes of classical play, such as the public contest or tourney among gladiators, always entailed a stake of some sort. In order to play, something needed to be placed in the ring (if only symbolically), and this risk was

rewarded with an equivalent prize or price. These words—*prize* and *price*—come from the same root, and they overlap with the word *praise*, a related type of classical reward, but the key point here is that what one loses and hopes to gain in such games is not only often moral or virtuous but also economic and increasingly so (48–51). More broadly, as Caillois's work suggests, the classical games referenced throughout the *Wick* films hark back to a moment in Western civilization in which the concept of selfhood became a tabulatable combination of training, luck, and opportunity; in this way, the rapidly developing identity of the player, increasingly rationalized and abstract, mirrored an increasingly rational and bureaucratic world, while the exchanges that took place within and around play space resembled the emerging world of commercial trade (86–87, 11). The films suggest that, in our play, we are still working through this same shift—a shift in economics as well as related concepts of selfhood—a problematic that is moral, historical, and deeply economical. In this, Wick's struggle recalls the economic emergence of modernity famously outlined by Max Horkheimer and Theodor Adorno in *Dialectic of Enlightenment*, specifically the fraught ways in which certain social contracts are negotiated and manipulated by the struggling hero Odysseus. Like Odysseus, Wick must navigate the transition from an old to a new economy, with newly abstract and rationalized terms of debt and exchange, and all that he wagers to preserve his humanity can never be fully won back. In fact, both heroes must lose their human distinction and declare themselves "no man"—or specter, *il Spettro*—in order to survive and maintain some coherent identity in the alienating terms of the new economy.

Wick, of course, would rather not play at all, but when he must, he insists on an older form of play that he believes is fair, in which the exchange is real and equivalent. Thus, in *John Wick*, he demands

repayment in equivalent form and value. He asks Viggo to "step aside, give me your son," a sacrifice equal to his own sense of grief and loss. While the books don't quite balance, Wick, ever a moralist, believes he is owed a life, a very specific price or prize, for what he himself has put into the ring, but the terms of repayment only perpetuate his cycle of grief and debt. In *John Wick 2*, Santino calls him on his false hope: "You think you're Old Testament?" he asks. "No, John, no. Killing me won't stop the contract. Killing me will make it so much worse." Perhaps more than any other character, Santino—as perhaps a *New* Testament manipulator of human guilt—plays in bad faith, hiding sinister motive behind impersonal rules of order, recognizing that the game is inherently compromising and using this knowledge to manipulate play. Wick tries to give everything he's won in the arena back to Santino—his car, his house, all of it—but Santino reminds him that a greater debt is owed, that the trade is never even, and that John is bound, owes his identity as much as his life, not just to the marker or even Santino but to the game itself, which is overseen elsewhere by an office fittingly named "Accounts Payable."

The history of this economic transition from older to newer forms of competition and exchange seems to structure the trilogy as a whole and its large cast of characters. While "bad players," such as Iosef and Santino, exploit the rules of play to gain wealth and power, "good players," such as Marcus and Cassian, present models of equity and fairness. Cassian, for instance, appears a telling counterpoint to Santino insofar as his insistence on an even trade is as much moral as it is economic. His Latin name suggests an older and more genuine tradition of sacrifice and exchange, and he seems to abide by a different order than the one that Santino exploits. "So you're free?" he asks Wick, but then he provides his own answer: "No, not at all. You killed my ward. An eye for an

eye, John. You know how it goes." We see a further distinction in Sofia's lofty critique of the entire system of exchange and debt in *John Wick 3*; when John asks for her help with marker in hand, suggesting, "Either way, you and me, we'll be even," she boldly retorts, "No, after this, we are less than even." Still, all characters are swept up in the High Table's uneven system of exchange, and this vicious logic shapes and drives the franchise as a whole. In fact, John's hope of fair play, some future moment when all debts have been paid, certainly informs the "happy ending" of the first film, in which he is rewarded with restoration of both car and dog—a decisively good life. But the falseness of this hope informs and secures the structure of the franchise's sequeling, with each subsequent film revealing new levels of indebtedness and thus ensuring a return to the world of the High Table.

Accordingly, we might celebrate the trilogy as a critique of all that's been lost in the historical transformation of play, but the films them- selves engage in ideological fantasies that block or distract from what theorists have outlined as play's own critical power. As suggested, many of the Greek and Roman references that frame the films' action recall earlier forms of arguably more heroic forms of play, most notably the public contests or tourneys for which both cultures are known. The denizens of this world willingly accept the High Table's intricate rules of play as civilizing influences on their otherwise perverse behavior. Winston, their de facto representative, maintains a veneer of genteel ex- change as a way of affirming and glorifying their violence (fig. 6.1). Here, though, we run into the heart of the matter, as the *Wick* franchise is not so clear on whether the forms of play it offers as models are progressive or backward, whether the intricately constructed rules that define the world of the High Table serve to curb the impulses of its players or actu- ally unleash and affirm their worst impulses. As Viggo nervously asks in *John Wick*, "What happened, John? We were supposed to be civilized."

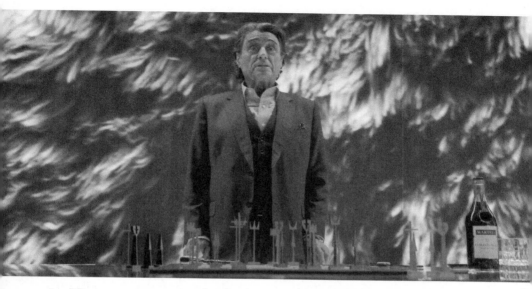

6.1. Winston as representative of civilized play. *John Wick 3* (2019).

It is perhaps critical habit to understand the advance of culture as devised from forms of play, and vice versa, to interpret games as they reveal the character, patterns, and values of a society in which they are played. Theorists such as Huizinga and Caillois provided the tools to read the identity as well as the destiny of cultures, their chance to flourish or stagnate, by their preference for one or another of the basic categories of games. It is equally habitual, thanks to the same theorists, to interpret specifically Greek and Roman games as the pinnacle of play culture, as mechanisms of cultural progress, guarantors of honors and virtues that have perhaps been lost in the modern world. Huizinga reads the ceremonial contest as the highest form of play and the driver of all cultural progress. In his account, the public battles of Greece, Rome,

and China typify a culture of discipline, focus, honor, pomp, and braggadocio, in which the success or loss of any one fighter reflected the esteem of society as a whole (60). These agonistic spectacles demanded intense training, knowledge, skill, courage, and strength, so that the winner was applauded as a man of virtue that was at once physical and moral and served as a model for others (48, 63–64). And certainly, as a man of "focus, commitment, sheer will," Wick typifies this classic gladiator, one whose professional training and dignified play figure as salvation for the world of the High Table as a whole.

Caillois's history of play, however, offers a more complex and critical account of this history. His study begins with the primitive and ecstatic forms of prehistoric play, what he calls *mimesis*, play that entails masking and spirit possession, and *ilinx*, play that involves physical tumult and giddy perceptual disruption. These residual forms of play continue to structure the world of the assassins, affording them alternative forms of pleasure and value. Mimesis, of course, continues to shape all of the activity of John and his colleagues, as they adopt different identities and costumes to channel the ecstatic power of their training. Ilinx is experienced in their dizzying chases and kinetic combat, but it spreads out into other areas as an irrepressible pleasure, as in the film's many pulsing club scenes or when we see John angrily joyriding in his Mustang. For Caillois, though, these earlier forms of play were supplanted in Greek and Roman culture by what he calls *agon* and *alea*, games of sport and games of chance, respectively. Of course, John and his colleagues' main mode of play involves agonistic battles, battles by which fame and glory are won and lost through physical combat. Chance, of course, determines the course of every battle; the High Table oversees its domain like a massive casino, setting prizes and time limits based on calculated odds, while individual players enter the fray, risking all

in hoping to score big. For all the players in this dicey world, their lives are ruled by fate—"fate, or happenstance, or just bad fucking luck," as Viggo claims—and fate is the mystical force that they credit for all their success or failure.[10]

As Caillois explains, with games of sport and gambling, Greek and Roman culture brought a disciplinary quality to play in terms of rules, training, and expertise as well as a larger rationalistic framework regarding the administration of play that tied the world of gaming to advances in economics, medicine, and science. Yet Caillois is troubled by how these games reflect the economic shifts of the era insofar as agonistic play, as a spectacular vindication of personal agency, serves to counter older forms of inheritance and dynasty, and games of chance, games for which all players purportedly have an equal opportunity to win or lose, alleviate concern about disadvantages of wealth and influence on the marketplace. While the *Wick* films depict all of Caillois's forms of play, the figure of Wick himself seems to embody and redeem this specific dynamic of agon and alea. His stunningly tattooed back features the Latin inscription "Fortune Favors the Bold," a near-perfect encapsulation of the closed dynamic that Caillois outlines between contest and chance, the ideological mast to which our hero is lashed. When John and his colleagues cannot simply master their lives by force and sheer will, they resort to the language of fate or luck—"bad fucking luck," according to Viggo. And when their luck runs out, they resort once more to force and will—"baser instincts," according to Viggo. Simply put, gameplay in the *Wick* franchise mediates concerns about a very specific economy, our hero's entire journey enlivened and enflamed by the compulsive fantasy that, in the world of the High Table, what can't be gained by personal effort and responsibility can still be won by sheer luck, and vice versa.[11]

What simultaneously excites and frustrates me about the *John Wick* franchise is its depiction of the totality and ultimate closure of the contemporary state of play and games. I appreciate its analysis of how the borders of play cannot be secured, an analysis that extends to contemporary gamer experiences both small and large (from simple board games for kids to massive multiplayer worlds of the digital playscape), but I'm concerned about its complacency regarding the larger economic forces that seem to drive this seemingly implacable expansion. The gamified world of John Wick, with all its mirrored exhibits and glass houses, appears to be a world without edges, a world that only accumulates, and in this it reflects the larger and ever-expanding infiltrative playscape of mobile game apps, legacy-edition board games, open-world game formats, gamified health and productivity programs, crowdsourced funding schemes, and so on. What exactly does it mean to live in a culture in which experiences of play are constantly quarantined and yet bleed out everywhere? What does it mean to insist on the borders of play and then gamify the rest of the world? "You call this out?" Winston asks with a grin in *John Wick 2*. John Wick can't figure a way out. He's stuck in it just like everyone else. The homeless are in it. The cabbies are in it. Even the dogs are in it. The whole Wick franchise is stuck in it, hence its apparently endless sequels and television spinoff. "Do not make the mistake of thinking you exist outside the rules," the Adjudicator warns in *John Wick 3*. "No men do."

Moreover, no injection of personal morals, no nostalgic harking back to a more romantic form of play, not even cheating can redeem this world. In fact, the world of the High Table already offers all the value we seek—responsibility, honor, clarity, professionalism, civility, justice, and redemption, not to mention style and aesthetics. Choosing to play or not play are false alternatives—playing fairly or not—it

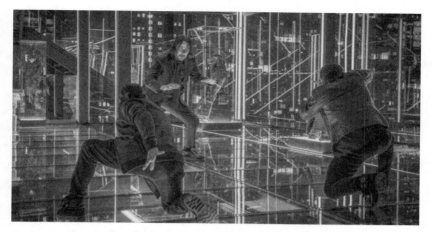

6.2. Battle in the executive suite. *John Wick 3* (2019).

makes no difference at all. In fact, I had hoped to end this essay with an account of the cheaters in *John Wick*—Iosef, Ms. Perkins, Marcus—but their moves always ultimately uphold the ethos and rules of the High Table, and they themselves succumb to the system they thought they could master. What we need is a spoilsport. There's a long tradition in game theory, initiated by Huizinga, of distinguishing between the cheat and the spoilsport. In many ways, the cheat is an ideal player, one who operates fully within the rules and goals of the game, even if their approach is underhanded. The spoilsport, though, has no interest in playing anymore. The spoilsport ignores not just the rules but the game itself, upends the board and table too. What the world of John Wick needs is the miracle of the spoilsport—an otherworldly avenger—a true revolutionary of play-space destruction. At the end of *John Wick 3*, the Bowery King promises to be such a spoilsport, with Wick as his agent

of destruction, but he is already compromised in attitude and commitments, and really, his revolutionary promise is merely an advertisement for the next installment of the franchise.

In this regard, the climax of the trilogy is also its nadir. The final boss battle of the third film occurs in what Winston affectionately refers to as the "administrative lounge" (fig. 6.2). Much like the famous Westin Bonaventure Hotel, which critics such as Edward Soja and Fredric Jameson deemed emblematic of a postmodern loss of space and time, the administrative lounge is a disorienting space, constructed almost entirely out of glass and expanding in all directions apparently without end.[12] It is, like so many other spaces in the film, lined with transparent display cases that showcase but decontextualize the historical costumes and weapons of previous gladiators. Here, our hero battles two vicious henchmen and then Zero himself (Mark Dacascos), a high-level assassin employed by the Adjudicator to bring down Wick once and for all. Contrary to all former claims in the film, the fighting in this scene is neither civilized nor primitive but simply administrative. John and his opponents are more or less evenly matched, and their fitful bursts of martial prowess end in a flat series of draws. The architecture of the space nullifies any sense of progress or even change in the battle; while John moves up and down stairs and the combatants swing each other madly through rooms and walls, they hardly seem to be advancing or withdrawing in any way. Each new arena is more or less the same as the last, and the very notion of leveling up is nullified. To borrow from Rune Klevjer's commentary on the first-person shooter, the "on-rails, repetitive and ritualistic dimension" of such play "represents an exclusively modern form. . . . The individual is given the opportunity to engage intensely with the grotesque and destructive dimensions of modernity, in a ritualistic dance of spectacle, power and powerlessness." The player

rehearses "socially useful forms of strategic and administrative intelligence," but the "action-adventure is too spectacular, too rigid, too grotesque and too industrial to be able to offer any significant degree of healthy, developing play. It does play with the powers of explorative and experimental rationality, but is no 'adventure of civilization' in Roger Caillois' meaning of the words."[13] I cannot help but lament what has happened to the quality and capacity of play in such a world. Is it, at best, as in the *Wick* franchise, always manic, exhausting, boring, unethical, and unending? Of course, it still looks like play. It bears some fragments or features of the structures of true play and occasions in debased form some of the pleasures that define true play, and perhaps that's the point. But, to return to the promises of play outlined by Caillois and Huizinga, it entails no new cultivation of personal skills, no new flowering of uplifting aesthetic forms, no new deliberation of moral or ethical concerns. No, here in the administrative wing, the presumedly highest form of play in our culture occurs within and alongside an economy that mirrors and saps its key pleasures and critical functions.

Notes

1. See, for instance, Stephen M. Colbert, "The World of John Wick Explained," Screen Rant, May 17, 2019, https://screenrant.com/john-wick-world-guide-continental-sommelier/; Peter Sobczynski, "John Wick: Chapter 3—Parabellum," RogerEbert.com, May 17, 2019, https://www.rogerebert.com/reviews/john-wick-chapter-3--parabellum; Ignatiy Vishnevetsky, "Keanu Reeves Shoots His Way through the Entertaining Action Fantasy *John Wick*," A.V. Club, October, 23, 2014, https://film.avclub.com/keanu-reeves-shoots-his-way-through-the-entertaining-ac-1798181681.

2. Johann Huizinga, *Homo Ludens: A Study of the Play Element of Culture* (Kettering, OH: Angelico, 2016); Roger Caillois, *Man, Play, and Games,* trans. Meyer Barash (Urbana: University of Illinois Press, 2001). Quotations from both are followed by page numbers in the text.

3. See related commentary in Mark Kermode, "*John Wick: Chapter 3—Parabellum*," BBC Radio, May 17, 2019, https://www.bbc.co.uk/programmes/po79jt2z.

4. Jack Giroux, "Interview: 'John Wick: Chapter 2' Screenwriter Derek Kolstad on Expanding the World and Paying Homage to 'Open Range,'" /Film, February 10, 2017, https://www.slashfilm.com/john-wick-chapter-2-screenwriter-derek-kolstad -interview/.

5. Michael Phillips, "'John Wick 3' Review: Keanu Reeves Burns Ultraviolence Candle at Both Ends," *Chicago Tribune*, May 14, 2019, https://www.chicagotribune .com/entertainment/movies/sc-mov-john-wick-3-keanu-review-0514-story.html; James Berardinelli, "John Wick (United States, 2014)," ReelViews, October 24, 2014, www.reelviews.net/reelviews/john-wick.

6. Chris Reid, "Games, Videogames, and the Dionysian Society," *Ribbonfarm: Constructions in Magical Thinking* (blog), January 26, 2017, https://www.ribbonfarm .com/2017/01/26/games-videogames-and-the-dionysian-society/.

7. See Tom Bissell, *Extra Lives: Why Video Games Matter* (New York: Vintage Books, 2011). Quotations from this source are followed by page numbers in the text.

8. Bithell Games, *John Wick Hex*, v. 1.01 (Good Shepherd, 2019), Windows, MacOS, PlayStation 4, Nintendo Switch, and Xbox One.

9. Multiple reviewers of the *Wick* franchise have described it as alternately Hellenic or Roman in its rigidly codified rules of order, epic scenes of honorific battle, and heroic depiction of Wick's moral reckoning. See Vishnevetsky, "Keanu Reeves"; Sarah Bond, "Five Ancient Greek and Roman Influences in 'John Wick 2,'" *Forbes*, February 13, 2017, https://www.forbes.com/sites/drsarahbond/2017/02/13/fortune -favors-the-bold-5-greco-roman-reasons-to-see-john-wick-chapter-2/#7166edda87ef; Sophie Gilbert, "*John Wick*: An Idiot Killed His Puppy and Now Everyone Must Die," *Atlantic*, October 24, 2014, https://www.theatlantic.com/entertainment/archive /2014/10/john-wick-an-idiot-killed-his-puppy-and-now-everyone-must-die/381921/; David Sims, "A Week after Its Release, *John Wick* Already Seems Like a Cult Classic," *Atlantic*, October 31, 2014, https://www.theatlantic.com/entertainment/archive /2014/10/one-week-after-its-release-john-wick-is-already-a-cult-classic/382169/.

10. See Reid, "Games," for connecting Caillois's categories of play to the modes and experiences of contemporary video gaming.

11. For a related but perhaps more balanced critique of agon and alea, see Brian Sutton-Smith, *The Ambiguity of Play* (Cambridge: Harvard University Press, 1997), chaps. 4 and 5.

12. Edward W. Soja, *Postmodern Geographies: The Reassertion of Space in Critical Social Theory* (London: Verso, 1989); Fredric Jameson, *Postmodernism, or The Cultural Logic of Late Capitalism* (London: Verso, 1990).

13. Rune Klevjer, "Dancing with the Modern Grotesque: War, Work, Play and Ritual in the First Run-and-Gun First Person Shooter," University of Bergen, accessed October 17, 2021, https://folk.uib.no/smkrk/docs/dancing.htm; first published as "Danzando con il Grottesco Moderno: Guerra, lavoro, gioco e rituale nei First Person Shooter run-and-gun," in *Gli strumenti del videogiocare: Logiche, estetiche e (v)ideologie*, ed. M. Bittanti (Milan: Costa and Nolan, 2006).

EDWARD P. DALLIS-COMENTALE is Professor of English, Associate Vice Provost for Arts and Humanities, and Director of the Arts and Humanities Council at Indiana University Bloomington. His recent books include *Sweet Air: Modernism, Regionalism, and American Popular Song* (2014) and, with Aaron Jaffe, the anthologies *The Year's Work at the Zombie Research Center* (2014) and *The Year's Work in Lebowski Studies* (2009), both published by Indiana University Press in the series The Year's Work: Studies in Fan Culture and Cultural Theory.

7 "THE ONE YOU SENT TO KILL THE BOOGEYMAN"

FOLKLORE AND IDENTITY DECONSTRUCTION IN THE JOHN WICK *UNIVERSE*

CAITLIN G. WATT

Introduction

The third installment of the *John Wick* franchise, *John Wick: Chapter 3—Parabellum*, opens with an invocation of fairy tales that underscores these tales' significance to the series as a whole. On the run from an entire society of assassins, John Wick visits the New York Public Library to look for a volume of Alexander Afanasyev's nineteenth-century collection of Russian folktales.[1] Having found the desired tome, he peels back an illustration of heroine Vasilisa the Beautiful to reveal a hidden trove of objects, each of which speaks to some aspect of his past and identity (see fig. 7.1). These include a picture of John and his deceased wife, Helen, symbolizing the domestic bliss he shared with her and John's embattled identity as her husband; gold coins and a "marker," both of which represent John's network of associations and obligations within the assassin society; and a Russian Orthodox rosary that, as we learn, represents both John's childhood home and a favor he intends to claim from this home. As he prepares to put the book away, he is approached by fellow assassin Ernest (Boban Marjanović), who greets him with a quotation from Odysseus in Canto 26 of Dante's *Inferno*: "Consider your origins. You were not made to live as brutes, but to follow virtue and knowledge." A fight ensues, which ends with John killing Ernest with the collection of fairy tales (perhaps an overdetermined sign of

7.1. John Wick's hiding place at the New York Public Library. *John Wick 3* (2019).

the collapse of John's origins into his life as a brute) before he replaces it on the shelf.

The scene in some ways encapsulates the Wickverse's multifaceted central character and the role of fairy tales and mythology in constructing a hero who is constantly torn between a domestic, "civilized" life and the brutal violence for which he has become famous among his peers. The disparate signifiers of John's identity, hidden behind an illustration of a fairy-tale heroine, reflect the contrasting elements—masculine and feminine, civilized and wild—that have hitherto defined his character. In suggesting the wider importance of this snapshot, however, my goal is not to present folkloric ambiguity as a static element in John's characterization but rather to offer the fairy tale as a useful lens through which to interpret his evolution throughout the franchise.

John Wick establishes that John's nickname in the assassin underworld is "Baba Yaga," the name of an alternately villainous and benevolent witch. Like the scene in the library, this nickname seems to encapsulate his paradoxical double role of monster and protagonist in his quest for vengeance. Though his grief for his wife, his occasional displays of mercy to an opponent, and his vulnerability to deception or

injury humanize him as a sympathetic hero, his legend as a man who can perform "impossible tasks" looms large as he inexorably succeeds in his mission. As the series progresses, however, John's hybrid identity begins to fall apart as his impossible tasks ensnare him in a system of conflicting obligations that transform him from active pursuer to reactive prey, and the sense of horror and mystery initially attached to him is gradually transferred to other characters and to the underworld in which he is ever more firmly entangled. Originally presented as a singular and mythic figure, John Wick is repeatedly compelled to discard and reclaim aspects of an increasingly inchoate identity. Rather than describing him as the hero or antihero of the franchise, then, we might more accurately use Taha Ibrahim's term "semi-hero" to describe him as "a protagonist whose success in attaining the goal of the text is doubtful or partial, or whose success is not final, that is, it allows for further complexity."[2] Building in particular on the work of folklorists and scholars of film and literary character, this paper traces the gradual fragmentation of John's initial identity from the hybrid Baba Yaga figure into a series of increasingly powerless narrative roles. I argue that this deconstruction of John's identity demonstrates the incommensurability of his initial role of heroic monster with the mystical but highly rigid hierarchy of the High Table, signaling the inevitability of John's expulsion from all of the worlds that shape his identity. This shifting fragmentation, however, does not foreclose the possibility of the semi-hero's return.

John Wick: The Fairy-Tale Monster

To describe John Wick as a fairy-tale hero or an Odysseus-like figure of legend would be to echo the sentiments of numerous commentators on the *Wick* films: for example, Sonny Bunch argues in the *Washington Post* that "Wick and [Keanu] Reeves synthesize into a wonderful modern

folk hero, a larger-than-life exemplar of that which is best in life."[3] Moira Hicks, who notes as I do that John occupies a variety of fairy-tale roles throughout the films, describes him as successively a witch, a knight exultant, and a knight in exile, concluding that "*John Wick* does not tell one fairy tale. It tells fairy tales as a form."[4] An additional genre that may prove useful, however, is that of the anti-fairy tale: the fairy tale that subverts our expectations by having a sad or tragic ending, the fairy tale that *comments* on the fairy tale, or the non-fairy-tale text that incorporates elements of the fairy tale to draw contrasts between the idealized and the realistic.[5] While it would be difficult to categorize the highly stylized world of the *John Wick* films as either idealized or realistic, the contrast between the colorful implausibility of the world and its brutal violence may indeed render it the grim fairyland of an anti-fairy tale, an appropriate milieu for John to assume the role of monstrous hero.

John's incoherence as a character—his assumption of various roles at different times—is repeatedly remarked on by both the filmmakers and other characters. In the directors' commentary to *John Wick*, Chad Stahelski and David Leitch note the tension between "John," defined as Helen's husband, the normal everyman, and "John Wick," the mysterious and dangerous hitman. Characters ranging from mob boss Viggo Tarasov (Michael Nyqvist) to suave hotelier Winston (Ian MacShane) similarly use contrasting dichotomies—civilized man versus animal, priest versus devil, Helen's husband versus Baba Yaga—to describe John as a character who is consistently unable to conform to the dictates of a single role. Initially, however, John's ability to evade coherent definition is a position of power, contributing to his larger-than-life status as a figure of legend.

This status is established twenty minutes into the first film, when young Iosef Tarasov (Alfie Allen) misreads the grieving hitman as a defenseless victim, steals his car, and kills his dog. His horrified father,

Viggo, on hearing the news, angrily explains to his son the seriousness of his transgression:

> Viggo: It's not what you did, son, that angers
> me so. It's who you did it to.
> Iosef: Who? That fucking nobody?
> Viggo: That "fucking nobody" . . . is John Wick. He was once
> an associate of ours. They call him "Baba Yaga."
> Iosef: The Boogeyman?
> Viggo: Well, John wasn't exactly the Boogeyman. He was
> the one you sent to kill the fucking Boogeyman.

This scene is remarkable both for the emphasis it places on John's identity and for the mystery and multiplicity it attributes to him. The world of the action film, like the world of the fairy tale, is full of "fucking nobodies"—that is to say, the function of the hitman, bystander, or magic gift-giving bird in advancing the narrative is often more significant than the character's name, identity, or uniqueness. But here Viggo identifies John as a defined and individual assassin who stands apart from others and, simultaneously, as a mysterious and hybrid figure. John's exceptionality from the functional schemata of criminals and victims is marked by three separate folkloric measures: Baba Yaga, the Boogeyman (despite Viggo's disclaimer, his later song about the Boogeyman stealing children suggests that this is a figure associated with John), and the one you sent to kill the Boogeyman—in other words, a hunter of monsters. Intercut with Iosef and Viggo's conversation, shots of John descending a staircase to his basement and smashing his floor with a sledgehammer to reveal a case of guns and gold coins convey this ominous multiplicity; the lighting and framing obscuring John's face throughout and the literal unearthing of darker layers of his identity

cast John as an unknowable, undefinable, and unbeatable monster preparing his return to a world populated by other monsters.

As Stahelski and Leitch remark in their commentary, John's backstory is never explained in *John Wick*—his innocuous facade hides a violence that remains contained until an ignorant Iosef's transgression unleashes it. In his production of an elusive identity that bridges the pragmatic world of professional association and the realm of legendary invincibility, John is both an important figure in Assassin World and removed from it by time, marriage, and legendary status. This legendary status is in no way undercut by John's own vulnerability and occasional need of assistance from Marcus (Willem Dafoe). Indeed, these occasional moments of near-defeat emphasize essential traits that characterize John as "Baba Yaga": his resourcefulness, relentlessness, and ability to use the slightest advantage in his surroundings to snatch victory from the jaws of defeat—in Viggo's words, "focus, commitment, sheer will."

Some critics have mocked the idea that the nickname of a feared and highly trained killer is also the name of a typically female character: Baba Yaga, an old witch of Russian fairy tales known for eating children and living in a house that stands on chicken legs (see fig. 7.2). Georgy Manaev at *Russia Beyond* interprets the "Baba Yaga" name as a mistake on the part of the filmmakers, one born of a desire to make their hero exotic and mysterious; worse than their ignorance, this mistake represents for Manaev an appropriation and exoticization of Russian culture typical of American media. In his opinion, screenwriter Derek Kolstad must have mixed up Baba Yaga with *babayka*, a Slavic variant of the "Sack Man" or Boogeyman figure. "It's clear that John Wick, played by Keanu Reeves, is not an elderly woman!" Manaev quips, concluding that "as a movie character" he "definitely has nothing in common with Baba Yaga."[6]

7.2. Ivan Bilibin, Baba Yaga from "Vasilisa the Beautiful" (1899).

Without discounting the possibility that the filmmakers *are* conflating Baba Yaga and *babayka* in this scene—a suggestion strengthened by Iosef's equation of the two and Viggo's song about the Boogeyman—I would argue that, regardless of the filmmakers' accuracy or lack thereof, John Wick does in fact share important traits with Baba Yaga, traits that other filmmakers have drawn on in their deployment of male Baba Yaga figures. Moreover, the male Baba Yaga is not a uniquely American phenomenon—male actor Georgiy Frantsevich Millyar portrayed the old witch in five Soviet-made productions, beginning with *Vasilisa the Beautiful* in 1940 and ending with *Baba Yaga* in 1973. English-language cinema has also made comparatively extensive use of male Baba Yagas, a trend I'd like to explore here by briefly discussing John Duigan's 1997 film *Lawn Dogs* and Neil Marshall's 2019 *Hellboy*.[7]

While Guillermo del Toro's earlier *Hellboy* films also deploy fairy-tale elements, such as the elven court of *Hellboy II: The Golden Army* (2008), the 2019 film is the first to feature Baba Yaga. Adapting a plotline from Mike Mignola's *Hellboy* comics, the film presents Baba Yaga as a helper both to Hellboy (David Harbour) and to his enemy, Vivian Nimue (Milla Jovovich). Though the character is female and is voiced by Emma Tate, she is played on-screen by male contortionist Troy James. James's dynamic, unsettling performance contributes to Baba Yaga's menace and uncanniness, "imbuing her with a shocking speed that makes her a genuine threat."[8] Just as Georgiy Millyar's performance allows for the construction of a Baba Yaga who exhibits the exaggerated traits of "ugliness" of the fairy-tale figure, James's performance in *Hellboy* helps develop a Baba Yaga who is dangerous even when helping the hero. Despite the counterintuitive casting of a younger male actor to play an elderly female character, Millyar's and James's performances facilitate a paradoxical fidelity in depicting a character who comprises

"a composite of contradictory traits . . . life and death, destruction and renewal, the feminine and the masculine."[9]

By contrast, *John Wick* and *Lawn Dogs* feature Baba Yagas who not only are played by male performers but also are male characters. Just as Millyar's and James's Baba Yagas foreground the power and complexity of the Baba Yaga figure, *John Wick* and *Lawn Dogs* emphasize a different aspect of the fairy-tale Baba Yaga: her role as a tester or initiator of a young person seeking an independent adult identity. While this characteristic of the Baba Yaga figure is emphasized in other media, including television shows aimed at a younger audience (such as the animated shows *Arthur* and *Ivashka iz dvortsa pionerov*), the Baba Yagas of these media often serve as obstacles whom the young heroes face as part of their growth.[10] Conversely, both *John Wick* and *Lawn Dogs* construct anti-fairy tales with sympathetic male Baba Yagas at their centers, commenting on the fairy tale as a coming-of-age narrative.

Indeed, one might say that *Lawn Dogs* features multiple male Baba Yagas. Early in the film, ten-year-old Devon (Mischa Barton) becomes fascinated by Trent (Sam Rockwell), a working-class man who mows lawns in a wealthy gated community. As she follows him to his trailer in the woods, a home that, like John Wick's isolated contemporary house, signifies his position on the margins of the society the film depicts, she tells herself stories in which she casts Trent as "Baba Yaga Bony-Legs." As she and Trent become friends, however, he moves from being a menacing outsider in her mind to a friend threatened by the hostile forces of suburban middle-class conformity that come to occupy the role of Baba Yaga for her. Devon's fairy-tale fantasies allow *Lawn Dogs* to explore the monstrosity hiding below the surface of the hypocritical and sex-obsessed world of suburbia, personified by the hired security chief, a closeted young man and his child-molesting friend, and Devon's own father. The transferal of monstrosity from Trent to the

"respectable" members of Devon's society reflects the rejection of conventional classist and sexist mores that constitutes her initiation into maturity.

While also deploying a male Baba Yaga to comment on the fairy-tale coming-of-age narrative, *John Wick* reverses the heroic journey entirely by permitting a repudiation of the young "hero" and allowing the monster to occupy the central and most sympathetic position. In comparing Iosef Tarasov to the typical protagonist of the Russian fairy tale, many similarities emerge: the "prince" of his crime family, brash, careless, and desperate to prove himself to his father, he functionally occupies the same narrative role as Ivan Tsarevich, the hapless hero of such tales as "The Frog Princess," "Marya Morevna," and "Ivan Tsarevich, the Grey Wolf, and the Firebird."[11] Besides sharing a set of initials, Ivan and Iosef perform many of the same fairy-tale functions outlined by Vladimir Propp in his *Morphology of the Folktale*. Iosef, like Ivan, sets out in search of a prized and difficult-to-get object (John's vintage car), violates an interdiction (John's warning that his car is not for sale), obtains the object of his search, and is pursued.[12] Meanwhile, John's fearsome status as Baba Yaga develops not only from his monstrous capacity for violence but also from his status as a violated helper—as Viggo explains to Iosef, when John wanted to leave his employ to marry Helen, "I gave him an impossible task. A job no one could have pulled off. The bodies he buried that day laid the foundation of what we are now." "Impossible tasks" in fairy tales are typically performed not by the hero but by helpers: the gray wolf in "The Firebird," birds and bees in "Marya Morevna," or even Baba Yaga herself. In John's capacity as helper, he aided in Viggo's own "hero's journey," and in a morbid twist characteristic of the anti-fairy tale, John tests the "hero" Iosef and finds him wanting, cutting short Iosef's coming-of-age story to the cheers of the audience. After all, Iosef did kill his dog.

John Wick 2 and 3: The Fairy-Tale Hero

To some extent, John's mystique as Baba Yaga, the deadly paragon who serves as a metric or means of advancement for other assassins, persists through *John Wick* 2 and 3. In *John Wick* 2, for example, the Bowery King (Laurence Fishburne) greets him with "John Wick: the man, the myth, the legend" before relating an anecdote in which, when the Bowery King was a young "pawn in the game," John gave him a "gift from the Boogeyman": the choice between life and death and the resulting wisdom that facilitated his rise to his current position. In other words, John Wick served as the hostile helper in the King's story. Meanwhile, sushi-chef-cum-opponent Zero (Marc Dacascos) in *John Wick* 3 introduces himself as a "huge fan" and, in his repeated suggestions of kinship or similarity between himself and John, positions John as a test for himself that will, as Baba Yaga does, allow Zero to transcend his current status.

Yet John's "happy ending" in the first film is progressively undermined over the course of the series by "Baba Yaga's" inability to sustain a split self between the roles of legendary hitman and grieving widower, hovering on the border between the "real world" and the complicated fairyland of Assassin World. We might conclude that his original status as sympathetic monster is undergirded by the duality of his love for Helen and Daisy the puppy and his mystified, even superhuman capacity for violence. In other words, as the slippage between "Baba Yaga," "the Boogeyman," and "the one you sent to kill the Boogeyman" suggests, John's legendary status in the franchise arises from what Jeffrey Jerome Cohen calls the monster as "harbinger of category crisis." Monsters are powerful because "they are disturbing hybrids whose externally incoherent bodies resist attempts to include them in any systematic structuration," and similarly, John's refusal of categorization (a refusal repeatedly signaled by futile inquiries from others in Assassin

World as to whether he's "back" or not) allows him to inhabit multiple roles as he moves through the film's universe.[13] If his powers come from his refusal to be relegated to a single, comprehensible category, however, these powers shrink as the characters and indeed the world around John appropriate attributes of his role and increasingly contain him within categories that diminish his agency.

The first crack in the Baba Yaga identity comes not when John returns home after retrieving his car from Viggo's brother Abram—after all, we have already seen that, like Baba Yaga's chicken-legged hut, John's domestic space juxtaposes markers of sympathetic family life and monstrous violence—but when Santino d'Antonio (Riccardo Scamarcio) sits at John's table to call in his marker. By proffering a token of a favor owed, Santino strikes at the very heart of Baba Yaga's power by usurping his position in the fairy-tale narrative. "But remember," he tells John, "if not for what I did, on the night of your impossible task, you wouldn't be here right now, like this." This revelation transfers the powers of the magical helper from John to Santino. The nature of the impossible task remains mysterious, preserving the legendary nature of Viggo Tarasov's rise to power, but John's role in it has become demystified. Rather than being a singular figure of myth, John is now imbricated in a tangle of favors and obligations that compromise John's ability to wield power in Assassin World.[14]

Throughout *John Wick 2*, Santino, though hardly a formidable figure per se, manipulates the rules of the Continental and the High Table to deprive John of agency, a spider in the center of a web that directs John on an almost inevitable path. On a structural level, the filmmakers give Santino the role of inexorable driving threat that John occupied in *John Wick*; on the level of individual character choices, Santino deliberately undermines John's hybrid sense of self by blowing up his house. By destroying the house, Santino not only cuts John off from the majority of

his resources but also destabilizes the identity that was rooted in that home, the civilized, "normal" widower. As this identity provided the motivation for his bloody quest in *John Wick*, John seems almost resigned throughout much of *John Wick 2*, constantly in the position of reacting rather than acting. John kills Santino's sister Gianna because, according to the rules, Santino's marker must be honored; he kills the hitmen that pursue him because Santino, in an ironic echo of John's motives in the first movie, has claimed the right to seek revenge for Gianna. While John's feats of violence are as incredible as ever, the motives behind them no longer originate in his own, hidden wells of darkness but from the esoteric laws that govern Assassin World and Santino's mastery of them. John's lack of agency is recognized by others—as Cassian says when he hears of Santino's marker, "I see, you had no choice"—but it cannot totally acquit him or extricate him from peril as his paths for escape are continually cut off.

John's transgression of the rules at the end of *John Wick 2*, when he kills Santino in the sanctuary of the Continental, might initially seem to be a reclamation of the Baba Yaga identity, or at least evidence that he has recovered some measure of agency—after all, if his removal from the "civilization" of the society of assassins deprives him of practical resources, it also repositions him as outside of the system within which he has become entangled. Instead, *John Wick 3* continues the process, begun in *John Wick 2*, of transferring the attributes of the powerful fairy-tale witch to other characters and settings. The High Table goes from nonexistent in the first film to an organization of crime leaders in the second to a highly mystified system populated by such enigmatic figures as the Adjudicator and the Elder in the third. Rather than focus on the construction of Assassin World as a grim fairyland, however, the analysis of *John Wick 3* here focuses on two fairy-tale figures that

inform my reading of folklore in the film: the fairy tale hero(ine) and the wicked witch.

Returning to the initial scene of *John Wick 3*, I'd like to examine the volume of Russian folktales that conceals the signifiers of John's identity. Given his status as Baba Yaga, it should come as no surprise that he keeps his treasures in a book of fairy tales, a prop choice that once again situates John within the world of the fairy tale. It is, however, surprising that the image hiding these treasures is not of Baba Yaga but of Vasilisa the Beautiful (see fig. 7.3). Vasilisa, like Cinderella, is a virtuous young woman whose mother dies and whose father marries a wicked step-mother with two daughters of her own. The cruel stepmother sends her to Baba Yaga's hut for fire to light their home's candles, in hopes that the witch will kill her. But Baba Yaga does not kill her; instead, she gives her a number of impossible tasks, which are performed by a doll given to her by her dead mother, and Vasilisa succeeds in her quest for firelight—in the form of a lantern made out of a skull, which burns her stepfamily to death. It is Ivan Bilibin's 1899 illustration of this scene that appears in John Wick's book, rather than Bilibin's illustration of Baba Yaga in the same tale (see fig. 7.2). This raises the question: Is this illustration, with its grim lantern, meant to evoke John's kinship with Baba Yaga or with Vasilisa?

In Priscilla Page's reading of the opening of *John Wick 3*, the choice of illustration hints at a comparison between Vasilisa and John Wick: "Details of John's story are contained within Vasilisa's story: obviously the Baba Yaga connection, but they also share a terrible loss that prompts a journey where impossible tasks must be completed."[15] Page's phrasing here, "the Baba Yaga connection," subtly elides the transformation that the filmmakers have performed in this scene: in the first film, John *was* Baba Yaga, but now he, like Vasilisa the Beautiful, must receive Baba

7.3. Ivan Bilibin, Vasilisa from "Vasilisa the Beautiful" (1899).

Yaga's aid and survive the request. The revelation of John's backstory as Belarusian orphan Jardani Jovonovich robs him of some of the mystery that characterized his status as Baba Yaga in the first film, even as it signals that John should now be interpreted through the lens of the fairy-tale orphan, often characterized by passivity, vulnerability, virtue, and loss. The context of this revelation clarifies that even as John vacates the role of fairy-tale witch, the Director (Anjelica Huston) moves to occupy this role. The scene in which John first visits the Director in *John Wick 3*, in addition to revealing John's backstory, utilizes casting and setting to underscore more strongly the idea that the Director is John's Baba Yaga.

The fact that the Director's theater is a ballet school (which, underneath, hides a school for assassins) serves as a visual allusion that once again hints at important aspects of John's identity. On a more "realistic" axis, the association between Eastern European ballet dancers and assassins is one drawn by other media, including *La Femme Nikita* (Luc Besson, 1990), *Red Sparrow* (Francis Lawrence, 2018), and the backstory of comic-book heroine Black Widow, alluded to in *Avengers: Age of Ultron* (Joss Whedon, 2015). On a more folkloric register, however, the ballet school that hides a bloody and cruel secret recalls Dario Argento's *giallo* classic *Suspiria* (1977), whose German ballet academy hides a coven of murderous witches. That such an academy seems to have produced John Wick as Baba Yaga recalls his connection to the fairy-tale witch even as it removes him from the category of "witch" and transfers characteristics of fairy-tale monstrosity to the theater.

The character of the Director, too, appropriates qualities of the witch by virtue of both her position as the head of the sinister academy and her casting. As film scholars have long remarked, our understanding and perception of characters in movies is driven by a central paradox: while each character exists within the narrative created by the film and thus contributes to the creation of a fictional storyworld, the

character is also played by an actor who exists in our world and whose recognizable voice and appearance cue our memories of their previous roles, their personal lives, or their star persona.[16] Though this "twofoldness" may detract from our suspension of disbelief, if the actor has a particularly intrusive persona, it may also help audiences fill in blanks or add dimensions to their understanding of on-screen characters, a potential exploited by filmmakers. In discussing the possibilities of what he calls "allusive casting," Noël Carroll explains that the embodiment of characters by recognizable actors may function by "alluding to their screen persona in a way that beckons us to bring to bear associations we have regarding their earlier roles upon the character currently on screen before us."[17] Among the varied screen performances in Anjelica Huston's distinguished career, several may inflect our reading of her performance in *John Wick 3* with associations of fairy-tale witches. To list just a few, these include the Grand High Witch in *The Witches* (Nicolas Roeg, 1990), Morticia Addams in *The Addams Family* and *Addams Family Values* (Barry Sonnenfeld, 1991 and 1993), and wicked stepmother Rodmilla de Ghent in *Ever After: A Cinderella Story* (Andy Tennant, 1998). In fact, her career has at points so aligned her with the role of the witch or wicked stepmother that John Walsh's 1998 interview with Huston in the *Independent* specifically mentions these associations in its title, remarking, "Anjelica Huston has a thing about playing witches," and addresses the question of whether she is typecast in such roles.[18] If the Director herself remains subordinate to the High Table, casting Huston in the role suggests that the filmmakers sought to imbue her character with the danger and power associated with her previous characters. This suggestion is corroborated by Chad Stahelski's comment that "we wanted an actress that had the presence, the gravitas and someone you believe would just be this overpowering force in this world," and he goes on to compare the Director and John with Fagin and Oliver Twist.[19]

The associations created by Huston's casting are strengthened by the suggestions that the Director operates as a cruel, witchlike mother in her own right. "You know, when my pupils first come to me," she remarks to John, "they wish for one thing: a life free of suffering. I try to dissuade them from these childish notions, for as you know, art is pain, and life is suffering." Her words intimate that she serves as more than a ballet (or combat) instructor; she also serves as an initiatrix through the ordeals that mark her pupils' passage to adulthood. Just as Baba Yaga teaches characters and audiences "how to win treasure or understanding out of loss, fear, and pain," the Director teaches her students to create art and profit from their suffering.[20] In other words, if Santino usurps attributes of John as Baba Yaga in *John Wick 2*, the Director more directly repeats this process in *John Wick 3*, not only taking on the role of tester and helper in John's rise to legendary status but also taking on connotations of witch, initiatrix, and hostile mother that John cannot possess.

Conclusion: John Wick the Semi-hero

Vladimir Propp's morphological analysis of the Russian folktale describes its world in terms that will be familiar to viewers of the *John Wick* films. What he calls the "two-fold quality of a tale"—not to be confused with the twofoldedness of cinematic character—consists of "its amazing multiformity, picturesqueness, and color, and on the other hand, its no less striking uniformity, its repetition."[21] This, as he explains, is due to the fact that, although there may be any number of witches, wolves, and handsome young men in a fairy tale, the tale's number of plot functions is highly limited. Similarly, countless numbers of hapless goons fill the function of "security guard who is killed by John Wick" or "greedy, ambitious assassin out for a bounty—who is also killed by John Wick."

John himself, however, moves between multiple plot functions while still performing a single set of actions.

These actions, initially imbued with a semimythical force, increasingly become signs of a man who is not permitted to sustain either of the lives he has created. The residue of Baba Yaga clings to John, but the highly ritualized world of the High Table, which in its omnipresence eradicates the border between *inside* its system and *outside* its system as the series progresses, evacuates John's identity of its superhuman or folkloric attributes. Going into the final combat of *John Wick 3*, Winston asks John to choose between the identities of Baba Yaga and Helen's husband, but the irony is that neither choice allows John any particular agency, only allegiance to one side or the other, and both choices involve a lot of killing. In short, the ambiguous, high-powered assassin of *John Wick* has been almost entirely deconstructed.

At the same time, Winston's enigmatic remark after he has betrayed and shot John, "Baba Yaga," suggests that the seemingly defeated superassassin will make a return. Indeed, John's final conversation with the Bowery King—his simple "Yeah" in response to the question, "You pissed, John?"—recalls John's terse responses to questions about whether he's "back" in the first film. This conversation also hints at a return of Baba Yaga–esque power, in that John seems poised to call again on his own relentless wells of anger to accomplish vengeance against his enemies. Finally, I return to Taha Ibrahim's conception of the semihero, the hero whose success "is not final, that is, it allows for further complexity." If John has seemingly failed to achieve the goals of either the fairy-tale witch or the fairy-tale hero by the end of *John Wick 3*, he does not seem to have lost the resourcefulness and adaptability that characterized his initial legendary identity. This allows for the distinct possibility that his current failure, too, is far from final. The destruction of his identity over the course of the franchise may, like the apparent

defeats in *John Wick,* allow for the resurrection of the complex Baba Yaga identity in subsequent installments as John's final positioning outside the hierarchy of Assassin World in *John Wick 3* offers the potential to reclaim the mantle of monstrous avenger.

Notes

1. For a fuller explanation, see Rhonda Evans, "What Was John Wick Reading at the New York Public Library?," *Biblio File* (blog), New York Public Library, May 17, 2019, https://www.nypl.org/blog/2019/05/17/john-wick.

2. Taha Ibrahim, *Heroizability: An Anthroposemiotic Theory of Literary Characters* (Boston: De Gruyter Mouton, 2015), 7.

3. Sonny Bunch, "John Wick Is the Perfect Folk Hero for Our Age—and Keanu Reeves Is the Perfect Person to Play Him," *Washington Post,* May 22, 2019, https://www.washingtonpost.com/opinions/2019/05/22/john-wick-is-perfect-folk-hero-our-age-keanu-reeves-is-perfect-person-play-him/?noredirect=on.

4. Moira Hicks, "John Wick Is a Modern Fairy Tale: The Witch, the Knight, and the King," *Fanbyte,* June 6, 2019, https://www.fanbyte.com/features/john-wick-is-a-modern-fairy-tale/.

5. See Catriona McAra and David Calvin, eds., *Anti-tales: The Uses of Disenchantment* (Newcastle-upon-Tyne: Cambridge Scholars, 2011), especially the introduction and Larisa Prokhorova, "Some Notes on Intertextual Frames in Anti-Fairy Tales," 51–59.

6. Georgy Manaev, "How John Wick Got Baba Yaga Completely Wrong," *Russia Beyond,* May 31, 2019, https://www.rbth.com/arts/330441-how-john-wick-got-baba-yaga-wrong.

7. My thanks to Mary Nestor for calling *Hellboy* to my attention and for her insights on the film. Of *The International Fairy-Tale Filmography*'s twenty-four results for "Baba Yaga," the English-language entries are *Hellboy, John Wick, John Wick 2, Lawn Dogs,* Clive Tonge's 2005 animated short *Emily and the Baba Yaga,* and two entries in the *Ever After High* animated series, *Ever After High: Thronecoming* (2004) and *Ever After High: Epic Winter* (2016). If one adds *John Wick 3,* it becomes increasingly apparent that more than half of English-language Baba Yaga films include one or more male Baba Yagas. See Pauline Greenhill, Kendra Magnus-Johnston, and Jack Zipes, *The International Fairy-Tale Filmography,* University of Winnipeg, accessed June 24, 2020, http://iftf.uwinnipeg.ca/. One more film not listed on the *IFTF,* the animated

Year of the Fish (David Kaplan, 2007), features another Baba Yaga performed by a male actor, Randall Duk Kim—"a sexually and ethically ambiguous larger-than-life character" in keeping with the other male Baba Yagas examined here (Cristina Bacchilega, *Fairy Tales Transformed? Twenty-First-Century Adaptations and the Politics of Wonder* [Detroit: Wayne State University Press, 2002], 125). It's worth noting that Randall Duk Kim also appears as the Doctor in the *John Wick* franchise.

8. Brandon Zachary, "The Hellboy Reboot Focuses on the Wrong Villain," CBR. com, April 14, 2019, https://www.cbr.com/hellboy-2019-villain-should-be-baba-yaga/.

9. Marina Balina, Helena Goscilo, and Mark Lipovetsky, eds., *Politicizing Magic: An Anthology of Russian and Soviet Fairy Tales* (Evanston, IL: Northwestern University Press, 2005), 13. See also the introduction to Andreas Johns, *Baba Yaga: The Ambiguous Mother and Witch of the Russian Folk Tale* (New York: Peter Lang, 2004).

10. See, for example, Megan Armknecht, Jill Terry Rudy, and Sibelan Forester, "Identifying Impressions of Baba Yaga: Navigating the Uses of Attachment and Wonder on Soviet and American Television," *Marvels and Tales: Journal of Fairy-Tale Studies* 31, no. 1 (2017): 62–79; Jill Terry Rudy and Jarom Lyle McDonald, "Baba Yaga, Monsters of the Week, and Pop Culture's Formation of Wonder and Families through Monstrosity," *Humanities* 5 (2016): 40.

11. For the purposes of this essay, I refer to the versions of the fairy tales in A. N. Afanas'ev, *Russian Folk Tales*, trans. Robert Chandler, ill. Ivan I. Bilibin (Boulder, CO: Shambhala/Random House, 1980).

12. See Vladimir Propp, *Morphology of the Folktale*, 2nd ed., trans. Laurence Scott, rev. and ed. with a preface by Louis A. Wagner (Austin: University of Texas Press, 1986). These plot points correspond to Propp's functions XI (the hero departs on a quest), II and III (interdiction and violation), XIX (the initial lack is liquidated), and XXI (the hero is pursued).

13. Jeffrey Jerome Cohen, "Monster Culture: Seven Theses," in *Monster Theory: Reading Culture*, ed. Jeffrey Jerome Cohen (Minneapolis: University of Minnesota Press, 1996), 6.

14. For more on the role of debt compelling John's participation in the world of the High Table, see Edward P. Dallis-Comentale's chapter in this volume.

15. Priscilla Page, "The Universe of John Wick," *Birth. Movies. Death*, July 1, 2019, https://birthmoviesdeath.com/2019/07/01/the-universe-of-john-wick.

16. On this "twofoldness" of screen characters, see, for example, Murray Smith, "On the Twofoldness of Character," *New Literary History* 42, no. 2 (2011): 277–94; Ted Nanicelli, "Seeing and Hearing Screen Characters: Stars, Twofoldedness, and the Imagination," in *Screening Characters: Theories of Character in Film, Television, and Interactive Media*, ed. Johannes Riis and Aaron Taylor (New York: Routledge,

2019), 19–35; Paul McDonald, "Story and Show: The Basic Contradiction of Film Star Acting," in *Theorizing Film Acting*, ed. Aaron Taylor (New York: Taylor and Francis Group, 2012), 169–83.

17. Noël Carroll, "The Problem with Movie Stars," in *Minerva's Night Out: Philosophy, Pop Culture, and Moving Pictures* (Oxford: Blackwell, 2013), 112.

18. John Walsh, "The Stepmother Complex: Anjelica Huston Has a Thing about Playing Witches. But Can She Do More Than Just Scary? John Walsh Meets a Versatile Vamp," *Independent*, October 6, 1998, 10.

19. Susan King, "Anjelica Huston's Magical Movie Life, from 'Prizzi's Honor' to 'John Wick,'" *Los Angeles Times*, May 17, 2019, https://www.latimes.com /entertainment/movies/la-et-mn-classic-hollywood-anjelica-huston-john-wick -20190517-story.html.

20. Sibelan Forester et al., eds., *Baba Yaga: The Wild Witch of the East in Russian Fairy Tales* (Jackson: University Press of Mississippi, 2013), xli.

21. Propp, *Morphology of the Folktale*, 21.

CAITLIN G. WATT is Lecturer in the Department of English at Clemson University. Her work focuses on gender and sexuality and narrative theories of character in medieval romances. Her work has appeared in *Neophilologus, Erasmus Studies, Medieval Feminist Forum*, and *Postmedieval*. Her current project examines the development of the Arthurian storyworld in medieval manuscripts.

8 CAPTAIN DEAD WICK

GRIEF AND THE MONSTROUS IN THE JOHN WICK AND DEADPOOL FILMS

MARY NESTOR

Throughout the *John Wick* franchise, the cause of death of John's wife, Helen, is never revealed; the audience knows only that she died from a terminal illness. However, this does not affect our identification with John's emotions as his wife dies in the hospital, much as we can empathize with Wade Wilson's experience in the first *Deadpool* film (2016) as his doctor informs him of his terminal cancer. Even if we have not experienced such events ourselves, we know someone who has, and we can identify with the protagonists of these films despite their violence and ruthlessness. So, while on its surface *John Wick* may appear to be an action film whose primary purpose is making fun of the absurdity of most violent action films—after all, it was "just a fucking dog!"—it is also a treatise on the way that death and loss can upend the lives of those left behind and disrupt their motivations to the point of absurdity. Recognizing the way this film acknowledges the absurdity of the death of a puppy as its driving premise is essential to understanding the way that *John Wick* parodies action films more broadly and their often-ludicrous justifications of high body counts and extensive property damage. However, it is precisely this absurdity that generates parody in *John Wick*, an absurdity that the two subsequent films in the franchise identify and at times foreground. This kind of parody that employs exaggeration to draw attention to its own absurdity is also taken up by the *Deadpool*

franchise and put on overdrive. Indeed, the second *Deadpool* film—which connects itself explicitly to *John Wick* in its opening credits—reiterates the same questions posed by *John Wick*, one of which receives attention here: What brings a monster into being? In *John Wick* it is loss and grief, in *Deadpool*, cancer and loss, but in both the individual who loves becomes the most dangerous and vicious. This essay examines the intersections of parody, monster culture, loss, and hope in the *John Wick* and *Deadpool* film franchises, arguing that grief and anguish bring the monster into being and beget the violence in both. If so, these films offer an unsettling message, for while not everyone can be an internationally feared hitman or a superpowered mutant, every human being has the capacity to experience a type of loss that sparks the grief and attendant rage that drive them to do something, anything, about it. If we are all John Wick, what then?

While my argument is focused largely on the parodic aspects of the *John Wick* and *Deadpool* franchises, it is also informed by the ways these films engage with contemporary monster culture as part of their cultural work. It is through the intersection of parody and the monstrous that these works are able to make complex statements about the impacts of loss and grief on the individual and the concomitant effect of the grief-stricken man on the world around him. The conception of monster culture adopted here is derived from Jeffrey Cohen's foundational essay "Monster Culture (Seven Theses)."[1] Here, Cohen contends both that "the monster is the harbinger of category crisis" (thesis 3) and that "the monster stands at the threshold . . . of becoming" (thesis 7).[2] Thus, the monster is the herald of crises of identity outside itself at the same time that it stands on the border of its own transformation. However, the *John Wick* and *Deadpool* films further problematize the tension between these two theses, offering the possibility that category crisis may in fact

be the harbinger of the monster rather than the other way around: it is the transition from husband to widower that turns John Wick back into the Boogeyman, and it is a diagnosis of late-stage cancer that results in Wade Wilson seeking out Project X and becoming a disfigured, unkillable mutant. In his introduction to the collection *Monster Theory Reader* (2020), Jeffrey Andrew Weinstock identifies the social origins of contemporary monstrosity: "What differentiates contemporary monster theory from the theorization of monsters in earlier periods is primarily the position that monstrosity is a socially constructed category reflecting culturally specific anxieties and desires, and often deployed—wittingly or not—to achieve particular sociopolitical objectives. Contemporary monster theory thus disavows (or at least sidesteps the question of) the monstrosity of human subjects based on morphology and instead focuses on the means through which such subjects are 'monsterized' and the implications of this process."[3] So, while Weinstock shares with Cohen—whom he frequently cites—the focus on monstrosity as a representation of cultural fears and desires, he also builds on Cohen's theories to contend that the monstrous is not a static category but rather a process. This implies that when someone is monsterized, their categorization cannot be defined with certainty, as they could be enduring just one stage in the process of transformation and may be able to change further. This is significant for this conversation because it goes some way to explaining how John Wick and Wade Wilson can become more monstrous over the course of their film franchises and how their monstrosity can infect the worlds around them.

Moreover, these franchises provide case studies for examining the use of parody to comment on human nature and culture, since not only do both the *John Wick* and *Deadpool* film series function in part as parodies of their genres—in the case of *John Wick*, the ultraviolent action movie, and in the case of *Deadpool*, the comic-book superhero

film—but each serves equally well as an example of its respective genre, in contrast to parodies such as *Spaceballs* (1987), which can be understood only in the context of the sources they transform. This is not as contradictory as it appears on the surface, as Linda Hutcheon explains: "Like irony, parody is a form of indirect as well as double-voiced discourse, but it is not parasitic in any way. In transmuting or remodeling previous texts, it points to the differential but mutual dependence of parody and parodied texts. Its two voices neither merge nor cancel each other out; they work together, while remaining distinct in their defining difference."[4] Extending this "double-voiced discourse" from the transformation of individual texts to the transformation of genres, parody builds on and coexists with what it parodies. Indeed, Hutcheon acknowledges that "parody can manifest itself in relation to either particular works or general iconic conventions," and although she is referencing visual art primarily, this parody of "iconic conventions" can be found equally in other media such as film.[5] This thesis is supported by the work of Dan Harries, who agrees that films may parody whole genres as well as specific texts and argues that "by evoking a genre to be spoofed, film parody not only uses the genre's structure to create difference through the processes of exaggeration, extraneous inclusion, literalisation, inversion and misdirection, but also reiterates and reaffirms the conventions that constitute the genre's structure through these processes."[6] Therefore, parody can not only spoof and comment on a genre but also help define its borders—to create a generic "master map," in Harries's terminology.[7] It is worth noting that parody involves inversion and subversion in transforming and commenting on texts and genres, but parody is not necessarily humorous—although it often is, and certainly the *Deadpool* films employ parody for comic effect.

The assertion that not all parodies are necessarily comedies is important, as some theorists have approached parody as innately comedic,

which, if accurate, would challenge my reading of *John Wick*. For example, in his work *Parody as Film Genre: "Never Give a Saga an Even Break"* (1999), Wes D. Gehring examines parody as a cinematic subgenre of comedy.[8] Inherent in Gehring's analyses is the assumption that all film parody is primarily comedic in nature. While it is true that many parodies are comedies, not all are. *John Wick* is a perfect example of this, for while it contains significant elements of humor, it is certainly not a comedy. Moreover, the fact that the *John Wick* films are not primarily comedies does not make them any less parodic than the highly comedic *Deadpool* films. Despite the assumption that "the fundamental goal of parody is to be *funny*," Gehring also acknowledges the centrality of its "creative criticism."[9] Furthermore, he undercuts his own assumption that all parody must be funny by dividing the genre into two categories: films that achieve parody through "the broad and obvious puncturing of a genre or auteur, and a more subdued approach that manages comic deflation with an eventual reaffirmation of the subject under attack."[10] Gehring states that the latter category of reaffirmation film is "often confused with the genre being undercut.... This produces a fascinating tension between genre expectations ... and a parody that is comic without deflating the characters involved."[11] If the genre of a film parody can be confused with the genre it is parodying, then it is possible that it can simultaneously exist within the genre of parody and the genre it undercuts and reaffirms regardless of whether the original genre is comedic or otherwise. This would seem to challenge Gehring's own assumption that film parody must exist under the broader genre of comedy and suggests that the absurdity and creative commentary intrinsic to parody need not be overtly laughter-inducing. From this perspective, the *John Wick* films are a perfect example of reaffirmation parodies despite the fact that they cannot be classified as comedies. So, while the parodic elements of the *Deadpool* franchise (such as fourth-wall breaking) are more

obvious, it is equally possible to view the *John Wick* films as parody, in the same way that, like the *Deadpool* films, they exist in a fantasy universe. More important, both franchises revise well-established conventions of their genres in ways that audiences recognize and understand as commentary on those genres and on the human figures at their cores.

To be sure, although it might be argued that the violent world of the *John Wick* films and its economy of ultraskilled assassins are themselves parodic, the most striking element of their parody is, as I have mentioned, the event that catalyzes the action: the killing of Daisy, the puppy given to Wick by his dead wife (Bridget Moynahan). Iosef (Alfie Allen), son of Russian mobster Viggo Tarasov (Michael Nyqvist), steals John Wick's car as well, but there is little doubt that the puppy's murder is more determinative. Although an unjustifiable level of violence and death in response to a relatively contained event is a common feature of the action revenge film, *John Wick* takes this to the extreme as part of its parody of the genre.[12] The body count and property damage seem ridiculous—and to a certain extent they are. Yet, although *John Wick* films frequently remind viewers of the absurdity of this originating event, the carnage Wick wreaks has its roots in something that is far from absurd. This motivation is addressed directly in the first film during an exchange between John and Viggo:

> John: Step aside. Give me your son.
> Viggo: John Wick. Baba Yaga. It was just a
> fucking car. Just a fucking dog.
> John: Just a dog. . . . Viggo.
> Viggo: Yeah?
> John: When Helen died, I lost everything. Until that dog arrived
> on my doorstep—a final gift from my wife. In that moment
> I received some semblance of hope . . . an opportunity to
> grieve unalone. And your son . . . took that from me.

Viggo: Oh, God.
John: Stole that from me. Killed that from me!

Daisy clearly was not just a dog; she was John's lifeline to hope and his chance to be "unalone," both of which were destroyed by her murder. His quest for revenge is thus also a quest to both restore hope and erase a double loss and grief. At the end of the first film, John's liberation of a new dog signifies that he is reclaiming hope and attempting to undo his transformation into a monster, even if this hope and reversal are only temporary. The echoes of Wick's actions in the first film, however, reverberate so loudly that in its sequels he is inevitably drawn ever further back into his old world and old life—becoming more and more monstrous, even if it is against his will. These films also remind the audience that their events were precipitated by the murder of a dog. In *John Wick 3*, for example, when Wick seeks aid from the matriarch of Roma Ruska (Anjelica Huston), she exclaims incredulously, "All of this for what? [in Russian] Because of a puppy?" To which he answers (in Russian), "It wasn't just a *puppy*." These reminders are important, as each film is more violent and exacts a greater personal cost on Wick than its predecessor, ending in *John Wick 3* with his effectively disowning his identity as Helen's husband, defying the Elder and the High Table in a last-stand alliance with Charon (Lance Reddick) and Winston (Ian McShane), and finally being betrayed by Winston before being rescued by the Bowery King in what is obviously a setup for the fourth film. Without the frequent reminders, it would be easy to forget that all this started because a Russian mobster's son killed John Wick's dog and stole his car.

Deadpool differs from *John Wick* in that it is adaptive as well as parodic, and indeed some of its most notable parodic elements are derived from the numerous comic series on which it is based, including the

irreverent humor and fourth-wall-breaking aspect of Deadpool's character. However, the *Deadpool* film franchise is not a direct adaption of the multiple other versions of *Deadpool* in comics, video games, and animation. And despite being an offshoot of the *X-Men* film series, it does not belong in precisely the same canon as the other *X-Men* films either, though *Deadpool* does intersect with them. This incongruity is continually underscored in the films themselves and forms another layer of its parody, as when Wade (Ryan Reynolds) comments on the fact that only Colossus and Negasonic Teenage Warhead are ever seen at the Mutant Manor in the first film, or when the death of Wolverine in the R-rated *Logan* is used as a framing device for the opening of *Deadpool* 2. The *Deadpool* franchise parodies not only the comic-book superhero genre generally but also specific texts and franchises outside of the comic-book realm, such as the melodramatic *James Bond* film title sequence in the opening of *Deadpool* 2, which echoes other touchstones of popular culture such as *Flashdance* in addition to the *Bond* films. A similar allusion occurs later in the same film when Deadpool recruits Colossus by standing outside the Mutant Manor with "In Your Eyes" playing from a tiny boombox and begging him to help out with the mission in a direct reference to the teenage rom-com *Say Anything*. The adaptive aspects of this franchise do not conflict with its parody but rather are part of it, playing with and against the audience's horizons of expectation to develop its humor across both films.

Just as parody in the *John Wick* franchise begins early in the first film, *Deadpool*'s parody of the superhero genre begins in its opening scene and is extended as the film progresses. One of the more overt examples of this occurs in the immediate aftermath of Wade Wilson's transformation into a hideously disfigured mutant. Wade and his friend Weasel (T. J. Miller) discuss his plans to find the "British Villain" Francis who is responsible for his disfigurement:

Weasel: All you need now is a suit and a nickname . . . like Wade
 the Wisecracker . . . or Scaredevil, Mr. Neverdie. Oh, shit.
Wade: What?
Weasel: I put all my money on you and now . . . I just
 realized I'm never gonna win the, uh . . .
Wade: Dead pool. *Captain* Deadpool . . . No, just . . .
 just Deadpool, yeah. [emphasis added]
Weasel: Just Deadpool. To you Mr. Pool. Deadpool.
 That sounds like a fucking franchise.

Although it is not part of the fourth-wall-breaking narration that serves as a vehicle for much of the films' parody, this exchange identifies *Deadpool* as both a superhero origin film and a parody of superhero origin films—that is to say, this dialogue acknowledges the absurdity of many superhero name conventions and identifies the function of the origin-story movie as an impetus for a series rather than a standalone film.

The second *Deadpool* film both expands on the franchise's parodic commentary and enters into an explicit conversation with *John Wick* on the consequences of loss and grief. The plot of *Deadpool 2* is propelled by Russian bad guy Sergei Valishnikov's murder of Deadpool's girlfriend, Vanessa (Morena Baccarin). Wade had earlier failed to kill Sergei after Sergei had locked himself in a panic room; as a result, Deadpool takes a "catnap on 1,200 gallons of gasoline," which he ignites in an unsuccessful attempt to commit suicide. The spoof opening credits that follow this explosion clarify that the film stars someone "who obviously hates sharing the spotlight," is "written by the real villains" (a contrast to the credits of the first film, which call the writers the "real heroes here"), and—most relevant here—is "directed by one of the guys who killed the dog in John Wick." This "guy" is David Leitch, one of the producers of the *Wick* franchise and the uncredited codirector of *John Wick*. After the credit sequence, Deadpool's goal through the rest of the film is

saving a troubled teenage mutant named Russell in an attempt to get his heart "in the right place" and be worthy of reuniting with Vanessa in the afterlife. Deadpool's narration describes this sequel as "a family film" in the same tradition as *Bambi* and *The Lion King*, since "every good family film starts with a vicious murder." Although this statement is clearly part of the parodic irony so central to the franchise, it is also useful for understanding why Deadpool is able to regain hope after Vanessa's death, while John Wick descends so far into despair that he is willing to chisel off his wedding band—finger and all—to return to his identity as the master assassin, even if in theory he does so to remember Helen. Ultimately, Deadpool offers a different interpretation of the power of grief, as through his monstrosity he is able to use the motivating force of grief to rescue both the troubled teen mutant Russell and the people Russell would have killed in the future.

The *John Wick* films are far from the only works with which *Deadpool 2* directly engages; among these is the action-comedy *Keanu* (2016) starring Keegan-Michael Key and Jordan Peele. While this film about the kidnapping and rescue of a kitten shares striking similarities with *John Wick* and, in addition to its title, incorporates references to such films as *Point Break* (1991) and *The Matrix* (1999), it was already in production when *John Wick* was released and, despite speculation to the contrary, is not a parody of the latter work.[13] However, its frequent references to Keanu Reeves's films and the inclusion of a short voice-over from Reeves in a dream sequence place it within the broader intertextual conversation surrounding the *John Wick* franchise and Reeves's other films. The key scene at the end of *Keanu* involves one of the villains being run over by a car driven by Clarence (Keegan-Michael Key), which appears to come out of nowhere. This scene is replicated and parodied at the end of *Deadpool 2*, where this plot device is used to eliminate the evil headmaster of the young mutant reform school, and its implausibility

is humorously noted by Deadpool, who breaks out laughing and states, "I could hear you coming the last thirty seconds. I could barely keep a straight face." While *Keanu* may not be a direct parody of *John Wick*, its position within the intertextual reception of the *John Wick* franchise and Reeves's oeuvre further adds to the sense that *Deadpool 2* is engaging with this conversation as part of its broader parody.

It is worth noting at this point that the *John Wick* and *Deadpool* franchises are not the first film parodies to engage with the monstrous potential of grief. The 2007 film *Hot Fuzz*, starring Simon Pegg as Sergeant Nicholas Angel (a London Met police officer transferred to the rural village of Sandford as punishment for his superefficiency) and Nick Frost as Constable Danny Butterman (son of Angel's new boss and now his partner), is an action comedy that parodies multiple genres including the supercop action film and the *Midsomer Murders*–esque detective show. Unlike in *John Wick* or *Deadpool*, the figure in *Hot Fuzz* who allows his grief to fuel monstrous actions is not one of the protagonists but rather their opponent, Danny's father, Inspector Frank Butterman (Jim Broadbent), who controls the village through the members of the Neighborhood Watch Alliance and has anyone who endangers Sandford's chances of winning the village-of-the-year contest murdered. Ultimately, the film proves that Inspector Butterman's motivation for having dozens of people killed by a secret cabal of shop owners, teachers, and other upstanding community members is the death of his wife, who drove her car off a cliff after her efforts to help Sandford win the village-of-the-year contest failed. Frank explains, "We lost the title and Irene lost her mind. She drove her Datsun Cherry into Sandford gorge. From that moment on, I swore that I would do her proud and make Sandford great again." Thus, his grief at the loss of his wife results in an obsession with a twisted version of "the greater good," which in his view can justify killing not only annoying adults but also mildly delinquent

children. Although he may not be a master assassin or a deformed mutant, this makes the villainous Frank perhaps even more monstrous than Wick or Deadpool.

While the ultimate motivation for all the death and carnage in *Hot Fuzz* is in itself parodic, this film also targets specific texts and tropes not only from rural British crime shows but also from Hollywood action cinema, and—significantly for this conversation—it engages with a film in Reeves's oeuvre. Film theorist Neil Archer has examined the parodic nature of *Hot Fuzz*, regarding it as an example of British national film and arguing that its parodic elements allow it to negotiate between national and global audiences.[14] Archer focuses on the way that *Hot Fuzz* engages with scenes and tropes from *Bad Boys II*, but this is not the only film embedded within *Hot Fuzz*; another happens to be one featuring Keanu Reeves: *Point Break*. The scene from *Point Break* where Reeves's character, Johnny Utah, finds himself unable to shoot a fleeing bank robber (played by Patrick Swayze) because of the friendship that has developed between the pair during an undercover operation is reenacted three times during *Hot Fuzz*. Constable Danny Butterman first describes the scene to Sergeant Nicholas Angel early in *Hot Fuzz* while they are sitting and waiting for speeders; later, Angel and Danny are shown viewing this specific scene during an after-the-pub double feature of *Point Break* and *Bad Boys II*; and in the final scenes of the film, Danny plays the part of Keanu Reeves, shooting up into the air as his father flees from the final fight into Danny's own police car. However, in *Hot Fuzz* the monstrosity created by grief is contained, as an escaped swan—which Danny and Angel have been pursuing for most of the film and only caught minutes before—emerges from the back seat and causes Frank to crash the car into a tree. Subsequently, Frank and all of the perpetrators are rounded up and arrested. The penultimate scene of the film shows Danny placing flowers on his mother's grave before

he and Angel return to their duties as Sandford police officers, showing that Irene Butterman is no longer being honored by murderous monstrosity but by the proper enforcement of law and order. However, while the grief-induced monstrosity of *Hot Fuzz*'s antagonist is contained and defeated, that of the protagonists in *John Wick* and *Deadpool* intensifies over the course of multiple films and remains uncontained.

It is notable that both film franchises also employ self-parody in their later installments—in a more limited way in *John Wick* than in *Deadpool*—exploiting this self-criticism to comment on humanity's ever-expanding capacity for monstrousness. For instance, the opening credits of *Deadpool 2* echo the opening of the first film at the same time that they parody the earlier credits and comment on Vanessa's early and unexpected death, while *John Wick 3* includes a scene in Morocco where a dog belonging to John's former ally Sofia (Halle Berry) is shot by her mentor, Berrada (Jerome Flynn), and—although the dog is wearing a bulletproof vest and survives—Sofia shoots Berrada and goes on a killing spree in response. When she goes to deliver the kill shot to Berrada, John intervenes, saying, "Sofia, don't." She then shoots Berrada in the leg and states, "He shot my dog." To which John Wick dryly replies, "I get it." This exchange is both a parody of and a commentary on Daisy's death in the first film, which the audience will clearly understand. After this scene, Sofia's dogs have their metaphorical revenge as she and Wick fight their way out of Morocco. This scene involves not only their killing a horde of henchmen but also both of Sofia's dogs fighting alongside them. The dogs work in tandem with her in this scene, and, rather than being defenseless victims as Daisy was, they are equal partners in her battle. Instead of seeing Daisy's lifeless head lying next to John Wick's face, the audience is presented with snarling Belgian Malinois leaping over walls and overwhelming henchmen. However, while in *Deadpool 2* the self-referential parody is part of an arc that opens the possibility

that Wade Wilson can become a better kind of monster, the self-parody of *John Wick 2* and *3* does not lead to Wick's return from monstrosity. Instead, this canine triumph leads immediately to the scene in the desert where he sacrifices the finger bearing his wedding band in exchange for a chance to have the protection of the Elder and be free of the bounty on his head—a chance Wick squanders.

The self-parody in the *John Wick* franchise is heightened by its references to outside texts. The introduction of Laurence Fishburne as the Bowery King in *John Wick 2*, for example, is one of the more notable instances of a casting choice expanding the intertextual circle of the franchise, as the Bowery King explains that Wick gave him a lesson that opened his eyes to the truth of their world when the Bowery King was younger:

> Mr. Wick doesn't remember, but we met many years ago, before my ascension . . . when I was just a pawn in the game. We met and you gave me a gift, the gift that would make me a king. You don't remember, but there I was, standing in an alleyway. I didn't even hear you comin'. You gave me this. [Pulls down collar to reveal a scar on the side of his neck.] Gift from the Boogeyman. Perfect for every occasion. But you also gave me a choice. Pull my gun, shoot you in the back, and die, or keep the pressure on my neck . . . and live. And so you see, I survived. No one sneaks up on me anymore, thanks to you. I am all-seeing and all-knowing.

An informed audience recognizes this scene as a parodic reversal of the actors' roles as Morpheus and Neo in *The Matrix*, where Fishburne's character exposes Reeves's Neo to the realities of their world and releases him from a life of unwitting servitude as a human battery. While John Wick and the Bowery King are one-time opponents and tenuous allies through most of the franchise, the Bowery King's rescue of John

at the end of *John Wick 3* seems to be the punchline of a long joke playing against and with the audience's expectations of these characters. With his offer to join Wick in battling the High Table—since "under the table is where shit gets done"—the Bowery King once again becomes Morpheus offering Neo the only real solution to the problems in his life.

However, the most striking example of a casting choice enhancing the parodic aspects of a character in the series is that of Mark Dacascos as Zero, John Wick's biggest fan, who is thrilled when the Adjudicator tasks him and his cohort of ninja-assassin students with killing Wick. Zero is introduced as a sushi chef—which alludes to Dacascos's longtime role as the backflipping chairman of the Food Network's *Iron Chef America* cooking competition show and adds another layer of humor to this character. In his introduction, Zero is shown feeding a tidbit to a cat lounging on the counter of his sushi stall, thus implicitly positioning Zero as a "cat person" in opposition to John Wick, the dog avenger. When his first attempt to kill Wick is cut short on the steps of the Continental, Zero follows him into the lobby, and when he sits at one end of a long couch, Zero sits next to him despite the fact that there is plenty of room to sit at a normal distance. Wick moves to an armchair, whereupon Zero moves down the couch toward John's new seat and says, "I gotta tell you, I've been looking forward to meeting you for a long time. I'm a huge fan, John Wick. And so far you haven't disappointed." At this point in the scene, Dog, the Daisy replacement, runs up to John, and Zero says, "Is that the dog? He likes you. Me? I'm more of a cat person myself." Thus, this brief interchange confirms the cat-person-versus-dog-person opposition implied in Zero's introduction at the same time that Zero positions himself as a John Wick fanboy who does not see admiration as incompatible with deadly confrontation.

In addition, Zero tries to cast himself as the same as John Wick—claiming that they are both "masters of death"—but Wick rejects the

comparison, a rejection that in no way deters Zero from approaching their final fight with enthusiasm. At the beginning of their battle, Zero appears to toy with John, at one point standing behind a pane of bulletproof glass and wagging his finger, at another watching from an upper level as his students are bested by John and giving him a slow clap and double thumbs-up. One pair of his students play with John in a similar way, as they help John off the ground after getting him into a position where they could easily have dispatched him, and one comments that he is honored to be fighting John Wick. This pair fights with John a few more minutes until they are incapacitated but still alive. At this point, John gives the fallen pair a small bow and says, "Be seeing you," in a display of professional respect that differs markedly from the way he responds to the death of Zero himself.

Even after he has watched Wick kill or incapacitate his students, Zero approaches his confrontation as a long-anticipated contest rather than a life-and-death struggle. As he watches John approach after confronting the final pair of his students, Zero declaims, "John, you're incredible. Exhausted, outnumbered, obviously in pain, and you still beat all of my students. If I didn't have to kill you, we'd be . . . pals." To which John grimly replies, "Let's do this." Early in the fight sequence, Zero seemingly vanishes only to reemerge from behind a glass display case and once again claim, "See. We're the same." Following this, he appears to be gaining the advantage, but soon John recovers and toys with him in turn, vanishing and reappearing twice—at one point using Zero's trick of appearing behind a sheet of glass—until finally he disables Zero's left arm and delivers the killing blow. Zero maintains his fanboy attitude toward Wick even as he nears the point of death, having been impaled through the chest with a sword similar to a katana, spending his last breaths to remark, "Hey, John. That was a pretty good fight, huh? . . . Don't worry about me, John. I just gotta catch my breath.

I'll catch up to you, John." To which Wick responds, "No, you won't." This exchange contrasts sharply with the deaths of Viggo in *John Wick* and Ares in *John Wick 2*, where in each case his opponent states as they die, "Be seeing you," and John replies, "Sure." Thus, John denies Zero the final token of comradery that he offered Viggo, Ares, and even Zero's own students in recognition that they fought well. This seems strange, as Zero is even more highly skilled than Viggo or Ares and leads a crew of equally well-trained hitmen, so it follows that the change in the dynamic must come from Wick rather than his opponent. John's seriousness here is accentuated, contrasting sharply with the absurd humor of Zero, the John Wick fanboy. Perhaps this is because Zero is a cat person, but it may also suggest that as the series progresses, Wick is becoming ever more monstrous.

The reason why the *Deadpool* films end with hope while the *John Wick* films seem to descend ever further into darkness is that Wade Wilson embraces the absurdity of his situation and balances his grief with humor, thus allowing himself to overcome it, while John Wick denies the absurdity of his world and is largely unable to find the humor in his situation. This element of Deadpool's personality is discussed explicitly by the character Cable in the second *Deadpool* film, who tells Deadpool that the latter reminds him of his wife and that "she always struggled. But she was funny and filtered her pain through the prism of humor. Something I could never master." It is this variety of humor that gives Wade Wilson the hope that John Wick struggles to maintain. While Deadpool provides the bulk of the explicit commentary in these films through his frequent fourth-wall-breaking asides, ironically it is Cable in *Deadpool 2* who offers the most striking commentary on Deadpool himself. Furthermore, the contrasts between these two figures who are otherwise so similar illuminate what is crucial about Deadpool's character: though the deaths of the women they love are both perpetrated

by bad guys that Cable and Deadpool failed to assassinate, Cable blames only the bad guy who got away, while Deadpool attributes Vanessa's death to his lifestyle. Cable goes back in time to kill a kid, while Deadpool tries to save that kid; Deadpool filters his "pain through the prism of humor," while Cable, like Wick, maintains a largely humorless approach to the tragedy of life.

Since John Wick cannot see the absurdity of life, he has no filter for the pain of the double loss of his wife and Daisy, and his grief becomes all-consuming. Thus, he is dragged ever further down the dark rabbit hole of loss to the point where he severs his connection with humanity and the love that spawned his grief in the first place. The ripple effects of Wick's actions in response to his loss are so wide-reaching—and also so psychically resonant—that he gradually loses the grief that motivated those actions. This is evidenced by his relinquishment of the replacement for Daisy in *John Wick 3*—even if ultimately this is not permanent—as well as by his willingness to amputate the finger bearing his wedding band in exchange for an opportunity to have the bounty removed from his head by the mysterious Elder (Saïd Taghmaoui). The opening of John's interview with the Elder is indicative both of how far his grief has taken him from the man he was with Helen and of how much further he could fall:

> Elder: Never seen a man fight so hard to end up back where he started. So tell me, Jonathan. Why do you wish to live?
> John: My wife, Helen. To remember her. To remember us.
> Elder: So you seek to live for the memory of love?
> John: At least a chance to earn it.
> Elder: I can give you one last chance to earn a life. However, it might not be the life that you wish. Complete a task for us, and your Excommunicado will be reversed. The open contract closed, you would be permitted to continue to live. Not free

under the Table, but bound to it. Doing what you do best for the rest of your days. The choice is yours. Die here and now or continue to live and remember through death.

The Elder's assessment that he has "never seen a man fight so hard to end up back where he started" perfectly summarizes Wick's character arc. He completed impossible tasks in order to escape the hitman life and marry Helen, and now the ocean of blood he has shed because a mobster's son killed his dog and stole his car has returned him to his former life. When he claims that he wishes to live in order to remember Helen and their life together, the Elder counters that he cannot give John the life he desires but rather the option to "live and remember through death." This seems at least partly to be a denial of John's desire to remember Helen, as there is no possibility that he can become the man who was Helen's husband—he must be a man who kills to live. He can remember his dead wife only by disavowing his identity as the retired hitman and once again becoming the man he was before he married Helen: Baba Yaga, the Boogeyman, the monster.

Importantly, the Elder never explicitly instructs John to sever his ring finger and hand over his wedding band. Two men simply place a table with a chisel in front of John, and the Elder states, "Mr. John Wick. [in Arabic] I want to see. Show me." John then removes the finger bearing his wedding ring. The Elder does not seem surprised by this and nonchalantly tucks the wedding band in his top pocket. The fact that another man is ready with a red-hot brand to cauterize the stump indicates that something of this sort was expected, but it still seems jarring as a demonstration of fealty—handing over the physical signifier of his marriage to Helen. Of course, this painful physical sacrifice is not enough to return John to the fold of the High Table and have the bounty removed from his head: he must also execute his friend Winston. This

leads to the predictable confrontation between John and Winston at the Continental, which in some ways mirrors John's interview with the Elder, as Winston also offers him a choice and asks for an act of fealty. However, Winston is negotiating from a far weaker place, as he has violated the rules of the High Table and faces losing his position as manager of the New York Continental. The Elder knows he has all the power in his interaction with John. His attendants do not even remove John's gun when they bring him in from the desert, as the Elder is in a position where he feels no threat, even from the great John Wick, and has no need of John's services if they are refused to him. Winston, in contrast, needs John's help and recognizes that while John's grief has made him more monstrous, the monster in John Wick still clings to that grief. In an effort to convince John to abandon fealty to the High Table and ally with him at the Continental, Winston invokes John's identity as the grieving widower:

> Winston: You shoot me, you sell your soul.
> John: But I'll be alive. And I can remember her.
> Winston: Until you die as a servant of the High Table. Now, you did the impossible, you stopped, you got out. You only came back because Helen was taken away from you. The real question is, who do you wish to die as? The Baba Yaga? The last thing many men ever see? Or as a man who loved and was loved by his wife? Who do you wish to die as, Jonathan?

John never answers Winston's question, but the fact that he joins with him and Charon against the High Table suggests that he is at least cognizant of how far his actions have transformed the man he was with Helen. In some ways, however, the choice Winston offers John is a false one, as it appears that aligning with the Continental means more killing, just

as much as he would in defending the High Table. Furthermore, Winston's betrayal and John's rescue by the Bowery King at the end of *John Wick 3* hint at the war on the horizon for *John Wick 4*, in which John will doubtless still be the "last thing many men ever see."

Thus, all the effort Wick exerted in getting to the Elder is wasted when he allies with Winston, but the loss of his ring finger and wedding band remains. This leaves him divorced from his identity as the grieving widower but without the protection of the Elder that his sacrifice was intended to attain. Indeed, the ending of *John Wick 3* not only confirms Cohen's second thesis of monster culture—"the monster always escapes"—but also suggests that the monster is always growing more monstrous.[15] In spite of this, there is perhaps a spark of hope for Wick in his descent into darkness. While he never officially reclaims his dog from Charon after handing him over before leaving for Morocco, the ending of *John Wick 3* makes it clear that Dog has not accepted abandonment. Dog is shown running out of the Continental as John is being wheeled in an old grocery cart to the Bowery King and can be seen hopping onto a red leather couch in the Bowery King's lair as John is deposited onto the floor. There is a possibility, then, that John will be able to reclaim his identity as a dog owner and with it some semblance of humanity.

Just as Wade Wilson's shift from able-bodied mercenary to cancer-ridden boyfriend is what leads him to become the deformed mutant Deadpool, John Wick's transition from husband to widower, and from dog owner to single-minded former hitman hell-bent on revenge, is the category crisis that underlies his transformation from man to monster—a transformation that the ending of *John Wick 3* indicates is far from complete. However, the *Wick* films do not limit their constructions of monstrousness to the titular man himself. Even as John Wick becomes increasingly dangerous, so does the world he inhabits, for almost no one

and nothing is free from complicity in this economy of crime, including the random cabbie waiting in traffic and the New York Public Library. This almost byzantine network frequently intensifies the parody and dark comedy of the franchise, but it also makes its implications that much more unsettling. We come to understand this world as one that grows ever darker and more fantastic and is divorced from the laws of nature and humanity—a world where the goal of a man's greatest fan is to kill the man he admires, where ultimatums and final judgments are not so final, and one where anyone can be a monster—from the rank hobo panhandling for change to the chef serving sushi. Even you. You could be a monster.

Notes

1. Jeffrey Jerome Cohen, "Monster Culture (Seven Theses)," in *Monster Theory: Reading Culture*, ed. Jeffrey Jerome Cohen (Minneapolis: University of Minnesota Press, 1996), 3–25.

2. Cohen, "Monster Culture (Seven Theses)," 6, 20.

3. Jeffrey Andrew Weinstock, "Introduction: A Genealogy of Monster Theory," in *Monster Theory Reader*, ed. Jeffrey Andrew Weinstock (Minneapolis: University of Minnesota Press, 2020), 20.

4. Linda Hutcheon, *A Theory of Parody: The Teachings of Twentieth-Century Art Forms* (1985; repr., Urbana: University of Illinois Press, 2000), xiv.

5. Hutcheon, *Theory of Parody*, 12.

6. Dan Harries, "Film Parody and the Resuscitation of Genre," in *Genre and Contemporary Hollywood*, ed. Stephen Neale (London: British Film Institute, 2002), 283.

7. Harries, "Film Parody," 286.

8. Wes D. Gehring, *Parody as Film Genre: "Never Give a Saga an Even Break"* (Westport, Conn: Greenwood, 1999), EBSCOhost.

9. Gehring, *Parody as Film Genre*, 3, emphasis in original.

10. Gehring, *Parody as Film Genre*, 6.

11. Gehring, *Parody as Film Genre*, 7.

12. This is something the first *Deadpool* movie comments on explicitly with reference to the *Taken* films when Wade Wilson remarks, "At some point you have to wonder if he's just a bad father."

13. Much of this speculation occurred in early reporting on industry sites as well as the comments section of the official trailer for *Keanu* on YouTube and is addressed by Tanya Ghahramani, "'Keanu' Is Not a 'John Wick' Parody, OK?," *Bustle*, April 14, 2016, www.bustle.com/articles/154579-is-keanu-a-parody-of-keanu-reeves-john-wick-not-if-you-ask-well-everyone-who.

14. Neil Archer, "'This Shit Just Got Real': Parody and National Film Culture in *The Strike* and *Hot Fuzz*," *Journal of British Cinema and Television* 13, no. 1 (2016): 42–60, https://doi.org/10.3366/jbctv.2016.0295.

15. Cohen, "Monster Culture (Seven Theses)," 4.

MARY NESTOR graduated with a PhD in English from the University of Aberdeen in 2016 and currently teaches in the English Department of Clemson University. Her research interests include Romanticism and the long nineteenth century, British literature, adaptation studies, cultural memory theory, and the intersections of intellectual property law, popular culture, and reception theory. Mary's most recent work is an article on the linguistic framing of Walter Scott's narrative poem *The Lady of the Lake* titled "Revisiting *The Lady of the Lake*: Walter Scott and the Representation of Scotland" (*Scottish Literary Review*, 2020).

PART IV
JOHN WICK'S MATRIX:
SPACE AND TIME

CLASSICAL ORDERS, MODERNIST REVISIONS, FANTASTICAL EXPANSIONS

READING THE ARCHITECTURE OF THE JOHN WICK *FRANCHISE*

ANDREW BATTAGLIA & MARLEEN NEWMAN

The characters of the *John Wick* franchise agree to disagree. Viggo Tarasov, Santino D'Antonio, and the One above the Table—central figures in each of the first three films, respectively—suspect that John has returned to his abandoned profession. For his part, John insists that he is simply "sortin' some stuff out." As if to convince the world of this, he reinters his weapons immediately after his campaign against the Tarasov syndicate. This, in turn, leaves him without weapons in *John Wick: Chapter 2* when, at Santino's behest, he arrives in Rome to assassinate Gianna D'Antonio. As the chase scene proceeds, John empties and discards each gun only to suffer from a lack of firepower for his impending move against his erstwhile employer and the usurper of Camorra power, Santino. Moreover, in the opening scenes of *John Wick: Chapter 3—Parabellum*, John is forced to assemble a six-shooter and pull knives off the wall to defend himself. Yet through it all, he refuses either to announce his return to retirement or renounce his revenge. With John killing his way through a horde of people—all of whom insist he is a better killer than a grieving husband—the only judgment on his professional status might be one of *non liquet*.

In addressing the question of John's place in the Wickverse, one could do worse than to discount the films' dialogue and attend to their architecture. As Renée Tobe writes in her introduction to *Film,*

Architecture, and Spatial Imagination (2017), film uses architecture as a "visual shorthand" to convey meaning without diverting dialogue to the purpose.[1] Like other films, the *Wick* franchise communicates the moral value of characters, actions, and even physical location through architecture. Given the films' minimal and elliptical dialogue, architecture expresses more to the viewer familiar with the languages of the built environment than John's terse utterances. In short, this essay assumes that *where* a character stands frequently betrays his convictions better than his choice of words. Our purpose is to explicate the architectural aspect of the mise-en-scène in order to draw out its latent meaning to the franchise diegesis. Historically, the legibility of the built environment relies on a semi-stable set of meanings derived from universally accepted architectural vocabularies, which in turn are associated with a particular style. The *Wick* franchise invokes and modifies three paradigmatic architectural languages that each announce a dramatic shift in the boundaries of the diegetic world or stylistic portrayal of the characters; in the course of our analysis, a fourth, liminal space emerges that is characterized by the absence of a unified architectural language. These liminal spaces are neither modern nor classical and ultimately have no single coherent architectural language. Their multifarious languages constitute spaces for ordinary criminal contract work (i.e., they are physically distinct from but exist under the aegis of the injunction against business on Continental grounds). As such, we might add, the function of these interstitial spaces is dictated by their diegetic placement in the film and is thus peripheral to our central argument.

The first and second installments of the *Wick* series express the conflicts between John and the criminal underworld in terms of the mythic and mythologized conflict between his poetic modernist house and the historical styles (most notably classicism and neoclassicism)

that represent and host the ordered criminal underworld. In particular, *John Wick* deploys a semiotic link to gesture toward the modification of the Modern movement by Portuguese architect Álvaro Siza, whose work has been termed *poetic modernism*.[2] In our explication of the Wick house, Siza inherits the Modern movement in order to play freely with its tenets without renouncing its programmatic goals. *John Wick 2* again inscribes the dichotomy between poetic modernism and historical styles even as it expands the Wickverse by appending a world of liminal spaces (hallways, highways, subways, and industrial complexes with no particular or unified architectural language) and anticipates the fractally expanding Wickverse through the mirrored art installation of its ultimate fight sequence. *John Wick 3* further extends the Wickverse through the annexation of non-Western architecture (the Islamic market and riad house) and more importantly through the introduction of the executive glass suite that occupies a hitherto unseen floor of the New York Continental. While the Islamic setting expands the Wickverse, it does so through recourse to a rule-based vernacular architectural language; the Moroccan architecture is legible because, like Western classicism, it deploys symmetry to define spaces. In spite of its novelty (bordering on exoticism) for Western audiences, the market and the riad house form a piece of the criminal world contiguous and commensurate with New York and Rome, where rule-based architectural languages act as metonyms of social order. In contrast, the executive suite of the New York Continental introduces to the Wickverse a fantastical turn that defies the order of historical styles and the intuitive freedom of contemporary construction techniques (i.e., glass and steel structure). Although it putatively guarantees transparency, the executive suite obscures and reveals in alternation, which distinguishes it from the other diegetic spaces of the film franchise.

Between the Machinic and the Poetic:
The Wick House as Interstice

John Wick's house, within the context of the Wickverse's built environment, reiterates the intersection of two related but not wholly compatible architectural moments: the Modern movement of the twentieth century and, as we have already suggested, the poetic modernism of Álvaro Siza. In the highly anthologized and equally contested history of the Modern movement, a disparate set of architects coalesced in the early twentieth century around a new set of programmatic goals, most notably to align the aesthetic design of buildings with new methods of construction. This consensus contrasted sharply with the imitative building styles of the nineteenth century, where historical ornamentation was simply applied to a building without any relationship to its form and structure. In its most conspicuous and highly celebrated form—known as the International Style—the Modern movement stripped the building to its barest essentials, reading material and structure alone as decorative elements.[3] The reductive move that characterized much of the Modern movement came with an explicitly social and moral valuation, which the Swiss architect Le Corbusier articulated in the delightfully sententious polemic, "The house is a machine for living in."[4] Le Corbusier's call is of course equal parts polemic, bon mot, and utopian ideal—but one that crystallizes the desire to reform architecture along the lines of the utility of the machine.

Any introductory gloss of the Modern movement will emphasize that it left a great many unhappy homeowners in its wake—as it turns out, most people do not want to live in a machine—and if John Wick resembles a machine in his resolution, he supersedes the machinic in his emotion. The man of "focus, commitment, sheer will"—as Viggo Tarasov (Michael Nyqvist) puts it in *John Wick*—is, after all, motivated

9.1. Daisy's introduction and the link to Álvaro Siza. *John Wick* (2014).

by grief and rage at the murder of his dog and the theft of his car. It is not, however, that John exceeds the aesthetic ideology of his house but rather that his house is more than it appears to be. During the funeral reception and the introduction of the now-famous puppy, for example, the camera frames the animal over a coffee-table monograph entitled *Álvaro Siza: The Complete Works, 1952–2013*, which invokes the cult figure of poetic modernism (see fig. 9.1). Apropos of his receipt of the prestigious Pritzker Prize, the jury summarized Siza's work: "Like the early Modernists, his shapes, molded by light, have a deceptive simplicity about them; they are honest."[5] In this sense, Siza is an heir to Le Corbusier's (and others') vision of modern architecture, but Siza distinguishes himself from his forebears. As he remarked in an interview with Amy Frearson for *Dezeen*, arguing in contrast to other modernists, "You have to feel what you are doing, and not be so rational that you just solve the problems, because emotion is very important." He adds, "Without it, something is missing."[6] Siza's brief gloss on his own work injects emotion into the spiritual asceticism that accompanies the radical honesty

of the Modern movement's aesthetic program. With Siza as a guide, the Wick house is saved from the mythic reduction of the modernist house to its barest essentials.

The hybrid aesthetic of the Wick house, visible on-screen and gestured to by the coffee-table monograph, motivates its double role as the site of conflict between, on the one hand, memories of a former life and, on the other, mourning and murder. In the post-title sequence, the camera follows John through his morning routine. From the bedroom, which is framed diagonally to show both the bed and the balcony, the film cuts to a straight-on long shot of the living room with the staircase in the upper-right corner of the frame, from which John turns and crosses behind the open-backed bookcase that formally (if not substantially) delimits the living room. A close-up of three photos reflects his passing figure, and as he passes, the camera refocuses to reveal one photo of Helen and two of them together. The film cuts to another close-up of a coffee percolator and a green mug. John's hand with wedding band pulls the green mug toward him, and again the camera readjusts to bring Helen's white mug into the plane of focus; here is Helen's mug present but largely invisible in the blurred background. Like the open-backed bookcase, which belongs simultaneously to the hallway and the living room, separating and conjoining the two spaces, John's mug stands adjacent to but also obscures Helen's. In both instances, the visible spaces refuse to code themselves; each space participates ambivalently in what Le Corbusier termed *le plan libre* (the free plan) of the house—that is, the interpenetration of spaces makes it impossible to settle the borders between physical place and emotional space. No wholly impenetrable thing separates the objects and spaces of Wick's world, yet some positive absence interposes.

Just as the opening sequence depicts John's bereavement, it also maps the house, making it legible to the viewer in preparation for the

fight sequence between John and Viggo's hitmen. In spite of the formal ambivalence of the house's *plan libre*, the constructive editing of the sequence moves from the alarm clock to the coffee maker in five shots while providing a maximum of information about the house. The shots from the funeral reception reinforce the location of the living room in relationship to the hallway and staircase, and the morning routine with Daisy connects the kitchen to the front door and, via another hallway, to the garage. The staircase acts as the controlling vertical axis, while the two hallways serve as horizontal axes that control all forward and lateral motion. In the fight sequence that follows Viggo's failed diplomatic overture, the camera frames John in his bedroom, where he lifts the gun from the nightstand and switches off the light. The camera cuts to the first team of hitmen, which enters through the kitchen door, and then back to the now-empty bedroom, where a second team files in through the balcony door. Thus, at the beginning of the home invasion sequence, the second team marks the origin of John's morning routine, and the first team marks its termination. Unless John is to shoot the upstairs hitmen and then return to bed, the position of the two groups dictates that he retrace his familiar morning routine. In short, the firefight pulls John from the private space of the bedroom and leads him to the front door, the formal threshold of the house, without introducing unfamiliar spaces. He dispatches the men upstairs, then follows a body sliding downstairs before leaping over the banister at the landing. From there, he circles the free-standing staircase (and in each shot, the camera marks his passage by keeping the staircase in the frame), shoots and fights his way down the hallway into the kitchen, and then struggles with the final assailant until he fatally stabs him in the hallway that leads to the front door.

During the incredibly choreographed and complex set of movements that comprise the home invasion sequence, the free-flowing

9.2. Wick reloading. The staircase marks his entry point to the living room and the bookcase his exit to the kitchen. *John Wick* (2014).

interplay of spaces makes John's movements legible. The landmarks of the house—staircase, bookcase, kitchen—locate John's position, while the open floorplan allows the camera to include the next forward point of his trajectory (see fig. 9.2). Equally important, the formal spatial ambivalence permits improvisation and variation to meet the exigencies of combat. The vertical axial control of the house forces John to switch levels by the same staircase that he ordinarily uses—as opposed to an alternate route—yet the open design allows for greater maneuverability. Set apart from the wall, the stairs mediate between the multiple conceptual spaces that converge there; although the basement, living room, hallway, and another unidentified room converge at a single point, the staircase distributes movements in much the same way that the island embankment of a roundabout redirects all traffic from intersecting lines into a single circular pattern. Similar to the vertical control of the staircase, the two hallways direct lateral movement without constraining motion. Unlike, for example, a nineteenth-century house in which room opens onto room or a single narrow hallway connects two rooms,

9.3. Exterior of John Wick's house. *John Wick* (2014).

John traverses the ground floor even as he transgresses the conceptual boundaries of each room to engage the hitmen within them. The bookcase marks his progress, but its open design offers shifting yet reliable lines of sight to his targets—that is, he moves laterally and shoots diagonally. The conceptual space does not dictate the terms of John's engagement: he can shoot or fight hand-to-hand in a room as well as he can in the hallway.

John's success against the Tarasov hitmen cannot be attributed entirely to the *plan libre* of his house. After all, the house does not kill anyone; John does, which is to say, the architectural interior expresses psychological interiority. Still, the aesthetics of the house conform to a particular ideology that distinguishes John from workaday criminals and the buildings they occupy (see figs. 9.3 and 9.4). In line with this distinction, the establishing shots of the first film connect the most important criminal locales with distinctive neoclassical buildings of New York City. Notably, the 1904 neo-Renaissance Beaver Building fronts for the Continental, while the 1907 beaux arts Surrogate's Courthouse in

9.4. Exterior of the Continental. *John Wick* (2014).

Manhattan stands in as the facade for the Red Circle Club. Such buildings derive their meaning from the classical building tradition inaugurated in Greek and Roman antiquity, so while the Continental and the Red Circle Club are introduced in the first film, we attend to their meaning in the next section as part of the second term in the dichotomy of poetic modernism/classicism.

Wick among the Romans: The Catacombs Fight

John Wick 2 expands the diegetic world of the *Wick* franchise without substantially altering the aesthetic polarity that characterizes the first film. The poetic modernism/classicism binary returns with a vengeance when Santino D'Antonio (Riccardo Scamarcio) demands that Wick move against his sister, whose seat at the High Table he covets, and explodes the retired assassin's house and hope for home when he balks at the assignment. The destruction of the Wick house (alongside the awkward fight sequence that totals his beloved car) emphasizes the

incompatibility of poetic modernism and the historical styles that host the criminal world—as if the antinomy were not sufficiently proved in the first film—and thus the post-title sequence is less interesting for its brief return to the Wick house than for the institution it introduces: the marker. Santino's claim to John's labor derives from the presumption of an outstanding obligation. On the night of his impossible task, John turned to Santino for aid, who consecrated the request and his fulfillment of it by a blood oath. New to *John Wick 2*, this peculiar social contract—services rendered and recorded by a bloody thumbprint that can be repaid only by further service and sealed by a second bloody print—is grounded in an immense ledger book (held by Winston) that indexes the participants without managing the exchange rate for various services. The tabulated social obligation finds its architectural equivalent in the classical galleries of the New York Modern—a fictional museum that borrows Rome's Galleria Nazionale Arte Moderna for its facade—and the parade of Roman and Vatican City buildings for the international scenes. The central fight scene of the Roman sequence occurs in a series of catacombs putatively located below the D'Antonio estate. Equally important to the historical vernaculars of the film is the introduction of liminal spaces that offer a set of architecturally multifarious rebuttals of the spatial and social logic of Wick's criminal world as administered by the Continental. Unlike spaces organized by historical vernaculars and corresponding to places governed by the rules of the High Table, the liminal spaces reflect a lawlessness unique to them. The central example of this is the mirrored gallery in which Ares (Ruby Rose) and her security team confront John and rescue Santino.

The architecture of *John Wick 2* reifies the social relationships codified in terms of reciprocal obligation and fulfillment. Under the sign of the blood oath, the primary socio-professional relation of the film is the promise, emblematized by the marker and guaranteed by the ledger

book maintained at the New York Continental. To quell any doubt concerning the legitimacy of Santino's invocation of his marker, Winston (Ian McShane) clarifies that there are "two rules that cannot be broken, Jonathan: No blood on Continental grounds, and every marker must be honored." These two injunctions delimit the total legislation of the criminal underworld; apart from them, Winston implies, the High Table permits any and every criminal contract and any act performed in the fulfillment of a legitimate contract. Although it is largely left unstated, the presumption of totality and universality grounds each of the unbreakable rules; under no circumstances may any party be granted an exception. The totalizing rules that govern social relations find their natural correlate in the hierarchically arranged and highly symmetrical buildings of Rome, the seat of Camorra power and the veritable sourcebook for European classicism; in short, Roman architecture serves as a metonym of the ordered social relations in Wick's criminal world. The establishing shots do not linger long enough to read the city properly, so we turn to the first and most influential presentation of the ideas that motivated the buildings depicted: Vitruvius's *On Architecture*.[7] Considering the success of public buildings, he writes, "Without symmetry and proportion there can be no principles in the design of any temple; that is, if there is no precise relation between its members, as in the case of those of a well-shaped man."[8] Architecture follows the proportions of humankind, the body of which was conceived, as Indra Kagis McEwen writes, as "a whole whose wholeness . . . was above all, a question of coherence." She continues, "Vitruvius understood architecture in terms of a purposeful universe, a world-body shot through with the same cohesive ratio," one that was operative on all levels and among all parts.[9]

The ordered arrangement of architectonic parts in the buildings of Rome corresponds to the inescapable reciprocity of the blood oath that

governs the social boundaries and pathways of *John Wick 2*. In addition to being ordered, Vitruvius's world and architecture are hierarchical, with, unsurprisingly, humans placed above the brute animals. As he writes, "Nature had not only endowed the human race with senses like the rest of the animals, but had also equipped their minds with the powers of thought and understanding, thus putting all other animals under their sway, [and] they next gradually advanced from the construction of buildings to the other arts and sciences, and so passed from a rude and barbarous mode of life to civilization."[10] In this sense, the order of classical buildings reiterates Winston's declaration that rules separate humans from animals. Thus, before John departs New York, his conversation with Winston anticipates the Roman shots' reinforcement of a particular vision of how society coheres. The rules admit no exceptions or amendments, injunctions as impressive and oppressive as the marble edifices that represent them on-screen.

The film modifies the magnitude and order of Roman architecture by framing the establishing shots diagonally instead of orthogonally. The establishing aerial shots track toward the Colosseum such that, were the flight path to continue, the camera would pass by instead of over the building; likewise, the camera traverses the central axis of St. Peter's Square as it tracks backward. The camerawork formalizes the diegetic relationship between Wick and his Roman assignment by instantiating a world that depends on but never names the fact to which Wick alludes vis-à-vis Santino: the task to kill Gianna (Claudia Gerini) binds him even as it threatens to obliterate him.[11] He cannot fulfill the blood oath except at the price of excommunication for moving against the High Table. As he says to Santino, "It can't be done," to which he must add, after Santino offers the technical details of the assassination, "It doesn't matter where she is." Santino's assignment places John in an

untenable position. To perform the task will set the High Table against him for moving against a Table member, and to refuse, resist, or run will incur the Table's ire for violating the sanctity of the blood oath.

Although the Roman facades emblematize the social relationship of the Camorra in Italy and the criminal world more broadly, the museum conversation marks an important change in the evolution of architecture in the *Wick* franchise—namely, a changed relationship of set design to action choreography. The major fight set pieces of *John Wick 2* are characterized by an ambiguous relationship to their shooting location. Before being interrupted by his adversarial pseudo-ally, Santino explains that John must use the catacombs to infiltrate the coronation ceremony.[12] The Camorrista's directive motivates a sequence of shots with the antiquarian book dealer in the preparation montage. What is critical about the conversation is that the antiquarian's remarks explicate a set of movements that will be largely invisible to the audience; in other words, what distinguishes the Roman firefight from the home invasion scene in *John Wick* is the utter absence of a legible plan. Instead of a series of connected shots that schematize a diegetic space, the preparation montage provides only a brief shot of the maps to the D'Antonio estate. The bookseller lays a yellowed map on the table and explains, "This is the original map of the D'Antonio estate. Here you have all the ancient ruins. . . . This is the map of the temple and catacombs underneath," and, pulling up a modern schematic, he adds in a subsequent shot, "And this is the modern blueprint." The antiquarian then counts out three gates before handing Wick a chatelaine with the corresponding three keys.

Interpolated between the scenes at the sommelier-armory and tactical tailor, speech instead of sight outlines the contours of Wick's assignment. Dialogue prepares the viewer for Wick's in- and exfiltration; the mise-en-scène itself does not provide a legible terrain. In the

9.5. Wick's retreat through the D'Antonio catacombs. *John Wick 2* (2017).

sequence of shots that prepare his retreat, the camera shows this and that dark corner in an equally dark tunnel with Wick placing guns in unseen but surely strategic locations. After Gianna's assassination, Wick ducks into the catacombs and retraces his steps under heavy fire from Ares's men, but the darkness obscures his movements. Working his way from cover to cover, Wick shoots and reloads (using hand-to-hand combat for those henchmen too close for firearms) largely within a uniformly shadowy space. The movements eclipse the specific place in which Wick fights so that continuity editing must stitch together the scene. The home invasion from the first film relies equally on continuity editing, but unlike the former scene—where continuity is sutured to a legible house—in the catacombs Wick travels through a homogeneous space of deep shadows broken only by the directional lighting embedded in the mise-en-scène as barrel-mounted flashlights and muzzle flashes (see fig. 9.5). The tenebrous catacombs repeat themselves as an architectonic-cinematographic fractal—a self-similar scene in which motion can be registered only within the frame and which does not correspond reliably to movement in the diegetic world.

The establishing and interior shots of the Roman sequence emphasize the symmetry of the criminal underworld, but as the assassination plot resolves with Gianna's defiant suicide—and John's corroboration of her death—the architectural world totters; its coherence threatens to come undone. On the one hand, the mapmaker proposes that the catacombs belong to the D'Antonio estate, which would make them part and parcel of the classical world. On the other hand, John escapes into the catacombs. A glance over his shoulder assures him that he is alone, and the henchmen he kills in the subsequent sequence answer to Ares, not Cassian (Common). Inasmuch as they neither exhibit a distinct and comprehensible architectural vocabulary nor host an honest opponent—Ares's subordinates hunt John for the execution of the task Santino put to him—the catacombs inaugurate a diegetic space in which the rules of the High Table no longer obtain. Gianna's murder liberates John from the marker and delivers him to the disingenuous grief of his erstwhile employer. Thus, the catacombs occupy an unstable place in which they are both conjoined diegetically to a classical space and distinct from that space—that is, they are liminal—by dint of their lawlessness. There is no architecture, properly speaking; each shot is too dark to distinguish any feature of the space beyond wall, floor, and ceiling.

If the catacomb firefight—whatever its status as classical or liminal—comes off as repetitive and flat, the fractal cinematography it deploys finds better service in the final fight sequence of the mirrored art installation *Reflections of the Soul* that culminates in Ares's death. Beneath the classical galleries of Santino's reception, an art installation of shifting mirrors duplicates and displaces the images of Santino, Ares, and their henchmen. Wick must contend with the virtual multiplicity of his opponents even as he traverses a space that, if it doesn't quite

9.6. Fight scene in the art installation *Mirrors of the Soul. John Wick 2* (2017).

fight back, fights crosswise to the other combatants, so to speak. The art installation thematizes the facile questions posed by the automated narrator and the jejune psychological diagnoses that Santino calls out from hiding. In spite of the on-the-nose convergence of set and plot, the mirrored art installation picks up a minor motif of reflectivity present in *John Wick*, but whereas in the first film reflections are straightforward and largely legible, the installation artwork multiplies and thus distorts the mirrored images. Simply put, there is too much reflectivity, and yet, unlike the reflectivity of the executive glass suite in *John Wick 3* (discussed below), the infinite images are discrete (see fig. 9.6). The stable world of *John Wick 2*, balanced by a commensurate ethics of reciprocity, collapses after Wick doubles down on the sin of killing a member of the High Table. Gianna's assassination puts a bounty on his head even as it fulfills the blood oath, and his pursuit of Santino is the turn of the metaphysical screw. The assassination of the Camorrista concludes the thinly motivated revenge plot of the film and delivers the titular character not to retirement but excommunication *latae sententiae*.

The Fantastical Turn of *John Wick* 3

John's excommunication precludes the franchise's return to the dichotomy between a poetic modernism and the various, rule-based historical styles that dominated the first two installments, and his beleaguered escape from New York in *John Wick* 3 inaugurates a redemption plot in which the once-retired assassin must negotiate the terms of his ostensibly irrevocable return to the criminal world. The escape plot simultaneously expands the boundaries of the Wickverse through a set of liminal spaces (the streets and alleys of New York) and new places contiguous with the criminal world (the Tarkovsky Theater and the Moroccan Continental), but what interests us more is the introduction of a unique third term in the built universe—namely, the executive glass suite appended to the New York Continental. The executive suite borrows elements from the modernist movement and classicism itself but modifies the rules of each language to create a hybrid, duplicitous space that defies the aesthetic ideology of both the Wick house and the criminal world at large. The executive suite arrogates to itself the disposition of classical order and appropriates the materials of modernism, but as a discrete conceptual space it conforms to the expectations of neither. It is inconsistently transparent in spite of the glass and unpredictable in spite of its ordered symmetry. Instead, the shifting play of light transforms the glass suite into a mercurial space that reveals and hides in turn.

The executive suite appears without introduction. Wick ascends a grand staircase, and turning the corner at the top, the camera cuts: Winston stands before a chess game and calls out, "Tread carefully, Jonathan." John's gait falters as he holds up his hand to feel for an invisible obstruction, which ultimately is not there, as Winston introduces the room from off-screen: "We only use this room on special occasions. When you simply have to see what your opponent is holding under the

table." Despite Winston's rhetorical gesture toward transparency, the architecture of the room underwrites duplicity and double play rather than openness. The expansive glass windows that open to the New York cityscape transmit the shifting light of electronic billboards that capitalize on the reflective and transparent qualities of glass. Depending on the direction and intensity of the light source, glass either reflects or transmits light, shifting between transparency, translucence, opacity, and reflectivity. The Continental's executive glass suite, in short, defies easy comprehension and thus makes a poor arena for both negotiation and combat.

Winston performs the same rhetorical legerdemain as the room does light. By substituting reflectivity for transparency, Winston reframes the terms of his encounter with John and gradually undermines his friend's determination to kill him. Whereas the One above the Table spoke of earning a life, Winston asks, "Who do you wish to die as? The Baba Yaga? The last thing many men ever see? Or as a man who loved and was loved by his wife?" Winston's appeal to friendship and memory achieves its purpose; John enters as an adversary and stays as an ally. The plot exposes Winston's question to be more self-serving than sincere—his subterfuge postpones his death and secures his control of the hotel—but as we argue throughout, the architecture of the room already tells the audience more than his words do. Winston's betrayal of John to the Adjudicator on the rooftop terrace should come as no surprise; the compact was made in a lawless wilderness of glass. After the repulse of the first wave of High Table troops, the film alters the positions to be defended and attacked in a few lines of dialogue: Winston invokes New York's solidarity with his cause, the Adjudicator (Asia Kate Dillon) revises their opinion of Winston's rebellion, both agree that John Wick must die, and after the shots are fired, the Adjudicator reconsecrates the New York Continental. Given Charon's subdued

praise—"Well played, sir"—surely Winston deliberately misses the vital organs of his former ally. But what is clear at the end of *John Wick 3* is the animal cruelty that descends on the executive glass suite. Harking back to Winston's position on rules from *John Wick 2*—"Without them, we live with the animals"—the confusion of architecture that characterizes the glass suite corresponds to the disorder and lawlessness that obtain within its borders. The transparency of glass, which putatively gives sight to what lies beneath the table, ultimately distorts and obscures more than it reveals.

Like the negotiations before it, the fight between Zero, his students, and John occurs on shifting grounds (see fig. 6.2). In the opening shots of the fight, John exits the elevator and traverses the corridor flanked by vitrines. Two hitmen surprise him from the shadows, disarm him with several sharp blows, and then disappear into the darkness. John recovers his gun and, turning at the sight of Zero (Mark Dacascos), shoots four times, but a glass partition protects the sushi-chef-assassin. He waggles his fingers in rebuke and steps backward into obscurity. The opening moves of the fight sequence set the template for the remainder of the action: opponents appear out of and disappear into the darkness. Typically, the rules of the room dictate the rules of the fight, except in this case the rules of the room are mercurial, capricious, and inconsistent. The play of light, shadows, and reflections eclipses the spatial logic of the physical space. The glass architecture harbors unseen opponents, who may disappear and reappear at will, but in an ironic twist, the room later obstructs their own movements and blocks their killing strokes. The glass vitrines that brutalize John's body in the first movement of the fight shield him from the killing strokes of his first two opponents in the second movement. Just as an invisible glass partition protects Zero from John's shots on the first level, a piece of glass interrupts Zero's last two sword strokes before John gains the upper hand and ultimately

dispatches him. Zero disappears after throwing his opponent to the ground only to reappear behind samurai armor and taunt, "See, we're the same"; minutes later, John disappears after throwing Zero only to reappear behind him. What distinguishes the executive glass suite from the other settings of the franchise is its instability. It is not an architecture, properly speaking, but a site of illusion. In a sense, then, it forms part of a triad of relations between the openness of modernism, the solid opacity of classicism, and the hyperreflectivity of the fantastical.

The Laws of the Wickverse

In a throwaway line of dialogue, the Adjudicator overexplains the state of the Wickverse to Zero: "You've heard the stories. He's killed scores of people this past week alone because of—" The sushi-chef-assassin interjects, "A dog. I know." The Adjudicator's exposition pertinently reminds the audience that only a week separates Helen's funeral from John's delivery, broken and bloodied, to the feet of the Bowery King. In spite of the infamous body count, the world in which those bodies fall is neither a neutral earth nor a moralized fairy tale. The architecture of the *Wick* franchise is neither a plea for filmic authenticity (i.e., life on the streets), nor a jerky attempt at exoticism (i.e., look where violence lives), nor an afterthought (i.e., a movie must be filmed somewhere). Instead, the on-screen architecture is a set piece all its own and one that serves as an elegant counterpoint to the magnificently choreographed violence central to the films and a necessary supplement to the elliptical, often opaque dialogue. The first three installments of the *Wick* franchise, as we have attempted to demonstrate here, track the slow displacement of a fundamental dichotomy between poetic modernism (the Wick house) and a set of historical styles, most notably classicism. Whereas the former style stands for a hybrid aesthetic of openness tempered by

purpose, asceticism motivated by emotion, the latter metonymizes the strict rules of the underworld. Yet in *John Wick* 3, the accretion of architectural styles dissolves, even deconstructs, the poetic modernist/classicism binary. The film spends more time in liminal spaces that come without a clear or unified language (and thus have no clear or unified meaning), but more importantly, it introduces a new architectural paradigm that supersedes the ordered unity of the criminal underworld and its favorite style, classicism. Waiting for future installments of the franchise, the Wickverse totters at the edge of a world that exists now under the sign of a wilderness of glass. And, as it expands, the Wickverse will inherit an architectural world that must be simultaneously maintained and revised so that its characters can do what they do best: shooting first and speaking obliquely after.

Notes

1. Renée Tobe, *Film, Architecture and Spatial Imagination* (London: Routledge, 2017), 13.

2. The British giant of architecture and architectural criticism Kenneth Frampton writes, "Insisting, as few have either the capacity or the inclination to do, on the ethical imperative of attempting to reconcile countervailing forces in a multifaceted, fragmented world, Siza constantly strives to reintegrate many conflicting demands and affinities within a single, open-ended work." See his "In Praise of Siza," *Design Quarterly* 156 (Summer 1992): 2–5, https://www.jstor.org/stable/i386875. In his entry on Siza for Grove Art Online, Frampton writes, "In each instance [Siza] used an assembly of white-walled, vaguely cubic forms, to produce a reinterpretation of formal themes derived from the history of the Modern Movement." For an occasional assessment of Siza's work, see the Jury Citation for Siza's receipt of the 1992 Pritzker Prize.

3. The Modern movement was extraordinarily heterogeneous; thus, an engagement of its full complexity would eclipse our argument. For a summative treatment of the coherence of the Modern movement, see William J. R. Curtis, introduction to *Modern Architecture since 1900*, 3rd ed. (New York: Phaidon, 1996). For a treatment of the diversity of the movement, see the remaining chapters of his book.

4. Le Corbusier, *Towards a New Architecture*, trans. Frederick Etchells (New York: Dover, 1986), 107.

5. J. Carter Brown et al., "Pritzker Prize Jury Citation," 1992, accessed June 15, 2020, https://www.pritzkerprize.com/laureates/1992.

6. Amy Frearson, "Interview with Álvaro Siza," *Dezeen*, December 19, 2014, https://www.dezeen.com/2014/12/19/alvaro-siza-interview-porto-serralves -museum/.

7. Vitruvius might appear to be a far cry from the Wickverse, but as Indra Kagis McEwen writes, "The only major work on architecture to survive from classical antiquity, and the first self-consciously comprehensive account of the subject, Vitruvius's *De architectura* in time became the text on architecture to which, at least until the eighteenth century, all other texts referred." *Vitruvius: Writing the Body of Architecture* (Boston: MIT Press, 2003), 1.

8. Vitruvius, *On Architecture*, trans. Morris Hickey Morgan (Cambridge, MA: Harvard University Press, 1914), 72.

9. McEwen, *Vitruvius*, 56, 57.

10. Vitruvius, *On Architecture*, 40.

11. The Adjudicator is the first to mention the injunction against killing members of the High Table. The Bowery King's guilt originates in his gift to John of a Kimber 1911 when he knew the weapon would be used against Santino D'Antonio. The Adjudicator's accusation exposes a plot gap: no one other than Cassian is particularly upset that John also killed Gianna, a fact ostensibly recorded by Winston when he marks the blood oath as fulfilled.

12. In reality, the catacombs belong to the tunnel network below the Baths of Caracalla, the shooting location for the scene. Thus, although they do not display a classical architecture, the film dialogue positions them into a classical diegetic space.

ANDREW BATTAGLIA holds an MA in English from Rice University, where he is also a doctoral candidate. He received his BA in English and philosophy from Seattle University and has served as a Fulbright Scholar to Germany.

MARLEEN NEWMAN, AIA, is Associate Director of the J. Irwin Miller Architecture Program and a faculty member in the Indiana University Eskenazi School of Art, Architecture + Design. Her teaching focuses on design studio, architectural history and theory, and historic preservation and sustainability. She has worked for such prominent architects as Moshe Safdie, Benjamin Thompson and Associates, and Perry Dean Rogers and Associates. Her design work has resulted in prize-winning buildings including the Yankee Bank in Boston and the Solution Tree (formerly the Hirons Building) in Bloomington, Indiana. Presently, her design focus is on off-site and prefabricated modern house design leveraging custom and repetitive aspects of construction systems. Her present academic research project is centered on a new history of modernism, steeped in historic reference and regionalism.

OUT OF TIME AND GOING SIDEWAYS 10
JOHN WICK, TIME TRAVELER

CHARLES M. TUNG

John Wick is out of time. At the start of *John Wick: Chapter 3—Parabellum*, because Wick has killed a High Table member "on company grounds" and broken the rules about the inviolable space of the Continental Hotel, the hotel manager, Winston, gives him just one hour before all resources from this posh criminal underworld are cut off and the contracts on his life begin. But audiences of the *John Wick* films have noticed that Wick is out of time in other ways. The entire criminal establishment revolving around the Continental appears to be "constitutively out of time," as the critic Robert Barry puts it: its anachronistic object world is steeped in a "kind of old world glamour . . . that comes in luxury hotels with oak paneled walls, marble floors, and gilt filigree."[1] In addition to the stylish "timelessness" communicated by the films' set design, fans have enjoyed imagining the *Wick* films as the most recent episodes in an autobiographical filmography of an immortal, time-traveling Keanu Reeves: strewn among press photos of an apparently ageless actor, one might also find Parmigianino's 1530 portrait of Keanu posing as an Italian nobleman (*Portrait of a Man*), Louis-Maurice Boutet de Monvel's 1875 painting of Keanu hiding as a French medical student (*Paul Mounet*), and ad slicks from Keanu's surprisingly self-referential *Bill and Ted* films of 1989 and 1991.[2] Keanu Reeves is the time traveler you send to play the fucking time traveler. Finally, in more intricate fan

theorizing about Wick's out-of-time-ness, *John Wick* is the name of a simulation in *The Matrix* featuring Morpheus (Laurence Fishburne) as the Bowery King and the Keymaker (Randall Duk Kim) as the Continental Doctor.

In this essay, I would like to take the *Wick* films as an opportunity to think about a version of out-of-time-ness and anachronism, and a way of thinking about time travel, that together are perhaps more outlandish than any fan theory. Being out of time is not just being short on time, being outside of temporal passage, or being in the world of members-only clubs, old-fashioned rules, and gold coins, where retro maintains its currency. It is rather a condition that enables a peculiar kind of time travel, not back and forth in time as a singular medium but across the internally heterogeneous landscape of the present in which one encounters horses and motorcycles, carriages and cars, ticker-tape machines and teletypes. To discuss this type of "sidewise" time travel as a way of understanding the temporal jumble at the Continental Switchboard and Wick's weird horseback ride, I'll start with Fredric Jameson's claim about certain kinds of action film as demonstrating "the end of temporality" and the loss of genuinely historical possibility. Keeping the focus on Keanu films, I'll argue that Wick's "bullet time," like the technical attraction in *The Matrix*, works against the freezing and messianic control of time and instead makes visible the dilation and acceleration of different times as the relation between reference frames. Finally, drawing on Murray Leinster's peculiar science-fiction take on alternate history, I'll read Wick's ride-through-New-York-City sequence in *John Wick 3* as a sidewise diagnosis of the multiplex nature of history mediated by communication technology, storage protocols, and variable transmission rates at the Continental Switchboard.

Being-Out-of-Time versus Bullet Time

Writing about an earlier Keanu movie, Jameson claimed that the 1994 film *Speed* exemplified "the form of current action film" and was a "cultural symptom of the historical tendency of late capitalism"—that is, "the end of temporality."[3] The form can be given clarity by the film's primary plot point: most of *Speed* takes place on a bus that must travel at least at fifty miles per hour lest a bomb planted on board detonate. Whereas moving through the spaces of an earlier phase of modernity entailed the disjunctive experience in which "people . . . still lived in two distinct worlds simultaneously"—inhabiting, for instance, "peasant fields with the Krupp factories or the Ford plant in the distance"—contemporary action films reveal "the absence of temporality altogether."[4] Like sexual pornography, Jameson argues that "violence pornography" features an unremitting repetitiveness that, in conjunction with its high-speed seriality, defines not only the formal shape of action films but also their dissemination, consumption, and detemporalizing political consequences.[5] The fact that these films and their audiences "do" action the same way again and again—that they demand "a succession of explosive and self-sufficient present moments" that "crowds out the development of narrative time and reduces plot to the merest pretext or thread on which to string a series of explosions"—is, for Jameson, an expression of a "dramatic and alarming shrinkage of existential time and a reduction to a present that hardly qualifies as such any longer," "a reduction to the body" that is the "structural effect of the temporality of our socioeconomic system," an impediment to our "perception of the present as history," and ultimately a "wholesale liquidation of futurity."[6]

The *John Wick* films certainly seem to confirm Jameson's thesis about the end of temporality. The leveling of time, its detemporaliza-tion into a series of repetitive instants, is thematized right at the start of *John Wick*, when the protagonist's former associate Marcus (Willem Dafoe) says at Helen Wick's funeral that "there's no rhyme or reason to this life. It's just days like today scattered among the rest." The films are aesthetically eye-popping violence porn: according to George Hatzis's kill-count visualization website, 77 people die in *John Wick*; 128 people are killed spectacularly in *John Wick: Chapter 2*; and in *John Wick 3*, out of 307 shots taken, 85 people are killed.[7] Formally, the films do not demonstrate much narrative structure: between the motivating event for Wick's rampage and the setup for the next film at the end of *John Wick 3*—the Bowery King's question, "Are you pissed? Hmmm?" to which Wick replies, "Yeah," full stop—the films are held together by the fluid choreography of gun fu. As critics have pointed out, the films' primary emphasis on the endless stream of action scenes and titillating atmospherics can be understood as the limitation (or virtue) of their di-rector, Chad Stahelski, the former stunt double for Keanu in the *Matrix* films. Jameson's point about the loss of history to repetitive elaboration is underscored even by the standard marketing strategy of the franchise, which is to continue on at high speeds with sequels, video games, and other embodiments of what might be thought of as merchandising porn.

However, as an alternative to Wick's being-out-of-time and the fran-chise's contributions to an undialectical present removed from history, I want to propose a stranger way of thinking about time and history, which I think the *John Wick* films give us the occasion to do. Jameson re-marks in "The End of Temporality" that "the better a given film suits our purposes here in the context of the present argument, the worse it has to be," presumably because such films are deficient in narrative develop-ment and outside of historical time.[8] But I think the aesthetic features of

the *Wick* action films reveal something important about the deficiencies of narrative and historical temporality themselves. The death of Wick's dog and the destruction of his modernist mansion are, in my reading, elements of the film's refusal of the kinds of time too easily aligned with the bourgeois time of heteronormative development, with the narrative arc from adolescence to marriage and family and to the hypermasculine violence spree that avenges their loss. What I mean is that while the *John Wick* films are thematically interested in (and perhaps formally enact) the loss of linear development, they also seem to be fascinated with the multiplication of lines, their crossings and interpenetration, a world shot through with other worlds and with the traces of other timelines. Located in the nonstop onslaught of set piece after set piece, in set props and set dressing, is a peculiar way of thinking about multiple times that does not undergird an authoritative history of speed—a singular history of temporal accelerations characteristic of, for instance, the "timeless time" of Manuel Castell's "network society"—but rather invites an archaeology of different histories running at a variety of speeds.[9] If the films must be worse to suit this purpose, it is because narrative satisfactions cannot be gleaned from the historiographic questions raised by the image of bullets slowing down comically in a medium or by Wick's galloping on a horse down Eighty-Sixth Street beneath the elevated tracks of the D train in Bensonhurst.

I want to approach the question of media and time travel across histories by thinking about the matter of bullets first. A TV spot for *John Wick 3* was actually called "Bullet Time," which, in addition to time-traveling Keanu as both Neo and Wick, suggests a linkage between the major technical attraction of Lana and Lilly Wachowski's film *The Matrix* and the narrative content of nonstop violence in the *John Wick* films.[10] At the center of the trailer is the scene toward the end of *John Wick 3* in which Wick falls into a spa pool fighting the Adjudicator's

10.1. The underwater shot in the "Bullet Time" TV spot for *John Wick 3*.

enforcers. This fight, along with the other teasers in the promotional preview, reminded viewers/consumers that it was time to prepare for a third round of bullets in chapter 3 but also suggested that the film would contain a version of Neo's bullet-dodging ability. In this underwater scene, the enforcer fires his gun three times at Wick from several feet away, but the bullets are comically slowed by the medium of water and ineffectually curve to the bottom of the shallow pool (see fig. 10.1). Floating in an environment reminiscent of the weightlessness of Neo's bullet time, Wick pushes off the pool's wall, puts the muzzle of his gun directly on the man's body, and then fires one bullet into his chest and three into his head.

Central to the buzz about *The Matrix*, Neo's bullet-time scene—his ability to perceive and move so quickly that he can evade the agents' bullets—gave the audience similar powers of perception, as viewers marveled at the sight of projectiles slowed in midair and rotated around them with the camera. The special effect of bullet time draws on a lineage that extends from 360-degree product viewing on online shopping websites, to the spectacularizing of products in Matthew

Rolston's mid-1990s television advertisements for Gap Khakis and Michel Gondry's commercials for Smirnoff and Polaroid, to Tim Macmillan's "Timeslice" technology in the 1980s and Harold Edgerton's stroboscopic capture of bullets puncturing playing cards in 1964. Film scholars in Wanda Strauven's collection *Cinema of Attractions Reloaded* (2006) have read such effects in ways that extend the lineage back to the antinarrative impulses of early cinema, framing attractions like bullet time in Tom Gunning's terms as "theatrical display . . . over narrative absorption" and "delight . . . from the unpredictability of the instant."[11] The manipulation of the fleeting instant by slowing motion and immobilizing the instant, to use Jameson's framework, liquidates narrative and historical time by showing how the intensification of "thereness" in the new ability to freeze and encircle relates to the commercial simulation of the presence of commodities.

However, rather than reading bullet time in both *The Matrix* and the *John Wick* films as an example of what Bob Rehak called the "frozen-time aesthetic," I suggest that the special effect and the reference to it invite us to reframe high-speed events like the trajectories of bullets as occasions for exploring the dilations and contractions of time and history relative to speed and scale.[12] Like its precursor cubism, which rendered its objects across multiple timespace dimensions, bullet time shows presence to be an assemblage of differing times rather than a single instant solidified by differing angles. The slowing and freezing of bullet time are the effects of the construction of a *virtual* motion-picture camera moving at impossibly fast speeds.[13] In bullet time, as the object's or actor's movement continues along its trajectory in "real time," we begin to orbit in fast motion. Although the different speeds and shifting pulls would seem to signal, more than anything else, the technological fantasy of transcending and manipulating history from without, the constructed unity of the virtual camera as the effect of the multiplicity

of camera positions and digital frames suggests that we might reconsider the unity of time—perceptual, narrative, and historical—as an amalgam of multiple histories. While *The Matrix* thematizes Neo's and film's power "to manipulate the spatial and temporal dynamics of its visual narration," as Lisa Purse points out, the implications of the film's speed-ramping and variety of slow-motion speeds between and within shots are not reducible to the simple speed-up or slow-down of action. Rather, these deviations reveal that characters and objects are moving in different frames of reference within the same shot.[14] As the virtual singularity of perspective breaks down in scenes such as "the Rescue of Morpheus," the impression of a better immersion in a world's processes and in "the truthfulness of the space around them" (for which visual effects supervisor John Gaeta credits virtual cinematography) is undermined by different reference frames running at different rates. The kinetic and kaleidoscopic sublime space that Scott Bukatman attributes to science-fiction films and their wormhole rides is itself already a kind of utopian outside, but only because, as he argues, utopia functions as "less a place, a fixed site, than a trajectory" and more "a field of possible, and multiple, trajectories."[15]

The Sidewise Horseback Ride and the Continental Switchboard

John Wick is outside of time, with a capital T and in the singular, and is instead running sidewise across times. *John Wick* 3 begins with Wick's run-through-NYC sequence, which commenced at 3:58 p.m. at the end of *John Wick* 2. The time is now 5:08 p.m., which the establishing shot shows us on the Metropolitan Life Insurance Company tower clock, and we tick ahead two minutes to 5:10 p.m. with a shot of the Continental Switchboard clock above its main blackboard. Chronology and narrative—fabula and *syuzhet*—are aligned with one another and moving

forward. Although Winston tells Wick at almost 4:00 p.m. that he has an hour to start running, we see in *John Wick 3* that the consequences of Wick's violation of the rules start not at 5:00 p.m. but an hour later, a detail consigned to lists and YouTube videos of "Movie Mistakes." Two hours after Wick limps away from Winston in Central Park, the film provides us with some detailed views of the Continental Switchboard, the hub of High Table logistics, an assassin services central staffed by operators who are a mashup of midcentury administrative fashion and tattoo-sleeved contemporaneity.[16] As we follow Wick's paper file being carried through an office that uses card catalogs, leather-bound ledgers, wooden file storage boxes, typewriters, teletype machines, early PCs, and telegraph stock tickers, we land on the desk of a principal switchboard operator wearing a midcentury Western Electric headset who examines the file and announces, "John Wick, excommunicado: in effect, six p.m., Eastern Standard Time." Another operator enters "6:00 PM" into a retro IBM green-screen CRT from the 1980s, which as we see in *John Wick 2* is somehow connected to a Commodore VIC20 PC. In chalk, another operator writes "$14M" in the "Bounty" column of the main office blackboard. Wick is now running in the rain through Times Square, where, among the video-screen billboards, Buster Keaton's 1921 silent film *The Goat* is playing on one of the biggest screens. The film then doubles back to 5:40 p.m., the narrative presentation or *syuzhet* now departing from the chronological fabula, rewinding the clock to the New York Public Library scene. The head switchboard operator announces, "John Wick, excommunicado: in effect, 20 minutes."

This temporal jumble—in set piece, narrative, set dressing, and props—is a prelude to Wick's strange horse ride through the city, a stunt proposed and performed by Keanu himself and chalked up to the location scout's fortuitous discovery of a stable two blocks away from Central Park.[17] As the clock tolls 6:00 p.m. again, the Continental

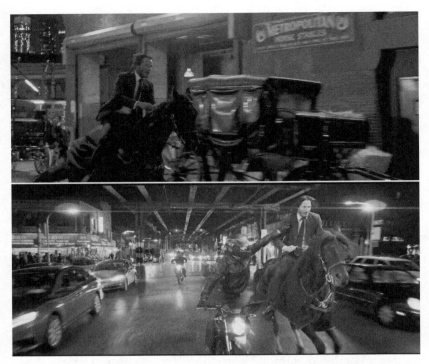

10.2. Wick's horseback ride from the Metropolitan Horse Stables to Eighty-Sixth Street. *John Wick 3* (2019).

Switchboard operators all freeze until the final chime, and the principal operator seems to complete her announcement from the previous 6:00 p.m. scene: "John Wick, $14 million: open contract is now in effect. All services are suspended." After defeating a number of bounty hunters in a Chinatown antiques store—where he briefly becomes Tuco in Sergio Leone's 1966 *The Good, the Bad and the Ugly* and assembles a "franken-revolver," a hybrid gun made out of Remington 1875 Long Colt with a

Colt 1851 Navy barrel and a Colt 1860 Army hammer—Wick then proceeds to a horse-and-carriage stable, where he fights off four assassins and takes off on horseback down the streets of New York (see fig. 10.2). Initially passing anachronistic carriages as he exits the stable, he gallops at full speed past parked cars on Eighty-Sixth Street, defeating two killers on motorcycles, both of whom take turns riding up alongside John's horse just long enough for the protagonist to fire several bullets into each under the elevated tracks of the D train.

While Stahelski's design of thrilling stunt after stunt and intricately planned set piece after set piece might bolster Jameson's reading of pornographic repetition that is ultimately an empty seriality, a string of undialectical climaxes, the film's deliberate mashups and accidental combinations provide opportunities to rethink temporality through the frameworks of even development and media archaeology's "variantology" of history itself. Wick's horseback ride through a contemporary New York City calls to mind H. G. Wells's insight in 1901 that "before every engine . . . trots the ghost of a superseded horse [that] refuses most resolutely to trot faster than 50 miles an hour, and shies and threatens catastrophe at every point and curve."[18] But if "variantology" is a "methodological time machine" in which we steer around "a naïve assumption of the linearity of time, and instead recognize it as recursive, reverberating, non-linear, and executable . . . in new ways," as Jussi Parikka describes Siegfried Zielinski's approach to media and variant historicity, then we might ride with Wick in ways that do not seek a single, straight, evolutionary line between the horse, the motorcycle, and the muscle car.[19] Moreover, Wick's movement—from the opening scene of *John Wick* in which we enter the films through his mobile phone as he watches a video of his dead wife, to the strange travels in *John Wick 3*—is not across isochronic space and spatially homogeneous time. Uneven development across the globe, in which older economic forms and

social relations coexist alongside newer ones, a scenario that Jameson thought belonged to an earlier experience of modernity, has created a timespace in which our movements in the world are often experienced as "a form of time travel within the same space, a spatial bridging of un-like times," as the Warwick Research Collective on World-Literature has recently put it. In these travels, experiences are marked by "discrepant encounters, alienation effects, surreal cross-linkages, unidentified freakish objects."[20]

In science-fiction literature, the text that describes this sort of time travel as "sidewise" is Murray Leinster's short story "Sidewise in Time" (1934), after which the Sidewise Award for Alternate History is named. However, if this story is interested in alternative understandings of history, it does not focus on a single forking of human history, as one moves back and forth in time, but rather on the patchwork of many unfamiliar times and historical outcomes, as one moves across different times.[21] Leinster's vision of "the present" is not of a singular, self-consistent temporal location linked between the past and future; rather, it highlights strange intrusions into the smooth regularity of historical timespace from different pasts/histories, and by implication, various futures. The main character, math instructor James Minott, takes his students to investigate these intrusions into history by other histories: Roman soldiers appear in a suburb of Joplin, Missouri, and a "jungle such as paleobotanists have described as existing in the Carboniferous period" appears in Bryan, Ohio, out of which a dinosaur emerges.[22] These intrusions soon add to a growing number of temporal synecdoches in which Romans, Vikings, Chinese, Native Americans, and Russians govern what appear to Minott's crew as alternate histories of the US. Moving sideways across this riven topography symbolizes the transverse cut one must make to construct a shared present; moreover, it shows us, as Minott explains, that the conception of time as a singular "path instead

of a direction" with "one present and one future" blinds us to the reality that "there are an indefinite number of possible futures" and, as his student Blake infers, "any number of pasts besides those written down in our histories. And—it would follow that there are any number of what you might call 'presents.'"[23]

Blake's redefinition of historicity generates a racist plot quest of seeking to avoid "a path of time in which America has never been discovered by white men" (101) and of a fearful sidestepping around any history that would begin to evaluate its relation to a "scalping party of Indians from an uncivilized America" (139). In Leinster's story, moving sideways across times rather than backward and forward in a singular time ends up, as John Cheng writes, "reinforc[ing] its linearity mathematically and historically," which, as in "most interwar time-travel stories," as he points out, ends up maintaining the imperative to return "travelers from their adventures to an unchanged present."[24] However, the story's reconceptualization of historicity reconfigures the present as a strange and bumpy plane comprising a variety of intersecting and parallel trajectories. As Minott explains it, the sideways movement across this patchwork reveals that fault lines are in fact the borders of "units from one time-path," and these time-paths are, in perhaps an unintentionally fitting pun, "elevators with many stories" (107). Significant portions of the earth's surface experience a shift into "some other time-path than its own," and as a result, "the dialectics of philosophy have received a serious jolt" (138). The sidewise historicity that deformed the object-world and canvas-space of cubism connects to this interwar fantasy of complex historical temporalities, which in turn plugs into later science-fiction explorations, such as Octavia Butler's *Kindred* (1979), in which the uneven historical terrain of the present is defined by a courthouse, a library, an old church, a Burger King, a Holiday Inn, and a wall with the protagonist's arm fused in it, each place bearing witness to the different

rates of institutional change and oppression in which African American life is lodged, as well as to the intense tactical nightmare of bending the arc of history in more hopeful directions.

Wick's present in *John Wick 3* is shown to be "forfeit," as Winston describes it, surrendered in penalty for breaching a code that is fortified by bounty, which the Continental administers. The Switchboard stands for the desire to motivate, control, and maintain a present and a history from which the franchise's title character wishes to escape, and yet, like Wick's sidewise horse ride across histories of movement itself, the command center offers up something strange about the heterogeneous consistency of history and the present, and specifically about the material ways in which technology and transmission rates produce now-time and the hodgepodge nature of historicity. In the space of the Switchboard—characterized, as already mentioned, by chalkboards, card catalogs, ledgers, file cabinets, and early PCs but also, as glimpsed in chapters 2 and 3, pigeons, pneumatic zip tubes, rotary telephones, a switchboard system, and a telegraph stock ticker with ticker tape scrolling out from its glass dome—the logistical management and tracking of the criminal underworld is governed by the clock at the front of the room, but the temporal jumble suggests that it is impossible to stack these synecdoches of the larger financial, bureaucratic, and administrative totality that is the Wickverse into a smooth, progressive media history (see fig. 10.3). Furthermore, the references to all of these past modes of communication and information storage—ancient messenger pigeons, eleventh-century writing slates, nineteenth-century messaging technology and office equipment—are coeval in the film, not because they are anachronistically "out of time" as elements of an old-world timelessness but because they form a kind of posthistorical assemblage, where posthistorical means, to quote Vilém Flusser's "Line and Surface," not that we are "no longer interested in history as such"

10.3. Wide shot of the Continental Switchboard. *John Wick 3* (2019).

but that any concept of history requires engaging "the possibility of combining various histories."[25] If John Wick is excommunicado, it is not only because he is expelled from the assassins' communion (and their sacraments and services) but also because he represents the desire to exit the idea of a singular history and a unitary communication network and to gallop, drive, run, and remember through histories differently mediated.

There is a danger to this emphasis on exiting and escaping, to be out of time, but just as bullet time does not mean an absolute outside, the traversal of relative reference frames does not aim to negate the historical but to reconfigure it. For example, the old-world charm of the Continental generating the aura of the time that the Switchboard manages and counts down is not sidestepped by Wickian time travel but offered up for critique. The heavily tattooed office workers in gray skirts and sleeveless light-pink blouses are elements of the hitman fantasy that inescapably conjure the history of gendered labor in financial information, war communication, and message management, all of which intersect in/as the present of the Continental Switchboard.

10.4. *From top left, clockwise*: the Waldorf-Astoria tickertape operators, 1918, US War Department, National Archives and Records Administration; Women's Army Corps operating teletype machines in World War II, US Army Center of Military History; Model 15 Teletype, in production from 1930 to 1963; Thomas Edison Gold and Stock Telegraph Ticker, Henry Ford Museum; principal operator at the Continental Switchboard behind an active tickertape machine in *John Wick 3*.

In the wider deep-focus shot, the clock's turning 6:00 p.m. freezes the room and becomes the governing vanishing point for the secretaries' upturned heads and orthogonal lines of perspective, but the suggestion of convergence in the mise-en-scène and the urgency activated in the

plot are undermined by the props and set dressing that for many viewers establish the temporal aura of the setting, its retro-historical "charm." The Switchboard scenes evoke the intertwined histories of telegraph and ticker tape, the first financial communications media and storage, stock market "girls" as information handlers, and the division of labor in military coordination, command, and enemy encounter. In figure 10.4, the US War Department's photographs of World War I provide us with a 1918 scene in which "the Waldorf-Astoria Hotel is employing girls to operate tickers and stock exchange boards. The Waldorf is the first to employ girls in its various departments, in order to release men for war work"; and the US Army Center of Military History's photograph shows "members of the Women's Army Corps operating teletype machines in England during World War II."[26] The Switchboard operators recall these scenes, and both the Thomas Edison Gold and Stock Telegraph Ticker and the Model 15 Teletype machine suggest the different histories running beneath and through the main action plot of violent men.

The Multiplex Present

Wick's ability to time travel across different histories does not absolve him of the various levels of his complicity in some or all of them; indeed, we can see that they are to varying degrees what constitute him. As Mi Jeong Lee points out in her essay for this volume, Wick's "blank cosmopolitanism"—his frictionless mobility across the globe—is an example of the neoliberal fantasy of free flows through a flattened, homogenized, synchronized universe and "is indebted to the universalist construction of the white, Western, English-speaking subject."[27] In *John Wick 3*, when Wick travels to the Moroccan Continental to ask Berrada (Jerome Flynn) where to locate "the Elder," the only one who "sits above the Table" and can save Wick's life, the film traffics in the stuff of textbook

Orientalism: colorful markets filled with Casablancans in headscarves, hookah-smoking villains, rolling dunes of the Saharan desert, and the quarter-toned music meant to evoke the exotic. The Elder (Saïd Taghmaoui), who speaks with John in a tent lavishly appointed with signifiers of Afroasiatic mystery, affirms what Berrada suggested with his etymology of "assassin" and display of the original coin and marker of the Table: Wick has returned to the source temporally and spatially. In true Orientalist form, Wick's travel to and through the space of Casablanca and the Elder's unmappable tent produces not an exit into heterochronic multiplicity but rather a solidification of the relation between the timelessness outside of history proper and the unilinear history that excludes such spaces from temporal development. To use Edward Said's reading of the cosmopolitan movements of Orientalist study, the non-Western subject consequently can never "outdistance the organizing claims on him of his origins" nor "shake loose the pastoral, desert environment of his tent and tribe."[28]

As the "blank cosmopolitan" who is suddenly back in New York, Wick is in obvious ways the needle that threads exotic exteriority to the single history that has always required the violent subtraction of historical and geopolitical particulars. He is at some level the embodiment of the US cultural fantasy of killing with impunity, the composite action hero of wronged-man revenge films and what Stuart Bender and Lorrie Palmer call "hero run shoot-outs," a twenty-first-century version of Rooster Cogburn in *True Grit*, the man who operates outside the law in "Indian country" but is glorified for living within a code.[29] The appeal of the code in the *Wick* films, legal or extralegal, is for Robert Barry "the fantasy of a perfectly ordered world, a kind of utopia of rules and records and accurate book-keeping," but it seems to me that this appeal is met with, or at least balanced with, a concern for the difference the platform makes in the legibility, experience, and even constitution of

the code.[30] Wick's alternative time traveling thus pits the historicism of harking back against the heterochrony of sidewise work that provincializes the cosmopolitan fantasy. For this reason, the Continental Switchboard cannot be read solely as a scene of remediation.[31] No doubt, *John Wick 3* invites the remediation reading in all sorts of ways, aware of itself as a "hypermediated" phenomenon concerned with its own work of mediation and its formal and thematic interest in exiting or becoming conscious of the machinery of immersion. The film, for example, incorporates into the Wick narrative the Times Square projection of Buster Keaton's 1921 silent film *The Goat*, also about a man being chased by everybody. As Stahelski says, in addition to "shots lifted straight from *Singin' in the Rain* and *West Side Story*. . . . we're mixing Buster Keaton and Charlie Chaplin with Hong Kong cinema from John Woo, Jackie Chan and the Shaw Brothers."[32] These allusions in the remediation reading would not be references so much as expressions of the repackaged and repurposed technologies and the immersive worlds they produced.

However, in addition to (perhaps in contrast to) the idea of constitution as remediation—of John Wick the character as much as *John Wick* the films—I would like to underline the historiographic implications of a technical advance that I think is the dominant note of the Continental Switchboard and that is perhaps most obvious in the reference to the teletype machines' automation of telegraph communication and printing (see fig. 10.5). In all of the shots of the Switchboard, *John Wick 3* invites a strange history of *history and data* in a genealogy of the bit, from the stock ticker punching out actual paper bits to the three models of teletype machines or teleprinters (models 15, 28, and 32) in the Continental. The technical invention I refer to is called the "synchronous distributor," a 1914 device for coordinating telegraph data so that more than one message can be sent at a time on the same line. Such synchronous coordination results in what is called "multiplexing,"

It is absolutely essential that both contact arms occupy the same relative positions at all times, that is, the must rotate synchronously. Such rotation is secured by the

Fig. 2.

use of manually-started motors having tooth-wheel iron armatures and periodically excited field magnets, the contact arms being mounted directly on the motor shaft. Periodic fied excitation is obtained by the use of reeds which are kept vibrating at their natural frequency. To maintain synchronism the distributor at one station sends

Fig. 3.

to that at the other station one more governing impulses during each revolution of the arm, which impulses control the speed of the distant motor.

10.5. A diagram of the Murray Multiplex Page-Printing Telegraph from Erich Hausmann's *Telegraph Engineering: A Manual for Practicing Telegraph Engineers and Engineering Students* (1915), and a diagram of basic time-division multiplexing from Tony Kuphaldt's "Socratic Electronics" website.

specifically "time-division multiplexing," in which multiple messages or parts of different messages are interleaved sequentially and assigned to channels. A scanner at the other end of the line connects each part of the interleaved signal to the proper message channel so that they can be assembled into their respective wholes. On the one hand, time-division multiplexing is a figure for the narrative present of the *John Wick* films, which is shot through with interleaved historical data. When distributor and scanner are not synchronized properly, the data become garbled and "improperly" reconstituted. One could argue that the films suggest that cinema itself aspires to the condition of multiplexer, that cinema's continuity conventions and narrative's consistency techniques are components of a cultural synchronous distributor.

On the other hand, such a multiplexer's failures are more interesting than its successes, because the former clarify less seductively the fact that history in the singular is a synchronizing construction. The anachronistic, inconsistent hodgepodge in *John Wick 3* lifts the veil on what Vittorio Morfino and Peter D. Thomas call "the *reductio ad unum* of times." For them, the plurality of times in the Marxist tradition reveals "the structural non-contemporaneity of the present and the 'fractured' nature of historical time" and requires us to acknowledge, as Morfino puts it, that "a society is therefore not a homogenous space permeated by a single time that would constitute the playing field of a simple contradiction."[33] Building on Ernst Bloch's analysis of the nonsynchronous or noncontemporaneous—the fact that not all people are living in the same present but may be located in different decades or centuries while occupying the same space—Morfino argues for a polytemporal and multispatial dialectic that goes "all the way," that relinquishes "a fundamental time with respect to which contemporaneity and non-contemporaneity are defined . . . [and that] runs inexorably in the direction of communism."[34] To think about polytemporality in this

way is to tend toward a science-fictional historiography that requires sidewise diagnoses.

In his *New Yorker* review, Richard Brody reads *John Wick 3* as "a post-apocalyptic political drama, conjuring a world in which a super-secret agency can order virtually public executions and pull them off without a trace, and without fear of exposure."[35] The film presents us with, as Brody writes, a "perfect network of surveillance," "a vision of the modern technological state."[36] Into the *John Wick* films' repetitive terror and violence in the twenty-first-century US, this is a timely insight. But I would also argue that, as a kind of posthistorical picaresque, *John Wick 3* generates untimely insights about the relationships among information media, storage technology, and modes of conceptualizing and moving across histories. Horse and car, telegraph and teletype, Keaton and Stahelski—these contrasts and juxtapositions in the film do not fortify a single historical scaffold. The out-of-time-ness that they exemplify is similar to the state and potentiality of technology that guide media archaeology's fascination with failed platforms and obsolete devices. Not only do outmoded platforms and technologies disrupt the smooth progression of media history, but they also reconfigure the process of historicizing as driven by the time-critical processes of different media and remind us that to imagine history otherwise entails unearthing and reactivating historical lines buried in what we take to be the present.

Notes

1. Robert Barry, "The Utopia of Rules: 14 Paragraphs about John Wick," *Quietus*, June 15, 2019, https://thequietus.com/articles/26646-john-wick-chapter-3 -parabellum-review.
2. For this fan theory about Keanu, *Bill and Ted Face the Music* (2020) would simply ironize the saddest time machine of all—aging.

3. Fredric Jameson, "The End of Temporality," *Critical Inquiry* 29, no. 4 (2003): 714, https://doi.org/10.1086/377726.

4. Jameson, "End of Temporality," 699; Fredric Jameson, *Postmodernism, or The Cultural Logic of Late Capitalism* (London: Verso, 1990), 307; Jameson, "End of Temporality," 715.

5. Jameson, "End of Temporality," 714.

6. Jameson, "End of Temporality," 714, 708, 718, 704.

7. George Hatzis, "John Wick: Kill Count," Visu, infographic, accessed November 7, 2019, https://www.visu.info/john-wick-kill-count.

8. Jameson, "End of Temporality," 714.

9. Manuel Castells, *The Rise of the Network Society* (Oxford: Blackwell, 1996), 464.

10. Lionsgate Movies, "John Wick: Chapter 3—Parabellum (2019) Official TV Spot 'Bullet Time'—Keanu Reeves," YouTube, May 10, 2019, https://www.youtube.com/watch?v=L4OFE_88n60.

11. See Tom Gunning, "Attractions: How They Came into the World," in *The Cinema of Attractions Reloaded*, ed. Wanda Strauven (Amsterdam: Amsterdam University Press, 2006), 31–40; Tom Gunning, "'Primitive' Cinema: A Frame-Up? Or, The Trick's on Us," in *Early Cinema: Space, Frame, Narrative*, ed. Thomas Elsaesser and Adam Barker (London: British Film Institute, 1990), 95–103; Tom Gunning, "'Now You See It, Now You Don't': The Temporality of the Cinema of Attractions," *Velvet Light Trap: A Critical Journal of Film and Television*, no. 32 (1993): 3–12.

12. Bob Rehak, "The Migration of Forms: Bullet Time as Microgenre," *Film Criticism* 32, no. 1 (2007): 35.

13. John Gaeta, the visual effects supervisor for *The Matrix*, used 122 computer-triggered still cameras surrounding the actor, combined with two 1,000-frame-per-second motion-capture cameras, topped off with CGI frame interpolations. Susan Broadhurst, *Digital Practices: Aesthetic and Neuroesthetic Approaches to Performance and Technology* (Basingstoke: Palgrave Macmillan, 2007), 142.

14. Lisa Purse, "The New Spatial Dynamics of the Bullet-Time Effect," in *Spectacle of the Real: From Hollywood to Reality TV and Beyond*, ed. Geoff King (Bristol: Intellect, 2005), 156.

15. Scott Bukatman, *Matters of Gravity: Special Effects and Supermen in the 20th Century* (Durham, NC: Duke University Press, 2003), 118, 125.

16. Walter Chaw describes them as "Suicide Girls with tattoo sleeves who speak with the courtesy and professionalism of 1950s switchboard operators." Walter Chaw, "John Wick: Chapter 2 (2017)," Film Freak Central, February 15, 2017, https://www.filmfreakcentral.net/ffc/2017/02/john-wick-chapter-2.html.

17. Chris Longo, "John Wick 3: How the Epic Horse Scene Came Together," Den of Geek, May 16, 2019, https://www.denofgeek.com/movies/john-wick-3-how-the-epic-horse-scene-came-together/. "'I'm like. . . . There's a stable right there,' Stahelski says. 'So I made [the location scout] take me in there like literally like a couple blocks up Central Park, and this brick face building was five-stories. I'm like, John Wick's going to run in this fucking place. And we're gonna have a gun fight with horses. And then fuck it, he's gonna get on a horse because Keanu said he can ride a horse.'"

18. H. G. Wells, *Anticipations of the Reaction of Mechanical and Scientific Progress upon Human Life and Thought* (London: Chapman and Hall, 1901), 11.

19. Jussi Parikka, "Time Machines," ed. Frances McDonald, *Traces, Thresholds*, accessed July 13, 2019, http://openthresholds.org/2/timemachines.

20. Warwick Research Collective, *Combined and Uneven Development: Towards a New Theory of World-Literature* (Liverpool: Liverpool University Press, 2015), 17. The members of the collective are Sharae Deckard, Nicholas Lawrence, Neil Lazarus, Graeme Macdonald, Upamanyu Pablo Mukherjee, Benita Parry, and Stephen Shapiro.

21. Murray Leinster, "Sidewise in Time," *Astounding Stories* 13, no. 4 (1934): 10–47, repr. in *The Time Travelers: A Science Fiction Quartet*, ed. Robert Silverberg and Martin Harry Greenberg (New York: D.I. Fine, 1985), 67–142.

22. Leinster, "Sidewise in Time," 75, 78.

23. Leinster, "Sidewise in Time," 98, 99, 100.

24. John Cheng, *Astounding Wonder: Imagining Science and Science Fiction in Interwar America* (Philadelphia: University of Pennsylvania Press, 2012), 201.

25. The filing cabinet is 1850s, the pneumatic tube is from 1855, the typewriter is from 1873, and the telephone is from 1876. Vilém Flusser, "Line and Surface," in *Writings* (Minneapolis: University of Minnesota Press, 2002), 33.

26. Underwood and Underwood War Department, 1789–1947, *American Unofficial Collection of World War I Photographs, 1917–1918*, November 12, 1918, 165-WW-595C(1), National Archives at College Park—Still Pictures (RDSS), https://catalog.archives.gov/id/533759; WAC photograph from the US Army Center of Military History in *Encyclopaedia Britannica*, s.v. "Women's Army Corps," accessed July 14, 2019, https://www.britannica.com/topic/Womens-Army-Corps.

27. See Mi Jeong Lee, "John Wick's Blank Cosmopolitanism and the Global Spatiality of the Wickverse," in this volume.

28. Edward Said, *Orientalism* (1978; repr., New York: Penguin, 2003), 234.

29. Stuart Bender and Lorrie Palmer, "Blood in the Corridor: The Digital Mastery of the Hero Run Shoot-Outs in *Kick-Ass* and *Wanted*," *Journal of Popular Film and Television* 45, no. 1 (2017): 26–39.

30. Barry, "Utopia of Rules."

31. For the way new media/digital media makes older media its content, see Jay David Bolter and Richard A. Grusin, *Remediation: Understanding New Media* (Cambridge, MA: MIT Press, 1998), 45.

32. Iain Marcks, "Slayin' in the Rain: John Wick Chapter 3—Parabellum," *American Society of Cinematographers*, May 24, 2019, https://ascmag.com/articles /john-wick-chapter-3-slayin-in-the-rain.

33. Vittorio Morfino and Peter D. Thomas, "Tempora Multa," in *The Government of Time: Theories of Plural Temporality in the Marxist Tradition*, ed. Vittorio Morfino and Peter D. Thomas (Leiden: Brill, 2017), 3, 11; Vittorio Morfino, "On Non-contemporaneity: Marx, Bloch, Althusser," in Morfino and Thomas, *Government of Time*, 126.

34. Morfino, "On Non-contemporaneity," 128.

35. Richard Brody, "'John Wick: Chapter 3—Parabellum,' Reviewed: Keanu Reeves, Empty Fight Scenes, and a Paranoiac Chill," *New Yorker*, May 17, 2019, https:// www.newyorker.com/culture/the-front-row/john-wick-chapter-3-parabellum -reviewed-empty-fight-scenes-with-a-paranoiac-chill.

36. Brody, "Paranoiac Chill."

CHARLES M. TUNG is Professor and Chair of English at Seattle University, where he teaches courses on twentieth- and twenty-first-century literature, temporal scales, and representations of racial anachronism. His book *Modernism and Time Machines* (2019) connects the obsession with time in modernist literature and art to the rise of time-machine narratives and alternate histories. His recent work on time and modernity has appeared or will soon appear in *The Edinburgh Companion to Modernism and Technology*, *Timescales: Thinking across Ecological Temporalities, Modernism and the Anthropocene*, *ASAP/Journal*, and *Modernism/Modernity*.

11 JOHN WICK'S BLANK COSMOPOLITANISM AND THE GLOBAL SPATIALITY OF THE WICKVERSE

MI JEONG LEE

How does John Wick travel? Does he have a passport and frequent-flier miles? Sure, he can kill three men with a pencil, but how does he get past TSA? Such questions arise as the *John Wick* series has branched out beyond its New York City setting in the first film, into Rome in the second chapter, and to Casablanca and the Sahara Desert in the third. These increasingly diverse geographies accentuate John Wick's transnational mobility, his easy multilingualism, and a seemingly endless adaptability to new locales and cultural combat techniques, which all in turn deepen the mythos of the character's legendary prowess—not just as an assassin but as an exceptional human being who excels at inhabiting an intensely globalized space. This essay probes John Wick's particular brand of cosmopolitanism—theorizing it as a "blank cosmopolitanism"—to understand how Wick excels at that inhabitance of his world (what some have termed the "Wickverse") as well as how his cosmopolitanism mutates with the destabilization of his status within it.

My questions about passports and TSA are moot for the whole of *John Wick* and well over half of its sequel. In the former, international travel is not a relevant issue, and by the time of *John Wick 2* he is firmly "back," albeit reluctantly so, as a member of the assassin world. Wick's privileged membership in the assassin network—in itself a world as globalized as ours—seems to come with a waiver for such mundane concerns of border-crossing. The carefree nature of this globetrotting and

the world space that serves as its condition is summed up by geographer Doreen Massey's description of the images conjured up by globalization in our geographical and social imaginations: "A vision of total unfettered mobility; of free unbounded space."[1] Massey yokes together the subject's "unfettered mobility" with the "free unbounded space" of the interconnected globe, a formula that encapsulates the mutual constitution of the cosmopolitan figure John Wick and the global spatiality of the Wickverse that I wish to explore here. John Wick's blank cosmopolitanism, however, is both a product of and an anomaly within the globalized Wickverse. It is, in the first instance, a cosmopolitanism made possible by his membership in that vast network of assassins all over the world, but it is also an aspect of the character that develops uniquely as his status within that network undergoes a series of changes. These changes, in turn, recalibrate the global spatiality of the Wickverse itself.

Notoriously difficult to pin down, cosmopolitanism as a philosophical concept can be traced back to the Stoics, who argued for a world citizenship (*kosmopolites* means a "citizen of the cosmos") that would emphasize allegiance to a worldwide community over one's local—or, later, national—circles. Immanuel Kant further developed this Stoic cosmopolitanism into a political project of the Enlightenment, through which he envisioned a European-led global polity that exists peacefully in rational agreement. In its most common vernacular usage, *cosmopolitan* refers either to someone who is worldly, well-traveled, and sophisticated or to something that has international elements.[2] Any of these definitions could be applied to *John Wick*—both the character and the world represented in the franchise. Although different national, regional, and religious groups exist within the assassin underworld, what unites the killers is a transnational allegiance to the High Table, a mysterious global government of crime. John Wick is in many ways a stereotypically cosmopolitan figure, as is evident in his aforementioned

mobility, multilingualism, and adaptability—and his stylish dark suits certainly help, too.

Cosmopolitanism (and the globality that undergirds it) is an illuminating lens through which the increasingly widening geographical stretch of the franchise's world-building may be understood as distinct from the deepening of its lore. As several of the chapters in this volume emphasize—and as the volume's title and introduction underscore—in the *John Wick* films, director Chad Stahelski aims to "isolate and show you a hidden world, and believe in the mythology."[3] Indeed, the network of high-end contract killers is a world in itself, bound to arcane and rigid rules of conduct and honor; the *John Wick* franchise has been lauded for this aspect of its remarkable world-building. If Stahelski's motive to expand the John Wick world finds immediate expression in the ever-deepening lore of the assassin underworld, a primarily vertical expansion, I contend that the horizontal expansion of the second and third films effects something more of a world-destroying that only then clears the ground for another world-building. Consisting of a centrifugal movement followed by a centripetal one, this horizontality of the Wickverse, along with its various cosmopolitanisms, can be further interrogated for the different kinds of worlds it entails. That is, the horizontal stretching out accentuates but also weakens John Wick's cosmopolitanism—revealing its blankness as a construction—and in turn contracts the Wickverse from the globe to New York City, a space and community rendered a "world" that is gradually rebuilt for a changed Wick. Focusing on the second and third chapters of the *John Wick* series, where the mutual constitution of John Wick's blank cosmopolitanism and the Wickverse's global spatiality is made explicit, I begin the discussion that follows by theorizing blank cosmopolitanism and then arguing that this cosmopolitanism and the global Wickverse within which

it operates act as premises of a world-building that is radically broken down in the sequence of the second and third films.

Blank Cosmopolitanism: John Wick and Keanu Reeves

Why a *blank* cosmopolitanism? Several reviewers of the films have turned to the word *blank* to describe a quality of the character John Wick and/or the actor Keanu Reeves. The term has even become a point of contention or ridicule in regard to the series' storytelling and the actor's performance. Indeed, the films' relative lack of expository dialogue, especially the protagonist's monosyllabic stoicism, has become something of a running joke in the franchise. Wick the character has been called "a blank slate," an "empty vessel," and a "cipher."[4] Crucially informing this discourse of the character's affective blankness is Reeves's own history of stardom as an actor whose sexual and racial ambiguities have been subject to speculations about unseen depths and hidden cores glazed over with a disconcertingly elusive surface. The mystery surrounding his sexual orientation produced a persona characterized by what Michael DeAngelis calls an "inbetweenness" of identity categories.[5] Reeves's so-called androgyny, DeAngelis explains, especially marked him as an unusual kind of action hero; in *Speed* (1994), for example, Reeves's Jack Traven was "a figure of considerable depth and individuality," a "softening of the stereotypical hard-man action hero, and [informed by] a subtle, 'minimalist' acting style that permits and requires spectators to infer the actor's withheld emotion rather than offering them a too overt demonstration of affect."[6] Reeves's muted performance can be read as authentic and effective insofar as this nearly blank—"minimalist"—kind of acting style is one that "withholds" emotion, not because it is not there, but because it is located too deep. His

ambiguous racial identity, which allows him to pass as white but also be discovered as Asian, adds to this sense of mystery; notably, Asianness has long been associated with inscrutability. This enigmatic opacity that goes way back with Reeves accentuates a similar quality in John Wick, whose own version of blankness, I argue, enables his particular brand of cosmopolitanism. Reviewers of the *Wick* films have also picked up on the qualities shared between Reeves and Wick. For example, in a piece commenting on how *John Wick* benefits from Reeves's acting style, A. A. Dowd writes, "The guy excels at ciphers, at characters defined more by their actions than their words, their relationships, or their psychologies. . . . The actor's blankness [is] perfectly suited to the man, the myth, the legend himself, John Wick, who's barely human in his supernatural drive and abilities [and is] a character that's basically all attitude and style."[7] This last emphasis on "attitude and style" (all surface, no depth), however, is one that I counter through the following reading of Wick's blank cosmopolitanism, which hinges on the misleading appearance of surface blankness.

By naming John Wick's cosmopolitanism blank, I mean to call attention to the veneer of universalism that his ostensibly effortless existence without need for a passport or translator entails, using *blank* to emphasize the privilege behind the apparent seamlessness of both the films' completely globalized and borderless world space and the person who moves within it—that is, John Wick as cosmopolitan is indebted to the universalist construction of the white, Western, English-speaking subject that can afford to travel light in the world. Any invocation of cosmopolitanism in the second decade of the twenty-first century must grapple with its troubled legacy—its complicity with Eurocentric universalism and imperialism, for instance. The concept's critics include geographers such as David Harvey, who takes issue with neoliberal

discussions of cosmopolitanism that often conceive of the individual in a world that is flat and homogenous.[8] And cultural theorists such as Timothy Brennan, who claims that cosmopolitanism is a term used to cover up American global imperialism, capitalism, and neoliberalism, argue that "cosmopolitanism is local while denying its local character" and Western while appearing to transcend Western perspective; Brennan sees "this denial [to be] an intrinsic feature of cosmopolitanism and inherent to its appeal."[9] *Blankness*, then, as I use it, refers to the *seeming* universalism of something that is Western and/or American, the glossing over of a particularity to make it look unremarkably neutral.

The *John Wick* series as a Hollywood product is inescapably American and Anglocentric in ways that confirm its complicity with such universalist versions of cosmopolitanism. Despite the series' efforts to establish the impression that all the international Continentals and their home cities are equal under the High Table, its cinematic world is firmly anchored in New York. Certainly, each Continental does function as a center in its own right; yet the centrality given to the medium of (American) English in all exchanges across the Wickverse clearly designates the US or at least New York as *the* center with other sites functioning more or less as peripheries. While English is the standard for communication, Wick's fluent command of a variety of languages often serves as an indicator of his exceptionality. Noting that "John is shown to be fluent in several languages, including English, Russian, Italian, Hebrew, American Sign Language, Arabic, Japanese, and Indonesian," Cristina Alonso-Villa claims that Wick's multilingualism is, in effect, a superpower.[10] If Wick's surprising multilingualism cements his perceived cosmopolitanism, what probably goes less noticed is that his non-American interlocutors, such as the D'Antonio siblings, in fact surpass Wick's cosmopolitan adaptability in their English fluency, revealing an

already uneven playing field that reflects the real world's rules by which everyone is already expected to speak English and to know John Wick even if he doesn't know them.

Among the many characters who converse with John Wick in accented English—their native tongues being Russian, Italian, Arabic, Indonesian, and so forth—Zero (Mark Dacascos), the assassin hired by the Adjudicator (Asia Kate Dillon) in *John Wick 3* to hunt Wick, stands out as someone whose cosmopolitanism rivals that of his quarry, at least in terms of linguistic and cultural adaptability.[11] We first meet him as a sushi chef in a hole-in-the-wall restaurant in New York; to a faint J-pop background, he dons traditional Japanese clothing, speaks Japanese with his fellow workers, and greets the Adjudicator with clearly accented English. Once the Adjudicator reveals their identity, Zero switches to perfectly American English, also abandoning his sushi chef guise and slipping without a glitch into assassin mode. One might say Zero's assumed accent and demeanor as sushi chef are the unmistakably artificial "blank" corresponding, however negatively, to Wick's own "blanknesses"—the analogy between these two kinds of blankness becomes clearer in the next part of the essay, where I focus on Wick's questionable ethnicity (which, in turn, is again buttressed by Reeves's own quality of ambiguous whiteness). Later, in combat with Wick, Zero switches in and out of Japanese (presumably also understood by Wick, though he never speaks it himself), and insists that "we're the same." Of course, they are not the same, for Wick wins the fight, leaving Zero to bleed to death. Zero's disconcerting insistence on their sameness, amplified by the mirror-room setting of their battle, brings up the issue of hierarchies within the assassin world in terms of cosmopolitan adaptability, whether that be mobility, language, or culture.

Massey, cited earlier on the spatial imagination of globalization, points out that the unfettered mobility and unbounded space of

globalization are a skewed result of "the *power geometry* of time-space compression," whereby "different social groups, and different individuals, are placed in very distinct ways in relation to these flows and interconnections."[12] Massey's point about groups *and* individuals occupying globalized space differently usefully illuminates a hierarchy within the Wickverse. In terms of the seamlessness of his transnational mobility, John Wick's blank cosmopolitanism is arguably not a privilege unique to him but in fact a prerogative enjoyed by all those in the upper echelons of the assassin "social group"—including the Adjudicator, Cassian, and Ares, who all cross borders presumably as easily as Wick does, even if their travels do not receive the same degree of narrative attention. Yet what makes John Wick's cosmopolitanism stand out is that its particular blankness is revealed as a construct as soon as his assassin citizenship is revoked.

From Elite Traveler to Vulnerable Migrant

So far John Wick's cosmopolitanism, in all its blankness, has been a sign of his privilege to move freely within his world. The drama of excommunicado that begins at the end of *John Wick 2* and drives all of the third film, however, creates a radical change in Wick's cosmopolitanism by casting him less as an elite traveler and more as a vulnerable migrant. After Wick kills Santino D'Antonio on Continental grounds, breaking one of the two cardinal rules of the assassin world, he is excommunicated from the organization. That excommunicado order, we see, is sent out globally from the command center. The brief shot of the screen rolling out the telephone numbers to which this announcement is sent, including locations in the UK, Japan, and Hungary, is the only map of the Wickverse that hints at the vastness of its geographical stretch (see fig. 11.1). Even then, it is not actually a comprehensive map, for the shot

```
]SENDING  MESSAGE  TO.....  +1-212-156-9932
]
]SENDING  MESSAGE  TO.....  +44-20-7946-0999
]
]SENDING  MESSAGE  TO.....  +81-97-8077-6590
]
]SENDING  MESSAGE  TO.....  +36-55-958-716█
```

11.1. The excommunicado notice. *John Wick 2* (2017).

does not linger long enough for us to get an entire list of countries to which John Wick's excommunicado notice is transmitted. Yet it is no coincidence that the only global map of the Wickverse would not exist if not for him; it is also worth noting that this cartography coalesces around his expulsion from that world, one he can longer venture into without encountering someone who wants to kill him.

In other words, the world is no longer John Wick's oyster. At first glance it seems his cosmopolitan privilege has been completely revoked, but the predicament unexpectedly complicates his blank cosmopolitanism by revealing his troubled relationship with home. Wick's privileged relationship to the Wickverse has skewed my discussion of his cosmopolitanism in terms of the global. Once that privilege is rescinded through his excommunication, his cosmopolitanism does not so much disappear as its blankness is reconfigured through Wick's resurfaced affective relationship to the local—his various homes. One of the selling points of the franchise is that its deadpan bloodbath is driven by something as trivial as (or at least perceived as trivial by most in the storyworld and some critics as well) the loss of a puppy, left to Wick by his

deceased wife, Helen. Helen (Bridget Moynahan) had been the reason he had gone to great lengths to leave the assassin world, and his anger at having been robbed of the peace to grieve and properly remember her and their domestic bliss motivates him throughout the series. The loss of this marital home precedes the first movie, and early into the second one Santino destroys Wick's physical home in New Jersey. Notably, the only time we see him make any fuss about travel is when he visits the Ruska Roma to gain safe passage to Casablanca. Entering the Tarkovsky Theater, Wick is clearly revisiting a familiar place; he knows the people, and he presents his beads and goods as a sign of a preestablished permission to enter. The Director of the ballet asks him, "Jardani, why have you come home?"

Bruce Robbins and Paulo Lemos Horta note a relevant tension between the global and the local in the very first use of the word *cosmopolitan*, which was an evasive response to the question, "Where are you from?": "When Diogenes the Cynic called himself a 'kosmo-polites,' or citizen of the world, he was preferring not to say that he was from Sinope, a distant Greek colony on the Black Sea from which he had been banished, as the questioner perhaps knew, for alleged misconduct involving the local coinage."[13] Robbins and Horta go on to expound on the mixture of these two impulses, the negative one that "asserts detachment from one's place of origin or residence" and the positive one that "asserts membership in some larger, stronger, or more compelling collective," as a characteristic of most cosmopolitanisms that have followed.[14] The revelation of John Wick's "real" home—the home he had before the one he made with Helen—as a solution to the pickle of global mobility presents a strikingly different balance between home and cosmopolitanism. If with Helen, Wick's domestic haven required the disavowal of his cosmopolitan membership in the assassin world

and all the benefits that came along with it, the return to the home of the Ruska Roma as Jardani Jovonovich (Wick's real name) helps him get back into that world under the High Table.

Wick's excommunication thus revokes his blank cosmopolitanism—epitomized by his access to the very infrastructure of mysteriously arranged transportation, fancy hotels, and state of-the-art weaponry—and in its place reveals something that complicates Wick's purported blankness. Hidden under the all-but-untraceable name and identity of John Wick is an ethnic name and identity: in Russian, Wick says to the Director, "I am Jardani Jovonovich. I am a child of the Belarus, an orphan of your tribe. You are bound to help me," and in English, "You are bound, and I am owed." The Anglicized John Wick turns out to have been a Western subject made universal; the name John Wick is so bland that it tells us seemingly nothing about his identity, but only if we assume an Anglocentric perspective.[15] Even Keanu Reeves's own racial ambiguity—the actor is of English, Chinese, Irish, Native Hawaiian, and Portuguese descent—plays subtly into John Wick's blankness, insofar as Wick's assumed identity turns out to have been a smoothing over, a making blank, of a previous one whose "foreignness" is undetectable until made explicit. Here, what Leilani Nishime calls "the public's collective amnesia" about Reeves's Asianness is strikingly relevant—that is, although he has never kept his racial genealogy a secret, he nonetheless remains "usually racially unmarked" because of "an absence that reads as white."[16]

One example of this belated exposure of a constructed blankness might be found in the disparate ways the cultural variety of Wick's physical prowess has been discussed by critics. Drawing on Wick's extraordinary linguistic capabilities to extend cosmopolitanism to his physical proficiency, David Ehrlich celebrates Wick's varied fighting styles: "This is a character who appears to know every single language

under the sun, but violence is the most expressive part of his vocabulary (Reeves speaks maybe 100 words in the entire movie). Chinese wushu, Japanese judo, Southeast Asian silat, American Glock . . . Wick is fluent in them all."[17] From a "native" perspective, however, Wick's martial language reads differently. Rizki Fachriansyah, an Indonesian film critic, notes that in the third film "Reeves's default, uncompromising choreography registers as a cultural blank slate compared to the ethnic art of *silat* introduced by renowned Indonesian martial artists Yayan Ruhian and Cecep Arif Rahman."[18] Fachriansyah calls Wick's fighting style an "anonymous" one that, "due to narrative contrivance . . . always emerges victorious."[19] The encounter between Wick and the pair of Ruhian and Rahman is, on the one hand, read by Ehrlich as an occasion for Wick to display his fluency in yet another cultural martial form and, on the other, read by Fachriansyah as a juxtaposition that reveals Wick's cultural blankness—like his Anglicized name, John Wick, his fighting style reveals nothing about him because it is blank, anonymous, smoothed over, made to look neutral. Wick's martial responses are creative; he meets *silat* not with *silat* but with some blend of styles that ultimately registers as blank because it has partly absorbed *silat* and also because he wins the fight. If his fighting style is a reflection of his identity in any sense, John Wick's "anonymity" or "cultural blankness" is not something that he is born with but something he has fashioned to come across as blank only when juxtaposed against its negative.

Clutching his rosary beads as he entreats the Director of the Ruska Roma ballet for safe passage to Casablanca, Wick understands that by doing so he will lose this home. The Director (Anjelica Huston) tells him that "with this, Jardani, your ticket is torn. You can never come home again." The moment signals the second loss of a home that Wick experiences within the series, the third if we count Helen as another "home." What sort of feelings Wick harbors for this particular home is

left ambiguous, but the backdrop of the ballerina's enduring physical pain and grueling training—"Art is pain, life is suffering," says the Director—hints at the origins of Wick's stoicism as something he might have learned in this home, as an acquired blankness, like a piece of art that hides its excruciating process. This is where the aforementioned affective blankness of John Wick (and Keanu Reeves) becomes relevant, as a blankness like his Western/American privilege is revealed as a construction. If film critics such as Dowd treat Wick's affective blankness as literal—reading Wick as an empty cipher—Angelica Jade Bastién makes a more nuanced claim about Wick's so-called blankness by roping in Keanu Reeves's own personal life as well as the metatextual arc of his acting career, through which "loneliness comes into focus as a thematic preoccupation."[20] She writes in praise of his "transfixing stillness," a greatness she finds "synthesize[d]" in the Wick films: "His central, thematic loneliness; his command of physicality and stillness; and his peculiarly vulnerable masculinity."[21] These qualities are admittedly not quite blankness. Still, their very negative slant—loneliness as the lack of intimate connections to the world, physicality as a restrained movement, and a vulnerable masculinity perceived as oxymoronic and therefore all the more powerful—makes Bastién's approach a relevant one for complicating blankness as I have done with John Wick's cosmopolitanism—as a blankness that appears as such only because it signifies a lack or a cover.

If the blankness of John Wick's cosmopolitanism, practiced when he was an elite traveler, is retroactively revealed as a constructed blankness when he becomes a vulnerable migrant, tellingly that revelation involves an act of literal inscription over that once-presumed blankness. Once Wick hands over the "ticket" for his passage, a cross, one of the Romani henchmen brands Wick's back with a Petrine cross, a back already tattooed with the same pattern as that on the ballerina practicing

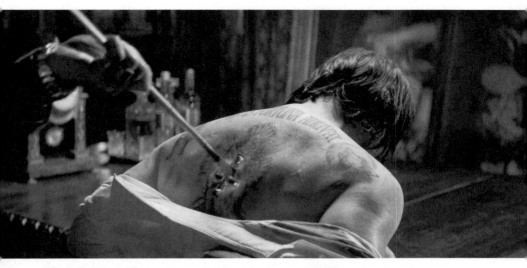

11.2. Branding scene: Wick's skin made less blank. *John Wick 3* (2019).

on stage.[22] His skin, already inked, is made even less blank by this act of branding (see fig. 11.2). Compared to the sleek smoothness of the dark suits and white shirts that cover up these marks, intimations of his complicated past, especially with regard to home and family, function as another kind of inking or branding of what was perceived to be a blankness. In his visit to the Ruska Roma, we gain a glimpse of the layers of inscription—pain, affect, history, and local ties to home—that preceded his life as John Wick, layers that had to be made blank in order for him to become John Wick but that had never been fully erased. The episode with the Ruska Roma makes it seem that John Wick has finally lost all of his homes—Helen, Belarus, and even the assassin network as some kind of community. His purpose in traveling to Casablanca is to meet with the Elder and regain his citizenship in the assassin world,

but in an unexpected turn of events, New York itself emerges as another "home" for Wick.

From Global Metropolis to Local Community

The last manifestation of Wick's transformed blank cosmopolitanism has to do with the capacious and mutable nature of New York itself, both city and world. As noted earlier, the Wickverse as a global space and John Wick's cosmopolitanism are intertwined; he cannot be cosmopolitan without a global space in which to be cosmopolitan, and the globality of the Wickverse narratively depends on Wick, for only through his travels do the films venture into different parts of the globe. The tumultuous transition in Wick's status, then, must go hand in hand with a change in the nature and scope of the Wickverse's spatiality. Before Wick's excommunication, the Wickverse is equal to the assassin world under the High Table. However, this is no longer the case the moment Wick is expelled from that world, and not even after he is reinstated by the Elder as an assassin, for he soon chooses to rebel against the High Table at the end of the third film. The world of the High Table remains that stereotypically, exaggeratedly globalized space (abstract and borderless), while the newly independent Wickverse—the space that John Wick embodies and sustains—is more local than it is global, more New York City than entire world.

The dominance New York enjoys in the three films is indisputable, even as the franchise starts reaching out geographically. That dominance, of course, is most pronounced in the first film, set entirely in the area. In an interview after the first film in 2014, director Chad Stahelski stated that "New York was central to the story" for several reasons: "Due to budgets, we looked at all kinds of different cities. But with the

11.3. New York as urban labyrinth. *John Wick 3* (2019).

mythology vibe, we wanted an underworld. If you're really thinking about when you walk around downtown Manhattan, it's subterranean. If you look up it's a vertical city. . . . It's the only place that you can be above ground and feel like you're below."[23] This verticality is greatly conducive to the conceit of the hidden underworld of killers that is the Wickverse. As a world in itself, the first film's New York (and parts of New Jersey) is broken down into different districts—the Red Circle nightclub on West Forty-Seventh Street, a church in Little Russia, a safe house in Brooklyn, and so on—and the movements between the districts are represented through aerial shots of the city (see fig. 11.3). The very capaciousness of New York City means it is more than wide and deep enough for the Wickverse to spread out and take root.

New York has been one of Hollywood's favorite urban spaces to treat as a world in itself. The city's size, density, diversity, and geopolitical status as a major metropolis in the West all contribute to its symbolic worth as a world.[24] Films such as Jules Dassin's *Naked City* (1948) and Sidney Lumet's *Prince of the City* (1981) have mined the geographies of New York City for their stories. It is not a coincidence that these films, along with the *John Wick* series, may be grouped loosely under the category of film noir, focusing on some dark aspect of urban crime and delving into a hidden underworld.[25] Nicholas Christopher emphasizes the centrality of the urban setting to the genre by explaining that "the city as labyrinth is key to entering the psychological and aesthetic framework of the film noir," and he borrows from the German historian Oswald Spengler's claim that "the [twentieth-century] city is a world, is *the* world" to note the genre's treatment of the city as "a closed system" that engulfs the hero.[26] Although *John Wick*'s New York is not so much a faithfully produced realist portrayal but rather a creative amalgam of the real New York and the fictional Wickverse (for example, the famous Flatiron Building on 175 Fifth Avenue is repurposed as the Continental Hotel), this version of New York still participates in and benefits from the construction of a "labyrinth" and a "system"—in short, a "world" that is vast, complexly interconnected, and all-encompassing.

While *John Wick*'s New York is certainly *a* world, the expansion of the series' geography into the actual larger world makes impossible the equation between that New York and *the* world. In other words, expanding the Wickverse overseas and then returning to New York results in a revised view of New York's function as a world: the city becomes situated as part of the larger world—connected to it—rather than an enclosed world in itself.[27] Moreover, when the Wickverse becomes clearly something that John Wick, and only Wick, embodies—rather

than the entirety of the global assassin world, as evidenced by Wick's ex-communication—New York City as Wickverse becomes distinct from the larger assassin world, which presumably spans the globe. As Wick himself moves away from that global network in the emergence of his cosmopolitanism not as blank but rather as rooted in his locality, New York is also redefined in the films, from global to local, so as to reflect and accommodate Wick's character arc.

The breakdown of Wick's blank cosmopolitanism necessitates a renewed attention, on his part, to his local rather than global connections. If cosmopolitanism is, whether politicized or not, an attitude of allegiance toward a community larger than one's local circles—usually the world at large—the drama of Wick's excommunication highlights his lack of fellow feeling toward his peers in the global assassin community. Up until well into *John Wick 3*, when he decides to fight back against the High Table, his adherence to its rules seems never quite motivated in good faith. The horizontal expansions of the Wickverse into Rome and Casablanca hinge on invocations of past relationships—a professional one between Santino and Wick and perhaps a more personal one with Sofia, the Moroccan Continental manager—but those relationships are honored so begrudgingly, even spitefully, that it is hard to see how Wick's ties within the global underworld may generate feelings of solidarity.[28] In contrast, his local acquaintances in New York—Aurelio the car dealer, Winston the Continental manager, and Charon the concierge—share distinctly more sociable, even intimate, connections with Wick.

The deconsecration of the Continental Hotel, a punishment for a building akin to the excommunication of the person John Wick, already hints at an equivalence between figure and space that should culminate in the equivalence between Wick and the Wickverse. Wick's two main

allies, the Bowery King (Laurence Fishburne) and the New York Continental's manager, Winston (Ian McShane), each articulate a relationship with their respective spaces that previews Wick's own (yet to be fully articulated) relationship to the Wickverse. To the Adjudicator's demand that he abdicate his throne, the Bowery King claims, "I *am* the throne, I am the Bowery." The Adjudicator, who has spent the entirety of the third movie doling out punishments to John Wick's allies, later also warns Winston to stand down from war against the High Table. Winston responds defiantly, "My allegiances run way beyond this building," and what is more, "We are New York City."

This "we" in Winston's declaration, encompassing a community uncontained by the visible boundaries of the hotel, includes Wick implicitly, even as the third movie ends on the purposefully ambiguous note of Winston's betrayal. The more immediate "we" into which Wick is included is presented at the end of the third chapter, as Wick is folded into the secret local networks of the Bowery, connecting a vast New York underground visible only to the discerning eye. From the bird's-eye view of the Adjudicator from the rooftop of the Continental, Wick's disappearance is like a disconcerting visual trick. If John Wick's own blank cosmopolitanism is rendered not blank by his expulsion from the assassin world, this juxtaposition between the High Table view of New York from above and the on-the-ground urban networks reveals a related, opposite logic of blankness. From the global perspective, too high up or far away, the operations of New York's "we" are indiscernible to the point of being read as blank. We might think back to the urban aerial shots of the first *John Wick* movie, similarly looking down from above but vastly different in the implications of that height. Only after the franchise has given us glimpses into the global geographies of the assassin network is New York able to take on both a vertical depth and a horizontal reach that are defined as local against a bigger global space.

Conclusion

Expressing dissatisfaction with the awkward expansion of *John Wick: Chapter 3—Parabellum*, IndieWire's David Ehrlich hypothesizes that the success of the franchise might hinge on its "find[ing] a way to deepen the John Wick mythos instead of just stretching it out."[29] He explains, "The film's world-building works best in small doses."[30] My reading of the series' geographical expansion as a function of John Wick's character development—namely, the collapse of his cosmopolitanism's blankness—ultimately concurs with Ehrlich's diagnosis of both the failures and successes of the films' world-building. Yet the "stretching out," however unsatisfying and unwieldy, needed to happen in order for a new kind of "deepening" to take place. If a blankness can be perceived as such only through its negative, such as when juxtaposed against the layers of inscription it hides or voids, a similar logic informs the horizontality and verticality of the series' world-building: only after its cinematic world is stretched out to its extreme can it snap back to New York City with a newly intensified depth.

Notes

1. Doreen Massey, *For Space* (London: Sage 2005), 81.
2. The literature on cosmopolitanism is a massive archive. See, for example, Pheng Cheah and Bruce Robbins, eds., *Cosmopolitics: Thinking and Feeling beyond the Nation* (Minneapolis: University of Minnesota Press, 1998), and Gillian Brock and Harry Brighouse, eds., *The Political Philosophy of Cosmopolitanism* (Cambridge: Cambridge University Press, 2005), for useful and provocative discussions of traditional and modern cosmopolitanisms. For a concise overview of the different strands of cosmopolitan thought, see Janet Lyon, "Cosmopolitanism and Modernism," in *The Oxford Handbook of Global Modernisms*, ed. Mark Wollaeger and Matt Eatough (New York: Oxford University Press, 2013), 387–412.

3. Luke Y. Thompson, "How 'John Wick' Developed Its Unique Fighting Style," *Forbes*, June 13, 2017, https://www.forbes.com/sites/lukethompson/2017/06/13/john-wick-chapter-2-keanu-reeves-chad-stahelski-interview/#6de44a047749.

4. Ignatiy Vishnevetsky, "Keanu Reeves Shoots His Way through the Entertaining Action Fantasy John Wick." A.V. Club, October 23, 2014, https://film.avclub.com/keanu-reeves-shoots-his-way-through-the-entertaining-ac-1798181681; Peter Suderman, "Why Keanu Reeves Is a Perfect Action Star," *Vox*, February 14, 2017, https://www.vox.com/culture/2017/2/14/14577884/keanu-reeves-action-star-john-wick.

5. Michael DeAngelis, *Gay Fandom and Crossover Stardom: James Dean, Mel Gibson, and Keanu Reeves* (Durham, NC: Duke University Press, 2001), 183, 185.

6. DeAngelis, *Gay Fandom*, 191.

7. A. A. Dowd, "How John Wick Makes the Most of Keanu Reeves' Emptiness." A.V. Club, February 15, 2017, https://film.avclub.com/how-john-wick-makes-the-most-of-keanu-reeves-emptiness-1798257928.

8. David Harvey, *Cosmopolitanism and the Geographies of Freedom* (New York: Columbia University Press, 2009), 51–76.

9. Timothy Brennan, "Cosmo-theory," *South Atlantic Quarterly* 100, no. 3 (2001): 660.

10. See Cristina Alonso-Villa, "John Wick and the Multilingual Kick," in *Multilingualism in Film*, ed. Ralf Junkerjürgen and Gala Rebane (Berlin: Peter Lang, 2019), 197–207, https://doi.org/10.3726/b16092.

11. Wick's non-English languages are apparently also noticeably accented, though an average Anglophone audience would presumably not be able to track all such accents. Reeves's Russian pronunciation is "awful," according to many internet forum threads, such as this one: u/dfinkelstein, "In the John Wick movies, the spoken Russian is so bad that a native speaker often also needs the subtitles," Reddit, July 31, 2019, https://www.reddit.com/r/movies/comments/ckb9rc/in_the_john_wick_movies_the_spoken_russian_is_so/.

12. Doreen Massey, "A Global Sense of Place," in *Space, Place, and Gender*, ed. Doreen Massey (Minneapolis: University of Minnesota Press, 1994), 149.

13. Bruce Robbins and Paulo Lemos Horta, "Introduction," in *Cosmopolitanisms*, ed. Bruce Robbins and Paulo Lemos Horta (New York: New York University Press, 2017), 2.

14. Robbins and Horta, "Introduction," 2.

15. "John Wick" is actually a name screenwriter Derek Kolstad took from his grandfather.

16. Leilani Nishime, *Undercover Asian: Multiracial Asian Americans in Visual Culture* (Urbana: University of Illinois Press, 2013), 24. Through this focus on race, Nishime (unlike DeAngelis or Dowd) traces another consistent trend in reviews commenting negatively on Reeves's blankness, finding his "air-headed or wooden" quality to be something that frustrates the viewers' search for "the true emotional source behind his actions" (39). This is often a racialized blankness that assumes Reeves to be "all surface beauty with no depth" (39). Also see Jeff Yang, "The Truth about Keanu Reeves and His Asian Roots," *Inkstone*, July 17, 2019, https://www.inkstonenews.com/arts/keanu-reeves-and-his-asian-roots/article/3018919, where Yang notes more recently that "every generation seemingly has to renew its love for Keanu, and then, shortly thereafter, rediscover that he has Asian ancestry."

17. See David Ehrlich on fighting style as language in "'John Wick: Chapter 3—Parabellum' Review," IndieWire, May 10, 2019, https://www.indiewire.com/2019/05/john-wick-chapter-3-parabellum-review-keanu-reeves-1202139580: "This is a character who appears to know every single language under the sun, but violence is the most expressive part of his vocabulary (Reeves speaks maybe 100 words in the entire movie). Chinese wushu, Japanese judo, Southeast Asian silat, American Glock . . . Wick is fluent in them all." Glock firearms are actually not American but Austrian; this confusion on Ehrlich's part nonetheless could add to the point about Americanization (and universalization) that I have been making.

18. Rizki Fachriansyah, "Peak Human Physicality and Cosmopolitanism Intersect in 'John Wick: Chapter 3,'" *Jakarta Post*, May 18, 2019, https://www.thejakartapost.com/life/2019/05/18/peak-human-physicality-and-cosmopolitanism-intersect-in-john-wick-chapter-3.html.

19. Fachriansyah, "Peak Human Physicality."

20. Angelica Jade Bastién, "The Grace of Keanu Reeves," Film Experience (blog), February 10, 2016, thefilmexperience.net/blog/2016/2/10/the-grace-of-keanu-reeves.html.

21. Bastién, "Grace of Keanu Reeves."

22. See Stephen Watt's "Style and the Sacrificial Body in *John Wick 3*" for an illuminating discussion of skin and pain, especially in this scene with the Petrine cross branding.

23. Jonathan Lees, "Keanu Reeves Came Up With a Badass Hashtag for 'John Wick,'" Complex, October 24, 2014, https://www.complex.com/pop-culture/2014/10/interview-john-wick-keanu-reeves.

24. New York, along with Los Angeles, London, and Tokyo, has received the lion's share of attention from urban geographers theorizing global or world cities. See Saskia Sassen, *The Global City: New York, London, Tokyo* (Princeton, NJ: Princeton

University Press, 1991). Conversely, recent critiques of the Anglo-Eurocentric bias of theories of world cities have pushed geographers to look toward non-Western cities, especially in the Global South. See, for example, Jennifer Robinson, "Global and World Cities: A View from off the Map," *International Journal of Urban and Regional Research* 26, no. 3 (2002): 531–54; Ananya Roy, "The 21st-Century Metropolis: New Geographies of Theory," *Regional Studies* 43, no. 6 (2009): 819–30.

25. For the importance of the city to the genre, see Edward Dimendberg, *Film Noir and the Spaces of Modernity* (Cambridge, MA: Harvard University Press, 2004); Gyan Prakash, ed., *Noir Urbanisms: Dystopic Images of the Modern City* (Princeton, NJ: Princeton University Press, 2010). For studies that focus on cinematic representations of New York, see James Sanders, *Celluloid Skyline: New York and the Movies* (New York: Alfred A. Knopf, 2001); Murray Pomerance, ed., *City That Never Sleeps: New York and the Filmic Imagination* (New Brunswick, NJ: Rutgers University Press, 2007); Richard Blake, *Street Smart: The New York of Lumet, Allen, Scorsese, and Lee* (Lexington: University Press of Kentucky, 2005). Finally, see Heather Shore, "Criminal Underworlds: Crime, Media, and Popular Culture," in *Oxford Research Encyclopedia of Criminology, April 26, 2017*, https://oxfordre.com/criminology/view/10.1093/acrefore/9780190264079.001.0001/acrefore-9780190264079-e-36, for a brief history of media representation of criminal underworlds.

26. Nicholas Christopher, *Somewhere in the Night: Film Noir and the American City* (Berkeley, CA: Counterpoint, 1997), 16.

27. See Eric Hayot, *On Literary Worlds* (New York: Oxford University Press, 2012), 42–47, for a relevant discussion of the noir world of Raymond Chandler's hardboiled novels. Hayot notes a "tension between world as whole world and world as self-contained unity" (45) in Chandler's literary world, which "feels like a restricted or closed-off perspective or framework occupying part of a larger world that may well not know *noir* exists" (45–46).

28. Wick's preestablished relationships with fellow assassins such as Cassian or Ms. Perkins hint at some residual professional camaraderie.

29. Ehrlich, "John Wick: Chapter 3."

30. Ehrlich, "John Wick: Chapter 3."

MI JEONG LEE is Lecturer in the Department of English Language and Literature at Seoul National University, South Korea. She received her PhD degree in English from Indiana University in 2020, specializing in modernist literature and the aesthetics of distance. Her research focuses on spatiality and forms of the global as well as narratives of large-scale catastrophe. Her work has been published in the *Journal of Modern Literature* and the *Journal of English Language and Literature.*

PART V
GENDER AND THE BODY IN JOHN WICK

JOHN WICK'S MULTIPLY 12
SIGNIFYING DOGS

KARALYN KENDALL-MORWICK

The *John Wick* series is rife with canine imagery and allusion, from Wick's Cerberus tattoo first glimpsed in *John Wick* to his journey across the desert following the "dog star" Sirius in *John Wick: Chapter 3—Parabellum*. Alongside these figurative dogs trot several literal ones—most notably Daisy, the beagle puppy posthumously gifted by Wick's wife, Helen (Bridget Moynahan), and killed by one of bad guy Iosef Tarasov's (Alfie Allen) men just fifteen minutes into the first film. As several commentators have noted, Daisy's death constitutes a novel instance of the narrative device known as "fridging"—a term first popularized in 1999 by the feminist comic writers and fans behind the website *Women in Refrigerators* to describe the brutalization of a female character at the beginning of a film that motivates the subsequent actions of the male protagonist.[1] Since then, in popular use the term's meaning has expanded to encompass a broad range of means—both violent and not—by which women are reduced to plot devices whose early death or disempowerment serves to propel a male character's story arc.

Under this expanded definition, of course, Helen herself can be regarded as a victim of fridging, and thus some critics, like video-game scholar Brendan Keogh, have characterized Daisy's death as merely a second fridging of Helen "by proxy."[2] At first glance, the film encourages such an interpretation by heaping an abundance of symbolic weight onto Daisy in the form of her name, her sex, and the image of the flower

317

that is her namesake on the handwritten card that accompanies her, which echoes the daisy-adorned bracelet and mug that mark Helen's absence in the scenes that preface the puppy's arrival. Of all the bodies in the series, moreover, Helen's and Daisy's are the only ones seen being laid to rest rather than unceremoniously removed or disposed of. The overdetermined link between Daisy and Helen has led critics such as Sophie Gilbert to regard the series' dogs merely as "emotionally manipulative plot devices."[3] Certainly, the dogs of *John Wick* play a crucial role in humanizing the series and its murderous protagonist, yet this is far from the extent of their impact. Beginning with Daisy's fridging, the series depicts multiple and competing modes of human/dog relating that open a Pandora's box of canine significations, ultimately revealing dog love to be far from innocent and undermining the humanity it ostensibly confirms.

Loving Dogs, Becoming Human

If the pathos generated by Daisy's perfunctory death a mere nine minutes after her introduction is any indication, fridging the dog makes for a far more compelling stimulus to male vengeance than does the more banal fridging of the wife.[4] Whereas Keogh calls the fridged woman a trope "so overused [as] to be utterly boring," Daisy's fridging is brilliantly calibrated for what Gilbert describes as "animal-worshipping, Cute Emergency-retweeting America" in the twenty-first century. Yet codirectors Chad Stahelski and David Leitch reportedly had to fight the film's distributor to keep the scene. "It's risky," Leitch explained in an interview with the *Austin Chronicle*. "You kill the dog, you alienate the audience, and the movie's done. . . . [But] we wanted to be a little unconventional, perhaps very unconventional. So we needed a set-up that would allow us to kill 80-some people and still allow John to recover

from it and have some empathy from the audience. The dog, it's a fresh take on the revenge thing."[5] Daisy's death does indeed make an impact. In contrast to the gauzy flashbacks that depict the ethereal Helen gracefully collapsing in Wick's arms and then succumbing to an unspecified illness without so much as a hair out of place, handheld camera shots and erratic editing document Daisy's brutalization as one of Tarasov's men silences her whimpers with an abrupt thump. As Wick regains consciousness the next morning, a tracking shot follows the trail of blood the dying puppy left while dragging her now-lifeless body to his side in a final act of fidelity, viscerally reinforcing the pitiable nature of her death.

It is therefore no surprise that a recurring theme in critics' and audiences' responses to the first film is shock and heartache over Daisy's death—even, in some cases, a reluctance or refusal to watch the scene in question. Film reviewer and self-professed action fan Brian Truitt admits, "Confession time: Before learning to love John Wick, I was pretty worried about him. But not because his penchant for cool, over-the-top vengeance gets him into various deadly predicaments. No, I was more concerned about his puppy. . . . I can watch him kill a dude with a library book all day or throw enough knives to make his foes Swiss cheese, [but] for . . . animal lovers like myself (a dog father to two Boston terriers), that first movie was a really hard sell."[6] If the on-screen death of a single puppy made *John Wick* a "hard sell" for moviegoers otherwise eager to experience a cinematic bloodbath, Daisy's function—and that of dogs in the series more generally—extends well beyond merely standing in for the departed Helen. Admittedly, Wick himself describes Daisy in *John Wick* as not "just a dog" but "a final gift from my wife," and the first film posits the theft of his car as equal justification for the ensuing violence. Yet, as the series continues, these other motives lose their potency, while at the same time the Wickverse and Wick himself become increasingly doggy. Viggo's (Michael Nyqvist) "It was just a fuckin'

car, just a fuckin' dog" in *John Wick* morphs into the ballet director's (Anjelica Huston) "All this . . . because of a puppy?" in *John Wick 3*. And when Sofia (Halle Berry) avenges the suffering of one of her own dogs by returning fire after Berrada (Jerome Flynn) shoots him—a decision that requires her and Wick to slaughter dozens of Berrada's henchmen in order to escape—Wick assures her, "I get it."

As Truitt's characterization of himself as a "dog father" indicates, much of the pathos generated by Daisy's death draws on an emotional-prosthetic mode of human/dog relating—one that Helen herself invokes in the note that accompanies Daisy, in which she writes, "I'm sorry I can't be there for you. But you still need something, someone, to love, so start with this. Because the car doesn't count." By contrasting Daisy's affectively generative body with the cold metal of Wick's prized muscle car and suspending her ontologically between some*thing* and some*one*, Helen promotes an understanding of the human/dog relationship first popularized in the nineteenth century, when rapid industrialization and urbanization dramatically reduced the demand for dogs' hunting and herding abilities. As Keridiana Chez explains in *Victorian Dogs, Victorian Men* (2017), "Neither fighters nor workers, dogs [became] lovers—emotional prostheses responsible for both domestic and individual emotional economies, particularly for men, for whom the relation was considered somehow more natural, salutary, and necessary."[7] At a time when the publication of Darwin's *On the Origin of Species* (1859) had profoundly undermined the exceptional status of the human species, owning and loving dogs as companions rather than working animals became a potent means of demonstrating one's attainment of civilized humanity, understood as a transcendence of the animality that was correspondingly projected onto people of color, the working class, and women. This humanizing function underpins a long cinematic tradition of man/dog love stories—including *Old Yeller* (1957), *Turner and Hooch*

(1989), and, more recently, *A Dog's Purpose* (2017), its sequel *A Dog's Journey* (2019), and the latest adaptation of *The Call of the Wild* (2020)—in which dogs facilitate the protagonists' cultivation of a properly humane masculinity.

Indeed, it is in the sequence of scenes depicting his burgeoning relationship with Daisy that Wick appears at his most physically vulnerable and human, performing prosaic actions such as getting into and out of bed, eating cereal, getting the newspaper, and walking around the house barefooted in a white undershirt and cotton pajama pants that sharply contrast with the slick assassin's attire he sports for the bulk of the series. And whereas we later see him coolly summon Charlie's "Specialized Waste Disposal" team to remove a dozen human corpses from his house, after Daisy's death, he cradles her lifeless body before painstakingly burying it and getting on hands and knees to scrub her blood from the floor. Because, as feminist rhetorical scholar Bailey Poland points out, viewers learn next to nothing about Helen—"what her life was like, what she did for a living, how she met Wick . . . [or] what it was about Wick that attracted her to him"—the scenes of Wick bonding with and then grieving over Daisy provide a rare glimpse into what made him deserving of Helen's love.[8] Both the *John Wick* franchise and the North Shore Animal League capitalized on the affective potency of juxtaposing an adorable puppy with the internet's favorite sad-boy-friend-cum-stoic-assassin in the viral video "Keanu Reeves Plays with Puppies while Answering Fan Questions." The video, which features Keanu Reeves kissing and cooing at adoptable puppies while sporting his all-black Wick attire, coincided with the May 2019 theatrical release of *John Wick 3* and has since garnered almost twenty million views on YouTube.[9]

John Wick, then, wants to have its cute puppy and kill it too. In doing so, it not only violates what one critic calls "a golden rule in

cinema"—"Don't kill the dog"—but also revises the conventional man/ dog love story.[10] While this genre is a notable exception to the prohibition against dog-killing, its exemplars dispatch the dog near the end and promptly assuage the human protagonist's (and audience's) grief with a replacement: Young Yeller in *Old Yeller* and a puppy sired by Hooch in *Turner and Hooch*. *John Wick* inverts this trope by beginning with Daisy's death and, at the end of the first film, ushering in an unnamed adult dog who becomes Wick's companion for the rest of the series to date. This dog, whom I'll call "Dog," is often regarded as a replacement for Daisy (although his role is also more complex, as I will discuss) who thus takes up the surrogate function of the Victorian emotional prosthesis. According to Stahelski, Dog serves to "keep the emotional connection and the symbolism of the puppy really just (being) the avatar for [Wick's] wife and love and the grief that he felt."[11]

The Twitter account for *John Wick 3* encouraged this emotional-prosthetic interpretation in a mock preview created for National Puppy Day (March 23, 2019), in which scenes featuring Wick and Dog from the first two films are edited together and set to swelling instrumental music to recast the franchise as a heartwarming story of "friendship that knows no bounds."[12] Though perhaps not deliberately, the video reads as an ironic nod to another sequel that would share an opening day with *John Wick 3* two months later: the unapologetically sentimental *A Dog's Journey*, in which a dog named Bailey undergoes several reincarnations so he can follow his boy Ethan throughout Ethan's life, finally crossing the "Rainbow Bridge" to reunite with him in heaven.[13] The simultaneous release of two otherwise starkly different sequels in which "dogs figure significantly" prompted predictable quips from reviewers and fans about the box office "going to the dogs."[14] More to the point, the commercial success of the franchise to which *A Dog's Journey* belongs, as well as the ease with which Wick and Dog's relationship

can be reimagined as a sentimental "tale of two strays," testifies to the continued resonance of such stories.[15]

Pit Bull, Wick Bull

Just as the emotional impact of Daisy's fridging demonstrates the incommensurability of wife and puppy, the connection that develops between Wick and Dog in *John Wick 2* and *John Wick 3* confirms that dogs are also not interchangeable with each other. According to Leitch, he and Stahelski sought out "the cutest dog in the world" to play Daisy in a straightforward attempt to humanize Wick, ultimately settling on a male beagle puppy named Andy whom trainer Kim Krafsky describes as irresistible: "He melts you with his eyes. . . . Who wouldn't love this puppy?"[16] But the shift from Daisy to Dog ushers in a host of mythological and breed-specific canine significations that complicate the humanizing function of dog love. Furthermore, it marks the series' rejection of the feminized, Victorian mode of human/dog relating that Helen endorses in favor of a masculine, classical mode. This latter mode is signaled by Wick's tattoo depicting a snarling dog against a backdrop of flames—a reference to Cerberus, the "hound of Hades." The tattoo is one of several details in the series that align Wick with the mythological figure of Heracles, whose twelve labors ordered by Eurystheus culminate in the successful capture of Cerberus. This association is reinforced when Wick entrusts Dog's safekeeping to the Continental concierge Charon, named for the ferryman of Hades, before setting out to complete the impossible tasks assigned to him in *John Wick 2* and *3*.

Cerberus is typically depicted as a chimeric three-headed beast with serpentine appendages, but the single-headed and unmistakably canine Cerberus inscribed on Wick's back resembles the much more modern figure of the "pit bull." I use scare quotes here (and ask the

reader to imagine them around all subsequent uses of this and the similarly problematic term *breed*) because, as animal-studies scholar Harlan Weaver points out, "there is technically no such thing as a pit bull."[17] Rather than a biological type or even breed, the term designates "an idea" that incorporates not simply the "squat, muscular, short-haired" appearance called for in the American Kennel Club standard for the American pit bull terrier (one of several recognized breeds frequently grouped under the pit bull umbrella) but a "reputation [that] precedes it" as "the categorical 'bad dog.'"[18] Wick's tattoo uncannily echoes pit bull iconography in contemporary American culture popularized by figures such as rapper DMX—whose album cover for *Year of the Dog . . . Again* (2006) features the rapper standing astride a pit bull snarling at the end of a heavy chain—and recognizable enough to be parodied by Weird Al Yankovic on the cover of *Straight Outta Linwood* (2006). Wick's Cerberus, too, is pictured head-on, showcasing a muscular chest and bared teeth.

Wick's tattoo thus invokes not only classical mythology but also the contemporary mythology of the pit bull as a fighting dog possessing supercanine abilities (such as anatomically impossible "locking jaws") and emblematic of outlaw masculinity. As Bronwen Dickey observes in *Pit Bull: The Battle over an American Icon* (2016), cultural artifacts ranging from the logos of tires, energy drinks, and hot sauces to 2008 Republican vice presidential candidate Sarah Palin's self-characterization as a pit bull with lipstick "trade on the idea of a Nietzschean *Überhund* who 'won't back down' or 'won't let go.'" Given this reputation, Dog would seem to be the perfect avatar for Wick; Dickey even calls the pit bull "an American bogeyman," and her paraphrase of popular pit bull lore uncannily evokes the legendary assassin: "Those dogs will turn on you. And once the aggression switch is turned on, there's no turning it off."[19] Indeed, the film encourages a reading of Wick as pit bull by assigning

him both visual and temperamental characteristics popularly associated with the breed in its fighting role: the scars of past fights etched on his face, his superhuman abilities ("He once killed three men in a bar ... with a fucking pencil!"), the grab-and-hold method he frequently employs in fight sequences, and his adversaries' repeated characterizations of him as an unrelenting monster propelled by "sheer fucking will." Viggo makes what we might call the Wick-bull connection most explicitly when he laments that Wick has been "unleashed" on him.

It is perhaps the link between him and his canine avatar as natural-born killers—more so than Dog's role as twice-removed surrogate for Helen—that motivates Wick's (and the franchise's) novel treatment of the pit bull. In a series that revels in violent and dizzying action, Dog never exhibits the fighting prowess or bloodlust that, according to pit bull mythology, is in his nature. Instead, he lounges on furniture, licks Wick's face, and calmly follows commands to sit and stay, never giving the slightest indication that he might "turn on" Wick or even Wick's nemeses. His most athletic feats include retrieving a tennis ball and trotting by Wick's side through New York City streets. And in *John Wick 3*, the franchise sends horses and hounds into the fray, as if to prove that Dog's couch-potato persona is not simply a by-product of the directors' unwillingness to tackle the challenges of incorporating unruly animal bodies into fight sequences. In fact, Dog is the only animal in the series—save a cat who appears briefly as Zero's companion in *John Wick 3*—who is never explicitly instrumentalized or weaponized. Perhaps wary of reprising the conventional canine redemption narrative cut short by Daisy's violent death, Wick resists absorbing Dog into his own story, declining even to name him and keeping him at a safe distance from most of the series' violence.

The films' resolute depiction of Dog as a lover, not a fighter, signals the creators' awareness that it is not just Wick who requires redemption

but the pit bull itself. To put it bluntly, over the last half century the pit bull has achieved the unenviable status of America's most disposable dog. While a series of exposés beginning in the 1970s increased public awareness of the breed's use in dogfighting, most pit bulls were dying not in the fighting ring but in animal shelters, where they "were almost always euthanized without any chance at adoption, regardless of temperament."[20] The last two decades have seen a major shift in attitudes toward pit bulls in the animal welfare and sheltering fields, where they are no longer widely viewed as categorically unadoptable. Still, they continue to be put to death in large numbers, thanks in large part to breed-specific legislation (BSL) that bans or restricts their ownership, breed restrictions imposed by landlords and insurance companies, limited access to affordable spay/neuter services in low-income communities, and what pit bull advocates term the breed's "bad rap." Even Stahelski's description of canine actor Burton as "the most gentle personality you could imagine *for a pit bull*" signals the stigma that still accompanies this label.[21]

Stahelski's qualification aside, the *John Wick* franchise is notable for its positive representation of the usually maligned breed. When Wick first encounters Dog in the animal shelter he breaks into at the end of *John Wick*, the words "To be put down" are stamped in ominous red ink on the sign hanging from his kennel door, confirming that Wick rescues him from the summary execution that has been countless pit bulls' fate. And unlike Cerberus, Dog does not need to be subdued; he signals his good nature with soft eyes and dropped ears. The scene previews how a dog commonly figured as trash will ironically become the least expendable creature—save Wick himself—in a series in which human life is represented as infinitely disposable. As Stahelski puts it in an interview about the release of *John Wick 3*, "Everybody always asks me, 'Did you kill a dog (this time)?' My answer is always the same: You get one of

those a career. I've burned my option there."[22] Both *John Wick 2* and 3 swiftly reassure viewers that Dog will avoid the sad fate of his beagle predecessor by having Wick place him in Charon's care at the safe haven of the Continental before departing on his international assassin adventures. Such actions have endeared Wick to pit bull defenders, as Crystal Dunn with the advocacy group Love-A-Bull explains: "He ends up serving as a protector for an animal a lot [of] people would rather see dead. Of course, Wick understands that just because you've been through some bad things, it doesn't mean you're bad."[23]

As the name "Love-A-Bull" indicates, efforts by pit bull advocates to redeem the breed have often centered on what we might call cute-ification, capitalizing on internet meme culture and DoggoLingo to popularize nicknames such as "pibble," "pittie," and "pittopotamous" and rebrand the dogs as "silly and sweet and gentle."[24] Yet the rehabilitation of the pit bull is fraught with racialized and gendered significations that have become inextricable from the breed in popular culture. In particular, many white pit bull advocates have endeavored to separate the breed from its association with Black masculinity, which dates at least to a 1982 *New York Times* article whose accompanying photograph made Carl Thompson—a young Black man who bred fighting pit bulls—"the face of pit bull owners everywhere." Throughout the late 1980s and 1990s, this association was strengthened as pit bulls, like young Black men, "were increasingly mentioned in [news] stories about drugs." While criminologists instilled the specter of the Black male superpredator in the national consciousness, numerous articles, broadcasts, op-eds, and even animal welfare industry pamphlets likewise characterized the pit bull as "a killing machine."[25]

The salience of this association was evident in 2007 when NFL quarterback Michael Vick pled guilty to federal dogfighting conspiracy charges, a crime for which he served eighteen months of a

twenty-three-month sentence and became the subject of racist memes and dog toys. As Weaver argues, the Vick case precipitated a seismic shift in the pit bull's public image wherein "the danger initially seen as inhering in breed came to be localized instead in the person of Vick, an African American man."[26] Efforts by the Utah-based Best Friends Animal Society and other predominantly white organizations to rehabilitate the dogs removed from Vick's Bad Newz Kennels were highly publicized, ensuring that Vick would succeed Thompson as the face of dogfighting but also garnering newfound sympathy for pit bulls as "Vick-tims." This status makes the pit bull an ideal avatar for Wick, a character in need of redemption portrayed by an actor described in a 1996 *Mademoiselle* article as an exemplar of "Vulnerable Puppy Syndrome. Everything we read about Reeves contributes to an urge to protect him."[27] The humanizing work Dog performs throughout the *John Wick* series thus owes much of its efficacy to white animal advocates' efforts to rebrand the pit bull as a vulnerable creature in need of protection by appealing to deeply entrenched stereotypes of Black men as inherently violent and dangerous.

Racism is likewise evident in ongoing debates about whether pit bulls belong in spaces framed as civilized. Weaver notes that both sides of the BSL debate mobilize race- and class-coded language in support of their cause. While BSL proponents "characterize the dogs' owners as 'thugs,' 'gangstas,' and 'white trash'" and pit bulls themselves as dangerous and unpredictable—qualities white supremacy also projects onto Black men—pit bull advocates appropriate the language of racial justice movements by characterizing anti-pit-bull legislation as "canine racism" while simultaneously distancing pit bulls from Black masculinity with memes and merchandise bearing slogans like "Pit bulls are for hugs, not thugs."[28] As one white animal shelter volunteer put it when interviewed by Weaver, today "you see a lot more people with pit bulls who

look like regular people. . . . You don't see the ghetto image, which is what used to be the case with pit bulls most of the time."[29] While this volunteer uses racially coded language, an excerpt from a stand-up performance by comedian Michael Che lays bare the implicit whiteness (and femininity) of mainstream pit bull advocacy: "White women are scary. They rescue pit bulls for fun. You know how dangerous you gotta be to rescue a pit bull? If I seen a stray pit bull walk in my neighborhood I wouldn't walk in that neighborhood anymore. A white girl'll take that pit bull home [and] put a sweater on it. This dog used to win tournaments. Now his name's Nicole and he's eating vegan treats out of some white lady's hands. You know how dangerous you gotta be to convince a pit bull he doesn't eat meat anymore? That'd be white-girl dangerous."[30] As Che's observations indicate, efforts by animal welfare organizations to rehabilitate both individual pit bulls and the breed's image often center on physically and discursively separating dogs from the dehumanized Black male "thugs" who own them and "recuperating them into a tacit whiteness," demonstrating how intersecting race and class hierarchies inform conceptualizations of properly human(e) ways of being with dogs.[31]

Living with Animals

The ways in which constructions of race, class, and gender intersect in the figure of the pit bull reveal that the mode of human/dog relating practiced by John Wick, played by the multiracial but white-passing Reeves, is not equally available to all dog lovers. Born in Beirut to a white English mother and Chinese Hawaiian father, Reeves "self-identifies as a person of color," yet as Anglo-Indonesian poet Will Harris observes, "Most people don't realize he's mixed race."[32] In a book that interweaves autobiography with analysis of Reeves as a multiracial but

white-passing celebrity, Harris confesses his own desire to emulate the actor's racial plasticity while growing up: "Keanu could choose whether or not to wear the cape of whiteness. . . . Though it now seems shameful to admit, his was the sinuous and racially unmarked version of the face that I wanted to present to the world."[33] Reeves's racially unmarked (and therefore tacitly white) performance in the *John Wick* films means that the Wick/Dog bond does little to challenge the implicit whiteness of pit bull redemption narratives, while his masculinity shields the relationship from the kind of critique Che directs at pibble-loving white women.

A look at the second most notable dog-lover in the Wickverse, Sofia, reveals how such narratives might be disrupted. Attaching the pit bull to Sofia would situate the human/dog relationship quite differently in the matrix of canine significations, implicitly undermining both the hypermasculinity so often invested in the figure of the pit bull and the whiteness through which the breed's image is rehabilitated. Instead, Sofia's attachment to a pair of bulletproof-vested Belgian Malinois—a breed Stahelski specifically chose because of its use as a "military and police" dog—evokes and inverts the historical weaponization of dogs as tools of white supremacy. Sofia's dogs are the series' most potent reminder that dogs have acted throughout history "as adjuncts for the evil that people do, as well as the good, and sometimes both at once," as journalism professor and cadaver dog trainer Cat Warren points out: "They can be used to consolidate or pervert power in concrete ways. They can track a slave, a lost child, or a rapist without distinguishing. They can help suppress peaceful civil rights protesters or control an angry mob that's up to no good. People create the problems, and working dogs come along for the ride."[34] Earlier versions of the screenplay had Sofia's dogs belonging to Wick instead, but Stahelski explains, "It didn't feel as good as we were hoping. To give [the dogs] to Sofia, as an avatar for her daughter

the way Wick had for his wife, we thought it came full circle to see a mature version of that connection."[35] I submit that another reason pairing the dogs with Wick instead of Sofia would feel "less good" is that by commanding two powerful, militarized dogs with a penchant for taking men down by their genitals, Sofia turns the tables on white supremacist patriarchy to claim a fully human status historically denied to both women and people of color—and particularly women of color—that, in Wick's case, is never in question.

Dogs' potential to become adjuncts for human evil should likewise engender skepticism about the humanity they ostensibly affirm. The moral dubiousness of this function is evident in the violence enacted by Sofia's dogs—who make clear with bared teeth that they would just as eagerly rip Wick to shreds as they would one of his adversaries—but also in the relationship between Dog and Wick. Dog's physical resemblance to Wick's Cerberus tattoo notwithstanding, his humanizing function throughout the series makes him much more reminiscent of another classical canine figure: Argos, the dog who recognizes the disguised Odysseus and, "though he had no strength to drag himself an inch toward his master," welcomes him home with dropped ears and wagging tail. Just as Wick finds Dog discarded and destined for euthanasia, Odysseus returns to Ithaca to find the formerly magnificent Argos "castaway, on piles of dung . . . half-dead from neglect."[36] From the start, Dog, like Argos, is linked to the concept of home: "Let's go home," Wick tells him after opening the kennel door, echoing Helen's words from the cell phone video he repeatedly views. After Santino (Riccardo Scamarcio) destroys Wick's house in *John Wick 2* to punish him for refusing to honor a marker, home for Wick becomes (as many a decorative pillow would have it) "where the dog is," and Dog provides a slobbery welcome befitting a hero's homecoming when Wick returns to the Continental in *John Wick 3*.

Of course, Dog's unconditional love for Wick overlooks all manner of sins, problematizing his humanizing function. The dirtied white Henley shirt and jeans Wick wears as he and Dog cross the Brooklyn Bridge on their way to the Continental in *John Wick 3* signal his return from the domesticity of his brief pajama-clad life with Daisy (and by extension Helen) to the dark-suited underworld of assassins, but it also suggests the ethical ambiguity of his relationship with Dog. Dog's namelessness encourages us to extend this ambiguity to the human/dog relationship more generally and acknowledge the more troubling aspects of man's relationship with his proverbial best friend. As Donna Haraway reminds us, dogs are "partners in the crime of human evolution" whose work as hunting and herding partners and sentinels facilitated the rise of hunter-gatherer and agricultural societies and thus human civilization as we know it.[37] They have likewise aided in war, conquest, colonialism, genocide, and other crimes against humanity in the name of that very civilization. This legacy is inextricable from their much-touted fidelity (from which the quintessential dog name "Fido" derives), linking them to the amoral code of fealty that governs the Wickverse.

As the series repeatedly reminds us, the assassin's code serves no moral purpose but instead exists because "without [rules] we'd live with the animals." Yet if this code serves to define the human as not-animal, it fails spectacularly, not only because fealty to one almost invariably requires betrayal of another (as when Wick must betray Winston in order to demonstrate his fealty to the High Table in *John Wick 3*) but also because the dogs of the series prove far more loyal and rule-abiding than the humans. Whereas Dog and Sofia's companions are repeatedly seen scrupulously obeying commands—and even Daisy appears to be house-trained overnight—the series' humans routinely disobey and are punished accordingly. Simply put, if humans followed rules, there would be no *John Wick* (or, to adapt one Hollywood commentator's quip, "Any

sequel [would] just be him with a puppy").[38] The rules and rituals of the assassin's code thus fail to meaningfully differentiate the human from "the animals," instead providing a veneer of civilized order that conceals an underlying animality perpetually threatening to erupt—hence Viggo's unsuccessful appeal to Wick in *John Wick*: "Let us not resort to our baser instincts and handle this like civilized men." If the concept of "civilized men" seems ironic in the first film, with its relatively low body count, *John Wick 2* and *3* expose it as downright oxymoronic by staging carnage in locations that would seem to epitomize civilization's highest achievements: an art museum and a library, respectively. The scene at the New York Public Library gives the lie to human exceptionalism by having Ernest (Boban Marjanovic) repeat Ulysses's famous words from Dante's *Inferno*, "Consider your origin: you were not made to live as brutes, but to follow virtue and knowledge," before attempting to kill Wick in a flagrant violation of the terms of Winston's excommunicado order. Wick, in turn, demonstrates the brutality inherent in human nature by using a book—usually emblematic of the human pursuit of knowledge—to break Ernest's jaw and neck.

Feeding the Dog

Rather than being distinct from (and superior to) "the animals," humans in the world of *John Wick* are inextricably linked to them, and thus Wick's existential choice is not simply between civilized humanity and brute animality. The howling wolf tattoo opposite the Cerberus tattoo on Wick's back is indicative of how the series blurs the human/animal distinction by exposing not only the animality of the human but the diverse ways of being that are falsely homogenized under the concept "animal," a term that, Jacques Derrida reminds us, grossly oversimplifies the "heterogeneous multiplicity of the living" that exists "beyond

the edge of the *so-called* human."[39] The juxtaposition of dog and wolf might seem to symbolize Wick's struggle to choose between civilized domesticity and unleashed brutality; however, this interpretation is complicated not only by the contradictory meanings infused in the figure of the pit bull, as I have discussed, but also by the duality of the wolf as both sociable pack animal and feared predator. The fictional "Tale of Two Wolves" production advertised on the Tarkovsky Theater marquee in *John Wick* 3 invokes this duality by alluding to an oft-told story of uncertain origin but usually attributed to Cherokee legend in which an elder describes the warring forces within the human as a struggle between two wolves (or, in some versions, two dogs), one good and one evil. Asked by his grandson which wolf wins, the elder replies, "The one that you feed."[40] By feeding the good wolf via his relationship with Dog, Wick nurtures a part of his humanity that connects him to some modes of animality as much as it separates him from others.

Thus, dogs in the series (and Dog in particular) become repositories for those "good" qualities ostensibly unique to the human and are paradoxically needed to affirm those qualities in Wick. To fulfill this function, Dog must remain external to the violence of Wick's life as an assassin, which is why Wick must keep him safely stowed away from the action and perhaps why he resists naming (and thus implicitly instrumentalizing) him. Wick's desire to let Dog simply be a dog, though, competes with the unwieldy canine signification that peppers the series, where dogs simultaneously invoke and problematize their familiar roles as emblems of unconditional love, fidelity, and civilized humanity. While we should be wary of interpretations that reduce *John Wick*'s dogs to mere surrogates or prostheses, we should likewise remain attuned to the complex, malleable, and volatile ways in which human/dog relating in the Wickverse participates in broader projects both of world-building

and of defining the human that arbitrarily mark some lives as disposable and others as worthy of redemption.

Notes

1. Nichole Perkins, "Why Don't the Women in *John Wick* Talk?" *BuzzFeed News*, February 15, 2017, https://www.buzzfeednews.com/article/tnwhiskeywoman/why -wont-john-wick-let-women-talk.

2. Brendan Keogh, "On John Wick and Fridging," *ungaming* (blog), Tumblr, May 12, 2015, https://ungaming.tumblr.com/post/118778602485/on-john-wick-and -fridging.

3. Sophie Gilbert, "John Wick: An Idiot Killed His Puppy and Now Everyone Must Die," *Atlantic*, October 24, 2014, https://www.theatlantic.com/entertainment /archive/2014/10/john-wick-an-idiot-killed-his-puppy-and-now-everyone-must-die /381921/.

4. Another instance of canine fridging occurs in the 2016 Western *In a Valley of Violence*, in which troubled ex-cavalryman Paul (Ethan Hawke) rides into a desert town and promptly gets into an altercation at the local saloon with a man who subsequently kills his dog, Abbie (who, like Daisy, is portrayed by a male canine actor but gendered female). Like Wick, Paul spends the rest of the film exacting spectacularly violent revenge on his dog's killer and anyone who gets in the way. Unlike Daisy, Abbie is not symbolically linked to a woman (or any other human) from Paul's past, indicating that canine fridging is itself a compelling cinematic trope, perhaps thanks in part to its prior use in *John Wick*.

5. Quoted in Richard Whittaker, "Don't Shoot the Dog: *John Wick* Co-directors Talk Keanu and Cold Canine Revenge," *Austin Chronicle*, October 24, 2014, https:// www.austinchronicle.com/daily/screens/2014-10-24/dont-shoot-the-dog. Leitch is not officially credited as codirector but is described as such in this interview and numerous articles.

6. Brian Truitt, "*John Wick* Once Killed off Keanu Reeves' Puppy, but Now It's a Full-on 'Dog Movie,'" *USA Today*, May 17, 2019, https://www.usatoday.com/story /life/movies/2019/05/15/john-wick-3-keanu-reeves-franchise-turned-into-dog-movie /3664169002/.

7. Keridiana W. Chez, *Victorian Dogs, Victorian Men: Affect and Animals in Nineteenth-Century Literature and Culture* (Columbus: Ohio State University Press, 2017), 130.

8. Bailey Poland, "Fridging Helen Wick," Patreon, September 19, 2018, https://www.patreon.com/posts/fridging-helen-19905920.

9. BuzzFeed Celeb, "Keanu Reeves Plays with Puppies while Answering Fan Questions," YouTube, May 17, 2019, https://www.youtube.com/watch?v=rOqUiXhECos.

10. Whittaker, "Don't Shoot the Dog."

11. Quoted in Truitt, "*John Wick.*"

12. John Wick (@JohnWickMovie), "It was never just a puppy. #NationalPuppyDay," Twitter, March 23, 2019, 10:00 a.m., https://twitter.com/johnwickmovie/status/1109470045602607105?lang=en.

13. *A Dog's Journey* is the sequel to *A Dog's Purpose* (2017). Both films are part of a shared universe that includes *A Dog's Way Home* (2019). All three are based on novels of the same names by W. Bruce Cameron.

14. Joe Morgenstern, "*John Wick: Chapter 3—Parabellum* Review: Elegant Escapism," *Wall Street Journal*, May 16, 2019, https://www.wsj.com/articles/john-wick-chapter-3parabellum-review-elegant-escapism-11558038042; "Simply the Beast: 18 of the Greatest Dog Sidekicks in Pop Culture," A.V. Club, May 15, 2019, https://www.avclub.com/simply-the-beast-18-of-the-greatest-dog-sidekicks-in-p-1834753999.

15. John Wick, "It was never just a puppy."

16. Quoted in Bryan Alexander, "Andy the Beagle Is the Tail Wagging Wick," *USA Today*, October 22, 2014, Newspaper Source Plus.

17. Harlan Weaver, "Becoming in Kind: Race, Class, Gender, and Nation in Cultures of Dog Rescue and Dogfighting," *American Quarterly* 65, no. 3 (2013): 691.

18. Harlan Weaver, *Bad Dog: Pit Bull Politics and Multispecies Justice* (Seattle: University of Washington Press, 2021), 3.

19. Bronwen Dickey, *Pit Bull: The Battle over an American Icon* (New York: Alfred A. Knopf, 2016), 148, 9, 8, 24.

20. Dickey, *Pit Bull*, 146.

21. Quoted in Kelly Connolly, "Bradley Cooper, Tiffany Haddish and More Stars Who Fell in Love with Their Furry Costars," *People*, October 8, 2018, https://people.com/pets/stars-bonded-with-cats-dogs-on-screen/.

22. Connolly, "Bradley Cooper."

23. Quoted in Truitt, "*John Wick.*"

24. Katy Brink, quoted in Marisa Meltzer, "The Trouble with Pibbles: Rebranding a Fearsome Dog," *New York Times*, January 6, 2019, Gale OneFile: News.

25. Dickey, *Pit Bull*, 148, 146, 149. The choice to feature Carl Thompson was deliberate, Dickey explains. The reporter also interviewed Thompson's brother, Kevin, who

bred pit bulls to sell as pets and described them as "good companions," but Carl, who claimed that fighting is "all they're good for," was featured most prominently.

26. Weaver, "Becoming in Kind," 696.

27. Lauren David Peden, "In Search of Keanu," *Mademoiselle*, March 1996, 108–10, quoted in Michael DeAngelis, *Gay Fandom and Crossover Stardom: James Dean, Mel Gibson, and Keanu Reeves* (Durham, NC: Duke University Press, 2001), 188.

28. Weaver, "Becoming in Kind," 694; "Pit Bulls Are for Hugs Not Thugs Magnet," Pibbles and More Animal Rescue, 2020, https://www.pmarinc.org/product/pit-bulls-are-for-hugs-not-thugs-magnet/.

29. Quoted in Weaver, *Bad Dog*, 3.

30. Just for Laughs, "Michael Che—White Women Took Brooklyn," YouTube, October 5, 2018, https://www.youtube.com/watch?v=if_sEUffzjE&list=RDif_sEUffzjE&start_radio=1.

31. Weaver, "Becoming in Kind," 696.

32. Joi-Marie McKenzie, "Keanu Reeves Is a Proud Person of Color, but Doesn't Want to Be 'a Spokesperson,'" *Essence*, May 16, 2019, https://www.essence.com/entertainment/keanu-reeves-person-of-color-doesnt-want-to-be-a-spokesperson/.

33. Will Harris, *Mixed-Race Superman: Keanu, Obama, and Multiracial Experience* (Brooklyn: Melville House, 2019), 3, 4.

34. Cat Warren, *What the Dog Knows: Scent, Science, and the Amazing Way Dogs Perceive the World* (New York: Simon and Schuster, 2015), 34.

35. Quoted in Eric Francisco, "*John Wick: Chapter 3*: How It Trained Two Dogs into Action Movie Heroes," *Inverse*, May 16, 2019, https://www.inverse.com/article/55882-john-wick-chapter-3-director-interview-how-dogs-were-trained-to-kill.

36. Homer, *The Odyssey*, trans. Robert Fagles (New York: Penguin Books, 1996), 364, 363.

37. Donna Haraway, *The Companion Species Manifesto: Dogs, People, and Significant Otherness* (Chicago: Prickly Paradigm, 2003), 5.

38. Dave Karger, quoted in Alexander, "Andy the Beagle."

39. Jacques Derrida, *The Animal That Therefore I Am*, trans. David Willis (New York: Fordham University Press, 2008), 31.

40. Nanticoke Indian Tribe, "The Tale of Two Wolves," 2011, https://www.nanticokeindians.org/page/tale-of-two-wolves.

KARALYN KENDALL-MORWICK is Associate Professor of English at Washburn University, where she teaches courses in British and American literature, theory, and composition. Her research focuses on representations of animals and intersections of animality, race, and gender in literature and culture since 1900. Her book *Canis Modernis: Human/Dog Coevolution in Modernist Literature* (2020) examines how dogs, as our coevolutionary partners, challenge human exceptionalism and the humanist underpinnings of traditional literary forms. Her published work also includes articles in *Modern Fiction Studies* and the *Journal of Modern Literature*.

MASCULINITY, ISOLATION, AND REVENGE 13
JOHN WICK'S LIMINAL BODY

OWEN R. HORTON

Introduction: John Wick, in Between

At the core of 2014's *John Wick* is the question of whether or not the titular assassin is "back." The refrain, coming from several different characters, seeks to answer the question, "Are you working [killing] again?" Wick finally answers, facing death after being beaten and captured by Viggo Tarasov (Michael Nyqvist) and his men, by first admitting that he had not been quite sure up until that moment. The rejoinder, "Yeah, I'm thinking I'm back," is a fiery, fist-pumping moment for audiences, but it is also ridiculous on its surface: Wick has already killed dozens of people at this point. His return to "work," then, is not contingent on violence, murder, or assassination; rather, it appears that Wick's regression toward his previous life is based entirely on his embrace of his role in the assassin economy. Yet this embrace of his return to work quickly fades before the beginning of *John Wick: Chapter 2*, as we find him living his same uneventful domestic life at the film's opening. Wick's re-retirement is short-lived, however, as Santino D'Antonio (Riccardo Scamarcio) arrives on his doorstep to pry John out of his house and back into the criminal orbit of assassins-for-hire.

The tension of the back-and-forth pull between John's work world and his home life is a recurring theme through each film in the franchise

and serves as the basis for this essay. Wick's assassin world calls to him and pulls him back into the darkness, and then as he comes to the precipice of reentry, some figure reminds him of why he got out in the first place: his wife. Of all the choreography in the film, this dance between Wick's two selves—husband and assassin—is the heaviest and most plodding. And yet, the melodramatic love triangle between John, his wife Helen, and his work adds a unique depth to the films. Why can't Wick be allowed to fully embrace his "Baba Yaga" identity? What function does it serve to place him in a state of limbo between the fantasy of his domestic life and reality of his work life? And more pressing for this chapter, what kind of action hero emerges out of this constant in-betweenness? I am concerned not just with how Wick's connection to his two past lives pendulums back and forth but also with the ways in which he is always both and neither. In other words, Wick comes to the edge of a domestic life and a work life, a sociopathic bloodlust and an empathetic sense of honor, a soft vulnerability and a superheroic invulnerability, and yet he consistently moves back from that edge and into a liminal middle.

Here, though, *liminal* possesses several connotations. For example, while I call attention to Wick's "liminal body" in my title, his liminality is incorporeal as well. Wick's ability to be kind and gentle and then ferocious and bloodthirsty is at the core of what makes his character so fascinating. Wick is among the most brutal and deadly heroes in modern action cinema, and yet none of his contemporaries so ardently retreat toward their softness again and again. I contrast *liminal* in this chapter with the concept of *hybrid*, the latter of which I conceive as a type of identity that is multiple things at once (a werewolf is both man and wolf, for example); by contrast, liminality connotes the "both" part of that experience as well as the "neither" part. The in-betweenness of liminality allows it to occupy the both and the neither simultaneously.

While John Wick is both a husband and an assassin, he is also neither of those things fully. Another reading of these films might argue that Wick embodies polysemic "masculinities" and therefore represents the multiplicity of manhood through his various ways of being.[1] By focusing on Wick's masculinity as liminal, however, I want to identify the unique ways that this character is not multiple but rather frozen: he represents a masculinity in limbo. My analysis of Wick's in-betweenness focuses on a few points of tension, both textual and metatextual. I begin with a reading of Wick and Helen's (Bridget Moynahan) domestic space as a layer-cake structure designed to house the both-and-neither nature of his identity; next, I move to an analysis of the prevalent "bisexual lighting" trend of the late 2010s and instead argue for the desexualized dilation of that binary. Continuing with the metatext, I examine the master-scene technique and editing of the *Wick* films in direct contrast to the action movies that precede them with their emphasis on spectacle and hybridity. In sum, this chapter seeks to prize open the presentations of masculinity throughout the *Wick* films and argue that what we find is not something stable-yet-multiple but rather something that exists in between.

The Domestic Layer Cake

While the film's narrative opens at the conclusion of the plot before working backward, the story of *John Wick* opens in his home. The asynchronous sound of an alarm transitions from the title card to Wick's bedroom, and we see him arise at the break of dawn. This introductory sequence takes us through a normal morning in his life, with the raw wound of his recently departed wife apparent everywhere in an empty duality. He descends from the second-floor bedroom to the first-floor living space and grabs his coffee cup, revealing his former wife's

empty cup behind it. Wick stares into the bathroom mirror, his side of the sink spartan and hers still filled with daily skin-care and beauty products. The tone of the image is gray, washed-out, almost colorless. Juxtaposed to these present-day images are flashbacks to his last night out with Helen—including her collapse from what we can assume is a brain tumor. The parallel structure of these sequences is highlighted most boldly by the rich and warm colors of the memory, which features highly saturated golds, reds, and oranges. The next memory, Wick's last moments with Helen before she is taken off life support, matches the desaturated and gray tones of the present-day morning sequence. The montage continues: while his memories of their life together before her illness are vivid and colorful, his memories of everything after—including his present day—are desaturated and gray.

Wick's world post-Helen is colorless. Her funeral is a rainy, gray affair. Some warmer yellows return during the postfuneral visitation at his house, but Wick stands alone and isolated, staring out the window at the black night. Notably, this shot peers through the opposite side of that window and into the house—there is a barrier between Wick and his audience. After the visitation, a doorbell rings, signaling the arrival of an adorable intruder into his space: the pet beagle Daisy, whom Helen left for John as a parting gift. The camera during the delivery of Daisy is still outside the living space, as we get an over-the-shoulder shot of the deliverywoman from Wick's front steps. It is not until Wick brings Daisy into his home that the camera is invited inside as well.

Earlier in this volume, Marleen Newman and Andrew Battaglia offer a fascinating analysis of the architecture of John Wick's home. My discussion of Wick's home, however, is less interested in history, modernity, or material and more interested in thinking about the structure as a series of semiotic layers. We see three levels of the Wick home: the first floor, the second floor, and the basement. The first floor features the

13.1. The split sections of the Wick family's first floor: a raised modern space contrasted by a sunken softer space. *John Wick* (2014).

living room, the kitchen, and a magnificent smoky glass bookshelf that blocks off the entryway (fig. 13.1).

This space is where most of the domestic action happens in the first two films, and it represents the liminal space of the house. Rather than being a clean hybrid of both John and Helen, the first floor is jaggedly separated into industrial and modern spaces (the aforementioned glass structure) and softer and classic spaces (the living room features comfortable plush couches and chairs). A single step divides the two spaces, creating a sharp line between their respective softness and harshness. The kitchen is similarly divided. John's industrial functionality reigns supreme here—the kitchen is dark, metallic, and brutal in its efficient structure—yet the couple share cutesy "Mr." and "Mrs." coffee mugs left out each night. As the liminal space, the first floor highlights the two sides of Wick's life—the sharp and the soft—but never blends them. The difference is important when we consider the other two levels of the house.

The second floor represents John's softness and his connection to Helen. We see very little of this space, essentially just the bedroom. These short shots of the bedroom, however, are enough to convey the contrast between the second floor and the first floor and basement. The bedroom floor is covered in a fuzzy rug, which immediately contrasts with the wooden floors, tiles, and concrete of the other levels. Similarly, the bed itself is soft, with a puffy comforter and a half dozen pillows. More than these physical features, the bedroom's softness is also accentuated by lighting. During his first night with Daisy, for example, Wick's bedroom is shot in a soft, warm, yellow-orange light, which might be mistaken for candlelight. This lighting is noticeable; however, it does more than just soften the frame—it replicates the warm tones used in Wick's flashbacks about Helen and the yellower lighting used after her wake. We are called to associate these things together: softness, Helen, and Wick's happiness. This warmth and softness contrast starkly with the coldest level of the house: the basement.

Wick first enters his basement after the assault by Iosef Tarasov (Alfie Allen) and his men, after the first floor has been professionally cleaned and he has buried Daisy. As with the second floor, the lighting also marks this scene in contrast. The basement is low-key lit, with a single overhead fixture serving as the light source. In contrast to the second floor, this light is blueish in color and aids in establishing the coolness and harshness of the concrete setting. The scene opens with a basement shot of Wick at the top of the stairs, masked in shadow, tilted at an oblique angle. While this scene is very much about unearthing a previously buried darkness, this shot suggests that perhaps it has always been there below the surface. With his bloodied shirt and weapon in hand, he looks the part of a slasher-film villain. His reason for entering the basement is soon revealed in a parallel edit with the elder Tarasov lecturing Iosef about Wick's monstrous past, as Wick shatters the

concrete floor to unearth a cache of guns, clothing, and secret assassin currency. Having John literally unearth his past after Daisy's death feels a little too blunt, but I find it more interesting that he buried this cache in the first place. Burying the locker underneath a few feet of concrete signifies several things: first, and most obviously, that Wick had cut off and discarded a part of himself. The bloodthirsty assassin, the "Baba Yaga" of Tarasov's legend, was wrapped up neatly in a box and then entombed beneath the foundation of a new home Wick built with Helen. Second, and more importantly, burying the box instead of destroying or getting rid of its contents signals that Wick's desire to leave that world behind was not a full commitment. Sure, the box is entombed, but it is also only a few solid blows with a sledgehammer away. This home, the perfect representation of this life John told himself he wanted to lead, rested on a destabilized foundation.

The domestic layer cake of Wick's home is meant to be read not as a unified, blended, or hybrid space but rather as three distinct sections of his life. In the basement, Wick's dark side lingers, the "mystic writing pad" of his consciousness, the past life he wishes he could bury: the ultramasculine legendary killer with cool guns and cooler suits. On the second floor, we see the life Wick desired: fully domesticated, soft, warm, and gentle, with Helen's touch at the core of all things. The first floor featuring harsh lines between those two spaces serves as an ideal metaphor for the liminality I chart in this essay: Wick's reality and his fantasy collide, creating a space that is neither and both, but never hybrid.

Bisexual Lighting, Liminal Lighting

Wick's home space is notable for its distinct layers, but what I find most fascinating is his ability to move through those layers. No other

character in any of the films ventures into the upstairs or the basement—not even the hit squad sent to clean up Iosef's mess. Wick's ability to move through these spaces in a figurative sense is what makes his liminality so interesting, and his ability to move through spaces outside of the clearly demarcated lines of his house forms a pattern as he dips his toes back into the assassin world and then back into his domestic fantasy world. An early moment in his quest of vengeance is the shootout at the Red Circle Club, and the use of a particular kind of lighting strongly emphasizes Wick's neither-and-both hybridity.

The shootout at the Red Circle Club again features Wick moving through layers of a building (the titular club), starting in the basement bathroom and working his way up to the top-floor balcony; however, what is most notable about this scene is the use of a lighting technique most popularly described as "bisexual lighting."[2] Kyle Kallgren describes bisexual lighting as "a combination of reds, pinks, purples, and blues," reminiscent of the bisexual flag's pink top, lavender middle, and blue bottom.[3] The pink of the flag represents same-sex attraction, the blue of the flag represents opposite-sex attraction, and the lavender of the flag represents attraction to more than one gender. The three-layer structure of the flag resembles the three-layer structure of Wick's house in that the layers are distinct and separate with the key difference being that Wick's house is comparatively colorless, indicating a more stable "husband" identity not present as he returns to the assassin world.

Beyond the color triad, bisexual lighting is also associated with bright neon light in darker spaces. For this reason, it is also sometimes called "club lighting" for its resemblance to lighting frequently deployed in nightclubs because it is flattering and disguises blemishes—people just look sexier in bisexual lighting. Nightclubs are designed to be spaces for sexual liberation and exploration—their main export is the

fantasy prospect of sex. Because of this, as well as its connections with the flag, bisexual lighting is a sexually stylized form of cinematography. Ironically, sexual lighting seems out of place in *John Wick* or any of the sequels. While Reeves himself is a handsome man, and Wick is the object of many longing gazes, he is strikingly asexual.[4] Wick's only feelings are toward his wife, which leaves him with no physical body to lust after—only a memory. Read through the lens of hybridity, this presentation of Wick makes no sense: he is neither blue, pink, nor lavender. In a later scene in the bar area of the Continental, Addy the female bartender slips Wick a drink and ogles him—he politely changes the subject to work. We see him form similarly platonic relationships with his female coworkers, such as Ms. Perkins and Sofia, both of whom he interacts with at length without any sexual chemistry. The attraction toward Wick may even be read as bisexual, if we regard Zero's obsession in *John Wick* 3 as having a sexual tinge, but it only works in that single direction. Instead, I offer the liminal presentation of Wick through this lighting: he is both and neither. He is desired by women and men, and he desires no one.

Theorizing "bisexual lighting" just through the lenses of sexual attraction, however, ignores a crucial element of the cinematographic style: the neon aesthetic. Neon is both a timeless mainstay of the club scene and a nostalgic callback to its heyday in the 1980s. For this additional reason, bisexual lighting is liminal in nature. However, this timeless and stuck-in-time structure also provides a way to understand other choices made around Wick's character. A large amount of attention, for example, is paid to his car. It is, after all, the impetus for the attack on him and the murder of Daisy. Wick's car, a 1969 Ford Mustang, has been updated with all the bells and whistles by Aurelio (John Leguizamo), making it a car that is both classic and modern at the same

time. His car, then, displaces him in time in the same way the neon aesthetic does.

But, perhaps most important, the reds, blues, and lavenders of bisexual lighting in the Red Circle Club scene fall *onto* but are never integrated *into* the monochromatic Wick. Neither are the longing gazes he receives from men and women—they never stick. The significance of this lighting style thus originates in its ability to be both red and blue at the same time. Like Wick's house, the light becomes distinct when we expect it to mix—while it is red and blue, it never blends into that hybrid lavender. Similarly, the neon hues extend toward both the past and the future, presenting a scene that is at once classic and cyberpunk future. We see Wick's liminality extended through this lighting—he is awash in it and rejects its hybridizing impulses.

Gladiators and Gunslingers: The Masculine Spectacle

Liminality in both the mise-en-scènes of and cinematography in the *John Wick* films informs their sense of masculinity in general and action-hero masculinity specifically; in doing so, the films provide a visual presentation of the ideological push-and-pull that Wick experiences. Although we never see it, we are to understand that before he met Helen, Wick was "single-minded" in his focus on meting out death and destruction. He was pure masculine id—omnicompetent and invincible.[5] Wick's off-screen meeting with Helen and his subsequent performance of an "impossible task" to grant him his freedom led him to reject the hypermasculine world of assassination for the domestic world he tries to build with his wife. After Helen's death, and more immediately after Daisy's murder, Wick feels the siren call of the hypermasculine world. The tension of the franchise rests in the struggle between the ease with which he reenters that world through his "Baba Yaga" alter ego and his

constant desire to renounce it. The hypermasculine world of assassin-for-hire is a lure that constantly seeks to pull him under.

On the surface, the narrative elements of *John Wick* are not that different from other forms of action cinema. There are plenty of action heroes who do not engage in romantic subplots (Liam Neeson in the *Taken* films, for example) and plenty more who pine for their dead wives (Robert McCall [Denzel Washington] is a widower in *The Equalizer*). Similarly, there are heroes who must be coaxed out of retirement and those who try and fail to distance themselves from their violent pasts. What makes the *Wick* franchise different from these myriad examples is its constant back-and-forth between the distinct phases. Wick's liminality is crucial to this reading: he is both hypermasculine and domestic but also neither. He both embraces and rejects the violence but slips off both of those paths. In other words, the fact that Wick never returns to a domesticated life or gets pulled into the deep dark waters of masculinity, while simultaneously moving to the precipice of each, is what makes him a unique action hero. He is both a round and a flat character—constantly in flux but never changing. His is a spectacular masculine body that critiques generic tropes.

When I use the term *spectacular masculine body*, I am referencing the work on hypermasculine action heroes and their up-for-display bodies by Yvonne Tasker, Susan Jeffords, and, more recently Lindsay Steenberg, particularly her work on gladiators.[6] These theories of ubermasculinity underpin a theory of the masculine body on display in action cinema, one to which *John Wick* pays homage even as it challenges this theory. The type of masculine spectacles that Tasker and Jeffords critique are those of the 1980s and 1990s—the hard, shirtless bodies of Arnold Schwarzenegger, Sylvester Stallone, and Jean-Claude Van Damme. These muscular (and oiled-up) bodies are designed to represent an engorged penis, matching the physical power of their characters to their

phallic power. The largely male audiences of these films are not meant to draw erotic information from the bodies but rather a sense of perfected masculinity. Certainly, John Wick is not presented in the same way as the action stars of eras past—although he does have a prefight shower scene that showcases Reeves's impressive and tattooed physique. More often, Wick is presented in a sleek black suit, promoting a sense of urbanity and modernity that contrasts sharply with the wild and rugged bodies discussed by Tasker and Jeffords. The spectacle of John Wick is not in the way his body glistens with perfect mechanical function; instead, the spectacle of John Wick is presented through two methods: the textual legends told by other powerful men and the metatextual continuity editing during action scenes.

Wick's deeds of exemplary violence require diegetic observers as well. The oral spectacle of John Wick occurs through lengthy monologues about his exploits delivered by the most dangerous gangsters in the world. In *John Wick*, Viggo Tarasov lectures his son about Wick's unprecedented "focus" and the ways in which it allows him to be the perfect killing machine. Not to be outdone, his brother Abram (Peter Stormare) opens *John Wick 2* with an anecdote about how John Wick once killed three men in a bar "with a fucking pencil," crosscut over a parallel edit of Wick striking from the shadows and eliminating his men. This feat, one the film later references, functions as an in-joke for the entire series, as the audience hears constantly about how terrifying and skilled Wick is, and the filmmakers cannot help but display the reality behind the legend. The spectacle of Wick's masculinity is presented to us not just through his actions but by literalizing the very concept of spectatorship through ancillary characters.

While watching *John Wick* in 2014, I found myself struck by a foreign experience: I could tell what was happening in the action sequences.

Beginning with *Saving Private Ryan* in 1997 and reaching its apex in *The Bourne Identity* in 2002, discontinuity editing ruled action cinema for the aughts. While these two films worked with discontinuous editing to masterfully capture the chaos of war and hand-to-hand combat, most films presented visually incoherent set pieces.[7] Quick cuts, 180°-line breaks, inconsistent spatial relationships, and shaky cams combine to create an illegible text. What made *John Wick* notable was its bucking of this ubiquitous trend and creation of a stylistic action sequence more resembling a martial arts film than an American action film. The Wick films use long and extended takes, steady camerawork, adherence to the 180° rule, long shots, and standard lighting to create a clearly legible document of Wick's combat mastery. The spectacle of Wick lies not in putting his body on display but in putting his capabilities on display. His masculinity is based in his action, but its importance lies in its ability to be clearly read by the audience. A scene from *John Wick 2* stands out for both its continuity editing and its generic blending. Near the midpoint, just after Wick has fulfilled his murder contract, he encounters his old colleague Cassian (Common). Cassian and Wick square up as the former realizes that Wick has just killed his ward. For the first time in the franchise, we see Wick up against someone possessing a similar skill set—the first film sees him taking out lackies and thugs on his way to mob bosses and their adult children—and the framing illustrates this in a long shot of the two men staring each other down. The visual language pulls directly from the American Western: two gunslingers standing off before a duel. The master shot provides the audience with a sense of spatial relationships before cutting to matching two-shots from the perspective of each man's gun belt. As the two men draw, the action descends into chaos, but the cinematic technique never breaks down. Through the use of stable camerawork, callbacks to familiar genres, and

adherence to the spatial relationships of the master shot, the film presents a digestible action sequence meant to be easily observed by the audience.

The genre hybridity on display in this scene is notable for how well Wick embodies the American gunslinger as an outlaw and outcast, but with a strong sense of justice: a ronin in a lawless world. The connections between Wick and *Unforgiven*'s William Munny (Clint Eastwood), for example, are especially striking: dead wife, retired killer, exploits retold through legend, and a hesitancy to embrace his past life. The biggest difference between the two is that while Munny resummons his legendary wrath and skills for one final shootout, Wick spends most of his journey trying to restrain his inner demon—or monster. The genre hybridity for Wick does not end with martial arts films and Westerns—the genre most attached to the spectacle of masculinity is the gladiator film. In a recent essay, Lindsay Steenberg situates the gladiator within the larger field of spectacular cinematic masculinity. For Steenberg, the function of the gladiatorial body in cinema is to "[link] the suffering body of the celebrity fighter with virtue, nostalgia, and iconic philosophical principles."[8] Of the iconic philosophical principles Steenberg mentions, the most important is "stoic masculine virtue."[9] The specific type of stoicism and virtue Steenberg theorizes is connected to unemotional masculinity and the constant potential for violence.

As noted elsewhere, Wick's potential for violence is known both to the audience and to the characters in the film, and it simmers below the surface of every interaction. Wick's stoicism is presented, as is commonly the case in modern action cinema, through his emphasis on actions over words. Similarly clichéd is Wick's ability to withstand massive amounts of physical pain and injury and continue fighting. In *Contemporary Action Cinema* (2011), Lisa Purse argues that the male body's abilities both to signify physical mastery and endure physical pain are a

staple of action flicks: "In an environment fraught with risk and danger, it is the body poised between mastery and loss of control that holds our attention, and in the action film it is the precarious predicament of the action hero mid-action, as well as the hero's eventual overcoming of the presented challenge, that the action film underlines in its staging and presentation."[10] Wick spends half of the first film nursing a gunshot wound suffered at the Red Circle, manages to get injured even through his bulletproof suit in the second film, and spends the entirety of the third film suffering through increasingly distressing injuries beginning with a puncture wound in the shoulder only a few minutes in. A core part of Reeves's skill set as an actor is emoting Wick's physical pain—limping, grimacing, writhing—all while managing to fire a perfectly accurate shot, engage in hand-to-hand combat, and throw knives in a dangerously narrow hallway. It is never enough for action heroes to exhibit mastery of violence, skill with weapons, or incredible strength; they must also take physical punishment and feel pain. Wick embodies all these traits to an extreme degree. His stoicism, however, falls apart when we consider the other type of pain he experiences: the emotional pain of loss and grief.

In the physical sense, Wick is a perfect gladiator: his exploits serve to entertain us as viewers and provide legend and myth for the spectator characters in the film world. He is virtuous (he is gentleman at all times and remains loyal to the memory of his dead wife), nostalgic (see my above commentary on Wick's out-of-time aesthetic), and stoic in battle and in response to pain. His stoicism does not extend outside of his physical presence, however, as he breaks two cardinal rules by focusing on events he cannot control (the past) and embracing emotional responses to situations over rational ones. Wick's fixation on the past comes in the form of the memory of Helen. His emotional responses come in the same form. Helen becomes a Shakespearean ghost, haunting the living

and preventing them from making choices. In Wick's case, his ability to embrace his hypermasculine killer "Baba Yaga" identity is thwarted by constant returns to Helen. In *John Wick 3*, he double-crosses Winston (Ian McShane) for the Elder (Saïd Taghmaoui) when the latter brings up the memory of his wife, only to double-cross the Elder when Winston brings up Helen. This emotional side of Wick, marked by his grief and sadness at the loss of his wife, causes his pain as much as any gunshot wound, stabbing, or broken bone.

Yet again we find Wick inhabiting the liminal space between. He is the classic action cinema hero—the gladiator who embodies lethal mastery while shrugging off tremendous amounts of physical pain. He is also the melodramatic lead—unsure of how to proceed after a traumatic event, destabilized by his own grief and sorrow. As with other sections of this essay, I find it most compelling that Wick never seems to synthesize those two antithetical identities—he never becomes a gladiator who exhibits emotional strength, for example. Instead, as with the double-double-cross push-pull outlined above, Wick drifts between the invincible action hero and the melodramatic widower in sometimes jarring ways. The juxtaposition of these moments, such as when Wick confronts Winston with ill intent only to be swayed by a plea toward the memory of his wife only to then murder dozens of highly trained assassins, illustrates the difference between hybridity and liminality.

The Liminality of Grief

In *John Wick*, Wick confronts Viggo Tasarov over Iosef's actions in killing Wick's dog. In response to Viggo's assertion that "it was just a dog," Wick explains, "When Helen died, I lost everything. Until that dog arrived on my doorstep, a final gift from my wife. In that moment I received some semblance of hope, an opportunity to grieve unalone.

Your son took that from me, stole that from me, killed that from me!" The word *unalone* is a microcosm of the split I see in Wick: he is not quite alone yet not quite partnered, both and neither. More significantly, the grief at the core of the *John Wick* franchise is what contributes to Wick's inability to embrace either side of his personality. These films illuminate the ways in which grief can freeze even the strongest among us in limbo, unable to move forward and unable to capture the past. Wick fractures his identity into shards at various turns through his life—his transition from Jardani Jovonovich to John Wick (and the move from civilian to assassin), his transition from assassin-for-hire to husband, his transition from husband to widower, his transition from widower to puppy father, and his reintroduction into the world of assassins. In each of these transitions, a fragment of the past self remains—Jardani is tattooed all over Wick's body, Wick's assassin past is buried under the foundation of his home, and Helen remains a specter surveying every action he takes. The pull between these multiple Wicks seems to be part of his every experience, and in his grief that split becomes most pronounced. When Wick asserts, as I outlined at the beginning of this chapter, that he is in fact "back," he does so with a sincere ignorance of his own grief. Because of his inability to "grieve unalone," Wick remains frozen between his identities—always both assassin and husband, and yet never fully either.

Notes

1. See Raewyn Connell's *Masculinities*, 2nd ed. (Berkeley: University of California Press, 2005), which is valuable as a deconstruction of hegemonic and essentialist discourses of masculinity. This essay is less interested in deconstruction than in construction—at least illuminating construction—and in theorizing the ways in which Wick shrugs off a simple "hybrid" presentation of manhood. Furthermore, my rejection of "polysemic masculinities" is intended to suggest that while Wick fits into a few categories, he consistently runs from and toward competing versions of himself.

My focus on liminality over hybridity is the result of Wick's identity never being a "mix" of the competing versions himself but rather an embrace-and-rejection of both at the same time.

2. Wick moves between bounded spaces in *John Wick 3* when he is led through the back stages of the theater in which he was trained. Beyond simply slipping behind the curtain of the performance space, he also moves between the strictly coded masculine and feminine spaces of the wrestling and ballet rooms. The scene culminates in Wick renouncing his connection to the Belarusian mob in exchange for a favor of passage. Here we learn that even his identity has been hybrid: prior to his renunciation, he was both "John Wick" and "Jardani Jovonovich." Although this renunciation would suggest a rejection of that liminal in-betweenness, the mob brands him as a final act—ensuring that he will always retain that earlier identity.

3. Kyle Kallgren, "Bisexual Lighting: The Rise of Pink, Purple, and Blue," YouTube, July 6, 2018, https://www.youtube.com/watch?v=8gU3IA4u-J8. I want to express my thanks to David Carter from the IUCinema blog, who initiated a discussion of lighting at the conference from which this volume was organized.

4. Reeves occupies an interestingly liminal space with regard to sexual attraction. During his early career, Reeves was cast in "himbo" roles: harmless, incompetent eye candy staged as softer than hypermasculine action stars like Stallone and Schwarzenegger. "Himbos" were for female viewers. However, as Gita Jackson argues in a June 22, 2020, article on Vice titled "The Himbo Is the Harmless, Dumb Hottie of Our Dreams," the modern "himbo" is defined as much by his rejection of toxic masculinity as he is by his good looks. Thus, Reeves's attractiveness would seem to be more about his kind personal affect than his jawline. And yet, in a January 27, 2021, post on the A.V. Club titled "*Cyberpunk* Developers Ask Players to Please Stop Having Sex with Keanu Reeves," William Hughes chronicles the moves made by video-game developer CD Projekt Red, who were forced to remove a mod that allowed players to have sex with Reeves's character in their 2020 game *Cyberpunk 2077*. While his flattened affect and "himbo" past frequently paint him as an airhead, fans of his works consistently sexualize him. In this way, Reeves himself lives a similar situation to the one I outline for Wick: constantly sexualized by others without doing anything sexual. For further discussion, see Gita Jackson's article.

5. Omnicompetence is strongly associated with specific types of action heroes—most famously James Bond. The *John Wick* franchise pays homage to this lineage of action star—for example, Wick's hyperstylish yet classic bespoke suit, a staple in the Bond franchise. We also see semiotic play with the concept of "bespoke," as the suits are not just well-tailored but mission-ready with gadgets (in Bond's case) or state-of-the-art bulletproof inserts (in Wick's). Similarly, the preparation montage in

John Wick 2 references the traditional Q-Branch meetings Bond would yawn through before undertaking a mission. Bond's omnicompetence allowed for a masculine calmness in the face of certain death and danger; in the *Wick* films, it serves to reinforce the spectacle of John Wick as told to us by the characters he encounters.

6. Lindsay Steenberg, "Bruce Lee as Gladiator: Celebrity, Vernacular Stoicism and Cinema," *Global Media and China* 4, no. 3 (2019): 348–61.

7. Michael Bay's *Transformers* films are perhaps the worst offenders of this style. In these films, space, location, time, and proximity blur in quickly edited flashes of violence without context.

8. Steenberg, "Bruce Lee as Gladiator," 349.

9. Steenberg, "Bruce Lee as Gladiator," 349.

10. Lisa Purse, *Contemporary Action Cinema* (Edinburgh: Edinburgh University Press, 2011), 3.

OWEN R. HORTON is Lecturer in the English Department at Indiana University Bloomington. His writing focuses on the intersections of masculinity, popular cinema, and trauma. In particular, he focuses on American iconography in the twenty-first century. He has published articles on masculinity and trauma in the post-9/11 superhero film, time travel as prosthesis in science-fiction films, and the fantasy cityscape in comics. His current project focuses on aging masculinity and fatherhood.

14 PROFESSIONALISM AND GENDER PERFORMANCE IN THE JOHN WICKVERSE

VIVIAN NUN HALLORAN

There is no such thing as work-life balance within the *John Wick* cinematic world. The film franchise centers on a complex global criminal organization whose corporate culture, tightly regulated by the High Table, exhibits the hallmarks of what David Warfield Brown has called "America's culture of professionalism," an ideology that leverages, on the one hand, specialized knowledge unavailable to most laypeople and, on the other, a byzantine set of agreed-upon rules that promote self-regulation in the style of a guild system. In his study of professionalization as an ideology, Brown explains that mutually agreed-upon deference among professionals helps maintain group coherence but at the expense of individual freedoms: "The golden rule of deference in the culture of professionalism keeps the peace but also seriously restrains those who might otherwise trespass for good reason."[1] This tension between the demands of professional etiquette and ethical principle is at the heart of *John Wick: Chapter 3—Parabellum*, which depicts wayward employees, Wick among them, repeating the company motto, "I have served. I will be of service," before willingly submitting to punishment and then being brought back into the fold.

For Wick, the cost of such a declaration of fealty is the loss of his left ring finger, which he must amputate himself. And it is this symbolic castration that most clearly epitomizes how the franchise presents its antihero: as a hybridized figure occupying what Michael DeAngelis,

describing Keanu Reeves's star construction, terms a "state of inbe-tweenness."[2] In his study of Reeves's early roles, DeAngelis critically marks this space as it relates to sexuality, usefully parsing distinctions between androgyny, bisexuality, and "pansexuality" to explain the ac-tor's appeal to a wide audience "across the lines of sexual orientation."[3] And pansexuality leads to "panaccessibility," an openness to audience interpretation that is predicated on the actor's or character's refusal to be labeled: "By denying his own specificity according to categories of identity, he accommodates and sustains individual constructions of his persona according to the subject's constitution of individual subject-hood, opening up new spaces for the deployment of desire."[4] My read-ing of the *John Wick* texts extends this last concept beyond Reeves's persona and applies it to analyze how Wick and select female or gender-queer characters subvert the High Table's rigidly gendered standards of professionalism to craft a tenuous location between them. Reluc-tantly recalled from retirement, Wick refuses to conform to the toxic dimensions of a masculinist professional identity that denies him the prerogative of claiming a private, personal space in which to mourn his loss. In the ethical calculus of the filmic universe, his refusal to iden-tify with a patriarchal logic of professionalism as self-regulation is what makes Wick most heroic, even as he kills those who cross him. Thus, the *Wick* franchise critiques the masculinist values imbricated in American standards of professional conduct at the workplace by valorizing Wick's emotional vulnerability, loyalty to his friends, and characteristic reti-cence, which alpha males take as an invitation to mansplain his duties to him.

Professional women and nonbinary employees of the Continental and High Table must also navigate this familiar gendered professional world, and their efforts to do so constitute the most compelling evidence in support of the films' use of panacessibility to critique the binaristic

logic that sees the personal and the professional dimensions of people's lives as inherently at odds. Drawing from feminist organizational communication scholarship, I contend that the *John Wick* films upend the dominant stereotypes regarding gendered professional power dynamics in the workplace through a strategic depiction of female and gender-queer characters' panaccessibility as consummate professionals whose job performance outwardly aligns with values that have traditionally been coded as male. Moreover, and for the most part, they carry out their duties without being burdened by excessive emotions or family obligations, while Wick endures harassment and persecution for clinging to his. Angela Trethewey explains that corporations' organizational structures support a heteronormative management culture that in turn "serves to foster masculinized forms of authority" by enforcing a strict division between the realms of the personal and the professional.[5] At pivotal moments in *John Wick 3*, Wick transgresses against the culture of professionalism by failing to relinquish his commitment to the private life he has lost, a breach of conduct that the High Table punishes through physical assaults that pierce the flesh and undermine his body's integrity. In this way, Wick's injured body performs his panaccessibility as the "excessively sexual or undisciplined body [which] draws attention to the otherness of the female, private body in the masculine, public sphere of work."[6] As Stephen Watt suggests in the essay that follows this one, Wick's "undisciplined" body, which prompts a response from the hierarchy of the criminal world in which he once worked, parallels that of the ballerina (Unity Phelan) whom the Director (Anjelica Huston) compels to rehearse until she falls to the stage floor from exhaustion. And, as I shall discuss, this issue resurfaces, albeit quite differently, when Wick travels to meet Sofia (Halle Berry) and their conversation turns to her daughter.

In what follows, I analyze how effectively female and genderqueer secondary characters in the High Table's employ carry out their professional duties to eliminate or discipline John Wick. Ms. Perkins's (Adrianne Palicki) greedy entrepreneurship is in full display in *John Wick*, as she works to double the announced bounty by breaking hotel rules; gender-fluid Ares's (Ruby Rose) steely determination and effective leadership as Santino's chief of security ensure their employer's safe arrival at the Continental in *John Wick: Chapter 2*. And *John Wick 3* features two strong women and one nonbinary person in positions of authority: the Director and Sofia both exercise managerial supervision over others (ballet and wrestling students, hotel employees) but also maintain their own autonomy, while the Adjudicator (nonbinary actor Asia Kate Dillon), a one-person human resources department, arrives at the New York Continental to reinstate order, hire assassins, and dole out punishment as needed. But most important, in their various methods of pursuing their careers and whatever fluidity in terms of gender or sexuality they possess, these characters all adopt or succumb to a professionalism that would constrain their mobility.

Feminist communication studies scholars Janell C. Bauer and Margaret A. Murray explain that within corporate work culture, "professional roles align with an ethos of masculinity" that is also assumed to be culturally white.[7] Though the criminal underworld of the High Table comprises a global network, its wealth, traditions, and values reflect a predominantly European or Eurocentric orientation. Trethewey complicates the picture by pointing out that historically, "discourses of professionalism have privileged formal terms such as male, public, mind, and rational over their informal opposites—female, private, body, and emotional. The subordinated terms are subsequently marginalized."[8] As career assassins or administrators within the High Table, Perkins, Ares,

the Director, Sofia, and the Adjudicator deploy what Trethewey calls strategies of "gender management" through their unwavering commitment to carrying out their assigned tasks professionally, performances of competence that demonstrate their internalization of such terms as "public, mind, and rational" despite inhabiting female or genderqueer bodies. With the notable exception of Sofia, a Black woman who transitioned from service to management, these characters are always working—or supervising others' work—and seem to have no personal life to distract them from their obligations.

In contrast, the franchise's eponymous protagonist has been retired for some five years by the time audiences first meet him in *John Wick*, and the most definitive action he performs in the opening scene is to play a video of him and his wife kissing on the beach. By staggering out of the company car and seeking solace in re-viewing a text that commemorates his private life, Wick clearly signals that he most values his identity as Helen's (Bridget Moynahan) husband, rather than the public persona that has won him renown as an assassin for hire. John Wick's actions in the first scene align his self-image with the characteristics described by Trethewey as feminine or unprofessional: "nurturance" of his wife evident in the on-screen embrace, "dependence" on the video as proof of the loving nature of his marriage, "passivity" in that he lies down and appears resigned to die, and, finally, "incompetence" because he crashes the SUV he was driving rather than park it. The film's concluding scene returns to this liminal space and shows Wick overcoming his feminine-coded behavior through a renewed reliance on masculine attributes: he draws from his remaining "strength" to get up on his feet and relies on his "intelligence" to enter the veterinary clinic/pet shelter, where he locates medical supplies to patch himself up. However, rather than affirming his masculinity, this final scene demonstrates that the impulse to nurture is now an abiding part of his overall identity: rather than giving

up and dying, Wick literally performs self-care by stapling his wound shut, and then he crosses professional boundaries to nurture once more when he rescues a black pit bull scheduled to be put down, thereby honoring his wife's last wish that he should have some companionship.

In what follows, I first examine how the trope of boundary crossings works across the three films to usher in Wick's panaccessibility and gradually eliminate the distinction he tries to maintain between his work and his home life. Then I present three case studies in which the female or genderqueer characters' conduct is demonstrably more professional than that of their male colleagues. Together these examples comprise the film franchise's feminist critique of the toxic masculine ethos at the heart of the cult of professionalism that the High Table preaches and ruthlessly enforces.

Boundary Crossings

Whereas *John Wick 3* finds Wick on the run, without a home to call his own and exiled from the sanctuary of the New York Continental, the first two *John Wick* films center on the idea of boundary crossing between the worlds of work and home, the latter of which, for all intents and purposes, equals marriage and retirement. Bauer and Murray explain that "the boundary metaphor refers to the way that public and private are treated as separate bounded spaces where actions and feelings that are appropriate in one space are not appropriate in the other."[9] As discussed earlier, the video John watches on his phone in the first film's opening sequence informs the audience about his domestic life through both flashbacks and intertextuality. In contrast, Wick's backstory as a legendary assassin is revealed only through narration during the original *John Wick* and the start of *John Wick 2*. The highlights are as follows: by successfully performing an impossible task five years before the

opening shot, John Wick earned the right to walk away from organized crime and enjoy his early retirement, which coincided with his marriage to Helen. Even as they recall these events, the male raconteurs still appear utterly surprised that Wick would not only insist on but achieve the right to divide his life into two separate spheres with temporal implications—his past in the public realm where he exercised his profession as Baba Yaga and the private domestic space where he was simply "John," who enjoyed his retirement in the company of his loving wife.[10] As Bauer and Murray explain, "in the context of feminist organizational research, the communicative and embodied practices that articulate, reproduce, or contest the construct of separate spheres impact individuals' experiences of work and family life."[11] All of Wick's broader circle of professional associates—auto mechanic Aurelio (John Leguizamo); Winston (Ian McShane), the owner-manager of the New York Continental; Marcus (Willem Dafoe), a fellow assassin; and brothers Abram (Peter Stormare) and Viggo Tarasov (Michael Nyqvist), heads of the Russian mafia in the first two films—discuss his retirement as nothing less than miraculous, betraying a vision of their own lives as entirely beholden to the High Table.

If Wick's retirement is the stuff of legend, his domestic life lacks a fairy-tale ending. Wick's wife, Helen, dies of illness after less than five years of marriage. Her burial brings about two unexpected boundary crossings that call into question whether this widower can enjoy retirement. The first such instance is a show of friendship and loyalty: Marcus shows up at the cemetery to personally convey his condolences. The encounter surprises John but does not immediately threaten his new way of life, presumably because the meeting takes place at a neutral space where both private and public interests overlap. The second instance, however, is an act of reckless vandalism, which ironically only serves to illustrate how completely Wick had succeeded in severing ties

with the criminal underworld. Entirely unaware of whom he targeted with his brazen actions, young Iosef Tarasov (Alfie Allen) invalidates the deal his father had made with Wick by breaking into his house, killing his dog, Daisy, and stealing his car. After this violation, Wick feels compelled to avenge his losses—both the material, in terms of property, and the more abstract, such as the puppy's value as a lingering emotional connection to Helen as well as the unwarranted disruption of the tranquility of his retirement. Thereafter, the one question everyone consistently asks Wick is: "You working again?"

I suggest that these two events activate gendered scripts that render Wick panaccessible because they evoke attributes typically associated with marginal or female workers—namely, nurturance and emotion. Bauer and Murray argue for the importance of reading the professional as an embodied being who occupies spaces with overdetermined meanings: "It is through the material interactions with organizational and personal spaces that employees draw relevant and gendered scripts to perform the experience of grief as professional workers and to make sense of their loss. In viewing organizational space as performative, we refute the coding of space as static or natural and explore the messy and nuanced ways that work-life boundaries and conceptions of public-private space are reimagined or reinforced."[12] Wick's professionalism, past and present, is up for debate by everyone around him. Reading his forced return to the workplace through Bauer and Murray's theory of the "messy" and "nuanced" allows us to bypass the binaries of gendered expectations for what constitutes professional behavior. Because Wick refuses to downplay his grief when interacting with former employers or coworkers, his behavior illuminates how unstable other workers' own adherence to work-life boundaries is. Moreover, the ferocity of his mourning forces Viggo Tarasov to betray his own son, whose ill-judged criminality motivated Wick's return.

The matter of his employment status is definitively settled when Wick acknowledges the speculation and finally answers, "People keep asking if I'm back and I haven't really had an answer. But now, yeah, I'm thinking I'm back!" However, he makes this declaration under duress, as he is being tortured by Tarasov's men. It is therefore unclear whether it carries the weight of an official reentry into the workforce and, if so, what the terms of his employment would be. Having previously worked for the Tarasovs, the postretirement Wick has been operating as a free agent, the physical embodiment of retribution who answers to himself alone. The constant inquiry about his employment status, combined with Addy (Bridget Regan) the bartender's claim during his first visit to the Continental that Wick looks newly "vulnerable" due to the loss of his wife, suggests that his personal troubles have negatively impacted his public performance of a professional identity. As Bauer and Murray's research into bereaved workers in white-collar jobs reveals, "Grief is an emotion that is often positioned in contrast to what is acceptable in organizations. For many it is a time of 'undoing' around the professional status quo, and so bereaved workers may find themselves in uncharted territory as they try to navigate new work/life and professional/personal tensions."[13] Though this exchange at the bar might appear, at first, to be another instance of unsolicited boundary crossing, I contend that Addy's performance here is an example of the "feeling labor" that hospitality workers like bartenders are expected to carry out as part of their job duties, as Tali Seger-Guttmann and Hana Medler-Liraz explain: "Some organizations exploit their hospitality employees' emotions as if they were the organization's property. Hospitality organizations were seen as sanctioning flirting responses, deeming them appropriate for their workers' own emotional experience, as well as for the firm's financial benefit, in the context of a commercial friendship with their customers."[14] In expressing both her condolences and concern for Wick,

Addy's words and actions are simultaneously examples of institution-alized flirting and a diversionary tactic through which Winston, her employer, conveys to Wick information about Iosef Tarasov's where-abouts without being seen to do so. Addy combines her duties as both bartender and intermediary when she writes the Red Circle's name on a napkin that accompanies Wick's drink, and this exchange of informa-tion strengthens the male characters' existing "commercial friendship" with one another, a dynamic that increases in importance as the film installments progress.[15]

The domestic space at the start of *John Wick: Chapter 2* once again sets the stage for Wick's reluctant reintegration into the criminal or-ganization ruled by the High Table. This time around, however, the consequences of the very feat he performed to earn the right to retire are what come back to haunt him. Santino D'Antonio (Riccardo Scarma-cio) visits his home and demands that Wick simultaneously uphold the values of two distinct cultural systems. The first is hospitality, and Wick upholds his duty as host by serving Santino a perfect cup of coffee. The second is honor, and he fails this test by reneging on the pledge he made when asking Santino for help on the night he performed his impossible task. The film depicts this arcane system of professional obligations concretely through the image of elaborately crafted markers signed in blood. Wick's refusal costs him the domestic space in its entirety, since Santino blows up Wick's house as both punishment for his rejection and a reminder that he must live up to his part of the agreement.

Though it is motivated by his desire to continue enjoying his well-earned retirement, Wick's initial refusal to honor the marker constitutes a breach of professional conduct. When Wick seeks shelter in the New York Continental Hotel after losing his designer home, Winston speaks to him as a colleague rather than as a friend, reminding him of the two cardinal rules of the High Table's legislation:

- No "business" conducted on Continental grounds.
- Every marker must be honored.

The transaction of giving a colleague a marker comes with its own set of ironclad obligations and punishments as determined by the High Table. Winston informs Wick, "You dishonor the marker, you die. You kill the holder of the marker, you die. You run, you die." By the end of the film, we see the consequences of Wick's violation of each of the cardinal rules: being rendered "excommunicado" from the Continental, which entails forfeiting all its attendant protections and services, and having a bounty placed on his head. While Wick suffers the effects of open defiance, Santino's underhanded actions demonstrate how the debt economy enacted by markers can be manipulated, thereby revealing the intrinsic corruption at the core of the High Table. Upon the death of his father, he privately calls in his marker to have Wick kill his older sister, Gianna (Claudia Gerini), to usurp her claim at the High Table and then publicly puts a price on Wick's head as a performance of his fraternal duty to avenge his sibling. The High Table's nepotism depends on family structures for leadership, but this system perpetuates infighting and betrayal.

This sets the stage for the three case studies that comprise the core of the film franchise's feminist critique of the High Table as an organization that promotes toxic masculinity at the workplace as a central aspect of its corporate culture. These discussions follow an inverse chronological order from the third to the first film to show that each installment has increased the tension between the cultural values its male protagonist abhors and the embodied gender identity (as female or genderqueer) of the employees who most competently perform them, something that has been there from the start. However, as the film series has grown in critical and commercial success, it has attracted female and genderqueer actors of greater name recognition. In the first film, the indomitable

Ms. Perkins was played by Adrianne Palicki, known primarily for her television roles. *John Wick 2* featured Ruby Rose from Netflix's *Orange Is the New Black* as Santino's chief of security, Ares, who memorably goes mano a mano with Wick in a hall of mirrors. In *John Wick 3*, Keanu Reeves squares off against two Oscar winners, Anjelica Huston and Halle Berry, in more nuanced exchanges where each contender seeks to outstrategize the other, though they are not direct competitors.

Wick versus the Director and Sofia

Wick's refusal to fulfill the obligation Santino presents him by honoring the marker stands in contrast to the reception he receives when presenting his own markers first to the Director of the ballet and wrestling academy and then to Sofia, the manager of the Casablanca Continental. Though neither woman is happy to see Wick bearing a token that compels them to help him, both fulfill their obligations without needing the advice or counsel of an intermediary. The nature of both characters' ties to Wick differs, though they each have a familial dimension. The Director, whose name is not nearly as important as her professional credential, is simultaneously in the employ of the High Table and also an official representative of the Ruska Roma. When Wick brandishes a crucifix in *John Wick 3*, declares himself an orphaned child of the Roma, and demands safe passage, the Director looks frustrated for a moment but then agrees to get him safely out of the country. In exchange, he must surrender the token and undergo ritual scarification so that his body bears witness to the repayment of his claim. By maintaining her focus on conducting the transaction—transport in exchange for branding— the Director signals that her academy is not a suitable space in which to discuss the ethnic ties they share. Instead, she asks Wick to remember the days he spent training in a facility like the one where their meeting

takes place, thereby reaffirming the power differential between them: not only is he, as a former student, always already less of a specialist than she is as an instructor and administrator, but Wick is doubly marginalized as an outlaw, a desperate man who is deemed excommunicado from the criminal organization to which they both belong.

Although he succeeds in getting out of the country, Wick's emotional appeal to the Director as a mother figure falls on deaf ears. The Director, in contrast, knows she has to pay a price for her own conflict of interest by helping Wick. She nonetheless chooses to uphold her ethnic obligation as a Ruska Roma even though this action goes directly against the best interests of the High Table, where she also plays a leadership role. Thus, when the Adjudicator comes to render judgment, the Director steels herself for the physical punishment that marks her atonement. After repeating the company motto, she holds her hands up as if in prayer and submits as an attendant pierces them with a dagger, thus demonstrating that the High Table's terms of employment require workers to endure painful punishment as the result of a negative performance review if they wish to remain part of the organization. Because she accepts the consequences of her actions without complaint, the Director's conduct is more professional than Wick's.

Whereas the Director had served as a mentor of sorts to young Wick, Sofia, the manager of the Casablanca Continental, is an analogous figure to Wick because they share the pain of personal loss of a family member. As a former assassin who opted into the managerial career track rather than staying active in the field, Sofia sends out her security chief to intercept Wick and ensure his safe arrival at the hotel so she can inquire as to the motive for his visit. Wick's negotiation with Sofia takes place in the part of the hotel where she both lives and works. Within this space, the camera pans to items that convey traces of Sofia's personal life: five framed photos of Sofia with her daughter

and dogs. As Wick picks up one photo, the focus shifts away from the familial scene and toward the ferocious dog that approaches Wick head-on. He turns his head to see another growling dog bring up the rear before Sofia emerges, gun in hand, and takes a shot after greeting John. She then asks whether John is "a dog person." Within Wick's world, as Karalyn Kendall-Morwick has discussed earlier in this volume, dogs hold a special emotional resonance, since the protagonist can trace the beginning of his pet ownership to his wife's final act of caring for him. Thus, the appearance of Sofia's dogs might at first suggest that she is Wick's double, since he also has ties to two distinct dogs. The murder of Daisy the beagle puppy prompts his return to the organization, whereas he rescues the unnamed black pit bull, Dog, as he makes his way back home at the end of *John Wick*. However, it soon becomes clear that while Wick's dogs are pets and part of his private domestic life, Sofia's dogs are her most trusted colleagues, trained to protect her and use their fangs as weapons. As the photos on the table show, Sophia gave up her daughter but kept her canines.

When Wick presents Sofia with the marker signed in her blood, her first reaction is to feel irritated. However, she eventually agrees to help Wick find out how to petition to be reincorporated into the High Table's organization. In essence, Wick needs Sofia to vouch for him so he can interview to get his old job back. In exchange, Wick offers to tell Sofia her daughter's whereabouts—information she does not want, because she had previously hired him to take her child far away to ensure her safety. She resolutely rejects this offer, as not only would this invalidate the terms of their prior agreement, but it would also endanger both mother and child. According to the logic of the organization, Sofia can be a good mother only by giving her child up; if she had selfishly done otherwise, her daughter would have been a hostage to fortune given the terms of her employment. This act of self-sacrifice is also racially coded

since, as Nina Banks points out, "Discriminatory public policies have reinforced the view of black women as workers rather than as mothers and contributed to black women's economic precarity."[16] Sofia's insistence on performing only her professional identity as hotel manager/former assassin at all times stands in contrast to both Viggo Tarasov and Santino D'Antonio, both of whom publicly claim ties of kinship to fellow professionals they eventually betray: Viggo proves himself to be an unfit father who ultimately tells John Wick his son's whereabouts so the latter can wreak his revenge, and Santino's ambition trumps his devotion to his older sister as he demands Wick's services to usurp her rightful seat at the High Table.

Ares versus Cassian

John Wick 2 depicts two different approaches to the role of chief of security through the staff that each of the D'Antonio siblings hires to protect them. Older sister Gianna relies on Cassian (Common) to serve as her personal bodyguard and coordinate security at the great ball she hosts to mark her ascension to the family seat at the High Table. Cassian and John Wick have previously interacted as colleagues, and their relationship can best be understood as a "commercial friendship," though not as intimate as the affective bonds that tie Wick and Winston. Seger-Guttmann and Medler-Liraz explain that "commercial friendship is characterized by a practical progression, with the providers and customers not knowing each other at first, but with the passage of time, gradually [increasing] their acquaintance and eventually [establishing] a long-term commercial friendship. The nature of the service will determine if commercial friendship will be of an intimate nature."[17] Cassian and Wick know each other professionally as fellow assassins, so when they see one another at the party in Rome, Cassian asks if he is back

on the clock and also if he has successfully carried out his assignment. The tone and wording of Wick's reply, "Afraid so," are courteous but also convey his acknowledgment that his victory came at the expense of Cassian's loss. "LED Spirals," the electronic dance music track by Le Castle Vania that plays as this scene unfolds, sonically ties the Roman bacchanal with the Red Circle scene in *John Wick*, thereby implying that Cassian's inquiry into Wick's employment status originates in part from their coworkers' skepticism about the retiree's ability to become Baba Yaga again.[18] Both men draw their weapons, and a fight scene ensues that ends only when they stumble into the Rome Continental and the manager, Julius (Franco Nero), exhorts them to respect house rules. As he motions for them to enter the bar and cool down, they reclaim the polite demeanor that is the hallmark of professional conduct: each man orders the other's drink of choice, thereby performing their commercial friendship within the space of the hospitality industry.

The upshot of this encounter is that by the time Cassian recognizes Wick, he has already failed in his duty to protect his charge twice over. The first is because Gianna has decided to commit suicide rather than suffer her fate at Wick's hands, though he nonetheless delivers the coup de grace by shooting her in the head before she dies from blood loss. The second is because in gaining entry to Gianna's private chambers, Wick has demonstrated the failure of the security measures that Cassian and his team had put in place to prevent such an eventuality. Thus, Wick's success proves that Cassian is both an inattentive bodyguard and a bad planner.

By contrast, Ares, Santino D'Antonio's chief of security, excels at the central duty required of the position: keeping him alive through multiple encounters with John Wick, most notably in the hall of mirrors, where Ares makes an ultimately fatal last stand to buy Santino time to escape. Earlier at Wick's home, Ares had kept a watchful eye on him but

stood with the security detail when Santino presented the marker to claim the debt. Likewise, the security measures Ares has put in place at the museum are so effective that Wick has to walk in through the main entrance and be surveilled by Ares and the team the whole time he is there, rather than sneaking in as he did in Rome. Finally, though, Wick fatally stabs Ares and Cassian, the latter of whom quietly smiles on the subway after Wick tells him to "consider this a professional courtesy," while Ares gets the last word by signing to Wick, "Be seeing you," a gesture that echoes Viggo's dying words at the end of *John Wick*. Interestingly, the first time Ares signed those words to Wick was also in the same bar at the Rome Continental, where, unprompted, Ares offers to buy him a drink that he refuses. When examined together, Wick's rude rejection of Ares's courtesy and his rash decision to kill Santino on hotel grounds prove that his professional conduct is marred by excessive emotion. In contrast, Ares's conduct throughout the film is a flawless display of professionalism that outclasses both Wick's and Cassian's.

Marcus versus Perkins

The last pair of professionals whose performance I evaluate here embody the two ends of the spectrum of the "gendered discourse of professionalism" in *John Wick*. As Trethewey reminds us, "the gendered discourse of professionalism enables emotional labour, but constrains work feelings."[19] Once again, the gender of the characters does not align with the type of professional conduct they perform. Marcus respects Wick's achievement in walking away from the criminal organization and takes great personal risks to ensure that his temporary foray back into the realm of the High Table does not bind him to that world again. While the narrative structure of the film obscures his motives to heighten suspense, Marcus performs his panaccessibility when he shoots the pillow

in Wick's room at the Continental to warn him of Ms. Perkins's impending attack, thereby revealing that his chief motive for taking Tarasov's contract is to carry out the "emotional labor" of saving Wick's life rather than earning the bounty. Marcus acts as Wick's guardian angel at several other points in the film, most notably when Tarasov's men try to asphyxiate him with a plastic bag. When Marcus is finally caught, he kills two of his captors before Ms. Perkins shoots him in the chest. She proves to be a better villain than Marcus, whose own downfall bears the hallmarks of the same feminine character traits Wick exhibited during his retirement: "nurturance, dependence, passivity, and incompetence." In other words, he does not fulfill the contract on Wick because he chooses to work against its first principle, nurturing the freedom Wick had won because he depends on Wick's success to validate his own vision of an alternative to the culture of professionalism demanded by the High Table. Finally, when faced with the inevitability of his own death, Marcus accepts it, though he does so on his terms.

Money is Ms. Perkins's primary motivation to ambush Wick, and Tarasov rewards her initiative by doubling the contract when she volunteers to break house rules. The "work feelings" this arrangement validates are those of greed, an emotion that plays into the corporate values shared by Tarasov mafia and the High Table. While "conducting business at the Continental" would appear to meet the standard for unprofessional conduct that Winston first warns Wick about in *John Wick 2*, by the end of that film the hotel owner/manager reveals that he has the prerogative to determine how to punish this infraction. Winston thus calls the Switchboard to declare Wick to be excommunicado for killing Santino. He exacts a much harsher punishment in the case of Ms. Perkins in *John Wick*, I suggest, because in killing Harry (the fellow hitman whom Wick had paid to watch her until housekeeping would find her the next day), Perkins took advantage of Wick's and Harry's (Clarke

Peters) efforts to avoid "conducting business on hotel grounds," without even the pretext of a bounty to excuse her violence. In short, by killing Harry, Perkins was working "off the books," so to speak, and thus her professional affiliation had to be permanently "revoked."

In sum, these case studies demonstrate that female or genderqueer characters in the Wickverse uphold the masculinist professional values that constitute cornerstones of the High Table organizational culture. The *Wick* films themselves leverage these depictions of consummate professionalism to critique an American workplace subsumed by patriarchy in casting its protagonist, a cisgender man, as the ultimate panaccessible hero who exposes the toxic masculinity that pervades corporate culture and dares to imagine a workplace more accepting of its workers' private lives, emotional traumas, and familial ties.

Notes

1. David Warfield Brown, *America's Culture of Professionalism: Past, Present, and Prospects* (New York: Palgrave Macmillan, 2014), 17.

2. Michael DeAngelis, *Gay Fandom and Crossover Stardom: James Dean, Mel Gibson, and Keanu Reeves* (Durham, NC: Duke University Press, 2001), 185.

3. DeAngelis, *Gay Fandom*, 181.

4. DeAngelis, *Gay Fandom*, 206.

5. Angela Trethewey, "Disciplined Bodies: Women's Embodied Identities at Work," *Organization Studies* 20, no. 3 (1999): 438.

6. Trethewey, "Disciplined Bodies," 438.

7. Janell C. Bauer and Margaret A. Murray, "'Leave Your Emotions at Home': Bereavement, Organizational Space, and Professional Identity," *Women's Studies in Communication* 41, no. 1 (2018): 61, https://doi.org/10.1080/07491409.2018.1424061.

8. Trethewey, "Disciplined Bodies," 426.

9. Bauer and Murray, "Leave Your Emotions," 62.

10. Chad Stahelski, dir., *John Wick* (Santa Monica, CA: Summit Entertainment, 2014).

11. Bauer and Murray, "Leave Your Emotions," 62.

12. Bauer and Murray, "Leave Your Emotions," 64–65.

13. Bauer and Murray, "Leave Your Emotions," 61.

14. Tali Seger-Guttmann and Hana Medler-Liraz, "Hospitality Service Employees' Flirting Displays: Emotional Labor or Commercial Friendship?," *International Journal of Hospitality Management* 73 (2018): 106.

15. Seger-Guttmann and Medler-Liraz, "Flirting Displays," 103.

16. Nina Banks, "Black Women's Labor Market History Reveals Deep-Seated Race and Gender Discrimination," *Working Economics Blog*, Economic Policy Institute, February 19, 2019, https://www.epi.org/blog/black-womens-labor-market-history-reveals-deep-seated-race-and-gender-discrimination.

17. Seger-Guttmann and Medler-Liraz, "Flirting Displays," 103.

18. Le Castle Vania, "LED Spirals [Extended Full Length Version] from the Movie John Wick (official)," YouTube, November 24, 2015, https://youtu.be/7Pvou7uMn-g.

19. Trethewey, "Disciplined Bodies," 441.

VIVIAN NUN HALLORAN is Associate Dean for Diversity and Inclusion in the College of Arts and Sciences and Professor of English at Indiana University Bloomington. She is author of *The Immigrant Kitchen: Food, Ethnicity, and Diaspora* (2016) and *Exhibiting Slavery: The Caribbean Postmodern Novel as Museum* (2009). Her current project focuses on Caribbean American narratives of belonging to US culture and politics.

15 STYLE AND THE SACRIFICIAL BODY IN *JOHN WICK 3*

STEPHEN WATT

Fortis Fortuna Adiuvat—this motto, etched across John Wick's upper back above a tattoo of praying hands superimposed over a cross, is prominently displayed as the camera pans downward from a shower head to a close-up in an early scene of *John Wick*.[1] And, in what Priscilla Page lauds as the *Wick* franchise's "meticulously-crafted world" with its "blend" of painting, Greco-Roman myth, religious iconography, and much more, such details as tattoos are there to be read, not ignored.[2] The hands folded in prayer replicate those in Albrecht Dürer's pen-and-ink drawing *Study of the Hands of an Apostle* (1508), absent the detailed shirt sleeves of the original and the blue ground on which it was drawn (see fig. 15.1).[3] The cross is Russian Orthodox, and, as Page explains, the wolf on Wick's right shoulder recalls a Russian *oskal*, a prison tattoo; the figure engulfed in flames on his left shoulder is most likely Cerberus, one of several "multiply signifying" dogs in the *Wick* franchise that Karalyn Kendall-Morwick discusses earlier in this volume. Considered together, these may function as "a brand, a biography, a sign of religious devotion, the mark of a soldier"—or, perhaps, "as all of these things."[4] Here, however, I want to speculate about only one of these functions—tattoos as a sign of devotion or commitment—and, more generally, about the ways in which the body, skin in particular, signifies in the *Wick* films. Moreover, I hope to show how this display of Wick's tattoos during his rather odd toilette—do most of us shower, then don a dress shirt with

15.1. Albrecht Dürer, *Study of the Hands of an Apostle* (1508). Courtesy of Albertina Museum, Vienna.

cuff links and a three-piece suit before our homes are invaded?—serves as an initiation into a world that grows in iconographic complexity and thematic resonance with each film. As discussed in the introduction, critics and actors agree that details like these define the "poetic and profane" universe that director Chad Stahelski, David Leitch, and screenwriter Derek Kolstad create that distinguishes the *Wick* films from more mundane fare.[5] Some of these details form the subject of what follows.

As many commentators, including Charles Tung earlier in this book, have observed, cultural allusions and stylistic flourishes throughout the *Wick* franchise are historically promiscuous: from the 1960s and 1970s "muscle cars" in *John Wick* to the Roman statuary in *John Wick: Chapter 2* to the Caravaggio paintings and ballet in *John Wick: Chapter 3—Parabellum*.[6] At the same time, functioning as a counter to the richly designed aesthetic of *John Wick 3* are the often savage killings and punishments mandated by what Adam Ozimek terms a "highly formalized criminal economy with rules and institutions."[7] The body and skin are central to both, intrinsic not only to the iconography of Wick's criminal world but also to its interdictions, strikingly so in scenes where rules are enforced, at times with a combination of brutality and religious connotation. More particularly, Wick's shower inaugurates a motif in which the body and skin function as analogues to the mass and surface in Le Corbusier's famous "reminders" to architects. For if, as Le Corbusier posits, the "task of the architect is to vitalize the surfaces which clothe" structural masses, Stahelski foregrounds what, after Sara Ahmed and Jackie Stacey's *Thinking through the Skin* (2001), might be called "the fleshy interface between bodies and worlds" as privileged elements of Wick's "meticulously crafted" universe.[8] As Jean-Luc Nancy theorizes, this interface tethers bodies not only to spiritual commitments—"For us, the body is always sacrificed: eucharist"—but also to thought itself:

"It makes no sense to talk about body and thought apart from each other, as if each could somehow subsist on its own."[9]

Yet, with apologies to Le Corbusier and noting the exceptions of operators at the Continental Switchboard and Gianna D'Antonio (Claudia Gerini) disrobing before her fatal bath in *John Wick 2*, skin is seldom vitalized or eroticized in the franchise, especially Wick's in *John Wick 3*. Instead, it is inscribed, scarred, branded, and mortified; and, in this regard, Wick's flesh encases a sacrificial body not unlike that of the ballerina (played by New York City Ballet soloist Unity Phelan) he sees in rehearsal at the Tarkovsky Theatre, exhausted and in pain in pursuit of her art. Endurance like hers underlies Stahelski's admiration of dance, as he emphasized in an interview before the release of the film: "Behind the scenes, behind the grace, the beauty, it's fucking pain and suffering. They're some of the toughest athletes I've ever met, gymnasts and ballerinas."[10] At the same time, both Wick and the dancer exemplify what Nancy calls "'Written bodies'—incised, engraved, tattooed, scarred"— which are also "precious bodies, preserved and protected like the codes for which they act as glorious engrams."[11] In both of these conceptual registers, the athletic and the semiotic, the body is not only a prolific signifier but also *in its pain* a potent weapon. In suggesting this, I should acknowledge my background in Irish studies and the influence of one recurring tactic in the chronicle of Ireland's struggle for independence: hunger striking and the martyrdom to which it often leads. The subject of international headlines in the early 1980s when Northern Irish political prisoners pushed Margaret Thatcher's government to the breaking point, the hunger strike has a long history and hagiography of self-abnegating patriots. This includes Irish republican Terence MacSwiney, who, in 1920, went on strike for seventy-three days, eventually dying and becoming a cause célèbre. Extolling the power of martyrdom, it was

MacSwiney who claimed, "It is not those who inflict the most but those who suffer the most who will conquer."[12] The Baba Yaga of *John Wick* known for his unrivaled ability to dispatch enemies—to inflict pain— becomes in *John Wick 3* something even more formidable: a martyr-like figure willing to suffer for a larger cause.

In this way, Wick differs both from the protagonists of recent action/vigilante franchises—Bryan Mills (Liam Neeson) in *Taken* and Robert McCall (Denzel Washington) in *The Equalizer*, for example— and from the "angry, beleaguered" characters experiencing a "crisis of masculinity," as Martin Fradley has described, in action films at the end of the past century. Fradley (correctly, I think) regards "'masochistic' spectacles of heroically suffering white men"—not to be confused with martyrs, whose commitments are rooted in neither angst nor anger—as a "key trope" in films like Ridley Scott's *Gladiator* (2000), and he identifies Joel Schumacher's *Falling Down* (1993) as the Ur-text of "Hollywood's take on the angsty, angry white male."[13] Yet Wick bears scant resemblance to the "angsty" William Foster (Michael Douglas) in Schumacher's film, who becomes so unglued just ordering breakfast at a fast food restaurant that he opens fire with an assault rifle; moreover, Wick's masculinity isn't "always already in crisis" or constantly "under negotiation." To be sure, similarities might be adduced between his physical abilities and those of a "warrior-hero" like Maximus (Russell Crowe) in *Gladiator*, but such prowess hardly evinces a fraternal or familial relationship.[14] Wick represents a different masculinity with a different body, different skin, and a different project; and revenge, as Reeves described to a Korean reporter before the premiere of *John Wick*, is not its narrative's only trajectory: "It's not only about revenge— he's fighting for his inner life, the grief and love he feels for his wife."[15] Our affective investment in him therefore might be distinguished from

our admiration of Neeson's redoubtable father in *Taken*—or Crowe's Maximus.

The sacrificial body in *John Wick*—foregrounded in scenes that rhythmically function as pauses in the otherwise "dynamic tempo" of fight scenes—is rendered more legible, after Ahmed and Stacey, by what are at times nuanced "dermographies."[16] This assertion hardly seems controversial, as we live in an age in which, as Steven Connor contends, skin has become "the visible object of so many and such various forms of imaginary and actual assault," including tattooing, piercing, and scarification (all of which serve as signifiers in the *Wick* franchise).[17] And because a fictive world is not created ex nihilo but from extant materials and "worlds," the dermal stylings of contemporary subcultures are rife with possibility in the process of worlding. More relevant, however, is the manner in which certain fleshly inscriptions in the Wick franchise are informed by religion, but not for the purpose of endowing subjects with a "Third Eye" or other mystical properties as Nancy outlines.[18] Instead, like the cross on Wick's left upper arm (and the ballerina's as well) and hands folded in prayer, bodies, skin, and even blood are framed within a Christian tradition that is complicated by his visit to the Elder in *John Wick 3*. So, in *John Wick 2* when Winston (Ian McShane) presses Santino D'Antonio (Riccardo Scamarcio) to acknowledge Wick's fulfillment of his marker, a contract that requires both characters' bloody thumbprints in a gilded reliquary, he in effect invokes the concept of an "indulgence": the performance of an act to lessen and eventually satisfy one's liability (and, after death, liminality in purgatory) caused by sin. The analogy is admittedly inexact; still, "indulgence" in Catholic discourse refers to a remittance *after* absolution is granted. This implies that final absolution does not really exist, only more obligations to pay, a condition Derek Kolstad regards as fundamental to the world-building

of *John Wick* 2: "The one thing that never changed was the idea of the marker.... The idea that if you walk away, they'll let you, but if you peer out from behind the bushes all the debts come back to haunt you."[19]

At the end of this scene, Winston poses a question to Santino conveyed by a mixed yet telling metaphor: "You stabbed the devil in the back" and "incinerated the priest's temple, burned it to the ground.... What do you think he'll do?" While Wick's prodigious ability to kill adversaries is associated with the demonic in his guise as Baba Yaga (*yaga* in some Slavic languages connotes a figure of evil), I am more interested in Wick's fulfillment of the latter role: his almost priestly devotion to his dead wife and the process of mourning her death.[20] As we learn in *John Wick* 3, the High Table's demand for corporal punishment verges on the insatiable, yet Wick's sacrifice of his wedding ring and finger as required by the Elder (Saïd Taghmaoui) is more than just a means of regaining his former status or commuting his sentence. To be sure, much as an indulgence reduces a sinner's time of punishment and the honoring of a marker exculpates the debtor (theoretically, anyway), Wick's offense against the High Table requires reparation, mortification of the flesh, and suffering. At the same time, his self-inflicted pain reaffirms his dedication to what Freud in "Mourning and Melancholia" (1917) termed the "work" of mourning, as it also recalls, however faintly, the self-flagellation of ascetics punishing themselves for moral weakness or perceived imperfections.

These claims are intended to complement Ahmed and Stacey's valorization of the "feminist project of taking bodies seriously as both the subject and object of thinking," for in the world of *John Wick*, bodies and skin similarly need to be taken seriously, Wick's in particular. Doing so, though, will require a slight revision of two very good questions they pose: "How does the skin come to be written and narrated?" and "How is the skin managed by subjects, others and nations?"[21] Implicit in both

is the premise that in some instances the inscription, decoration, and ascesis of skin are matters of volition (skin being managed by subjects) and in others are signs of fealty, subordination, and even enslavement (skin being managed by others). In the former case, skin may serve as a canvas where images announce affiliation with a group or subculture; as such, inscribed skin functions as part of a style or as a metaphor of a larger ideology, one building block in the enterprise of world creation or "worlding." For this reason, as Goodman maintains, the "discernment of style" is fundamental to the "understanding of works of art and the worlds they present." At the same time, however, a "complex and subtle style, like a trenchant metaphor, resists reduction to a literal formula."[22] Skin in *John Wick* frequently communicates with this plurality of connotation; thus, if style—*mere* style, we might say—is often theorized as something that might be considered "apart from its meaning," fleshly inscription in the *Wick* franchise resists such a reduction.[23] That is to say, in the latter case mentioned above, skin hardly constitutes a sign of volitional affiliation; on the contrary, it serves as documentation of a subject's accession to an almost medieval system of fealty that requires more chastisement than a penitent's hair shirt or cilice can provide. And this means that bodies and flesh in John Wick's world are often managed not by individuals but by the Ruska Roma, the Continental, and the High Table.[24] In this economy, your skin and body are their property.

Tattoos, Stigmata, and Other Perforations

Intimations of both types of ownership are conveyed by the decorated and pierced bodies of the men and women who serve one or another of these organizations, yet many of their decorations (tattoos in particular) contrast starkly with the largely monochromatic, hand-drawn images on Wick's back and shoulders. The most attractive and elaborate

15.2. Addy and Wick in the "green world." *John Wick* (2014).

tattoos adorn the arms, shoulders, and necks of women—for example, Addy (Bridget Regan), the bartender who greets Wick affectionately in the Continental's lounge in *John Wick*. A close-up, shot in faint chartreuse light, reveals an abstract image on her right shoulder and upper arm that rises to her neck, ending well below her jawline (see fig. 15.2). Both the lighting and the tattoo add thematic resonance to their conversation, one crucial to the narrative's exposition in clarifying Wick's absence from the Continental for over five years and underscoring his transformation:

> Addy: Tell me, how was life on the other side?
> Wick: It was good, Addy, far better than I deserved.
> ...
> Addy: I've never seen you like this.
> Wick: Like what?
> Addy: Vulnerable.

After an awkward pause, he tells Addy that he is "retired," to which she responds, "Not if you're drinking here, you're not." Their conversation

quickly shifts to an order for "the usual"—bourbon on the rocks—but another "usual" is inaugurated in this scene, I think, an expansion of my earlier point: tattoos and piercings may represent status in Wick's criminal hierarchy, a distinction Sofia (Halle Berry) underscores in *John Wick 3* when she asks him, "You do realize that I'm management now, right? I'm not service anymore." And, much like Winston and Julius (Franco Nero), manager of the Rome Continental hotel in *John Wick 2*, who lack any visible bodily art, Sofia displays only modest tattooing: a small scarab-shaped mark under her right eye and an often concealed inscription in Arabic encircling her neck that translates as "This is the life that I chose."

More important, Addy's shoulder and neck tattoo, unlike Wick's, contains a pattern of blossoms, stars, and other images. The tattoo is drawn in violet-colored ink, and in the light in which the scene is shot, it is not difficult to imagine Addy and Wick's exchange as occurring in an emotive, warm world distanced affectively from the cold legislation of the Continental. The pale green light both enhances the floral image on her arm and seems to elicit a more human, humble Wick, whose happiness with Helen was possible only at a remove from the city and his former life. In a nod to dramatic convention, the scene's lighting and opposition of city/country, urban world/"green world"—that "other side" Addy mentions—recall a long-standing trope in romantic comedy. Several shots of Wick's home nestled between bushes, landscape vegetation, and a forest before it is invaded by Viggo Tarasov's (Michael Nyqvist) hitmen reinforce this opposition. Thus, while the mise-en-scène of Wick's conversation with Addy, particularly her skin art, might not be so garish as that of the forest scenes in Peter Hall's 1968 adaptation of *A Midsummer Night's Dream* in which Puck's, Oberon's, and Titania's skin is dyed green, the opposition between a sterile city and the more natural setting of Wick's marriage is nonetheless reinforced.

Sadly, the "green world" that Northrop Frye famously deemed inherent to "The Mythos of Spring" and romantic comedy cannot survive for long.

Bodily inscription accrues more significance in *John Wick* 2 and 3. Perhaps the most-discussed tattoos, other than Wick's, decorate the arms of women at the Continental Switchboard. Their tattoos and distinct "uniforms"—sleeveless and pleated pink blouses, dressy gray pencil skirts, bright lipstick and fingernails, large earrings and glasses— match the historical eclecticism of the facility in which they work with its chalkboard, old-fashioned tickertape machine, pneumatic tubes straight from mid-twentieth-century department stores, antiquated computer monitors, and so on. The "rockabilly chic" of these sequences also introduces a whiff of mid-twentieth-century pinup culture.[25] Tattoos enliven this style, which in turn raises several questions. For example, do Addy's ornate tattoos and those of the operators reflect their positions within the Continental hierarchy, recalling Sofia's distinction between management and service? To expand my earlier point, Gianna D'Antonio in *John Wick* 2 lacks any visible skin art, and her body is on abundant display in her scene with Wick. Moreover, both Gianna and Wick are aestheticized as if they were the subjects of paintings—that is, both are positioned within heavily gilded picture frames as the scene begins, and they seem to walk out of them as their dialogue ensues (indeed, one shot creates a mise en abyme in which Wick is encased within several frames). But, again, tattoos are absent from the scene's design. In *John Wick* 3, the German word *Einfühlung* (empathy) appears in bold cursive script on the Adjudicator's neck, but this printing and ironic sentiment differ considerably from the images on the workers' arms and hands at the Switchboard. Tattoos or their absence, then, may serve as indices of more than style in John Wick's professional world.

15.3. Operators' tattoos. *John Wick* 2 (2017).

Furthermore, the tattoos of the women at the Switchboard look nothing like those on Wick's back or on the back of the dancer he sees at the Tarkovsky Theater. On the contrary, the sleeveless blouses of the Switchboard administrators and operators typically reveal painterly, in some instances floral, designs in blue, pink, and red; the Operator (Margaret Daly) who receives Winston's call excommunicating Wick at the end of *John Wick* 2, for example, has several navy-blue tattoos on her right arm, one of which actually says "tattoo" within a larger abstract shape, and brightly colored images of the four suits in a deck of playing cards on her fingers (see fig. 15.3). But hers are the rare tattoos in the office that communicate a univocal, if slightly banal, message; most of the ink on the women's arms represent wisps of flowers, in one case a bouquet of roses, or blur into abstraction. Many, in fact, appear as arm-length splatters of blue ink relieved by red blossoms or designs; as such, they contrast markedly with both the execution and signification of Wick's and the ballerina's tattoos, as I describe below.

One final observation about skin and switchboards: the Adjudicator's telephone call in *John Wick 3* ordering the deconsecration of the Continental is answered neither by the Operator nor by any of the women who work there but by a heavily pierced male Administrator (Robin Lord Taylor) in a pink shirt, a dark tie, a vest, and sleeves rolled up to reveal dark tattoos. This subtle change in what Charles Tung earlier in this volume describes as the "gendered labor" of information communication at the Switchboard also parallels the ways in which pledges of fealty—"I have served, I will be of service"—are ratified by penetrations of skin: the lancing of the ballet Director's (Anjelica Huston's) hands and the Bowery King's (Laurence Fishburne) punishment of seven cuts. While the Administrator's management may imply that the High Table has recently promoted its own functionary to run things—he appeared in a shot earlier in the film, studiously laboring away—his appearance also expands the palate of skin decoration in the film. Like tattoos, body piercings pervade John Wick's world—from the Administrator's pierced ears and other characters' lip rings to a myriad of stabbings and impalements—and these are intimately related, as Jacques Derrida posits in *Spurs*: "In the question of style there is always the weight or *examen* of some pointed object. At times this object might only be quill or a stylus. But it could just as easily be a stiletto, or even a rapier." Pointed objects might leave a mark, penetrate violently, or apply to the skin "some imprint or form."[26] Or the imprint might be overdetermined, emanating from more than one origin. The piercing of the Director's folded hands, for example, her "penance," creates stigmata—not a stigma of reproach or shame but a sign of her devotion to the High Table. Both words—*stigma* and *stigmata*—originate in the same Greek root, and, as the *Oxford English Dictionary* outlines, this root's connotations include branding in pre-Christian cultures. In the case of the Bowery King, the seven cuts he receives for providing Wick

with a Kimber 1911 and seven bullets in *John Wick 2* add a new chapter to his fleshly biography, joining the "gift" Wick gave him years earlier: a pair of track-like scars across his neck. If Wick's tattoos relate parts of his history, as Priscilla Page suggests, the Bowery King's scars similarly reiterate chapters in his. One chapter records the moment when Wick surprised him, eventually offering the choice of life or death; now, a new chapter has been carved into his dermal text.

The scenes at the Tarkovsky Theater extend a dermography that includes tattooing, piercings as both style and stigmata, and Wick's branding to obtain passage out of New York, thus continuing the motif of the mortified body in Wick's world. When he enters the theater, he is ordered to empty the contents of his pockets—gold coins, a marker, and rosary beads with a large crucifix—and remove his belt. Two security guards, one of whom is heavily tattooed on both his face and his shaved head, usher him into the auditorium, where the Director is putting a ballerina through a demanding rehearsal. The sequence begins with a close-up of the dancer's toes *en pointe*, and, after performing a dizzying series of pirouettes, she collapses, a long shot from behind capturing tattoos of crudely drawn crosses on her back and arm and a bloody abrasion on the calf of her left leg. The Director shouts, "Again," exacerbating the dancer's obvious exhaustion, and Wick is reminded that "art is pain, life is suffering"; only after the Director cries, "Enough," is the ballerina permitted to rest.

This scene and the ones that immediately follow it are, in my view, crucial to a reading of skin and bodies in *John Wick 3*, and I am hardly alone in regarding the dancer as a kind of double of Wick. In fact, the film's publicity invites this comparison in a poster featuring a tight close-up of Wick's face in the foreground and the dancer bathed in shades of magenta in the background (see fig. 15.4). Some reviewers, eager to advance this comparison, suggest that the tattooed epigraph

15.4. The ballerina as double? Promotional poster for *John Wick 3*.

in Latin across the ballerina's upper back matches Wick's.[27] This is not the case, as her tattoo alludes to the quotation from which the film's subtitle is taken: *Si vis pacem, para bellum*. And this kind of mirroring effect—the dancer as both Wick's doppelgänger and emblem of the world of *John Wick 3*—underlies speculation about the increasing significance

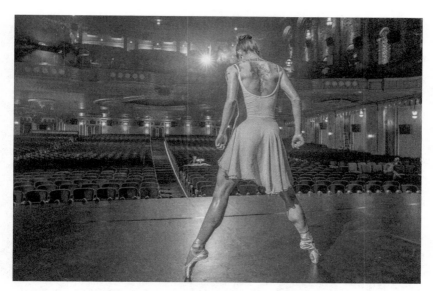

15.5. Bodies and drawn tattoos. *John Wick 3* (2019).

of ballet in future chapters of the franchise. Plans for a spin-off film *Ballerina*, announced in 2017, and subsequent announcements of the hiring of a director and screenwriter to develop the project, confirm this significance.

The graphic matches between Wick and the dancer—crosses on both characters' left arms and back, Latin epigraphs penned and not painted across their upper backs—further promote both characters' function as martyrs fully prepared to suffer for a greater cause: Wick, to mourn and memorialize his wife; the ballerina, to further her art (see fig. 15.5). The dissimilarity of their tattoos from others in the film reiterates their affinity. That is, consistent with Albrecht Dürer's belief that "the best artists can express [their] inner vision with greater artistic

merit in a pen drawing sketched on paper" than in a lavish painting using "expensive materials," the primitive simplicity of both characters' tattoos amplifies the strength of their fervor and "inner vision."[28] The origin of *Hands of an Apostle* or *Praying Hands*, which was intended to be the central panel of the *Heller Altarpiece*, further connects Wick to the church and its traditional architecture. In addition, the drawings, *not* paintings, on both Wick and the dancer revisit the traditional use of pen and ink in portraiture and self-portraiture, which, in Dürer's time, were thought by many to possess a more authentic quality than painterly forms of representation in communicating the essence of the body/thought duality.[29]

Equally important to viewing Wick as a sacrificial figure in *John Wick 3* is his reason for entering the Tarkovsky Theater in the first place not as an assassin but as Jardani Jovonovich, a pilgrim claiming his right to flee New York and gain an audience with the spiritual leader of the High Table. After the Director agrees to a private meeting, they pass through the backstage area, where a second ballerina demonstrates the imperative for bodily sacrifice by unceremoniously plucking a torn toenail from her foot. Once in the Director's private quarters, Wick presses his request, proffering his large cross as a "ticket"; she tears the cross off the beads and hands it to her tattooed assistant, who affixes it to a fireplace implement and holds it over a roaring fire. Once it is glowing hot, he brands Wick in the middle of his back, and the way in which this branding occurs and several details of the mise-en-scène accrue meaning in the context I am attempting to delineate here. One of them is that, after Wick removes his shirt, exposing his back—like a hunger striker, he is fully aware of what is about to happen—and the Director's assistant readies the glowing-hot cross, its orientation on the poker becomes visible: it is upside down. While an inverted cross has been at

times associated with Satanism, in Christian iconography this image is known as a Petrine cross, recalling St. Peter's condemnation by Nero and Peter's self-abnegating belief that he was not worthy to be crucified as Jesus was. Crucified upside down, Peter is therefore an exemplar of both self-sacrifice and profound humility.

Contrary, then, to the review of *John Wick 3* in the Catholic News Service, which labeled Wick's branding a "token"—the same reviewer also deemed the film "morally offensive" for appealing to the audience's "worst instincts"—such moments epitomize the multifoliate thematic of bodies and skin in the *Wick* films.[30] Attentive to this element of the Wickverse, Page observes that the branding occurs before a reproduction of Caravaggio's *Judith Beheading Holofernes* (1598–99). My supposition is that Caravaggio's representation of this episode from the Book of Judith in the Septuagint is best read in opposition both to Wick's (and St. Peter's) humility and to his masculinity. Holofernes, the Assyrian general charged with laying siege to Nebuchadnezzar's enemies, is a weaker man spiritually than Wick and is seduced by Judith, a beautiful Jewish widow acting in service of her people. (Indeed, one might argue that, as a widow in mourning and a model of piety pressed to help save her people, Judith resembles Wick more than Holofernes does.) Overwhelmed by her beauty, lust, and too much wine, Holofernes falls into a drunken sleep, affording Judith the opportunity to behead him. Wick's masculinity is precisely the opposite, as his later scene with the Elder indicates when he severs his own finger to confirm his commitment to mourning the loss of his wife. Recalling Terence MacSwiney's remark that he who is willing to suffer most will conquer and juxtaposing these two examples of masculinity—Holofernes' and Wick's—only Wick reveals a capacity for self-discipline, while Holofernes embodies the opposite weaknesses and excesses.

No "Tokens" Allowed: Body Art That Matters

The dermographies of the *Wick* franchise suggest that, contrary to the Catholic News Service's dismissal of *John Wick 3*, there are few "tokens" in scenes where bodies and skin—inscription and piercing—are concerned. On the contrary, as in the scene in *John Wick 2* where Gianna first sees Wick behind her in a heavy gilt picture frame, engagement with the worlds that comprise the Wickverse demands that we discriminate between tokens and art. It demands, in short, that we read bodies carefully, which is as much to say that the films' textuality and perhaps intertextuality—not the violence and mayhem—are for both fans and critics what distinguish the *Wick* films in the larger genre of action cinema.

I want to conclude with a few observations about why this thesis about religion, iconography, and sacrifice also pertains to the affective investments fans make in popular texts, performers, and characters. I am guided here by such commentators as Joseph Roach and Lawrence Grossberg, both of whom have contributed importantly to our understanding of fan culture, fans, and their feeling. In some ways, as Grossberg contends, we can never precisely know why some cultural artifacts, popular performers, or performances matter to us and why some matter more than others. Why, for instance, can a piece of music elicit a tear, or why does one performance or text excite audiences, while others produce indifference? He argues, reasonably enough, that in the former case such a response originates in an affective excess or, as Brian Massumi argues, intensity.[31] Similarly, we feel something strongly for characters who matter, and I would wager that for many filmgoers Wick matters to us with a unique and special intensity—or the films do, or Keanu Reeves and Laurence Fishburne do. Perhaps, as Roach theorizes, Keanu and Wick possess the "it" factor wrought from a kind of hybridity

or liminality discussed by essayists in this section of *The Worlds of John Wick*, the "apparently effortless embodiment" of such "contradictory qualities" as "strength and vulnerability, innocence and experience, and singularity *and* typicality."[32] When one of these attributes wanes, fans might resuscitate or invent it, and my argument is that the *Wick* franchise works hard to sustain Wick's hybrid and vulnerable masculinity. This, I suppose, makes Addy the bartender at the Continental a prescient affect theorist—after all, she correctly diagnosed the Boogeyman, the legendary assassin of unrivaled skill, as an emotionally vulnerable widower in mourning. Working through his grief, Wick is fully prepared to sacrifice himself to retain memories of a world that died along with his wife. This is not yet a eucharistic sacrifice that leads to the birth of a nation or creation of a community—a devoted congregation of followers—and by the conclusion of *John Wick 3*, this collective body has not yet been fully formed. But after Winston identifies New York as a future adversary of the High Table—and after Wick and the Bowery King appear to join forces in the film's final scene—it's only a matter of time.

Notes

1. Commentators have debated the origin and translation of *Fortis Fortuna Adiuvat* and its possible allusion to the Second Battalion, Third Marines motto, *Fortis Fortuna Juvat*—"Fortune Favors the Strong" or "Fortune Favors the Bold." In "Five Ancient Greek and Roman Influences in 'John Wick 2'" (*Forbes*, February 13, 2017, https://www.forbes.com/sites/drsarahbond/2017/02/13/fortune-favors-the-bold-5-greco-roman-reasons-to-see-john-wick-chapter-2/#7166edda87ef), classicist Sarah Bond notes that "the ink on Wick's back" was "originally stated by the Roman writer Terence—'fortis fortuna adjuvat' (Fortune aids the brave)"—in the play *Phormio* (161 BCE, 1.4.26). Most people who translate this quotation, she notes, are "actually pulling from Virgil's *Aeneid*, who similarly notes: 'Audentis fortuna juvat'" (*Aeneid* 10, 284).

2. Priscilla Page, "The Universe of John Wick," *Birth. Movies. Death,* July 1, 2019, https://birthmoviesdeath.com/2019/07/01/the-universe-of-john-wick.

3. See Christianne Andersson and Larry Silver, "Dürer's Drawings," in *The Essential Dürer,* ed. Larry Silver and Jeffrey Chipps Smith (Philadelphia: University of Pennsylvania Press, 2011), 22–23.

4. Page, "Universe of John Wick."

5. David Fear, "In Praise of 'John Wick,' the Last Great American Action-Movie Franchise," *Rolling Stone,* May 16, 2019, https://www.rollingstone.com/movies/movie-features/john-wick-the-last-great-american-action-movie-franchise-832310. Asia Kate Dillon describes the film's aesthetic in an interview with FabTV on May 14, 2019. I have borrowed the phrase "poetic and profane" from Barry Hertz, "John Wick: Chapter 2 Is a Delightful Collision of the Poetic and Profane," *Globe and Mail,* February 9, 2017, https://www.theglobeandmail.com/arts/film/film-reviews/john-wick-chapter-2-is-a-delightful-collision-of-poetic-and-profane/article33964131/.

6. Three of the four cars with which Wick is associated are from the 1960s and 1970s: his 1969 Ford Mustang Mach 1, 1970 SS454 Chevrolet Chevelle, and 1968 Dodge Charger in Aurelio's garage.

7. Adam Ozimek, "Understanding the John Wick Economy," *Forbes,* April 9, 2017, https://www.forbes.com/sites/modeledbehavior/2017/04/09/understanding-the-john-wick-economy/#65c14f4d70ed.

8. Le Corbusier, *Towards a New Architecture,* trans. Frederick Etchells (New York: Dover, 1986), 37; Sara Ahmed and Jackie Stacey, "Introduction: Dermographies," in *Thinking through the Skin,* ed. Sara Ahmed and Jackie Stacey (London: Routledge, 2001), 1.

9. Jean-Luc Nancy, *Corpus,* trans. Richard A. Rand (New York: Fordham University Press, 2008), 5, 37.

10. Eric Francisco, "Why the Director of 'John Wick' Is Obsessed with Ballet," *Inverse,* May 10, 2019, www.inverse.com/article/55687-john-wick-chapter-3-director-interview-why-ballet-matters.

11. Nancy, *Corpus,* 11.

12. Quoted in Patrick Radden Keefe, *Say Nothing: A True Story of Murder and Memory in Northern Ireland* (New York: Doubleday, 2019), 149. For most of the twentieth century, this sense of self-sacrifice as strength obtained in the struggle for Irish independence, as Keefe explains in a chapter entitled "The Ultimate Weapon," 148–61.

13. Martin Fradley, "Maximus Melodramaticus: Masculinity, Masochism and White Male Paranoia in Contemporary Hollywood Cinema," in *Action and Adventure Cinema,* ed. Yvonne Tasker (London: Routledge, 2004), 235, 236.

14. Fradley, "Maximus Melodramaticus," 240, 242.

15. Ji-youn Kwan, "Keanu Reeves, an Antihero in New Movie," *Korea Times*, January 8, 2015, http://www.koreatimes.co.kr/www/nation/2015/01/113_171333.html.

16. Jennifer M. Bean, "'Trauma Thrills': Notes on Early Action Cinema," in Tasker, *Action and Adventure Cinema*, 17.

17. Steven Connor, "Mortification," in Ahmed and Stacey, *Thinking through the Skin*, 36.

18. See Nancy, *Corpus*, 7–11.

19. Jack Giroux, "Interview: 'John Wick: Chapter 2' Screenwriter Derek Kolstad on Expanding the World and Paying Homage to 'Open Range,'" /Film, February 10, 2017, https://www.slashfilm.com/john-wick-chapter-2-screenwriter-derek-kolstad -interview/.

20. In "Mourning and Melancholia" (German version, 1917), Sigmund Freud underscores the relationship between mourning and an almost religious devotion to its practice. "Profound mourning," Freud contends, "the reaction to the loss of someone who is loved," causes a "loss of interest in the outside world" and an incapacity "to adopt any new object of love." This "circumscription of the ego" typically manifests itself as "exclusive devotion to mourning which leaves nothing over for other purposes or other interests" (244). Moreover, the "work" of mourning, he posits, must be completed before the ego "becomes free and uninhibited again" (245). See *The Standard Edition of the Complete Psychological Works of Sigmund Freud*, ed. James Strachey (London: Hogarth Press and the Institute of Psycho-analysis, 1953), 14:243–58.

21. Ahmed and Stacey, *Thinking through the Skin*, 3, 2.

22. Nelson Goodman, *Ways of Worldmaking* (Indianapolis: Hackett, 1978), 40.

23. E. D. Hirsch Jr., "Stylistics and Synonymity," *Critical Inquiry* 1 (1975): 564. Here, Hirsch discusses "the linguistic form of an utterance," not a visual form or fleshly inscription, and underscores the "uncertainty" of any concept in which form and content are separated.

24. In *Subculture: The Meaning of Style* (London: Methuen, 1979), Dick Hebdige notes that "the word 'subculture' is loaded down with mystery. It suggests secrecy, masonic oaths, an Underworld" (4). It is uncanny how closely this extended definition describes both the style and criminal economy of John Wick's world.

25. My thanks to Edward P. Dallis-Comentale, and to Deb Christiansen and Mary Embry from Fashion Design in the Eskenazi School of Art, Architecture + Design at Indiana University Bloomington, for their generous conversations on this topic.

26. Quoted in Connor, "Mortification," 39.

27. See, for example, Kervyn Cloete, "How John Wick 3 Sets Up That Spinoff Movie You Probably Forgot About," Critical Hit Entertainment, May 21, 2019, https:// www.criticalhit.net/entertainment/how-john-wick-3-sets-up-that-spinoff-movie-you

-probably-forgot-about. Here, Cloete incorrectly claims that the ballerina "boasts the exact same tattoos as Wick himself."

28. Andersson and Silver, "Dürer's Drawings," 16.

29. See Andersson and Silver, "Dürer's Drawings," 22–23.

30. See John Mulderig, "John Wick: Chapter 3—Parabellum," Catholic News Service, May 19, 2019, https://www.catholicnews.com/services/englishnews/2019/john-wick-chapter-3-parabellum-cfm.

31. Lawrence Grossberg, "Is There a Fan in the House? The Affective Sensibility of Fandom," in *The Adoring Audience: Fan Culture and Popular Media*, ed. Lisa A. Lewis (London: Routledge, 1992), 60–61. See also Brian Massumi, *Parables for the Virtual: Movement, Affect, Sensation* (Durham, NC: Duke University Press, 2002), 27–29.

32. Joseph Roach, *It* (Ann Arbor: University of Michigan Press, 2007), 8.

STEPHEN WATT is Provost Professor Emeritus of English and former Associate Dean of the Eskenazi School of Art, Architecture + Design at Indiana University Bloomington. Most of his published writing treats one of three topics: Irish studies; drama, film, and performance studies; or the contemporary university. His most recent books include *Bernard Shaw's Fiction, Material Psychology and Affect: Shaw, Freud, Simmel* (2018) and *"Something Dreadful and Grand": American Literature and the Irish-Jewish Unconscious* (2015). With Edward P. Comentale and Skip Willman, he edited *Ian Fleming and James Bond: The Cultural Politics of 007* (2005).

BIBLIOGRAPHY

Stahelski, Chad, dir. *John Wick*. Santa Monica, CA: Summit Entertainment, 2014.
——, dir. *John Wick: Chapter 2*. Santa Monica, CA: Summit Entertainment, 2017.
——, dir. *John Wick: Chapter 3—Parabellum*. Santa Monica, CA: Summit Entertainment, 2019.

THE *JOHN WICK* FRANCHISE AND SELECTED INTERVIEWS

Barber, James. "The Weapons of 'John Wick.'" Military.com, January 28, 2019. https://www.military.com/undertheradar/2019/01/28/weapons-john-wick.html.
Bunch, Sonny. "Gold Coins, Million-Dollar Contracts and the John Wick Economy." *Washington Post*, February 15, 2017. https://www.washingtonpost.com/news/act-four/wp/2017/02/15/gold-coins-million-dollar-contracts-and-the-john-wick-economy/?noredirect=on&utm_term=.873b547038ee.
——. "John Wick Is the Perfect Folk Hero for Our Age—and Keanu Reeves Is the Perfect Person to Play Him." *Washington Post*, May 22, 2019. https://www.washingtonpost.com/opinions/2019/05/22/john-wick-is-perfect-folk-hero-our-age-keanu-reeves-is-perfect-person-play-him/?noredirect=on.
Chitwood, Adam. "'John Wick 4' Release Date Delayed a Full Year." Collider, May 1, 2020. https://collider.com/john-wick-4-release-date-delayed/.
Colbert, Stephen M. "The World of John Wick Explained." Screen Rant, May 17, 2019. https://screenrant.com/john-wick-world-guide-continental-sommelier/.
Eusebio, Jonathan "Jojo." Interview with Cale Schultz. June 3, 2019. In *87Eleven Action Design Podcast*. Podcast audio, 55:56. https://www.87eleven.net/podcasts/.
Evans, Rhonda. "What Was John Wick Reading at the New York Public Library?" *Biblio File* (blog). New York Public Library, May 17, 2019. https://www.nypl.org/blog/2019/05/17/john-wick.

Fear, David. "In Praise of 'John Wick,' the Last Great American Action-Movie Franchise." *Rolling Stone*, May 16, 2019. https://www.rollingstone.com/movies /movie-features/john-wick-the-last-great-american-action-movie-franchise-832310.

Fleming, Mike Jr. "Lionsgate Selling 'John Wick' Sequel at Cannes." *Deadline*, May 4, 2015. https://deadline.com/2015/05/lionsgate-selling-john-wick-sequel-at-cannes -1201420556/.

Francisco, Eric. "Why the Director of 'John Wick' Is Obsessed with Ballet." *Inverse*, May 10, 2019. www.inverse.com/article/55687-john-wick-chapter-3-director -interview-why-ballet-matters.

Gemmill, Allie. "'The Continental': New Plot Details for 'John Wick' Spinoff Show Teased by Chad Stahelski." Collider, May 16, 2020. https://collider.com/john-wick -the-continental-plot-details-update-chad-stahelski/.

Giroux, Jack. "Interview: 'John Wick: Chapter 2' Screenwriter Derek Kolstad on Expanding the World and Paying Homage to 'Open Range.'" /Film, February 10, 2017. https://www.slashfilm.com/john-wick-chapter-2-screenwriter-derek-kolstad -interview/.

Gld6000. Comment, "John Wick would totally use Bitcoin, right?" *Reddit*, June 15, 2020 (July 9, 2019). https://www.reddit.com/r/Bitcoin/comments/cb28yj/john _wick_would_totally_use_bitcoin_right/.

Gunning, John. "Yama Succeeds after Sumo." *Japan Times*, January 18, 2020. https:// www.japantimes.co.jp/sports/2020/01/18/sumo/yama-succeeds-sumo /#.XtvLWkBFwot.

Hall, Jacob. "Heartbreaks and Headshots: The Action Movie Majesty of the 'John Wick' Series." /Film, February 15, 2017. https://www.slashfilm.com/john-wick -chapter-2-analysis/.

Hatzis, George. "John Wick: Kill Count." Visu. Infographic. Accessed November 7, 2019. https://www.visu.info/john-wick-kill-count.

Helloluis. "John Wick would totally use Bitcoin, right?" Reddit, June 15, 2020 (July 9, 2019). https://www.reddit.com/r/Bitcoin/comments/cb28yj/john_wick_would _totally_use_bitcoin_right.

Hicks, Moira. "John Wick Is a Modern Fairy Tale: The Witch, the Knight, and the King." Fanbyte, June 6, 2019. https://www.fanbyte.com/features/john-wick-is-a -modern-fairy-tale/.

JoBlo Movie Trailers. "JOHN WICK 2—Gun Fighting Featurette." YouTube, January 25, 2017. https://www.youtube.com/watch?v=0DrZ_oNOXsw.

John Wick (@JohnWickMovie). "It was never just a puppy. #NationalPuppyDay." Twitter, March 23, 2019, 10:00 a.m. https://twitter.com/JohnWickMovie/status/110 9470045602607105?lang=en.

Knight, Jacob. "A History of Violence: Eli Roth, John Wick, and the Morality of 'Gun Porn.'" /Film, March 12, 2018. https://www.slashfilm.com/death-wish-and-john -wick/.

Lattanzio, Ryan. "'John Wick' TV Series Details Emerge: 'The Continental' Will Be a Gritty Prequel about Young Winston." IndieWire, April 24, 2021. https://www .indiewire.com/2021/04/john-wick-tv-series-the-continental-prequel-1284632796/.

Lincoln, Kevin. "By Killing a Puppy, the Creators of *John Wick* Birthed a Franchise." *New York Magazine/Vulture*, February 10, 2017. https://www.vulture.com/2017/02 /how-john-wick-became-the-decades-most-unusual-action-movie.html.

Lionsgate Movies. "John Wick: Chapter 3—Parabellum (2019) Official TV Spot 'Bullet Time'—Keanu Reeves." YouTube, May 10, 2019. https://www.youtube.com /watch?v=L4OFE_88n6o.

Liu, Marjorie. "The Hero We Need: Keanu Reeves Is Demolishing All Our Dumb Stereotypes." *Literary Hub*, June 14, 2019. https://lithub.com/the-hero-we-need -keanu-reeves-is-demolishing-all-our-dumb-stereotypes/.

Lloyd, Brian. "The Elegant Simplicity of 'John Wick.'" *Entertainment.ie*, February 2, 2019. https://entertainment.ie/cinema/movie-news/the-elegant-simplicity-of-john -wick-388874/.

Manaev, Georgy. "How John Wick Got Baba Yaga Completely Wrong." *Russia Beyond*, May 31, 2019. https://www.rbth.com/arts/330441-how-john-wick-got-baba-yaga -wrong.

McFarland, Melanie. "Why Do Women Love John Wick? (It's Not Just the Puppy)." *Salon*, May 16, 2019. https://www.salon.com/2019/05/16/why-do-women-love -john-wick-its-not-just-the-puppy/.

Olavarria, Pedro. "Keanu Reeves's Fight Choreographer Talked to Us about 'John Wick.'" *Fightland Blog*, November 12, 2014. http://fightland.vice.com/blog/we -talked-to-keanu-reeves-fight-choreographer-on-his-new-film-john-wick.

Page, Priscilla. "The Universe of John Wick." *Birth. Movies. Death.*, July 1, 2019. https:// birthmoviesdeath.com/2019/07/01/the-universe-of-john-wick.

Pierce-Bohen, Kayleena. "John Wick Tattoos: All the Hidden Meanings behind the Ink." Screen Rant, November 30, 2019. https://screenrant.com/john-wick-tattoos -hidden-meanings-behind-ink/.

Poland, Bailey. "Fridging Helen Wick." Patreon, September 19, 2018. https://www .patreon.com/posts/fridging-helen-19905920.

Rutledge, Daniel. "Total Number of John Wick Kills in All 3 Movies Revealed." GeekTyrant, May 24, 2019. https://geektyrant.com/news/the-total-number-of -people-that-john-wick-has-killed-in-his-films-has-been-revealed.

Screen Junkies. "Honest Reactions: John Wick Directors React to the Honest Trailer!" YouTube, February 16, 2017. https://www.youtube.com/watch?v =3DNQJE8eHjw&feature=youtu.be&t=1017.

Spidell, Jackson "The Spider." Interview with Cale Schultz. May 20, 2019. In *87Eleven Action Design Podcast*. Podcast audio, 52:36. https://www.87eleven.net/podcasts/.

Sporne, Blake, and Jon Auty. "John Wick Special with Scott Rogers." June 16, 2019, in *The Stunt Pod*. Podcast audio, 1:24:08. https://player.fm/series/the-stunt-pod /john-wick-special-with-scott-rogers.

Stahelski, Chad. Interview with Cale Schultz. May 17, 2019. In *87Eleven Action Design Podcast*. Podcast audio, 43:03. https://www.87eleven.net/podcasts/.

Stone, Geoff. "Pitch meeting for John Wick." Facebook, July 1, 2019. https://www .facebook.com/246457042638614/posts/pitch-meeting-for-john-wickso-theres -this-guy-thats-really-good-at-killing-peopl/402594333691550/.

Surrey, Miles. "Is It a 'John Wick' Movie? A Guide." Ringer, January 30, 2019. https:// www.theringer.com/movies/2019/1/30/18202644/john-wick-movies-imitators.

Thompson, Luke Y. "How 'John Wick' Developed Its Unique Fighting Style." *Forbes*, June 13, 2017. https://www.forbes.com/sites/lukethompson/2017/06/13/john-wick -chapter-2-keanu-reeves-chad-stahelski-interview/#6de44a047749.

u/dfinkelstein. "In the John Wick movies, the spoken Russian is so bad that a native speaker often also needs the subtitles." Reddit, July 31, 2019. https://www.reddit .com/r/movies/comments/ckb9rc/in_the_john_wick_movies_the_spoken _russian_is_so/.

u/JohnWickMovie. "Hey, I'm director Chad Stahelski! Let's talk about John Wick: Chapter 3—Parabellum—AMA." Reddit, May 14, 2019. https://www.reddit.com/r /IAmA/comments/booyih/hey_im_director_chad_stahelski_lets_talk_about/.

Weintraub, Steve "Frosty." "'John Wick 3': Chad Stahelski on the Action Scene That's a 'Fk You' to Other Action Scenes." Collider, March 21, 2019. https://collider.com /chad-stahelski-interview-john-wick-3/.

Whittaker, Richard. "Don't Shoot the Dog: *John Wick* Co-directors Talk Keanu and Cold Canine Revenge." *Austin Chronicle*, October 24, 2014. https://www .austinchronicle.com/daily/screens/2014-10-24/dont-shoot-the-dog.

KEANU REEVES, WITH EMPHASIS ON *JOHN WICK*

Bastién, Angelica Jade. "The Grace of Keanu Reeves." The Film Experience (blog), February 10, 2016. thefilmexperience.net/blog/2016/2/10/the-grace-of-keanu -reeves.html.

———. "Why Keanu Reeves Is Such an Unusual (and Great) Action Star." *New York Magazine/Vulture*, February 17, 2017. https://www.vulture.com/2017/02/keanu-reeves-is-our-greatest-action-star.html.

Breihan, Tom. "*John Wick* Solidified Keanu Reeves as One of the Greatest Action Stars of All Time." A.V. Club, November 17, 2017. https://www.avclub.com/john-wick-solidified-keanu-reeves-as-one-of-the-greatest-1820411445.

BuzzFeed Celeb. "Keanu Reeves Plays with Puppies while Answering Fan Questions." YouTube, May 17, 2019. https://www.youtube.com/watch?v=rOqUiXhECos.

DeAngelis, Michael. *Gay Fandom and Crossover Stardom: James Dean, Mel Gibson, and Keanu Reeves*. Durham, NC: Duke University Press, 2001.

Dowd, A. A. "How *John Wick* Makes the Most of Keanu Reeves' Emptiness." A.V. Club, February 15, 2017. https://film.avclub.com/how-john-wick-makes-the-most-of-keanu-reeves-emptiness-1798257928.

Fry, Naomi. "Keanu Reeves Is Too Good for This World." New Yorker, June 3, 2019. https://www.newyorker.com/culture/culture-desk/keanu-reeves-is-too-good-for-this-world.

Ghahramani, Tanya. "'Keanu' Is Not a 'John Wick' Parody, OK?" *Bustle*, April 14, 2016. www.bustle.com/articles/154579-is-keanu-a-parody-of-keanu-reeves-john-wick-not-if-you-ask-well-everyone-who.

Harris, Will. *Mixed-Race Superman: Keanu, Obama, and Multiracial Experience*. Brooklyn: Melville House, 2019.

Hughes, William. "*Cyberpunk* Developers Ask Players to Please Stop Having Sex with Keanu Reeves." A.V. Club, January 27, 2021. https://www.avclub.com/cyberpunk-developers-ask-players-to-please-stop-having-1846147154.

Jackson, Gita. "The Himbo Is the Harmless, Dumb Hottie of Our Dreams." Vice, June 22, 2020. https://www.vice.com/en/article/v7gbnj/the-himbo-is-the-harmless-dumb-hottie-of-our-dreams.

Kwon, Ji-youn. "Keanu Reeves, an Antihero in New Movie." *Korea Times*, January 8, 2015. http://www.koreatimes.co.kr/www/nation/2015/01/113_171333.html.

Mayo, Simon. "Keanu Reeves Interviewed by Simon Mayo." BBC Radio 5 Live, May 17, 2019. www.bbc.com/programmes/p079j4pl.

McKenzie, Joi-Marie. "Keanu Reeves Is a Proud Person of Color, but Doesn't Want to Be 'a Spokesperson.'" *Essence*, May 16, 2019. https://www.essence.com/entertainment/keanu-reeves-person-of-color-doesnt-want-to-be-a-spokesperson.

Nishime, Leilani. *Undercover Asian: Multiracial Asian Americans in Visual Culture*. Urbana: University of Illinois Press, 2013.

Robb, Brian J. *Keanu Reeves: An Excellent Adventure*. London: Plexus, 2003.

Suderman, Peter. "Why Keanu Reeves Is a Perfect Action Star." *Vox*, February 14, 2017. https://www.vox.com/culture/2017/2/14/14577884/keanu-reeves-action-star -john-wick-matrix.

Vishnevetsky, Ignatiy. "Keanu Reeves Shoots His Way through the Entertaining Action Fantasy *John Wick*." A.V. Club, October 23, 2014. https://film.avclub.com /keanu-reeves-shoots-his-way-through-the-entertaining-ac-1798181681.

Yang, Jeff. "The Truth about Keanu Reeves and His Asian Roots." *Inkstone*, July 17, 2019. https://www.inkstonenews.com/arts/keanu-reeves-and-his-asian-roots /article/3018919.

Zageris, Larissa, and Kitty Curran. *For Your Consideration: Keanu Reeves*. Philadelphia: Quirk Productions, 2019.

REVIEWS OF *JOHN WICK*

Abele, Robert. "'John Wick' Brings A Game to the Violent Business of Revenge." *Los Angeles Times*, October 24, 2014. https://www.latimes.com/entertainment/movies /la-et-mn-john-wick-movie-review-20141024-story.html.

Alexander, Bryan. "Andy the Beagle Is the Tail Wagging Wick." *USA Today*, October 22, 2014. Newspaper Source Plus.

Andrews, Travis M. "Keanu Reeves Is Having a Keanussance with the John Wick Series—but Did He Ever Really Go Anywhere?" *Washington Post*, May 21, 2019. https://www.washingtonpost.com/arts-entertainment/2019/05/21/keanu-reeves-is -having-keanussaince-with-john-wick-series-did-he-ever-really-go-anywhere/.

Berardinelli, James. "John Wick (United States, 2014)." ReelViews, October 24, 2014. www.reelviews.net/reelviews/john-wick.

BitchesGetStiches. "John Wick is a prequel to The Matrix." Reddit, June 15, 2017. https://www.reddit.com/r/FanTheories/comments/6hjku7/john_wick_is_a _prequel_to_the_matrix/.

Bradshaw, Peter. "John Wick Review—the Action Sequences Grind On and On." *Guardian*, April 9, 2015. https://www.theguardian.com/film/2015/apr/09/john -wick-review-keanu-reeves-in-humourless-violent-generic-action-film.

Catsoulis, Jeannette. "Pet's Slaughter Uncorks a Latent Inner Assassin." *New York Times*, October 23, 2014. https://www.nytimes.com/2014/10/24/movies/in-john -wick-keanu-reeves-as-an-avenger.html?partner=rss&emc=rss.

Corliss, Richard. "Review: In *John Wick*, Keanu Reeves Is Back Up to Speed." *TIME*, October 27, 2014. http://time.com/3536452/keanu-reeves-john-wick-review/.

Debruge, Peter. "Film Review: 'John Wick.'" *Variety*, October 16, 2014. https://variety .com/2014/film/reviews/film-review-keanu-reeves-in-john-wick-1201331660/.

Dyer, James. "John Wick Review." *Empire*, March 23, 2015. https://www.empireonline
.com/movies/reviews/john-wick-review/.

Ebiri, Bilge. "John Wick Is a Violent, Violent, Violent Film, but Oh-So Beautiful." *New
York Magazine/Vulture*, October 24, 2014. https://www.vulture.com/2014/10/john
-wick-movie-review.html.

Gilbert, Sophie. "*John Wick*: An Idiot Killed His Puppy and Now Everyone Must Die."
Atlantic, October 24, 2014. https://www.theatlantic.com/entertainment
/archive/2014/10/john-wick-an-idiot-killed-his-puppy-and-now-everyone-must
-die/381921/.

Goodykoontz, Bill. "Review: Absurd Story but Superb Action in 'John Wick.'"
Arizona Republic, October 23, 2014. https://www.azcentral.com/story
/entertainment/movies/2014/10/22/review-absurd-story-superb-acting-john-wick
/17739581/.

Guzman, Rafer. "'John Wick' Review: Surprisingly Funny, Familiar Plot." *Newsday*,
October 23, 2014. https://www.newsday.com/entertainment/movies/john-wick
-review-surprisingly-funny-familiar-plot-1.9538065.

Hoffman, Jordan. "John Wick Review—a Thrill Ride Driven by a Relentless
Vengeance Machine." *Guardian*, October 23. 2014. https://www.theguardian.com
/film/2014/oct/23/john-wick-review-thrill-ride-relentless-vengeance-machine.

Howell, Peter. "John Wick Star Keanu Reeves Lights the Fuse of a New Action
Franchise: Review." *Toronto Star*, October 24, 2014. https://www.thestar.com
/entertainment/movies/2014/10/23/john_wick_star_keanu_reeves_lights_the
_fuse_of_a_new_action_franchise_review.html.

Ingram, Bruce. "'John Wick': Stylish Action Starring Keanu Reeves." *Chicago Sun-
Times*, October 23, 2014. https://chicago.suntimes.com/entertainment/john-wick
-stylish-action-starring-keanu-reeves/.

Keogh, Brendan. "On John Wick and Fridging." *ungaming* (blog), Tumblr, May 12,
2015. https://ungaming.tumblr.com/post/118778602485/on-john-wick-and
-fridging.

Kohn, Eric. "Review: Keanu Reeves Kicks Ass to Avenge His Dead Dog in Satisfying
'John Wick.'" IndieWire, September 19, 2014. https://www.indiewire.com/2014
/09/review-keanu-reeves-kicks-ass-to-avenge-his-dead-dog-in-satisfying-john
-wick-69837/.

Lees, Jonathan. "Keanu Reeves Came Up with a Badass Hashtag for 'John Wick.'"
Complex, October 24, 2014. https://www.complex.com/pop-culture/2014/10
/interview-john-wick-keanu-reeves.

Lemire, Christy. "John Wick." RogerEbert.com, October 24, 2014. https://www
.rogerebert.com/reviews/john-wick-2014.

Li, Anna. "Critique Cinéma: John Wick." *Caramie's Zone* (blog), October 20, 2014. https://caramiezone.blogspot.com/2014/10/critique-cinema-john-wick.html.

Long, Tom. "'John Wick' Wallows in Mindless Violence." *Detroit News*, October 24, 2014. https://www.detroitnews.com/story/entertainment/movies/2014/10/24/john-wick-review-keanu-reeves/17801593/.

Lowe, Justin. "'John Wick': Film Review." *Hollywood Reporter*, October 22, 2014. https://www.hollywoodreporter.com/review/john-wick-film-review-742842.

Lumenick, Lou. "Keanu Reeves Not Up to Speed in New Flick 'John Wick.'" *New York Post*, October 24, 2014. https://nypost.com/2014/10/24/keanu-reeves-not-up-to-speed-in-new-flick-john-wick/.

Masoudi, Paris. "An Appreciation for the Mythology of John Wick." Geek and Sundry, May 13, 2015. http://geekandsundry.com/an-appreciation-for-the-mythology-of-john-wick.

Mbrochh. Comment, "John Wick would totally use Bitcoin, right?" r/Bitcoin, *Reddit*, June 15, 2020. https://www.reddit.com/r/Bitcoin/comments/cb28yj/john_wick_would_totally_use_bitcoin_right/.

McCarrey, Cat. "Review: Deliciously Ridiculous 'John Wick' Showcases Star Keanu Reeves at Action-Packed Best." *Daily Free Press: Boston University*, October 31, 2014. https://dailyfreepress.com/2014/10/31/review-deliciously-ridiculous-john-wick-showcases-star-keanu-reeves-at-action-packed-best/.

Mendelson, Scott. "Review: 'John Wick,' with Keanu Reeves, Is a Terrific Action Blast." *Forbes*, October 15, 2014. https://www.forbes.com/sites/scottmendelson/2014/10/15/review-john-wick-with-keanu-reeves-is-a-terrific-action-blast/#90b1bc17ba28.

Merry, Stephanie. "John Wick Takes His Licks." *Washington Post*, October 23, 2014. https://www.washingtonpost.com/goingoutguide/movies/john-wick-movie-review-keanu-reeves-takes-his-licks/2014/10/23/593c128c-59f0-11e4-bd61-346aee66ba29_story.html.

Nashawaty, Chris. "John Wick." *Entertainment Weekly*, October 22, 2014. https://ew.com/article/2014/11/03/john-wick/.

Neumaier, Joe. "'John Wick,' Movie Review." *New York Daily News*, October 23, 2014. https://www.nydailynews.com/entertainment/movies/john-wick-movie-review-article-1.1984748.

Ordoña, Michael. "'John Wick' Review: Reeves Gets the Action Right." *San Francisco Chronicle*, October 23, 2014. https://www.sfgate.com/movies/article/John-Wick-review-Reeves-gets-the-action-right-5842639.php.

Ozimek, Adam. "Understanding the John Wick Economy." *Forbes*, April 9, 2017. https://www.forbes.com/sites/modeledbehavior/2017/04/09/understanding-the -john-wick-economy/#65c14f4d70ed.

Périllon, Thomas. "'John Wick' avec Keanu Reeves : Ludique et bien fichu, un film d'action comme on les aime." *Le Nouvel Observateur*, October 31, 2014. Modified November 1, 2014. http://leplus.nouvelobs.com/contribution/1266085-john-wick -avec-keanu-reeves-ludique-et-bien-fichu-un-film-d-action-comme-on-les-aime .html.

Perkins, Nichole. "Why Don't the Women in *John Wick* Talk?" BuzzFeed News, February 15, 2017. https://www.buzzfeednews.com/article/tnwhiskeywoman/why -wont-john-wick-let-women-talk.

Puig, Claudia. "'Wick' Has a Short Fuse—and Too Many Weapons." *USA Today*, October 22, 2014. https://www.usatoday.com/story/life/movies/2014/10/22/john -wick-movie-review/17619597.

Riaux, Simon. "John Wick: Critique qui déglingue." *EcranLarge*, February 4, 2018. https://www.ecranlarge.com/films/930015-john-wick/critiques.

Rocchi, James. "'John Wick' Review: Keanu Reeves Thriller Burns with Brisk, Bloody, Bruising Action." TheWrap, October 22, 2014. https://www.thewrap.com/john -wick-review-keanu-reeves-willem-dafoe-adrianne-palicki.

Romney, Jonathan. "John Wick Review: An Almost Zen-Like Exercise in Wholesale Slaughter." *Guardian*, April 12, 2015. https://www.theguardian.com/film/2015/apr /12/john-wick-observer-film-review-keanu-reeves.

Russo, Tom. "Keanu Reeves Roars Back in as 'John Wick.'" *Boston Globe*, October 23, 2014. https://www.bostonglobe.com/arts/movies/2014/10/23/keanu-reeves-roars -back-retired-hitman-role/lrXBfF9sulabwmo7jJyCmM/story.html.

Sims, David. "A Week after Its Release, *John Wick* Already Seems Like a Cult Classic." *Atlantic*, October 31, 2014. https://www.theatlantic.com/entertainment/archive /2014/10/one-week-after-its-release-john-wick-is-already-a-cult-classic/382169/.

Travers, Peter. "John Wick: Keanu Reeves Goes Ballistic in This Bloody Bit of B-Movie Fun." *Rolling Stone*, October 24, 2014. https://www.rollingstone.com /movies/movie-reviews/john-wick-95572/.

Wickman, Forrest. "*John Wick*: How Sad Keanu Got His Groove Back." *Slate*, October 24, 2014. https://slate.com/culture/2014/10/keanu-reeves-action-movie-john-wick -reviewed.html.

Wolin, Jacob. "Review: Reeves Makes Comeback in 'John Wick.'" *Utah Statesman: Utah State University*, November 4, 2014. https://usustatesman.com/review-reeves -makes-comeback-in-john-wick/.

Abele, Robert. "'John Wick: Chapter 2' Review: Keanu Reeves Kills Again in Action-Packed Sequel." TheWrap, February 6, 2017. https://www.thewrap.com/john-wick-chapter-2-review-keanu-reeves/.

Andersen, Soren. "'John Wick: Chapter 2' Review: Keanu Reeves Returns with a Bang." *Seattle Times*, February 8, 2017. https://www.seattletimes.com/entertainment/movies/john-wick-chapter-2-review-keanu-reeves-returns-with-a-bang/?utm_source=RSS&utm_medium=Referral&utm_campaign=RSS_movies.

Bastién, Angelica Jade. "John Wick: Chapter Two." RogerEbert.com, February 9, 2017. https://www.rogerebert.com/reviews/john-wick-chapter-two-2017.

Berardinelli, James. "John Wick: Chapter Two (United States, 2017)." ReelViews, February 10, 2017. http://www.reelviews.net/reelviews/john-wick-chapter-two.

Bond, Sarah. "Five Ancient Greek and Roman Influences in 'John Wick 2.'" *Forbes*, February 13, 2017. https://www.forbes.com/sites/drsarahbond/2017/02/13/fortune-favors-the-bold-5-greco-roman-reasons-to-see-john-wick-chapter-2/#7166edda87ef.

Brody, Richard. "'John Wick: Chapter 2' Is Just a Trailer for Chapter 3." *New Yorker*, February 10, 2017. https://www.newyorker.com/culture/richard-brody/john-wick-chapter-2-is-just-a-trailer-for-chapter-3.

Catsoulis, Jeannette. "Review: 'John Wick: Chapter 2,' a Roman Holiday with Shots Not Sparks." *New York Times*, February 9, 2017. https://www.nytimes.com/2017/02/09/movies/john-wick-chapter-2-review-keanu-reeves.html.

Chang, Justin. "Keanu Reeves Knows Gun-Fu in the Thrillingly Disciplined 'John Wick: Chapter 2.'" *Los Angeles Times*, February 9, 2017. https://www.latimes.com/entertainment/movies/la-et-mn-john-wick-chapter2-review-2017-story.html.

Chaw, Walter. "John Wick: Chapter 2 (2017)." Film Freak Central, February 15, 2017. https://www.filmfreakcentral.net/ffc/2017/02/john-wick-chapter-2.html.

Debruge, Peter. "Film Review: 'John Wick: Chapter 2.'" *Variety*, February 6, 2017. https://variety.com/2017/film/reviews/john-wick-chapter-2-review-keanu-reeves-1201977230/.

Dessem, Matthew. "*John Wick: Chapter 2.*" *Slate*, February 9, 2017. https://slate.com/culture/2017/02/john-wick-chapter-2-reviewed.html.

Diones, Bruce. "John Wick." *New Yorker*, November 10, 2014, https://www.newyorker.com/goings-on-about-town/movies/john-wick-2.

Douglas, Edward. "'John Wick: Chapter 2' with Keanu Reeves a Deadly Retread: Movie Review." *New York Daily News*, February 6, 2017. https://www.nydailynews

.com/entertainment/movies/johnwick-chapter=2=keanu-reeves-retread-movie
-review-article-1.2965333.

Ebiri, Bilge. "'John Wick: Chapter 2' Keeps the Brilliant Beatdowns at the Expense of
Feeling." *Village Voice*, February 7, 2017. https://www.villagevoice.com/2017/02/07
/john-wick-chapter-2-keeps-the-brilliant-beatdowns-at-the-expense-of-feeling/.

Edelstein, David. "*John Wick: Chapter 2* Is a Beautiful Descent into Hell." *New York
Magazine/Vulture*, February 10, 2017. https://www.vulture.com/2017/02/movie
-review-john-wick-2-is-even-better-than-the-original.html.

Goldberg, Matt. "The Problem with the Ending of 'John Wick: Chapter 2.'" Collider,
February 24, 2017. https://collider.com/john-wick-2-ending-explained/#keanu
-reeves.

Goodykoontz, Bill. "More Mayhem, Thrills in 'John Wick: Chapter 2.'" *Arizona
Republic*, February 9, 2017. https://www.azcentral.com/story/entertainment
/movies/billgoodykoontz/2017/02/09/john-wick-chapter-two-movie-review-keanu
-reeves/97609046/.

Graham, Adam. "Review: Keanu Reeves Kills in Thrilling 'John Wick 2.'" *Detroit
News*, February 9, 2017. https://www.detroitnews.com/story/entertainment
/movies/2017/02/09/movie-review-keanu-reeves-kills-thrilling-john-wick
/97662884/.

Grierson, Tim. "*John Wick: Chapter 2*: Urge Overkill." *New Republic*, February 8, 2017.
https://newrepublic.com/article/140499/john-wick-chapter-2-urge-overkill.

Guzman, Rafer. "'John Wick: Chapter 2' Review: Keanu Reeves Shines in Action-
Packed Sequel." *Newsday*, February 8, 2017. https://www.newsday.com
/entertainment/movies/john-wick-chapter review-keanu-reeves-shines-in-action
-packed-sequel-1.13082289.

Harrison, Margot. "Art Gets as Much Time as Action in *John Wick: Chapter 2*." *Seven
Days*, February 15, 2017. https://www.sevendaysvt.com/vermont/art-gets-as-much
-time-as-action-in-john-wick-chapter-2/Content?oid=4031962.

Hertz, Barry. "John Wick: Chapter 2 Is a Delightful Collision of the Poetic and
Profane." *Globe and Mail*, February 9, 2017. https://www.theglobeandmail.com
/arts/film/film-reviews/john-wick-chapter-2-is-a-delightful-collision-of-poetic
-and-profane/article33964131/.

Hoffman, Jordan. "John Wick: Chapter 2 Is a Shameful Example of Hollywood Gun
Pornography." *Guardian*, February 10, 2017. https://www.theguardian.com/film
/2017/feb/10/john-wick-chapter-2-gun-violence-keanu-reeves.

Kain, Erik. "'John Wick 2' Is a Completely Pointless Sequel." *Forbes*, May 30, 2017.
https://www.forbes.com/sites/erikkain/2017/05/30/john-wick-2-is-a-completely
-pointless-sequel/#76a69a0f16c5.

Klimek, Chris. "'John Wick: Chapter 2' Lives Its Life Like a Candle in a Hail of
Bullets." NPR, February 9, 2017. https://www.npr.org/2017/02/09/513694114/john
-wick-chapter-2-lives-its-life-like-a-candle-in-a-hail-of-bullets.

Kohn, Eric. "'John Wick: Chapter 2' Review: Keanu Reeves Kicks Ass (Again), and
the Franchise Has Begun." IndieWire, February 6, 2017. https://www.indiewire
.com/2017/02/john-wick-chapter-2-review-keanu-reeves-1201778273.

LaSalle, Mick. "'John Wick: Chapter 2' Fails Even on Its Own Limited Terms." *San
Francisco Chronicle*, February 10, 2017. https://www.sfgate.com/movies/article
/John-Wick-Chapter-2-fails-even-on-its-own-10917740.php.

Lowe, Justin. "'John Wick: Chapter 2': Film Review." *Hollywood Reporter*, February 6,
2017. https://www.hollywoodreporter.com/review/john-wick-chapter-2-review
-972205.

McCahill, Mike. "John Wick: Chapter 2 Review—a Bigger, Bloodier, Broodier
Sequel." *Guardian*, February 16, 2017. https://www.theguardian.com/film/2017/feb
/16/john-wick-chapter-2-review-sequel-keanu-reeves.

MoSJ. "The Significance of the Art in *John Wick 2*." Imgur, February 26, 2017. https://
imgur.com/gallery/VBNkr.

Nashawaty, Chris. "*John Wick: Chapter 2*: EW Review." *Entertainment Weekly*,
February 6, 2017. https://ew.com/movies/2017/02/06/john-wick-chapter-2-ew
-review/.

Nicholson, Amy. "*John Wick: Chapter 2*: Fantastic Fights and Where to Find Them."
MTV, February 10, 2017. http://www.mtv.com/news/2981113/john-wick-chapter-2
-fantastic-fights-and-where-to-find-them/.

Nugent, John. "John Wick 2: 12 Secrets from Director Chad Stahelski." *Empire Online*,
February 21, 2017. www.empireonline.com/movies/features/john-wick-2-chad
-stahelski/.

Phillips, Michael. "'John Wick: Chapter 2' Review: Keanu Reeves Is Back as the
Super-Assassin and Dog Lover." *Chicago Tribune*, February 8, 2017. https://www
.chicagotribune.com/entertainment/movies/sc-john-wick-2-mov-rev-0208
-20170208-column.html.

Roeper, Richard. "Keanu Reeves Back with a Vengeance in 'John Wick: Chapter 2.'"
Chicago Sun-Times, February 9, 2017. https://chicago.suntimes.com/entertainment
/keanu-reeves-back-with-a-vengeance-in-john-wick-chapter-2/.

Russo, Tom. "The Keanuverse Is Undergoing Expansion." *Boston Globe*, February 9,
2017. https://www.bostonglobe.com/arts/movies/2017/02/08/the-keanuverse
-undergoing-expansion/Z72HT1UC1DxJBjT4jEfNdL/story.html.

Sims, David. "*John Wick: Chapter 2* Is More Brilliant, Bloody Fun." *Atlantic*, February 9, 2017. https://www.theatlantic.com/entertainment/archive/2017/02/john-wick -chapter-2-keanu-reeves-review/516165/.

———. "*John Wick 2* and the Magic of the Surprise Sequel." *Atlantic*, May 5, 2015. https://www.theatlantic.com/entertainment/archive/2015/05/john-wick-2-and-the -magic-of-the-surprise-sequel/392381/.

Thompson, Luke Y. "Blu-ray Review: 'John Wick: Chapter 2' Showcases the Real-Life Heart and Humanity of Keanu Reeves." *Forbes*, June 13, 2017. https://www.forbes .com/sites/lukethompson/2017/06/13/blu-ray-review-john-wick-chapter-2- showcases-the-real-life-heart-and-humanity-of-keanu-reeves/#6b95a27b176f.

Travers, Peter. "'John Wick: Chapter 2' Review: Keanu Reeves Is Back in Delirious, Mayhem-Filled Sequel." *Rolling Stone*, February 7, 2017. https://www.rollingstone .com/movies/movie-reviews/john-wick-chapter-2-review-keanu-reeves-is-back-in -delirious-mayhem-filled-sequel-123271/.

Vishnevetsky, Ignatiy. "*Chapter 2* Gives *John Wick* an Irresistibly Surreal Follow-Up." *A.V. Club*, February 8, 2017. https://film.avclub.com/chapter-2-gives-john-wick-an -irresistibly-surreal-follo-1798190399.

Walsh, Katie. "Movie Review: 'John Wick' Returns for More Stylized Violence." *Tribune News Service*, February 8, 2017. https://www.starnewsonline.com /entertainment/20170208/movie-review-john-wick-returns-for-more-stylized -violence.

Willmore, Alison. "John Wick Is an Action Hero as Unhappy Workaholic." BuzzFeedNews, February 10, 2017. https://www.buzzfeed.com/alisonwillmore /john-wick-chapter-2-review.

Wilson, Calvin. "'John Wick: Chapter 2' Is Right on Target." *St. Louis Post-Dispatch*, February 9, 2017. https://www.stltoday.com/entertainment/movies/reviews/john -ick-chapter-is-right-on-target/article_ed277452-f45d-574e-81ac-444cee87339f .html.

Zacharek, Stephanie. "*John Wick: Chapter 2*: Keanu Reeves' Hitman Returns with Bone-Crunching, Glorious Violence." *TIME*, February 9, 2017. http://time.com /4663702/john-wick-chapter-2-review/.

REVIEWS OF *JOHN WICK: CHAPTER 3—PARABELLUM*

Abele, Robert. "'John Wick 3' Film Review: Keanu Reeves' Assassin Returns for Mostly Enjoyable Threequel." TheWrap, May 15, 2019. https://www.thewrap.com /john-wick-3-film-review-keanu-reeves-halle.

Barnes, Brooks. "'John Wick: Chapter 3' Puts Keanu Reeves Back on Top at the Box Office." *New York Times*, May 19, 2019. https://www.nytimes.com/2019/05/19/movies/john-wick-chapter-3-box-office.html.

Barry, Robert. "The Utopia of Rules: 14 Paragraphs about John Wick." *Quietus*, June 15, 2019. https://thequietus.com/articles/26646-john-wick-chapter-3-parabellum-review.

Brody, Richard. "'John Wick: Chapter 3—Parabellum,' Reviewed: Keanu Reeves, Empty Fight Scenes, and a Paranoiac Chill." *New Yorker*, May 17, 2019. https://www.newyorker.com/culture/the-front-row/john-wick-chapter-3-parabellum-reviewed-empty-fight-scenes-with-a-paranoiac-chill.

Catsoulis, Jeannette. "'John Wick Chapter 3' Review: Keanu Reeves Is Back for Another Brutal Round." *New York Times*, May 16, 2019. www.nytimes.com/2019/05/16/movies/john-wick-chapter-3-parabellum-review.html.

Cloete, Kervyn. "How John Wick 3 Sets Up That Spinoff Movie You Probably Forgot About." Critical Hit Entertainment, May 21, 2019. https://www.criticalhit.net/entertainment/how-john-wick-3-sets-up-that-spinoff-movie-you-probably-forgot-about.

Ehrlich, David. "'John Wick: Chapter 3—Parabellum' Review." IndieWire, May 10, 2019. https://www.indiewire.com/2019/05/john-wick-chapter-3-parabellum-review-keanu-reeves-1202139580/.

Fachriansyah, Rizki. "Peak Human Physicality and Cosmopolitanism Intersect in 'John Wick: Chapter 3.'" *Jakarta Post*, May 18, 2019. https://www.thejakartapost.com/life/2019/05/18/peak-human-physicality-and-cosmopolitanism-intersect-in-john-wick-chapter-3.html.

Francisco, Eric. "*John Wick: Chapter 3*: How It Trained Two Dogs into Action Movie Heroes." *Inverse*, May 16, 2019. https://www.inverse.com/article/55882-john-wick-chapter-3-director-interview-how-dogs-were-trained-to-kill.

"Halle Berry John Wick: Chapter 3—Parabellum." Girl.com.au. Accessed April 28, 2020. https://www.girl.com.au/halle-berry-john-wick-chapter-3-parabellum.htm.

Kermode, Mark. "*John Wick: Chapter 3—Parabellum*." BBC Radio, May 17, 2019. https://www.bbc.com/programmes/p079jt2z.

King, Susan. "Anjelica Huston's Magical Movie Life, from 'Prizzi's Honor' to 'John Wick.'" *Los Angeles Times*, May 17, 2019. https://www.latimes.com/entertainment/movies/la-et-mn-classic-hollywood-anjelica-huston-john-wick-20190517-story.html.

Longo, Chris. "John Wick 3: How the Epic Horse Scene Came Together." Den of Geek, May 16, 2019. https://www.denofgeek.com/movies/john-wick-3-how-the-epic-horse-scene-came-together/.

Marcks, Iain. "Slayin' in the Rain: John Wick Chapter 3—Parabellum." *American Society of Cinematographers*, May 24, 2019. https://ascmag.com/articles/john-wick -chapter-3-slayin-in-the-rain.

Mendelson, Scott. "Box Office: 'Avengers: Endgame' Nears $2.75 Billion, 'Aladdin' Tops $800 Million, 'John Wick 3' Nears $300 Million." *Forbes*, June 23, 2019. https://18wallstreet.wordpress.com/2019/06/24/box-office-avengers-endgame -nears-2-75-billion-aladdin-tops-800--million-john-wick-3-nears-300-million/.

———. "Why 'Avengers: Endgame,' 'John Wick 3,' and 'Aladdin' Are Towering over the Competition (Box Office)." *Forbes*, June 24, 2019. https://www.forbes.com/sites /scottmendelson/2019/06/24/box-office-avengers-endgame-john-wick-keanu -reeves-aladdin-toy-story-pikachu-godzilla-x-men-spider-man/#29a8bf663223.

Morgenstern, Joe. "*John Wick: Chapter 3—Parabellum* Review: Elegant Escapism." *Wall Street Journal*, May 16, 2019. https://www.wsj.com/articles/john-wick-chapter -3parabellum-review-elegant-escapism-11558038042.

Mulderig, John. "John Wick: Chapter 3—Parabellum." Catholic News Service, May 19, 2019. https://www.catholicnews.com/services/englishnews/2019/john-wick -chapter-3-parabellum-cfm.

Newby, Richard. "How 'John Wick 3' Scales Back While Pushing Forward." *Hollywood Reporter*, January 17, 2019. https://www.hollywoodreporter.com/heat-vision/how -john-wick-3-trailer-tops-what-came-before-1176801.

Philip, Tom. "Review: *John Wick: Chapter 3—Parabellum* Expands on an Already Great Franchise." *GQ*, May 15, 2019. https://www.gq.com/story/review-john-wick -chapter-3-parabellum.

Phillips, Michael. "'John Wick 3' Review: Keanu Reeves Burns Ultraviolence Candle at Both Ends." *Chicago Tribune*, May 14, 2019. https://www.chicagotribune.com /entertainment/movies/sc-mov-john-wick-3-keanu-review-0514-story.html.

Rougeau, Michael. "John Wick 3: Why the Underground World of Secret Assassins Is So Alluring." Gamespot, May 15, 2019. https://www.gamespot.com/articles/john -wick-3-why-the-underground-world-of-secret-as/1100-6466941/.

Sobczynski, Peter. "John Wick: Chapter 3—Parabellum." RogerEbert.com, May 17, 2019. https://www.rogerebert.com/reviews/john-wick-chapter-3--parabellum-2019.

Travers, Peter. "'John Wick: Chapter 3' Review: He's Back, Bloodier and More Brutal Than Ever." *Rolling Stone*, May 15, 2019. https://www.rollingstone.com/movies /movie-reviews/john-wick-chapter-3-parabellum-movie-review-keanu-reeves -834728/.

Truitt, Brian. "*John Wick* Once Killed off Keanu Reeves' Puppy, but Now It's a Full-on 'Dog Movie.'" *USA Today*, May 17, 2019. https://www.usatoday.com/story/life

/movies/2019/05/15/john-wick-3-keanu-reeves-franchise-turned-into-dog-movie
/3664169002/.

Valentina, Jessicha. "'John Wick 3': Excellent Fighting Scenes with Dash of Indonesian Culture." *Jakarta Post*, May 16, 2019. https://www.thejakartapost.com/life/2019/05/16/john-wick-3-excellent-fighting-scenes-with-dash-of-indonesian-culture.html.

Yamato, Jen. "Review: 'John Wick 3' Expands the Wickverse with Another Artfully Ridiculous Body Count." *Los Angeles Times*, May 15, 2019. https://www.latimes.com/entertainment/movies/la-et-mn-john-wick-chapter-3-parabellum-review-keanu-reeves-20190515-story.html.

CRITICAL, HISTORICAL, AND THEORETICAL TEXTS

Adorno, Theodor. *Aesthetics: 1958–1959*. Medford, MA: Polity, 2018.

———. "Cultural Criticism and Society." In *Prisms*, translated by Samuel Weber and Shierry Weber, 17–35. Cambridge, MA: MIT Press, 1967.

———. *Minima Moralia: Reflections from Damaged Life*. Translated by E. F. N. Jephcott. New York: Verso, 1974. First published 1951.

Ahmed, Sara, and Jackie Stacey, eds. *Thinking through the Skin*. London: Routledge, 2001.

Alonso-Villa, Cristina. "John Wick and the Multilingual Kick." In *Multilingualism in Film*, edited by Ralf Junkerjürgen and Gala Rebane, 197–207. Berlin: Peter Lang, 2019. https://doi.org/10.3726/b16092.

Altman, Rick. *Film/Genre*. London: BFI, 1999.

Anderson, Aaron D. "Action in Motion: Kinesthesia in Martial Arts Films." *Jump Cut* 42 (1998): 1–11.

Andersson, Christianne, and Larry Silver. "Dürer's Drawings." In *The Essential Dürer*, edited by Larry Silver and Jeffrey Chipps Smith, 12–34. Philadelphia: University of Pennsylvania Press, 2011.

Archer, Neil. "'This Shit Just Got Real': Parody and National Film Culture in *The Strike* and *Hot Fuzz*." *Journal of British Cinema and Television* 13, no. 1 (2016): 42–60. https://doi.org/10.3366/jbctv.2016.0295.

Armknecht, Megan, Jill Terry Rudy, and Sibelan Forester. "Identifying Impressions of Baba Yaga: Navigating the Uses of Attachment and Wonder on Soviet and American Television." *Marvels and Tales: Journal of Fairy-Tale Studies* 31, no. 1 (2017): 62–79.

Arroyo, José. "Mission: Sublime." In *Action/Spectacle Cinema: A Sight and Sound Reader*, edited by José Arroyo, 21–25. London: British Film Institute, 2000.

Bacchilega, Cristina. *Fairy Tales Transformed? Twenty-First-Century Adaptations and the Politics of Wonder.* Detroit: Wayne State University Press, 2002.

Bakhtin, Mikhail. "Forms of Time and of the Chronotope in the Novel." In *The Dialogical Imagination: Four Essays,* translated by Caryl Emerson and Michael Holquist, 84–258. Austin: University of Texas Press, 1981.

Banks, Nina. "Black Women's Labor Market History Reveals Deep-Seated Race and Gender Discrimination." *Working Economics Blog.* Economic Policy Institute, February 19, 2019. https://www.epi.org/blog/black-womens-labor-market-history-reveals-deep-seated-race-and-gender-discrimination.

Bauer, Janell C., and Margaret A. Murray. "'Leave Your Emotions at Home': Bereavement, Organizational Space, and Professional Identity." *Women's Studies in Communication* 41, no. 1 (2018): 60–81. https://doi.org/10.1080/07491409.2018.1424061.

Baxter, John. *Stunt: The Story of the Great Movie Stunt Men.* New York: Doubleday, 1974.

Bean, Jennifer M. "'Trauma Thrills': Notes on Early Action Cinema." In *Action and Adventure Cinema,* edited by Yvonne Tasker, 17–30. London: Routledge, 2004.

Bender, Stuart, and Lorrie Palmer. "Blood in the Corridor: The Digital Mastery of the Hero Run Shoot-Outs in *Kick-Ass* and *Wanted.*" *Journal of Popular Film and Television* 45, no. 1 (2017): 26–39.

Benjamin, Walter. "Critique of Violence." In *Reflections: Essays, Aphorisms, Autobiographical Writings,* 277–300. New York: Schocken Books, 1978.

——. "Theses on the Philosophy of History." In *Illuminations: Essays and Reflections,* translated by Harry Zohn, 253–64. New York: Schocken Books, 1968.

Bissell, Tom. *Extra Lives: Why Video Games Matter.* New York: Vintage Books, 2011.

Blake, Richard. *Street Smart: The New York of Lumet, Allen, Scorsese, and Lee.* Lexington: University Press of Kentucky, 2005.

Bolter, Jay David, and Richard A. Grusin. *Remediation: Understanding New Media.* Cambridge, MA: MIT Press, 1998.

Bordwell, David. "Aesthetics in Action: Kung Fu, Gunplay and Cinematic Expressivity." In *At Full Speed: Hong Kong Cinema in a Borderless World,* edited by Esther Ching-mei Yau, 73–93. Minneapolis: University of Minnesota Press, 2001.

——. *Planet Hong Kong: Popular Cinema and the Art of Entertainment.* 2nd ed. 2000. Reprint, Madison, WI: Irvington Way Institute Press, 2011.

——. "Unsteadicam Chronicles." David Bordwell's Website on Cinema, August 17, 2007. http://www.davidbordwell.net/blog/2007/08/17/unsteadicam-chronicles/.

Brennan, Timothy. "Cosmo-theory." *South Atlantic Quarterly* 100, no. 3 (2001): 659–91.

Broadhurst, Susan. *Digital Practices: Aesthetic and Neuroesthetic Approaches to Performance and Technology*. Basingstoke: Palgrave Macmillan, 2007.

Brock, Gillian, and Harry Brighouse, eds. *The Political Philosophy of Cosmopolitanism*. Cambridge: Cambridge University Press, 2005.

Brown, David Warfield. *America's Culture of Professionalism: Past, Present, and Prospects*. New York: Palgrave McMillan, 2014.

Brown, J. Carter, Giovanni Agnelli, Ada Louise Huxtable, Ricardo Legorreta, Toshio Nakamura, Lord Rothschild, and Bill Lacy. "Pritzker Prize Jury Citation." 1992. Accessed June 15, 2020. https://www.pritzkerprize.com/laureates/1992.

Brown, John Seely, and Paul Duguid. "Knowledge and Organization: A Social-Practice Perspective." *Organization Science* 12, no. 2 (2001): 198–213.

Bukatman, Scott. *Matters of Gravity: Special Effects and Supermen in the 20th Century*. Durham, NC: Duke University Press, 2003.

Caillois, Roger. *Man, Play, and Games*. Translated by Meyer Barash. Urbana: University of Illinois Press, 2001. First published 1961.

Carroll, Noël. "The Problem with Movie Stars." In *Minerva's Night Out: Philosophy, Pop Culture, and Moving Pictures*, 106–21. Oxford: Blackwell, 2013.

Castells, Manuel. *The Rise of the Network Society*. Oxford: Blackwell, 1996.

Cheah, Pheng. *What Is a World? On Postcolonial Literature as World Literature*. Durham, NC: Duke University Press, 2016.

Cheah, Pheng, and Bruce Robbins, eds. *Cosmopolitics: Thinking and Feeling beyond the Nation*. Minneapolis: University of Minnesota Press, 1998.

Cheng, John. *Astounding Wonder: Imagining Science and Science Fiction in Interwar America*. Philadelphia: University of Pennsylvania Press, 2012.

Chez, Keridiana W. *Victorian Dogs, Victorian Men: Affect and Animals in Nineteenth-Century Literature and Culture*. Columbus: Ohio State University Press, 2017.

Christopher, Nicholas. *Somewhere in the Night: Film Noir and the American City*. Berkeley, CA: Counterpoint, 1997.

Cohen, Jeffrey Jerome. "Monster Culture (Seven Theses)." In *Monster Theory: Reading Culture*, edited by Jeffrey Jerome Cohen, 3–25. Minneapolis: University of Minnesota Press, 1996. ProQuest Ebook Central.

Conley, Kevin. *The Full Burn: On the Set, at the Bar, behind the Wheel, and over the Edge with Hollywood Stuntmen*. New York: Bloomsbury, 2009.

Connell, Raewyn. *Masculinities*. 2nd ed. Berkeley: University of California Press, 2005.

Connor, J. D. Review of *Rhetoric, Sophistry, Pragmatism*, edited by Steven Mailloux. *MLN* 110, no. 4 (1995): 979.

Connor, Steven. "Mortification." In *Thinking through the Skin*, edited by Sara Ahmed and Jackie Stacey, 36–51. London: Routledge, 2001.

Curtis, William J. R. *Modern Architecture since 1900*. 3rd ed. New York: Phaidon, 1996.

Dang, Xianhai, and Dong Lu. "Shilun guangdong nanquan de xingcheng ji tedian" [Discussing the formation and characteristics of the southern fists]. *Wushu Yanjiu* [Martial arts studies] 1, no. 9 (2016): 51–56.

Derrida, Jacques. *The Animal That Therefore I Am*. Translated by David Willis. New York: Fordham University Press, 2008.

———. "Force of Law." In *Acts of Religion*, 230–98. New York: Routledge, 2002.

Dickey, Bronwen. *Pit Bull: The Battle over an American Icon*. New York: Alfred A. Knopf, 2016.

Dimendberg, Edward. *Film Noir and the Spaces of Modernity*. Cambridge, MA: Harvard University Press, 2004.

Eagleton, Terry. *Literary Theory: An Introduction*. 2nd ed. Minneapolis: University of Minnesota Press, 1996.

Fan, Victor. "The Something of Nothing: Buddhism and the Assassin." In *The Assassin: Hou Hsiao-Hsien's World of Tang China*, edited by Hsiao-yen Peng, 178–94. Hong Kong: Hong Kong University Press, 2019.

Farquhar, Mary Ann. "The Idea-Image: Conceptualizing Landscape in Recent Martial Arts Movies." In *Chinese Ecocinema: In the Age of Environmental Challenge*, edited by Sheldon Hsiao-peng Lu and Jiayan Mi, 95–112. Hong Kong: Hong Kong University Press, 2009.

Flusser, Vilém. *Writings*. Minneapolis: University of Minnesota Press, 2002.

Fore, Steve. "Home, Migration, Identity: Hong Kong Film Workers Join the Chinese Diaspora." In *Fifty Years of Electric Shadows*, edited by Kar Law, 126–35. Hong Kong: Hong Kong International Film Festival/Urban Council, 1997.

Fradley, Martin. "Maximus Melodramaticus: Masculinity, Masochism and White Male Paranoia in Contemporary Hollywood Cinema." In *Action and Adventure Cinema*, edited by Yvonne Tasker, 235–51. London: Routledge, 2004.

Frampton, Kenneth. "In Praise of Siza." *Design Quarterly* 156 (1992): 2–5.

Frearson, Amy. "Interview with Álvaro Siza." *Dezeen*, December 19, 2014. https://www.dezeen.com/2014/12/19/alvaro-siza-interview-porto-serralves-museum/.

Freud, Sigmund. "Mourning and Melancholia." In *The Standard Edition of the Complete Psychological Works of Sigmund Freud*, edited by James Strachey, 14:243–58. London: Hogarth Press and the Institute of Psycho-analysis, 1953.

Gardner, Jared. "Film + Comics: A Multimodal Romance in the Age of Transmedial Convergence." In *Storyworlds across Media: Toward a Media-Conscious Narratology*,

edited by Marie-Laure Ryan and Jan-Noël Thon, 193–210. Lincoln: University of Nebraska Press, 2014.

Gehring, Wes D. *Parody as Film Genre: "Never Give a Saga an Even Break."* Westport, CT: Greenwood, 1999. EBSCOhost.

Goodman, Nelson. *Ways of Worldmaking.* Indianapolis: Hackett, 1978.

Gregory, Mollie. *Stuntwomen: The Untold Hollywood Story.* Lexington: University Press of Kentucky, 2015.

Grossberg, Lawrence. "Is There a Fan in the House? The Affective Sensibility of Fandom." In *The Adoring Audience: Fan Culture and Popular Media*, edited by Lisa A. Lewis, 50–67. London: Routledge, 1992.

Groys, Boris. *Under Suspicion: A Phenomenology of Media.* New York: Columbia University Press, 2010.

Gunning, Tom. "Attractions: How They Came into the World." In *The Cinema of Attractions Reloaded*, edited by Wanda Strauven, 31–40. Amsterdam: Amsterdam University Press, 2006.

———. "'Now You See It, Now You Don't': The Temporality of the Cinema of Attractions." *Velvet Light Trap: A Critical Journal of Film and Television*, no. 32 (1993): 3–12.

———. "'Primitive' Cinema: A Frame-Up? Or, The Trick's on Us." In *Early Cinema: Space, Frame, Narrative*, edited by Thomas Elsaesser and Adam Barker, 95–103. London: British Film Institute, 1990.

Haraway, Donna. *The Companion Species Manifesto: Dogs, People, and Significant Otherness.* Chicago: Prickly Paradigm, 2003.

Harries, Dan. "Film Parody and the Resuscitation of Genre." In *Genre and Contemporary Hollywood*, edited by Stephen Neale, 281–93. London: British Film Institute, 2002.

Harvey, David. *Cosmopolitanism and the Geographies of Freedom.* New York: Columbia University Press, 2009.

Hayot, Eric. *On Literary Worlds.* New York: Oxford University Press, 2012.

Hebdige, Dick. *Subculture: The Meaning of Style.* London: Methuen, 1979.

Herman, David. *Basic Elements of Narrative.* Hoboken, NJ: John Wiley and Sons, 2009.

Hirsch, E. D. Jr. "Stylistics and Synonymity." *Critical Inquiry* 1 (1975): 559–79.

Horkheimer, Max, and Theodor Adorno. *Dialectic of Enlightenment.* New York: Continuum, 1972. First published 1947.

Huizinga, Johann. *Homo Ludens: A Study of the Play Element of Culture.* Kettering, OH: Angelico, 2016. First published 1938.

Hunt, Leon. *Kung Fu Cult Masters.* London: Wallflower, 2003.

Hutcheon, Linda. *A Theory of Parody: The Teachings of Twentieth-Century Art Forms.* 1985. Reprint, Urbana: University of Illinois Press, 2000.

Huyssen, Andreas. *After the Great Divide: Modernism, Mass Culture, Postmodernism.* Bloomington: Indiana University Press, 1986.

Ibrahim, Taha. *Heroizability: An Anthroposemiotic Theory of Literary Characters.* Boston: De Gruyter Mouton, 2015.

Ip, Chun. *Ye Wen: Yongchun* [Ip Man: Wing Chun]. Hong Kong: Infolink, 2009.

Jameson, Fredric. *Archaeologies of the Future: The Desire Called Utopia and Other Science Fictions.* New York: Verso, 2005.

———. "The End of Temporality." *Critical Inquiry* 29, no. 4 (2003): 695–718. https://doi.org/10.1086/377726.

———. *Late Marxism: Adorno, or The Persistence of the Dialectic.* New York: Verso, 1990.

———. *Postmodernism, or The Cultural Logic of Late Capitalism.* London: Verso, 1990.

———. "Reification and Utopia in Mass Culture." In *Signatures of the Visible,* 9–34. New York: Routledge, 1990.

Jeffords, Susan. *Hard Bodies: Hollywood Masculinity in the Reagan Era.* New Brunswick, NJ: Rutgers University Press, 1994.

Jeffries, Stuart. *Grand Hotel Abyss: The Lives of the Frankfurt School.* New York: Verso, 2016.

Jiao, Ran. *Shishi* [On poetic forms]. Shanghai: Shangwuyinshuju, 1937.

Johns, Andreas. *Baba Yaga: The Ambiguous Mother and Witch of the Russian Folk Tale.* New York: Peter Lang, 2004.

Kallgren, Kyle. "Bisexual Lighting: The Rise of Pink, Purple, and Blue." YouTube, July 6, 2018. https://www.youtube.com/watch?v=8gU3IA4u-J8.

Keefe, Patrick Radden. *Say Nothing: A True Story of Murder and Memory in Northern Ireland.* New York: Doubleday, 2019.

King, Geoff. "Spectacle and Narrative in the Contemporary Blockbuster." In *Contemporary Action Cinema,* edited by Linda Ruth Williams and Michael Hammond, 334–55. New York: Open University Press, 2006.

Klevjer, Rune. "Dancing with the Modern Grotesque: War, Work, Play and Ritual in the First Run-and-Gun First Person Shooter." University of Bergen. Accessed October 17, 2021. https://folk.uib.no/smkrk/docs/dancing.htm. First published as "Danzando con il Grottesco Moderno: Guerra, lavoro, gioco e rituale nei First Person Shooter run-and-gun," in *Gli strumenti del videogiocare: Logiche, estetiche e (v)ideologie,* edited by M. Bittanti. Milan: Costa and Nolan, 2006.

Knox, Paul, and Peter Taylor. *World Cities in a World-System.* Cambridge: Cambridge University Press, 1995.

Kulezic-Wilson, Danijela. *The Musicality of Narrative Film*. New York: Palgrave MacMillan, 2015.

Langkjær, Birger, and Charlotte Sun Jensen. "Action and Affordances: The Action Hero's Skilled and Surprising Use of the Environment." In *Screening Characters: Theories of Character in Film, Television, and Interactive Media*, edited by Johannes Riis and Aaron Taylor, 266–83. London: Routledge, 2019.

Lave, Jean, and Etienne Wenger. *Situated Learning: Legitimate Peripheral Participation*. Cambridge: Cambridge University Press, 1991.

Le Corbusier. *Towards a New Architecture*. Translated by Frederick Etchells. New York: Dover, 1986. First published 1931.

Lee, Bruce. *Tao of Jeet Kune Do: Expanded Edition*. 1975. Reprint, Valencia, CA: Ohara, 2015.

Legge, James. *The Sacred Books of China: The Texts of Confucianism*. New Delhi: Atlantic, 1990.

Leinster, Murray. "Sidewise in Time." In *The Time Travelers: A Science Fiction Quartet*, edited by Robert Silverberg and Martin Harry Greenberg, 67–142. New York: D.J. Fine [1934], 1985.

Li, Ruru. *The Soul of Beijing Opera: Theatrical Creativity and Continuity in the Changing World*. Hong Kong: Hong Kong University Press, 2010.

Linnett, Richard. "The Gondry Effect." *Shoot* 39, no. 19 (1998): 25.

Lyon, Janet. "Cosmopolitanism and Modernism." In *The Oxford Handbook of Global Modernisms*, edited by Mark Wollaeger and Matt Eatough, 387–412. New York: Oxford University Press, 2013.

Massey, Doreen. *For Space*. London: Sage, 2005.

——. "A Global Sense of Place." In *Space, Place, and Gender*, edited by Doreen Massey, 146–56. Minneapolis: University of Minnesota Press, 1994.

Massumi, Brian. *Parables for the Virtual: Movement, Affect, Sensation*. Durham, NC: Duke University Press, 2002.

Mato, Daniel. "All Industries Are Cultural." *Cultural Studies* 23, no. 1 (2009): 70–87.

McAra, Catriona, and David Calvin, eds. *Anti-tales: The Uses of Disenchantment*. Newcastle-upon-Tyne: Cambridge Scholars, 2011.

McDonald, Paul. "Story and Show: The Basic Contradiction of Film Star Acting." In *Theorizing Film Acting*, edited by Aaron Taylor, 169–83. New York: Taylor and Francis Group, 2012.

McEwen, Indra Kagis. *Vitruvius: Writing the Body of Architecture*. Boston: MIT Press, 2003.

Miller, Toby. "From Creative to Cultural Industries: Not All Industries Are Cultural, and No Industries Are Creative." *Cultural Studies* 23, no. 1 (2009): 88–99.

Morfino, Vittorio. "On Non-contemporaneity: Marx, Bloch, Althusser." In Morfino and Thomas, *Government of Time*, 117–47.

Morfino, Vittorio, and Peter D. Thomas. "Tempora Multa." In *The Government of Time: Theories of Plural Temporality in the Marxist Tradition*, edited by Vittorio Morfino and Peter D. Thomas, 1–19. Leiden: Brill, 2017.

Nancy, Jean-Luc. *Corpus*. Translated by Richard A. Rand. New York: Fordham University Press, 2008.

Nanicelli, Ted. "Seeing and Hearing Screen Characters: Stars, Twofoldedness, and the Imagination." In *Screening Characters: Theories of Character in Film, Television, and Interactive Media*, edited by Johannes Riis and Aaron Taylor, 19–35. New York, Routledge, 2019.

Needham, Hal. *Stuntman! My Car-Crashing, Plane-Jumping, Bone-Breaking, Death-Defying Hollywood Life*. Boston: Little, Brown, 2011

Parikka, Jussi. "Time Machines." Edited by Frances McDonald. *Traces, Thresholds*. Accessed July 13, 2019. http://openthresholds.org/2/timemachines.

Pomerance, Murray, ed. *City That Never Sleeps: New York and the Filmic Imagination*. New Brunswick, NJ: Rutgers University Press, 2007.

Prakash, Gyan, ed. *Noir Urbanisms: Dystopic Images of the Modern City*. Princeton, NJ: Princeton University Press, 2010.

Prokhorova, Larisa. "Some Notes on Intertextual Frames in Anti-Fairy Tales." In *Anti-tales: The Uses of Disenchantment*, edited by Catriona McAra and David Calvin, 51–59. Newcastle-upon-Tyne: Cambridge Scholars, 2011.

Propp, Vladimir. *Morphology of the Folktale*. 2nd ed. Translated by Laurence Scott. Revised and edited with a preface by Louis A. Wagner. Austin: University of Texas Press, 1986.

Puett, Michael J. *To Become a God: Cosmology, Sacrifice, and Self-Divinization in Early China*. Cambridge, MA: Harvard University Press, 2002.

Purse, Lisa. *Contemporary Action Cinema*. Edinburgh: Edinburgh University Press, 2011.

——. "The New Spatial Dynamics of the Bullet-Time Effect." In *Spectacle of the Real: From Hollywood to Reality TV and Beyond*, edited by Geoff King, 151–60. Bristol: Intellect, 2005.

Pyrko, Igor, Viktor Dörfler, and Colin Eden. "Communities of Practice in Landscapes of Practice." *Management Learning* 50, no. 4 (2019): 482–99.

Ray, Robert. *A Certain Tendency of the Hollywood Cinema, 1930–1980*. Princeton, NJ: Princeton University Press, 1985.

Rehak, Bob. "The Migration of Forms: Bullet Time as Microgenre." *Film Criticism* 32, no. 1 (2007): 26–48.

Reid, Chris. "Games, Videogames, and the Dionysian Society." *Ribbonfarm: Constructions in Magical Thinking* (blog), January 26, 2017. https://www.ribbonfarm.com/2017/01/26/games-videogames-and-the-dionysian-society/.

Roach, Joseph. *It*. Ann Arbor: University of Michigan Press, 2007.

Robbins, Bruce, and Paulo Lemos Horta. "Introduction." In *Cosmopolitanisms*, edited by Bruce Robbins and Paulo Lemos Horta, 1–17. New York: New York University Press, 2017.

Robinson, Jennifer. "Global and World Cities: A View from off the Map." *International Journal of Urban and Regional Research* 26, no. 3 (2002): 531–54.

Rodriguez, Hector. "Hong Kong Popular Culture as an Interpretive Arena: The Huang Feihong Film Series." *Screen* 38, no. 1 (1997): 1–24. https://doi.org/10.1093/screen/38.1.1.

Røsaak, Eivind. "Figures of Sensation: Between Still and Moving Images." In *The Cinema of Attractions Reloaded*, edited by Wanda Strauven, 321–36. Amsterdam: Amsterdam University Press, 2006.

Roy, Ananya. "The 21st-Century Metropolis: New Geographies of Theory." *Regional Studies* 43, no. 6 (2009): 819–30.

Rudy, Jill Terry, and Jarom Lyle McDonald. "Baba Yaga, Monsters of the Week, and Pop Culture's Formation of Wonder and Families through Monstrosity." *Humanities* 5 (2016): 40.

Ryan, Marie-Laure. "From Possible Worlds to Storyworlds: On the Worldness of Narrative Representation." In *Possible Worlds Theory and Contemporary Narratology*, edited by Alice Bell and Marie-Laure Ryan, 62–87. Lincoln: University of Nebraska Press, 2019.

———. "Possible-Worlds Theory." In *The Routledge Encyclopedia of Narrative Theory*, edited by David Herman, Manfred Jahn, and Marie-Laure Ryan, n.p. London: Taylor and Francis, 2010.

———. "Story/Worlds/Media: Tuning the Instruments of a Media-Conscious Narratology." In *Storyworlds across Media: Toward a Media-Conscious Narratology*, edited by Marie-Laure Ryan and Jan-Noël Thon, 25–49. Lincoln: University of Nebraska Press, 2014.

Said, Edward. *Orientalism*. 1978. Reprint, New York: Penguin, 2003.

Sanders, James. *Celluloid Skyline: New York and the Movies*. New York: Alfred A. Knopf, 2001.

Sassen, Saskia. *The Global City: New York, London, Tokyo*. Princeton, NJ: Princeton University Press, 1991.

Seger-Guttmann, Tali, and Hana Medler-Liraz. "Hospitality Service Employees' Flirting Displays: Emotional Labor or Commercial Friendship?" *International Journal of Hospitality Management* 73 (2018): 102–7.

Shaw, Bernard. *The Intelligent Woman's Guide to Socialism, Capitalism, Sovietism, and Fascism.* New York: Random House, 1928.

Shore, Heather. "Criminal Underworlds: Crime, Media, and Popular Culture." In *Oxford Research Encyclopedia of Criminology,* April 26, 2017. https://oxfordre.com /criminology/view/10.1093/acrefore/9780190264079.001.0001/acrefore -9780190264079-e-36.

Sikong, Tu. *Ershisi shipin* [Appreciating the twenty-four forms of poetry]. Taipei: Jinfeng chubanshe, 1987.

Sloterdijk, Peter. *Critique of Cynical Reason.* Minneapolis: University of Minnesota Press, 1988.

Smith, Murray. "On the Twofoldness of Character." *New Literary History* 42, no. 2 (2011): 277–94.

Soja, Edward W. *Postmodern Geographies: The Reassertion of Space in Critical Social Theory.* London: Verso, 1989.

Steenberg, Lindsay. "Bruce Lee as Gladiator: Celebrity, Vernacular Stoicism and Cinema." *Global Media and China* 4, no. 3 (2019): 348–61.

Sutton-Smith, Brian. *The Ambiguity of Play.* Cambridge: Harvard University Press, 1997.

Tasker, Yvonne, ed. *Action and Adventure Cinema.* London: Routledge, 2004.

——. *Spectacular Bodies: Gender, Genre, and the Action Cinema.* New York: Routledge, 2008.

Tobe, Renée. *Film, Architecture and Spatial Imagination.* London: Routledge, 2017.

Trethewey, Angela. "Disciplined Bodies: Women's Embodied Identities at Work." *Organization Studies* 20, no. 3 (1999): 423–50.

Vitruvius. *On Architecture.* Translated by Morris Hickey Morgan. Cambridge, MA: Harvard University Press, 1914.

Warren, Cat. *What the Dog Knows: Scent, Science, and the Amazing Way Dogs Perceive the World.* New York: Simon and Schuster, 2015.

Warwick Research Collective (Sharae Deckard, Nicholas Lawrence, Neil Lazarus, Graeme Macdonald, Upamanyu Pablo Mukherjee, Benita Parry, and Stephen Shapiro). *Combined and Uneven Development: Towards a New Theory of World-Literature.* Liverpool: Liverpool University Press, 2015.

Weaver, Harlan. *Bad Dog: Pit Bull Politics and Multispecies Justice.* Seattle: University of Washington Press, 2021.

——. "Becoming in Kind: Race, Class, Gender, and Nation in Cultures of Dog Rescue and Dogfighting." *American Quarterly* 65, no. 3 (2013): 689–709.

Weinstock, Jeffrey Andrew. "Introduction: A Genealogy of Monster Theory." In *Monster Theory Reader*, edited by Jeffrey Andrew Weinstock, 1–36. Minneapolis: University of Minnesota Press, 2020.

Wenger, Etienne. *Communities of Practice: Learning, Meaning, and Identity.* Cambridge: Cambridge University Press, 1999.

Williams, Stephen J. *Blockchain: The Next Everything.* New York: Scribner, 2019.

Wise, Arthur, and Derek Ware. *Stunting in the Cinema.* New York: St. Martin's, 1973.

Wittenberg, David. "Bigness as the Unconscious of Theory." *ELH* 86, no. 2 (2019): 333–54.

Wolf, Kelly. "Performance Unleashed: Multispecies Stardom and Companion Animal Media." PhD diss., University of Southern California, 2013.

Wong, Wayne. "Action in Tranquillity: Sketching Martial Ideation in *The Grandmaster*." *Asian Cinema* 29, no. 2 (2018): 201–23. https://doi.org/10.1386/ac.29.2.201_1.

——. "Nothingness in Motion: Theorizing Bruce Lee's Action Aesthetics." *Global Media and China* 4, no. 3 (2019): 362–80. https://doi.org/10.1177/2059436419871386.

Yan, Yu. *Canglang shihua* [Canglang poetry talks]. Taipei: Jinfeng chubanshe, 1986.

Yau, Esther Ching-mei, ed. *At Full Speed: Hong Kong Cinema in a Borderless World.* Minneapolis: University of Minnesota Press, 2001.

Zhang, Bowei. *Quantang wudai shige jiaokao* [A study of the poetic styles in Tang's Five Dynasties]. Xi'an: Shanxi renmin chubanshe, 1996.

Zhang, Shaokang. *Zhongguo wenxue lilun piping jianshi* [A concise history of Chinese literary criticism]. Hong Kong: Chinese University of Hong Kong, 2004.

Zhiyi. *The Essentials of Buddhist Meditation: The Classic Śamathā-Vipaśyanā Meditation Manual.* Translated by Bhikshu Dharmamitra. Seattle: Kalavinka, 2009.

Žižek, Slavoj. *Enjoy Your Symptom! Jacques Lacan in Hollywood and Out.* New York: Routledge, 1992.

——. *First as Tragedy, Then as Farce.* New York: Verso, 2009.

——. *Looking Awry: An Introduction to Jacques Lacan through Popular Culture.* Cambridge, MA: MIT Press, 1992.

——. *The Sublime Object of Ideology.* New York: Verso, 1989.

——. *Violence.* New York: Picador, 2008.

Zong, Baihua. *Zong Baihua quanji* [Complete works of Zong Baihua]. Vol. 2. Anhui: Anhui Jiaoyu Chubanshe, 1994.

Afanas'ev, A. N. *Russian Folk Tales*. Translated by Robert Chandler. Illustrated by Ivan I. Bilibin. Boulder, CO: Shambhala/Random House, 1980.

——. *Russian Folktales from the Collection of A.N. Afanas'ev: A Dual-Language Book*. Translated by Sergey Levchin. Mineola: Dover, 2014.

Atencio, Peter, dir. *Keanu*. Burbank, CA: Warner Brothers, 2016. DVD.

A.V. Club. "Simply the Beast: 18 of the Greatest Dog Sidekicks in Pop Culture." May 15, 2019. https://www.avclub.com/simply-the-beast-18-of-the-greatest-dog-sidekicks-in-p-1834753999.

Balina, Marina, Helena Goscilo, and Mark Lipovetsky, eds. *Politicizing Magic: An Anthology of Russian and Soviet Fairy Tales*. Evanston, IL: Northwestern University Press, 2005.

Benioff, David, and D. B. Weiss, creators. *Game of Thrones*. HBO, 2011–19.

Bithell Games. *John Wick Hex*, v. 1.01. Good Shepherd, 2019. Windows, MacOS, PlayStation 4, Nintendo Switch, and Xbox One.

Casascius. "Physical Bitcoins by Casascius." June 15, 2020. https://en.bitcoin.it/wiki/Casascius_physical_bitocins.

Chen, Ku-ying. *Laozi jinzhu jinyi* [A contemporary commentary and translation on Laozi]. 3rd ed. 1970. Reprint, Taipei: Shangwuyinshuguan, 2017.

Connolly, Kelly. "Bradley Cooper, Tiffany Haddish and More Stars Who Fell in Love with Their Furry Costars." *People*, October 8, 2018. https://people.com/pets/stars-bonded-with-cats-dogs-on-screen/.

de Bont, Jan, dir. *Speed*. Los Angeles: 20th Century Fox, 1994.

Duigan, John, dir. *Lawn Dogs*. Culver City, CA: Strand Releasing, 1997. DVD.

Eastwood, Clint, dir. *Unforgiven*. Burbank, CA: Warner Brothers, 1992.

Forester, Sibelan, et al., eds. *Baba Yaga: The Wild Witch of the East in Russian Fairy Tales*. Jackson: University Press of Mississippi, 2013.

Gibson, William. "Johnny Mnemonic." In *Burning Chrome*, 6–27. New York: Arbor House, 1986.

Gilliam, Terry, dir. *Brazil*. Los Angeles: Embassy International, 1985. DVD.

Greenhill, Pauline, Kendra Magnus-Johnston, and Jack Zipes. *The International Fairy-Tale Filmography*. University of Winnipeg. Accessed June 24, 2020. http://iftf.uwinnipeg.ca/.

Harlin, Renny, dir. *Cliffhanger*. Culver City, CA: Tristar Pictures, 1993.

Homer. *The Odyssey*. Translated by Robert Fagles. New York: Penguin, 1996.

Jackson, Peter, dir. *The Hobbit: The Battle of the Five Armies*. Burbank, CA: New Line Cinema, Metro-Goldwyn-Mayer, Wingnut Films, 2014.

Judge, Mike, dir. *Silicon Valley*, season 5, episode 7, "Initial Coin Offering." Aired May 6, 2018, on HBO.

Just for Laughs. "Michael Che—White Women Took Brooklyn." YouTube, October 5, 2018. https://www.youtube.com/watch?v=if_sEUffzjE&list=RDif_sEUffzjE&start_radio=1.

Laozi. *Daodejing*. Translated by Edmund Ryden. Oxford: Oxford University Press, 2008.

Le Castle Vania. "LED Spirals [Extended Full Length Version] from the Movie John Wick (official)." YouTube, November 24, 2015. https://youtu.be/7Pvou7uMn-g.

Leitch, David, dir. *Deadpool 2*. Los Angeles: Twentieth Century Fox, 2018. DVD.

Liman, Doug, dir. *The Bourne Identity*. Universal City, CA: Universal Pictures, 2002.

Mandela, Nelson. *Long Walk to Freedom: The Autobiography of Nelson Mandela*. London: Abacus, 1995.

Mangold, James, dir. *The Wolverine*. Los Angeles: Twentieth Century Fox Films, 2013.

Marshall, Neil, dir. *Hellboy*. Santa Monica, CA: Lionsgate, 2019. DVD.

Meltzer, Marisa. "The Trouble with Pibbles: Rebranding a Fearsome Dog." *New York Times*, January 6, 2019. Gale OneFile: News.

Miller, Tim, dir. *Deadpool*. Los Angeles: Twentieth Century Fox Films, 2016. DVD.

Nakamoto, Satoshi. "Bitcoin P2P e-cash paper." Cryptography Mailing List, October 10, 2008. https://satoshi.nakamotoinstitute.org/emails/cryptography/1/#selection-5.0-5.25.

Nanticoke Indian Tribe. "The Tale of Two Wolves." 2011. https://www.nanticokeindians.org/page/tale-of-two-wolves.

Orwell, George. *Nineteen Eighty-Four*. New York: Plume, 2003. First published 1944.

Pibbles and More Animal Rescue. "Pit Bulls Are for Hugs Not Thugs Magnet." 2020. https://www.pmarinc.org/product/pit-bulls-are-for-hugs-not-thugs-magnet/.

Rogoff, Kenneth. "Cryptocurrencies Are Like Lottery Tickets That Might Pay Off in Future." *Guardian*, December 10, 2018. https://www.theguardian.com/business/2018/dec/10/cryptocurrencies-bitcoin-kenneth-rogoff.

Scorsese, Martin. "I Said Marvel Movies Aren't Cinema. Let Me Explain." *New York Times*, November 4, 2019. https://www.nytimes.com/2019/11/04/opinion/martin-scorsese-marvel.html.

Scott, Ridley, dir. *Blade Runner: The Final Cut*. 1982; Burbank, CA: Warner Home Video, 2011.

Stahelski, Chad, and David Leitch. "Audio Commentary." *John Wick*. Santa Monica, CA: Summit Entertainment, 2014. Blu-ray.

Underwood and Underwood War Department, 1789–1947. *American Unofficial Collection of World War I Photographs, 1917–1918*. November 12, 1918.

165-WW-595C(1). National Archives at College Park—Still Pictures (RDSS). https://catalog.archives.gov/id/533759.

Wachowski, Lana, and Lilly Wachowski, dirs. *The Matrix*. Burbank, CA: Warner Brothers, 1999.

——, dirs. *The Matrix Reloaded*. Burbank, CA: Warner Brothers, 2003.

——, dirs. *The Matrix Revolutions*. Burbank, CA: Warner Brothers, 2003.

Walsh, John. "The Stepmother Complex: Anjelica Huston Has a Thing about Playing Witches. But Can She Do More Than Just Scary? John Walsh Meets a Versatile Vamp." *Independent*, October 6, 1998, 10.

Welles, Orson, dir. *Citizen Kane*. Los Angeles: RKO Pictures, 1941.

Wells, H. G. *Anticipations of the Reaction of Mechanical and Scientific Progress upon Human Life and Thought*. London: Chapman and Hall, 1901.

West, Ti, dir. *In a Valley of Violence*. Los Angeles: Blumhouse Productions, 2016.

Whedon, Joss, dir. *Serenity*. Universal City, CA: Universal Pictures, 2005.

"Women's Army Corps." In *Encyclopaedia Britannica*. Accessed July 14, 2019. https://www.britannica.com/topic/Womens-Army-Corps.

Wright, Edgar, dir. *Hot Fuzz*. Los Angeles: Universal Studios, 2007.

Zachary, Brandon. "The Hellboy Reboot Focuses on the Wrong Villain." CBR.com, April 14, 2019. https://www.cbr.com/hellboy-2019-villain-should-be-baba-yaga/.

INDEX

Adorno, Theodor W., 123–24, 137; *Aesthetics 1958–1959*, 123–24; *Minima Moralia*, 123, 124; *Prisms*, 143n23

Afanas'ev (Afanasyev), Alexander (A. N.), 194; *Russian Folk Tale(s)*, 101, 115n33, 194–95

Ahmed, Sara, and Jackie Stacey, 380, 383, 384–85

Aladdin, 1, 4

Allen, Alfie (Iosef), 45, 96, 128, 197–98, 203, 221, 317, 344, 365

Alonso-Villa, Cristina, 295

Andersson, Christianne, and Larry Silver, 398n3

Andrews, Travis M., 3

Archer, Neil, 227

architecture, 28; classical and neo-classical, 242–43; International Style, 244; *le plan libre*, layering, and "hybrid aesthetic" of Wick's house, 246–49, 340–45; "mise-en-surface," 42–43, 60; modern movement and poetic modernism, 242–43; Roman architecture and facades, 251–54; vocabularies of, 242–43. See also *John Wick* franchise

Argento, Dario, *Suspiria*, 209

Armknecht, Megan, et al., 214n10

Atomic Blonde (Leitch), 58

Atencio, Peter, 225–26

Avengers: Age of Ultron. *See* contemporary film franchises

Avengers: Endgame. *See* contemporary film franchises

Baba Yaga, 26–27, 196–203; in animated shows *Arthur* and *Ivashka iz dvortsa pionerov*, 202; male Baba Yagas in *Hellboy* and *Lawn Dogs*, 202–3, 213–14n7; as played by Georgiy Frantsevich Millyar, 201–2; in Russian folklore, 198, 199–200, 202. *See also* Bilibin, Ivan; *John Wick* franchise

Baccarin, Morena, 224

Bacchilega, Cristina, 213–14n7

Bad Boys II (Bay), 227

Bahktin, Mikhail, 27–28, 35n38

Banks, Nina, 372

Barnes, Brooks, 1

Barry, Robert, 265, 282

Barton, Mischa, 202

Bastién, Anjelica Jade, 302

Battaglia, Andrew, 28–29, 263, 342

Battle at Dogali (Cammarano), 144n34

Bauer, Janell C., and Margaret A. Murray, 361, 363–64, 365, 366

Bay, Michael, 227

Bender, Stuart, and Lorrie Palmer, 282

Benjamin, Walter, 122; "Critique of Violence, 133–34, 141; "Theses on the Philosophy of History," 136

Bernhardt, Daniel (Kirill), 46

Berry, Halle (Sofia), 77, 79, 80, 141, 228, 320, 330–31, 360, 369, 370–72, 387

Besson, Luc, 6; *La Femme Nikita*, 6, 209; *Léon: The Professional*, 6

Bilibin, Ivan: portrait of Baba Yaga, 200; portrait of Vasilisa, 207–8

Bissell, Tom, 178

Bitcoin and Blockchain, 24–25, 146–48, 150, 152–57

Blade Runner (Scott), 144n40; replicants and Wick, 143n21

Blake, Richard, 312n25

Bloch, Ernst, 285

Bloodsport 2. See contemporary film franchises

Bolter, J. David, and Richard A. Grusin, 289n31

Bond, Sarah, 192n9; on the origins of Wick's Latin tattoo, 397n1

Bordwell, David, 58, 85, 88, 90, 115n22

Boss, May, 65

Bourne Identity, The (Liman), 10, 75: discontinuity editing in, 351; Kali-inspired martial arts in, 74, 76; "run and gun"

style of, 41. *See also* contemporary film franchises

Bourne Ultimatum, The (Greengrass), 58. *See also* contemporary film franchises

Bradshaw, Peter, 34n16

Brazil (Gilliam), 144n40

Brennan, Timothy, 295

Broadbent, Jim, 226

Broadhurst, Susan, 287n13

Brock, Gillian, and Harry Brighouse, 309n2

Brody, Richard, 286

Bronson, Charles, 2, 4

Brown, David Warfield, 358

Bukatman, Scott, 272

Bunch, Sonny, 151–52, 196–97

Butler, Octavia (*Kindred*), 277–78

Butler, Taran, 77

Caillois, Roger, 26; *Man, Play, and Games*, 169; on play and games, 173–77, 182, 186, 187, 191

Cammarano, Michele (*Battle at Dogali*), 144n34

Canova, Antonio (*Ercole e Lica*), 99–100, 115n32

Caravaggio, 42, 380; *Judith Beheading Holofernes*, 395

Carroll, Nöel, 210

Castell, Manuel, 269

Catsoulis, Jeannette, 5

Chan, Jackie, 15, 114n7, 283

Changling, Wang, 86, 89. *See also* martial ideation

Chaplin, Charlie, 5, 173, 283

Chaw, Walter, 287n16

Che, Michael, 329–330

Cheah, Pheng, 15–16, 309n2. *See also* world-building and ways of worlding

Chen, Tiger Hu, 12, 84

Cheng, John, 277

Chez, Keridiana, 320

Christiansen, Deb, 399n25

Citizen Kane (Welles), 18–19

Cloete, Kervyn, 399n27

Cohen, Jeffrey Jerome: monsters and "category crisis," 204–5, 217–18

Colbert, Stephen M., 191n1

comic books and film, 14, 27; *Deadpool* comics, 218; *Hellboy* comics, 201

Common (Cassian), 7, 13, 131, 205; "commercial friendship" with Wick, 372–73; gunfight with Wick, 351–52

Connell, Raewyn, 355–56n1

Connor, Steven, 383

Constantine, Jason, 9

contemporary film franchises: *Avengers: Age of Ultron*, 209; *Avengers: Endgame*, 1, 4; *Bloodsport 2*, 69; *Bloodsport 3*, 69; *Bond* franchise, 223, 356–57n5; *Bourne* franchise, 10, 41, 58, 74, 75–76, 351; *Deadpool*, 27, 216–17, 222–24, 228–29, 231–32, 238n12; *Deadpool 2*, 76, 224–26; *Death Wish*, 2, 4; *The Equalizer*, 2, 6, 349, 382; *The Expendables*, 2; *Fast and Furious* franchise, 73; *Hellboy*, 201, 213n7; *Lethal Weapon*, 24, 94; *The Matrix*, 3, 23–24, 68–69, 84, 93–95, 112, 126, 142n14, 229–30; *The Mechanic*, 4; *Men in Black*, 4, 19; *The Raid*, 2, 12, 102; *The Secret Life of Pets 2*, 4; *Taken*, 2, 238n12, 349, 382, 383; *Transformers*, 357n7

Continental, the, and classical architecture, 249–50; glass executive suite in, 243, 258–60; "stylish timelessness of," 265

Coppola, Francis Ford, 121, 125

cosmopolitanism, 29–30; and globalism, 292–93, 304; philosophies and theories of, 291–92, 299–300. See also *John Wick* franchise

Coulthard, Lisa, and Lindsay Steenberg, 13, 22–23, 41–62

Crowe, Russell, 382–83

Cruise, Tom, 6

Curtis, William J. R., 262n3

Dacascos, Mark (Zero), 5, 95, 110, 190, 296; and fandom, 162–63; parodic aspects of fandom, 230–32, 260–61. See also *John Wick* franchise

Dafoe, Willem (Marcus), 169, 179–80, 268, 364, 374–75

Dallis-Comentale, Edward P., 26, 193, 214n14, 399n25

Daly, Margaret (Operator), 389

Damon, Matt, 74, 75

Dante, *Inferno*, 194, 333

Darwin, Charles: *On the Origin of Species*, 320

Dassin, Jules, 306

David, Jadie, 65

Day the Earth Stood Still, The (1951), 19

Day the Earth Stood Still, The (2008), 19

DeAngelis, Michael, 3, 293, 358–59

Deadpool (Miller). *See* contemporary film franchises

Deadpool 2 (Leitch). *See* contemporary film franchises

Death Wish. See contemporary film franchises

Delon, Alain, 53

Del Toro, Guillermo, 201

De Monvel, Louis-Maurice Boutet. *See* Reeves, Keanu: portraits of by Parmigianino and Louis-Maurice Boutet de Monvel

Derrida, Jacques, on the "animal," 333–34; on the inscription of skin, 390–91; on violence, 133

Desperado (Robert Rodriguez), 53

Dickey, Bronwen, 324

Dillon, Asia Kate (The Adjudicator), 7, 259, 261, 296, 308, 361, 388, 398n5

Dimendberg, Edward, 312n25

DMX, 324

dogs, 31–32; Belgian Malinois and Sofia, 79–80, 330–31; Cerberus, 323–24, 333; Daisy in *John Wick*, 317–20, 332, 365; "Dog" in franchise, 322, 325–26, 328, 331, 332, 334–35, 363; "doggy jujitsu," 79–80; *A Dog's Journey*, 321, 322–33; *A Dog's Purpose*, 321; man/dog "love story" films: *The Call of the Wild*, 321; *Old Yeller*, 320, 322; *Turner and Hootch*, 320, 322; pit bulls, 323–29

Douglas, Michael, 382

Dowd, A. A., 294, 302

Drescher, Daniel, 156

Duigan, John, 201

Dürer, Albrecht: *Heller Altarpiece*, 394; on pen-and-ink drawing, 393–94; *Study of the Hands of an Apostle*, 378–79, 394

Eagleton, Terry, 127, 142n18

Eastwood, Clint: William Munny in *Unforgiven* and Wick, 352

Ebiri, Bilge, 6, 11

Edgerton, Harold, 271

Ehrlich, David, 300–1, 308, 311n17

87Eleven Action Design, 64–81; animal stunts, 77–80; founding of, 68–69; philosophy of martial arts training, 72–76; and #Stand Up for Stunts, 72–73; use of previz production practices, 71–72, 125

Embry, Mary, 399n25

Epper, Jeannie, 65

Equalizer, The (Fuqua). *See* contemporary film franchises

Ercole e Lica (Canova), 99, 115n32

Eusebio, Jonathan "Jojo," 71, 73, 74–76, 101, 102

Evans, Rhonda, 213n1

Ever After: A Cinderella Story (Tennant), 210

Expendables, The (Stallone). *See* contemporary film franchises

Fachriansyah, Rizki, 301

fairy tales and anti-fairy tales: impossible tasks in, 195, 203, 205; roles of "helper" characters in, 203. See also *John Wick* franchise

Falling Down (Schumacher), 382

Fan, Victor, 88

fans and fan culture, 9, 11, 14, 55, 59, 265, 286n2, 317, 321, 396–97

Farquhar, Mary, 88

Fattori, Giovanni, 98–99, 144n34

Fear, David, 4

film genres: aging action star comeback film, 2–3; film noir and the urban landscape, 24–25, 134–35, 305–6, 312n25; gladiator films and masculinity, 352, 353–54, 382–83; westerns and gunfight with Cassian in *John Wick 2*, 351–52

Fishburne, Laurence (Bowery King), 7, 17, 141, 204, 308, 390–91; as Morpheus in *The Matrix*, 266

Flusser, Vilém, 160–61, 278–79

Flynn, Jerome (Berrada), 140, 170, 228, 281, 320

Fore, Steve, 114n7

Fradley, Martin, 382–83

Frampton, Kenneth, 262n2

Francisco, Eric, 32–33n1

Frankfurt School, the, 24; critique of the culture industry, 23, 122–23; cultural laborers as dupes, 64; inversion of means and ends in mass culture, 123–24; on violence, 23, 121, 124–25

Frearson, Amy, 245

Freud, Sigmund: "Mourning and Melancholia," 384, 399n20

fridging, 127, 317–18. See also *John Wick* franchise

"Frog Princess, The," 203

Frye, Northrop, 388

Fuqua, Antoine, 6. *See also* contemporary film franchises

Gaeta, John, 272, 287n13

Game of Thrones, 79

Gardner, Jared, 14

Gehring, Wes D., 220. *See also* parody

Gerard, David, 154

Gerini, Claudia (Gianna), 98, 130–31, 205, 253–54, 373

Ghahramani, Tanya, 238n13

Gibbs, Anisha, 79

Gibson, William: *Johnny Mnemonic*, 159

Gilbert, Sophie. 192n9, 318

Gilliam, Terry, 144n40

Gladiator (Scott), 382. *See also* film genres

Golumbia, David, 153, 154

Gondry, Michel, 271

Good, the Bad, and the Ugly, The (Leone), 274

Goodman, Nelson, 8, 10; on style and world-building, 385. *See also* world-building and ways of worlding

Grandmaster, The, 93

Greengrass, Paul, 58

Griffith, Tad, 77–78

Grossberg, Lawrence, 396

Groys, Boris, 149

gun fu, 55, 125, 268

Gunning, John, 37n63

Gunning, Tom, 271, 287n11

Hall, Peter, 387

Halloran, Vivian Nun, 22, 31, 377

Haraway, Donna, 332

Harbour, David, 201

Harries, Dan, 219. *See also* parody

Harris, Will, 3, 329–30

Harvey, David, 294–95

Hatzis, George, 268

Hawke, Ethan, 335n4

Hayot, Eric, 8–10, 15–16, 312n27. *See also* world-building and ways of worlding

Hebdige, Dick, 399n24

Heidegger, Martin, 8–9

Hellboy (Marshall). *See* contemporary film franchises

Hero (Zhang), 88

Hertz, Barry, 398n5

Hicks, Moira, 197

Hirsch, Jr., E. D., 399n23

Hobbit, The: Battle of the Five Armies (Jackson), 19

Hollywood stunt-craft history, 64–70; effect of *The Matrix*, 68–70; founding of the Society of Professional Stunt-women, 65–66; founding of Stunts Unlimited, 65–66

Hong Kong action aesthetics, 47, 55; in *Charlie's Angels*, 94; in *Lethal Weapon 4*, 94; in *The Matrix*, 94–95; in *Shanghai Noon*, 94. See also *John Wick* franchise

Horkheimer, Max, and Theodor Adorno, 122; on the culture industry, 122, 123, 182; on instrumental reason, 135; on the inversion of means and ends, 123–27. *See also* Frankfurt School; Adorno, Theodor W.

Horton, Owen R., 22, 31, 357

Hot Fuzz (Wright), 226, 227–28

Hu, King, 116n42

Huizinga, Johann, *Homo Ludens*, 26, 169; principles of play, 170–73, 185–86, 189, 191

Hunt, Leon, 90

Huston, Anjelica (The Director), 7, 127, 222, 299, 301–2, 320, 360, 369–70, 391, 394–95; and fairy tale witches, 209–11; interview with John Walsh, 210; piercing of hands and fealty, 390. Film roles: *The Addams Family, Addams Family Values, Ever After: A Cinderella Story, The Witches*, 210

Hutcheon, Linda, 219. *See also* parody

Huyssen, Andreas, 137

Ibrahim, Taha: the "semi-hero," 196, 212

In a Valley of Violence (West) and canine "fridging," 335n4

Inosanto, Dan (Inosanto Academy), 69, 74–76, 85, 92, 101, 105

International Fairy-Tale Filmography, The, 213–14n7

Ip Man biopics, 93

"Ivan Tsarevich, the Grey Wolf, and the Firebird," 203

Jack Reacher, 6

Jackson, Gita, 356n4

Jackson, Peter, 19

Jaffe, Aaron, 24–25, 81, 165

Jameson, Fredric, 29, 122, 126–27, 190; "figuring" late capitalism, 139–40; *Late Marxism: Adorno, or the Persistence of*

the Dialectic, 142n18; "Reification and Utopia in Mass Culture," 138; works of: "The End of Temporality," 144n41, 266, 268–69

Jaws (Spielberg), 138

Jeffords, Susan, 349, 350

Jeffries, Stuart, 123, 135

John Wick franchise: "balletics" of action scenes, 5, 42, 307–8; box office success, 1–2; "bullet time" in, 269–72; coins in, 25, 140, 146–48, 151–52; cosmopolitanism, 11, 29–30, 281, 282, 293–96, 297, 298–99, 301–2; debt and exchange in, 162–64; fairy tales and anti-fairy tales, 26–27, 194–95, 197–203; feminist critique in, 363–76; grief and mourning in, 21, 27, 28, 183, 195, 217, 222, 225–28, 233, 355, 365, 366, 382, 384, 397, 399n20; kill or "body" counts in, 5, 46, 48, 50, 52, 54, 56, 60n2, 115n31, 268; "markers" in, 130–31, 148, 194, 205, 252, 367–68, 371–72, 383–84; mixed martial arts in, 74–76, 101, 102, 103–4, 300–1; "mythic" aesthetic of, 6–7; and Odysseus, 182, 194, 196–97, 331; "para-action" sequence in, 46–47; parody and self-parody in, 27, 216–17, 221–22, 228, 229–30; principles of play in, 169–73, 184–85; professional women and nonbinary employees in, 369–76; utopian dimensions of, 140–41; and video games, 56–57, 161–62 177–78, 180; Wick as Baba Yaga or monster, 27, 48, 51, 128, 133, 195–203, 212, 221, 340, 344–45, 384; Wick as fairy tale hero,

204–11; Wick as gladiator, 352–54; Wick and James Bond, 356–57n5; Wick as pit bull, 323–26; Wick as semi-hero, 196, 212; Wick and Vasilisa the beautiful, 207–8; Wick's liminality, 340–41; Wick's masculinity, 21–22, 30–32, 348–52, 355–56n1, 362–63, 365, 382–83, 395; Wick's multilingualism, 295–96, 310n11; Wick's tattoos, 149, 187, 378, 383, 385. *John Wick*: "bisexual" and other lighting in, 31, 51, 346–48; Daisy's murder and "fridging," 317–21; Red Circle sequence in, 43–60, 61n6, 348, 353; and video games, 161–62. *John Wick 2*: art (painting and sculpture) in, 97–100, 144n34, 181; assassination of Gianna D'Antonio, 130–32, 205, 253–54, 373, 381, 388, 396; catacombs fight and liminal space, 250–51, 254–56, 263n12; destruction of Wick's house, 129, 250–51, 331, 367; final sequence of, 16, 272–73; fight in the mirrored art installation, 256–57, 369; markers in, 205–6, 251–52; Roman architecture in, 253–54; shooting of Santino D'Antonio, 97, 149, 206. *John Wick 3*: Caravaggio's *Judith Beheading Holofernes* in, 395; the Continental Switchboard, 144n41, 273, 278–81, 283; dog training for, 79–80; fairy tales and wicked witch in, 194–95, 207–11; fealty and bodily perforations in, 390–91, 402–3; fight in executive glass suite, 103–6, 110–11, 189, 258–61; horse ride in, 77–79, 273–76, 288n17, 390; library scene in, 19, 97, 101, 194–95,

207–8, 213n1, 333; opening scene in, 272–73; scene with the Elder, 107–9, 129, 137, 180, 233–35, 384; self-parody in, 228–29; Tarkovsky Theatre, scenes in, 209–10, 356n2, 391–92; Wick and the ballerina as doubles, 391–94; Wick's branding, 302–3, 394–95; Winston's "betrayal" of Wick, 143n30, 354; Zero as "fanboy," 162, 204, 230–32

John Wick Hex (video game), 179

Johnson, Julie, 65

Jovovich, Mila, 201

Kain, Erik, 8

Kaleida: "Think" (electropop), 50

Kallgren, Kyle, 346–47

Kant, Immanuel, 291

Kaplan, David, 213–14n7

Keanu (Atencio), 225–26

Keaton, Buster, 15, 173, 273, 283

Keefe, Patrick Radden, 398n12

Kelly, David Patrick (Charlie), 12, 136

Kendall-Morwick, Karalyn, 30–31, 79, 127, 338, 371, 378

Keogh, Brendan, 317–18

Kermode, Mark, 5–6

Key, Keegan-Michael, 225

Kill Bill 1 (Tarantino), 58

Kim, Randall Duk (The Doctor): as Baba Yaga, 213–14n7; as the Keymaker in *The Matrix*, 266

Klevjer, Rune, 190

Kolstad, Derek, 176, 199, 380; on indebtedness and markers, 383–84

Krafsky, Kim, 323

Kulezic-Wilson, Danijela, 47

Kurosawa, Akira, 15

La Battaglia di Custoza (Fattori), 98–99, 144n34

La Femme Nikita (Besson), 6, 209

Langkjaer, Birger, and Charlotte Sue Jensen, 116n38

Laozi, 116n43

Laustsen, Dan, 5

Lave, Jean, and Etienne Wenger, 81n4

Lawn Dogs (Duigan), 201–2, 213n7

Lawrence, Francis, 209

Le Castle Vania: "The Drowning," 48; "LED Spirals," 52, 53, 54, 373; "Shots Fired," 53, 54

Le Corbusier, 381; the house as machine, 244, 245; *le plan libre*, 246–49; "reminder" to architects, 380

Lee, Brandon: *The Crow*, 85

Lee, Bruce, 70, 92, 103; *Bruce Lee: A Warrior's Journey*, 92; *Enter the Dragon*, 24, 102, 111; *Fist of Fury*, 92; *Game of Death*, 92; *The Way of the Dragon*, 92

Lee, Mi Jeong, 11, 29–30, 281, 313

Leguizamo, John (Aurelio), 129, 162

Leinster, Murray, 266; "Sideways in Time," 276–77

Leitch, David, 10, 12, 34n15, 335n5, 380; on Daisy in *John Wick*, 318–19, 323; on "John" versus "John Wick," 197; martial arts training, 68–70, 101–2. Films: *Atomic Blonde*, 58; *Deadpool 2*,

76, 224–25. *See also* contemporary film franchises; 87Eleven Action Design; *John Wick* franchise

Lèon: The Professional (Besson), 6

Leone, Sergio, 15, 274

Le Samourai (Melville), 53

Leung, Tony, 93

Liman, Doug, 75

Liu, Marjorie, 21–22

Lloyd, Harold, 5

Longo, Chris, 288n17

Lumet, Sidney, 306

Lyon, Janet, 309n2

Macmillan, Tim, 271

MacSwiney, Terence, 381–82, 395

Manaev, Georgy, 199

Mandela, Nelson, 112

Mangold, James, 71

Man of Tai Chi (Chen), 84

Marjanović, Boban, 19, 101, 194

Marshall, Neil, 201. *See also* contemporary film franchises

martial arts: aikido, 55; Hung Gar, 90, 91–92; Jeet Kune Do, 70, 74, 85, 91, 102, 107, 114n6, 116n37, 116n43; Judo, 55, 101; Jun Fan Gung fu, 102; Kali (Escrima), 70, 74, 75–76, 101; Machado Brazilian jujitsu, 55, 74, 101; silat, 301; Wing Chun, 90, 91, 93, 94

martial ideation, 84–91; *guan* (perspicaciousness), 86, 91, 92–95, 104, 107–9, 110; *ren* (humaneness), 86, 95–101; *wu* (nothingness), 86, 92, 94–95, 101–6; tranquility, 86–87, 91, 95, 105–7

Marvel Studios, 121–22

"Marya Morevna," 203

Massey, Doreen, 291, 296–97

Massumi, Brian, 396

Mato, Daniel, 81n1

Matrix franchise, *The*, 3, 10, 225; "bullet time" in, 29, 266, 269–71, 272; fusion of Hong Kong classics in, 102–3; Leitch's, Stahelski's, and Reeves's collaboration in, 68–69; martial ideation in, 94–95; and science fiction, 126–27. *See also* contemporary film franchises

Mayo, Simon, 5–6

McAra, Catriona, and David Calvin, 213n5

McCarrey, Cat, 3

McDonald, Paul, 214–15n16

McEwen, Indra Kagis, 252, 263n7

McFarland, Melanie, 21–22

McShane, Ian (Winston), 7, 104, 132, 162, 197, 222, 258–59, 308, 354; arbiter of rules, 16, 367–68; symbol of civilized play, 185

Mechanic, The (with Charles Bronson), 4

Mechanic, The (with Jason Statham), 4. *See also* contemporary film franchises

Melville, Jean-Pierre, 53

Mendelson, Scott, 1, 4, 7

Men in Black: International. See contemporary film franchises

Midsummer Night's Dream, A (Hall), 387

Mignola, Mike, 201

Miller, T. J., 223

Miller, Toby, 81n1

Millyar, Georgiy Frantsevich, 201–2

Moneymaker, Heidi, 21

monster culture and theory, 196–98, 217–18

Moore, Toby Leonard (Victor), 45

Morfino, Vittorio, and Peter D. Thomas, 285–86, 289n33

MosJ, 144n34

Moynahan, Bridget (Helen), 20, 96, 221, 299, 317–18, 341, 353–54, 362

Mulderig, John, 400n30

Murray Multiplex Page-Printing Telegraph, 284

music, movement, and martial action, 47, 48, 49, 51–52, 56–57

Myers, Stevie, 65

Nakamoto, Satoshi, 154–55

Naked City (Dassin), 306

Nancy, Jean-Luc, 380–81, 383

Nanicelli, Ted, 214–15n16

Nash, Kevin (Francis), 19, 45

Needham, Hal, 65

Neeson, Liam, 2, 349, 383

Nero, Franco (Julius), 373, 387

Nestor, Mary, 27, 213n7, 238

Newby, Richard, 2

Newman, Marleen, 28–29, 264, 342

Nishime, Leilani, 300, 311n16

Norris, Chuck, 92

Nyqvist, Michael (Viggo), 9, 12, 48, 128, 169, 184, 197, 221, 244, 339

Orwell, George, 144n40

Ozimek, Adam, 150–51, 380

Page, Priscilla, 207; on Caravaggio in *John Wick* 3, 395; on Vasilisa the Beautiful, 207–8; on Wick's tattoos, 378, 391

Palicki, Adrianne (Ms. Perkins), 13, 361, 369, 375–76

Parikka, Jussi, 275

Parmigianino. *See* Reeves, Keanu: portraits of by Parmigianino and Louis-Maurice Boutet de Monvel

parody, 27; allusions to popular culture in, 223–24; as "double-voiced" discourse, 219; excessive violence as parodic, 221–22; "fourth-wall" breaking in, 224; and genre, 219–20; and grief, 226–27; self-parody and self-referentiality, 228–29; spoof of superhero genre, 223–24; as subgenre of comedy, 220–21. See also *John Wick* franchise

Peele, Jordan, 225

Pegg, Simon, 226

Périllon, Thomas, 6, 33n10

Peters, Clarke (Harry), 162, 375–76

Phelan, Unity (Ballerina), 360, 381, 391, 393

Philip, Tom, 2–3

Phillips, Michael, 5–6

poetic modernism in architecture. *See* architecture: modern movement and poetic modernism

Poland, Bailey, 321

Prakash, Gyan, 312n25

previz, 59, 70–72, 78, 125

Prince of the City (Lumet), 306

production studies, 63–64

Propp, Vladimir, 27, 203, 211–12; *Morphology of the Folktale*, 203, 214n12

Purse, Lisa, 59, 272, 352–53

Rahman, Cecep Arif (Shinobi), 12, 301

Raid, The. See contemporary film franchises

Ran, Jiao, 87. *See also* martial ideation

Ray, Robert, 128, 142n19

Red Sparrow (Lawrence), 209

Reddick, Lance (Charon), 7, 20, 142–43n20, 162, 222, 259–60, 323

Reeves, Keanu: acting style and affect, 293–94, 302, 311n16; early career, 293, 356n4, 358–59; horse training, 77–79; martial arts training, 61n4, 73–74, 300–1; mixed race and racial ambiguity, 42, 293–94, 300, 311n16, 329–30; portraits of by Parmigianino and Louis-Maurice Boutet de Monvel, 265; star persona, 42–43, 47–48, 293; stunt and wushu training, 71–74, 76; vulnerable masculinity, 302; youthfulness, 3. Films: *47 Ronin*, 3; early *Bill and Ted* films, 265; *Bill and Ted Face the Music*, 286; *Johnny Mnemonic*, 159; *Point Break*, 225, 227–28; *Speed*, 267, 293. See also *John Wick* franchise; *Matrix* franchise

Regan, Bridget (Addy), 20, 366–67, 386–88

Rehak, Bob, 271

Reid, Chris, 177

Reservoir Dogs (Tarantino), 53

Reynolds, Ryan, 223

Riaux, Simon, 2, 5

Roach, Joseph, 396–97

Robbins, Bruce, and Paulo Lemos Horta, 299–300

Robinson, Jennifer, 311–12n24

Rockwell, Sam, 202

Rodriguez, Robert, 53

Roeg, Nicolas, 210

Rogers, Scott, 72, 79

Rolston, Matthew, 270–71

Rondell, Ronnie, 65

Rose, Ruby (Ares), 256, 361, 369, 373–74

Roy, Ananya, 312n24

Ruhian, Yayan (Shinobi 2), 12, 301

Ryan, Marie-Laure, 10–11. *See also* storyworlds

Sadoski, Thomas (Jimmy), 9, 13

Said, Edward, 282

Sanders, James, 312n25

Sassen, Saskia, 311–12n24

Saving Private Ryan (Spielberg), 351

Say Anything (Crowe), 223

Scamarcio, Riccardo (Santino), 17, 97, 250–51, 339, 367, 383

Schiff, Evan, 5

Schultz, Cale, 70

Schumacher, Joel, 382

Schwarzenegger, Arnold, 349

Scorsese, Martin, 121–22, 125, 126

Scott, Ridley, 143n21, 144n40, 382

Secret Life of Pets 2, The. See contemporary film franchises

Seger-Guttmann, Tali, and Hana Medler-Liraz, 366–67, 372

Shaw, Bernard, 25

Shaw Brothers, the, 283

Shore, Heather, 312n25

Silicon Valley, 156–57, 164n22

Simpson, Andrew, 79

Sims, David, 192n9

Siza, Álvaro, 28, 243, 245–46

Sloterdijk, Peter, 142n16

Smith, Murray, 214–15n16

Sobczynski, Peter, 7, 191n1

Society of Professional Stuntwomen. *See* stunt work

Soja, Edward W., 190

Sonnenfeld, Barry, 210

spectacular masculine body, 349–50

Spiedel, Jackson "Spider," 76

Spielberg, Steven, 19, 138, 351

Stahelski, Chad, 4–5, 197, 268, 318; on ballet, 32–33n1, 381; on Belgian Malinois dogs in *John Wick* 3, 330–31; on casting Anjelica Huston in *John Wick* 3, 210; on the centrality of New York in the Wickverse, 304–6; on coins and markers in *John Wick*, 147; on "Dog," 322, 326; on martial arts and 87Eleven Action Design, 68–70, 85, 101–2, 103–4, 105–6; on mixing musicals, physical comedy, and action cinema, 283; on physical realities of the Wickverse, 12–13; on worldbuilding, 7, 380. See also *John Wick* franchise; 87Eleven Action Design

Stallone, Sylvester, 2, 349

Statham, Jason, 4

Steenberg, Lindsay, 349, 352. *See also* Coulthard, Lisa, and Lindsay Steenberg

Steimer, Lauren, 10, 23–24, 83, 127

Stormare, Peter, 12, 96, 127, 350

Story of Wong Fei-Hung: Part One, The, 91–92

storyworlds: fans and audiences as active agents, 14–15; principle of minimal departure, 11, 13; reality and stylization in, 13, 36n39; temporal dimensions of, 13; "two-foldedness" of characters in, 15, 214–15n16. *See also* Ryan, Marie-Laure

Strauven, Wanda, 271

stunt work, 64–68; Hong Kong influence and "previz" production, 68–71; Society of Professional Stuntwomen, 65–66; Stunts Unlimited (later Stuntmen's Association of America), 65–66

Sutton-Smith, Brian, 192n11

Suzuki, Daisetz T., 116n37

Taghmaoui, Saïd (The Elder), 107–9, 281, 354

Taken. *See* contemporary film franchises

Tarantino, Quentin, 53, 58, 126

Tarkovsky, Andrei, 42

Tasker, Yvonne, 20, 349, 350

Taylor, Robin Lord (The Administrator), 390

Tennant, Andy, 210

Thompson, Carl, 327, 336–37n25

Tobe, Renée, 241–42

Touch of Zen (Hu), 116n42

Travers, Peter, 5, 6

Trethewey, Angela, 360, 361–62, 374

Truitt, Brian, 319, 320

Tu, Sikong, 87.

Tung, Charles M., 13, 16, 144n41, 289, 380, 390

Van Damme, Jean-Claude, 349

Vasilisa the Beautiful, 194, 200, 201, 207, 208

Vick, Michael, 327–28

Vishnevetsky, Ignatiy, 191n1, 192n9

Vitruvius, *On Architecture*, 252–53, 263n7

Wachowski, Lana and Lilly, 47, 82n6, 269

War of the Worlds (Spielberg), 19

Warren, Cat, 330

Warwick Research Collective in World-Literature, 276

Washington, Denzel, 2, 6, 349

"waste pan," 18–20

Watt, Caitlin G., 26–27, 38, 215

Watt, Stephen, 31–32, 38, 311n22, 360, 400

Watts, Alan, 116n37

Weaver, Harlan, 324, 328–29

Weaving, Hugo, 94

Weinstock, Jeffrey Andrew, 218

Weintraub, Steve "Frosty," 34n15

Welles, Orson, 18–19

Wells, H. G., 275

West, Ti, 335n4

Whedon, Joss, 71, 209

Whittaker, Richard, 335n5

Wickverse, 10–11, 13, 43, 396; built environment of, 242–43, 244, 261–62; centrality of New York in, 304–6, 312n25; and cosmopolitanism, 11–12, 291; and fans, 9, 12, 396–97; global map of, 297–98; indebtedness and the marker in, 383–84; and subcultures, 399n24; as "submedial safe room," 163; temporal characteristics of, 27–28, 278–79. See also *John Wick* franchise

Wilder, Glenn, 65

Williams, Stephen J., 152–53, 156

Willis, Bruce, 4

Willman, Skip, 145

Witches, The (Roeg), 210

Wittenberg, David, 18–19

Wolf, Kelly, 77–78

Wolin, Jacob, 33n10

Wollheim, Richard, 15

Wolverine, The (Mangold), 71

Wong, Wayne, 24, 113n1, 117

Woo, John, 47, 283; *A Better Tomorrow*, 102, 103; *The Killer*, 103

Woo-ping, Yuen, 68, 70, 113n3; *The Matrix*, 84, *Drunken Master*, 102. See also contemporary film franchises; 87Eleven Action Design

world-building and ways of worlding, 8–21; gender in, 20–22; influence of stunt work and action cinema, 10; philosophies of, 10; real and represented worlds, 9, 11–12, 35n39; scale, space, and size, 17–20, 37n63; self-propagating

quality, 8–9; and subcultures, 383; time in, 15–17

Wright, Edgar, 226, 227–28

Yama, 19

Yang, Jeff, 311n16

Yankovic, Weird Al, 324

Year of the Fish (Kaplan), 213–14n7

Yen, Donnie, 93

Yimou, Zhang: *Hero*, 88

Yu, Yan, 87. *See also* martial ideation

Zhang, Yimou, 88

Zhiyi, 93

Zielinski, Siegfried, 275

Žižek, Slavoj, 12, 122; on the "Big Other" and the symbolic order, 134–35; on the richness of inner life, 129–30, 143n23; works of: *The Sublime Object of Ideology*, 142n16, 142n17, 143n21; *Violence* 135–36, 142n19

Zong, Baihua, 87–88, 89, 114n14. *See also* martial ideation